COLOR DRAWING

A Marker/Colored-pencil Approach for Architects, Landscape Architects, Interior and Graphic Designers, and Artists

Michael E. Doyle

VNB VAN NOSTRAND REINHOLD COMPANY
NEW YORK CINCINNATI TORONTO LONDON MELBOURNE

To James R. DeTuerk,
who passed his delight
in drawing on to me.

Library of Congress Catalog Card Number 79-15640
ISBN 0-442-22184-3

Printed in Hong Kong
Designed by Loudan Enterprises

Published by Van Nostrand Reinhold Company
135 West 50th Street, New York, N.Y. 10020

Van Nostrand Reinhold Limited
1410 Birchmount Road, Scarborough, Ontario
M1P 2E7, Canada

Van Nostrand Reinhold Australia Pty. Limited
17 Queen Street, Mitcham, Victoria 3132, Australia

Van Nostrand Reinhold Company Limited
Molly Millars Lane, Wokingham, Berkshire, England

16 15 14 13 12 11 10 9 8 7 6 5 4 3 2 1

Library of Congress Cataloging in Publication Data
 Doyle, Michael E
 Color drawing.

 Bibliography: p.
 Includes index.
 1. Color drawing—Techniques. I. Title.
NC892.D69 741.2'4 79-15640
ISBN 0-442-22184-3

Here is the golden rule: . . . With color you accentuate, you classify, you disentangle. With black you get stuck in the mud and you are lost. Always say to yourself: Drawings must be easy to read. Color will come to your rescue. —LeCorbusier

Contents

Acknowledgments

I would like to extend my acknowledgment and appreciation to the following people:

Ellen Burgess, Tom Lyon, Linda Turner, Jean Ann Fortier, and John Wolff for their love and support. John gave me the idea to do the book in the first place.

Jim Bloomer, Ed Hildebrand, and Bob Netterstrom for generously lending their photographic equipment.

Nancy N. Green, Editor-in-Chief, Trade Books, Van Nostrand Reinhold Company.

William Kirby Lockard and Faber Birren for kindly taking the time to review and comment on my early manuscripts.

Betty Cooney, librarian, Art and Architecture Library, University of Colorado at Boulder.

The graduate students in my graphic-communication classes at the College of Environmental Design, University of Colorado at Denver.

The undergraduate students in my graphic-communication classes at the College of Environmental Design, University of Colorado at Boulder.

Tony Lefton and Richard Aram of Art Hardware in Boulder, Colorado for their generous information, advice, and use of materials.

Leslie Rice and Ted Thomas of the Auraria Book Center, Denver, Colorado.

Mr. D. C. Urmston, President of Cooper Color, Inc., Jacksonville, Florida, for providing the information used to compile the Marker-brand Cross-reference Chart in Appendix A.

Mrs. Louise P. Galyon, Resident Manager of Munsell Color, Baltimore, Maryland, for providing the photograph of the Munsell Color Tree and permission to show the photographs of hue charts from the Munsell Student Set.

Marilyn Leivian Harvey, Penny Burt, Carol Thurman, The Leprechaun's Typing Service, and especially Kay Libertone not only for their excellent typing, but also for their patience.

Material quoted in this book is from the following sources: *A Color Notation* by A. H. Munsell, *Color for Architecture* by Tom Porter and Byron Mikellides, *Color Structure and Design* by Richard G. Ellinger, *Drawing as a Means To Architecture* by William Kirby Lockard, *Drawings of Architectural Interiors* by John Pile (editor), *Principles of Color* and *Creative Color* by Faber Birren, *The Art of Color* by Johannes Itten, and *The Enjoyment and Use Of Color* by Walter Sargent.

Introduction

My original intent in writing and illustrating a book on color drawing was limited to a demonstration to students and practitioners of environmental design of the simple and relatively fast techniques possible with markers and colored pencils—by far the most prevalent color-drawing media in their classrooms, studios, and offices.

As work progressed however, it became increasingly obvious to me that, if the book were to be truly useful, it would have to go beyond a discussion and illustration of techniques and to address those questions that are often ignored in writings on color or shrouded in mystery (" . . . it comes from within . . . "): What can be done to make colors relate—that is, "go together" or *harmonize*? How does one create a color composition? This book presents a clear set of fundamentals upon which to base one's decisions in creating a color composition, *whatever* color medium one chooses. Rather than advocating color composition by gimmick or formula, however, these fundamentals offer a *framework*, not a crutch, which can help free the designer from indecision while still allowing room for emotional or aesthetic expression.

But why draw in *color*? Isn't black-and-white line drawing sufficient and less trouble as well? Maybe so. Yet the question states the prob-

lem. I have often wondered about the relationship between a designer's drawing skills and his resultant environments. Louis Sullivan was a master at freehand drawing of complex ornamentation. Was it ultimately because of his drawing skill that such ornamentation appeared on his buildings? I think so. His understudy, Frank Lloyd Wright, became an accomplished renderer and could draw exquisite perspectives that bore a startling likeness to his finished buildings. Since he made the effort to *draw and thus to document* his superb detailing, it therefore appeared in the final product. I fantasize about the design origins of many of the post-1950 buildings that surround me. Not a line or tone departs from those dictated seemingly unintentionally by T-square, triangle, and pencil—gray, elevation-generated facades, bearing in reality the bleak tones of unrendered paper probably left so during the design process. They speak not of decisions about color but of the lack of them. More recently it seems that the felt-tipped marker is influencing the design of larger buildings, though unfortunately not yet in color. "Marker buildings" abound, and I can imagine their origins on the drawing board: study elevations done in alternating swipes of gray and black markers, respectively indicating those long, unbroken horizontal

strips of curtain wall and window—taken directly into working drawings. Color, interest, detail, and that most unpardonable of architectural sins, decoration, threaten to disappear forever. What one sees one mile away is no more interesting at a distance of ten feet. Bare, colorless concrete, we are told, is sophisticated. More often than not the people who use and occupy the gray neo-bunker buildings lavished with it find them just plain depressing.

Our response to color is impulsive and emotional, and we are generally far more affected by the *color* of an object than by its *form*. Porter and Mikellides, in their book *Color for Architecture*, have shown that the people whom we supposedly "design for" have long desired more and better color in their built environments—color that goes far beyond the fashionable supergraphic stripe of token color common in the 1960s.

A premise of this book is that perspective drawing is a most appropriate means by which to explore and express the design of form and space. William Kirby Lockard uses the term "design drawing" to describe this essential use of perspective drawing and his approach to it in the design process. Many of the drawings in this book are design drawings, made quickly and time-efficiently, using felt-tipped markers and colored pencils in the loose, expressive manner typical of drawings done in the early design-exploration stages of a project. To provide a range of design-drawing types, however, more formal "renderings" or "persuasive drawings," the kind done at the *end* of the design process, are also evident throughout this book. In keeping with the design-drawing premise most of the illustrations in this book were designed, then drawn, from "scratch," with a handful drawn from life. Tracing from slides or photographs was avoided except in those few cases where it was appropriate. In those instances the slides appear as photographs and are shown along with the drawings.

It is my hope that you, the artist and designer, will use this book as a catalyst for drawing and creating your compositions in color, progressing to the point at which you outgrow this book and develop your *own* approach to color drawing and color composition. If design schools, students, and professionals again start teaching and learning to respond, think, and design competently and comfortably in color, it will ultimately be reflected in a much more interesting and human built environment.

Besides, drawing in color is more fun.

ONE

Materials, Methods, and Techniques

As buildings are built with the use of a variety of materials, so too can drawings of buildings—whether exteriors, interior spaces, or landscaped views—be built when one possesses the knowledge of how to draw these materials.

Part One is an introduction to the media with which color drawing is presented in this book. It is addressed especially to those who have little or no experience in drawing and thinking in terms of color or with using markers and colored pencils together as a color medium. Examples of a variety of possible techniques and effects are included, especially those applicable to architectural graphics. They are used in Chapter 3 in a series of step-by-step demonstrations that show how commonly used materials in environmental design can be drawn.

1 A Marker / Colored-pencil Approach to Color Drawing

Markers and colored pencils are ideal for use *during* the design process as well as for final renderings or persuasive drawings. Since much rough drawing and sketchwork is done on thin tracing papers, brush media such as watercolor and tempera are unusable, since they will buckle the paper. Markers dry quickly with no buckling and, along with colored pencils, can be quickly used on almost any drawing surface.

Neither extensive practice nor a high level of skill is necessary with these two color media, since methods are simple and direct, though by becoming familiar with the methods you will probably speed your work considerably. For most designers this approach to color is faster and easier to handle than brush media and one with which most students and professionals are to some degree familiar.

Many of the advantages and subtleties of watercolor and other brush media are attainable with markers and colored pencils. The mingling and graded washes of watercolor and airbrush techniques can be imitated, as can the highlighting achieved with opaque brush media such as casein and tempera.

Markers and colored pencils are readily available commercially and are probably the most widely used color media in professional design offices today—more so than the brush media of tempera and watercolor.

Suggested Palettes of Markers, Colored Pencils, and Line Media

A variety of marker brands is available at stores that specialize in art or drafting supplies. AD Markers, Magic Markers, and Design Art Markers are among the most popular trade names in this country. Choose a marker brand with a full range of colors so that a wide choice is possible (C1–1). Each of the brands mentioned above offers between 100 and 200 different colors, many of which are variations of a single hue. AD markers were used for the illustrations in this book. A cross-reference chart of brand-name colors is given in Appendix A. You can refer to the Appendix to match your brand with the one used in this book.

It pays to use a high-quality colored pencil for this kind of drawing.

A soft, waxy pencil is preferable to a hard, brittle type, as it produces a more brilliant deposit of color, a necessary characteristic for effecting lighted surfaces on tracing or toned print paper. I have found Eagle Prismacolor colored pencils to be the best available for the kind of drawing discussed and illustrated in this book. Another comparable line of pencils is Venus Spectracolor by Faber Castell.

Whether you are primarily involved with interiors, exteriors, or general colorwork, black-line media in a variety of widths are necessary for texturing and outlining (1–1). Since technical pens often clog when used over waxy colored pencils, it is best to use felt-tipped and ordinary fountain pens. Of course, other types of line media that you find workable may be substituted for those suggested. The important point is to have a variety of line widths available.

As with the line media mentioned above, you will also need a palette of gray markers and colored pencils (including black and white), regardless of the type of colorwork you are engaged in (C1–2).

Warm-gray pencils and markers are slightly reddish, while cool- and cold-gray markers and pencils are slightly bluish. It is recommended that you obtain both a warm-gray pencil series and a cool-gray marker series. With this variety neutral grays and neutralized reductions of color intensity may be mixed when desired. Cool-gray markers also seem to represent exterior windows more believably.

If your design work primarily encompasses natural materials and outdoor design, as does that of a landscape architect, a natural palette of markers and colored pencils (C1–3) is recommended. These colors can be used to draw plant materials, various kinds of wood, brick, a variety of stone types, and other related materials. The steps involved in drawing these materials are illustrated and explained in Chapter 3.

1–1. The black-line media that I use most in my color-drawing work are listed here according to their line thickness. From top to bottom are the Pilot Razor Point, a good thin-line felt-tipped pen used for layout; a fountain pen (this one is my favorite—a refillable Parker 21); a Sharpie felt-tip made by Sanford; and a Markette felt-tip made by Eberhard Faber. I use the Pilot Razor Point and the fountain pen almost exclusively; I use the other two pens only occasionally for extraheavy lines. A good nonclogging ink for the fountain pen is Sheaffer's Skrip Permanent Jet Black #32.

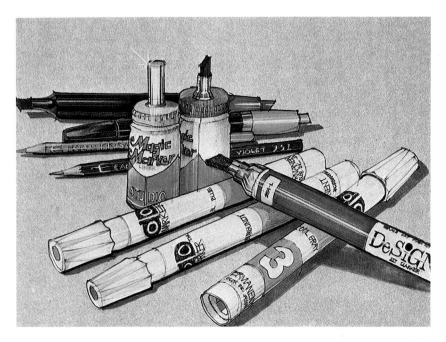

C1–1. Drawn here are a variety of the most popular brands of markers and colored pencils suitable for the color-drawing technique discussed and illustrated in this book. Choose a marker brand that offers a wide selection of colors.

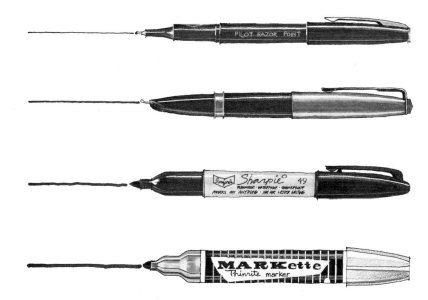

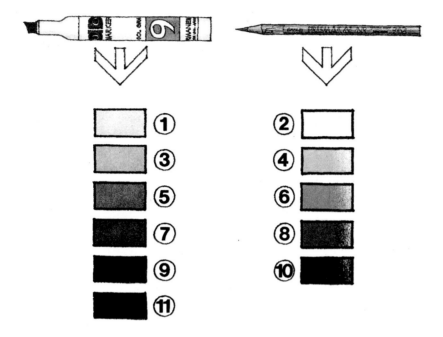

If you work with interiors or generally want to explore the use of color in design beyond the limited palette of naturals, an additional palette of colors is suggested (C1–4). This palette presents usable versions of the 10 basic Munsell hues discussed in Chapter 4. The marker colors are similar to each other in lightness and brilliance (discussed later as "value" and "chroma") and were chosen for two reasons. First, *more* brilliant marker colors are not needed, since colored pencils are usually used to supply the brilliant spots of color. Second, if *less* brilliant versions of these colors are desired, they may be reduced with gray markers or colored pencils (see the section on mixing basics in Chapter 4).

The palettes listed above are *basic* sets of markers and colored pencils, and, while they will fill many of your color-drawing needs, they may not fill all of them. In the future you will probably want to purchase additional markers and colored pencils for specialized uses. Use Appendix B as an aid in locating additional colors needed for your colorwork.

C1–2. A useful palette of grays. The boxes on the left were toned with gray AD markers, while the boxes on the right were toned with gray Prismacolor pencils:

Cool Gray #1	[1]	[2]	White
Cool Gray #3	[3]	[4]	Warm Grey Very Light
Cool Gray #5	[5]	[6]	Warm Grey Light
Cool Gray #7	[7]	[8]	Warm Grey Medium
Cool Gray #9	[9]	[10]	Black

C1–3. The palette of naturals. Most natural architectural and plant materials can be drawn with this palette of colors. Boxes colored with AD markers are on the left, Prismacolor pencils on the right:

Slate Green	[1]	[2]	Peacock Green
Dark Olive	[3]	[4]	Olive Green
Light Ivy	[5]	[6]	Apple Green
Light Olive	[7]	[8]	Cream
Olive	[9]	[10]	Sand
Pale Olive	[11]	[12]	Burnt Umber
Sand	[13]	[14]	Burnt Ochre
Beige	[15]	[16]	Flesh
Burnt Umber	[17]	[18]	Terra Cotta
Redwood	[19]	[20]	Violet
Brick Red	[21]	[22]	Light Violet
Kraft Brown	[23]	[24]	Light Blue

C1–4. The general palette. These colors are recommended as a supplement to the palette of naturals and together form a complete basic set of colors for general color drawing and color design. The colors shown here are the approximate equivalents of the 10 basic Munsell hues (though not all appear at strong chroma). Again, the boxes colored with AD markers are on the left, Prismacolor pencils on the right. The arrows denote markers and colored pencils across from each other that are approximately the same in hue. The boxes with stars indicate colored pencils already included in the palette of naturals (C1–3):

Munsell hue	AD marker			Prismacolor pencil
Red	Salmon	[1]	[2]	Scarlet Lake
Yellow Red	Golden Tan	[3]	[4]	Orange
Yellow	Golden Ocher	[5]	[6]	Canary Yellow
Green Yellow	Chrome Green	[7]	[8]	Apple Green
Green	Forest Green	[9]	[10]	Grass Green
Blue Green	Sea Green	[11]	[12]	Peacock Green
Blue	Sea Blue	[13]	[14]	Non-Photo Blue
Purple Blue	Colonial Blue	[15]	[16]	Light Blue
Purple	Grape	[17]	[18]	Violet
Red Purple	Pale Burgundy	[19]	[20]	Pink

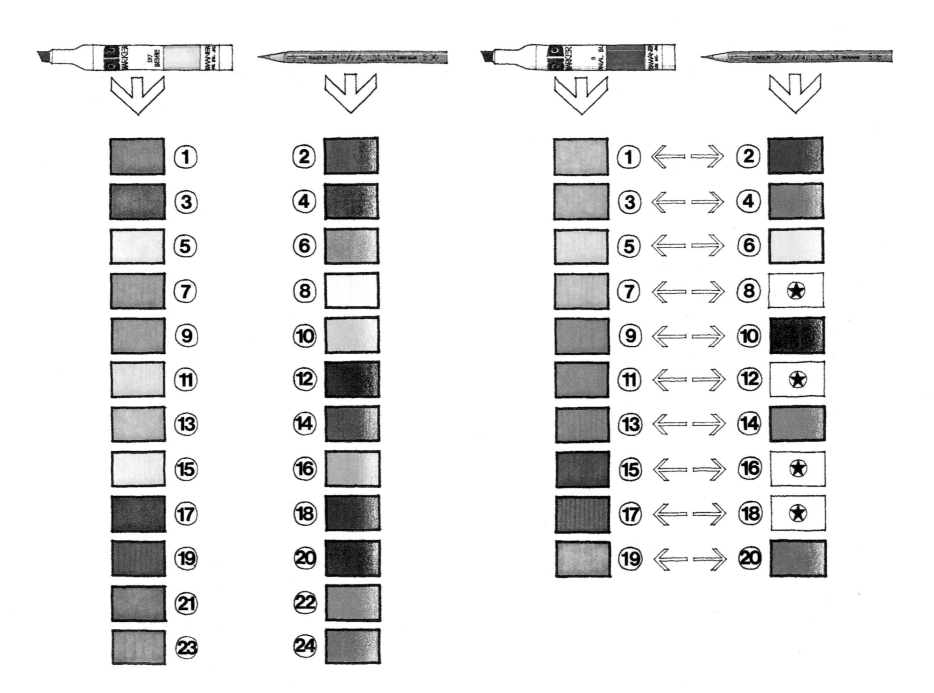

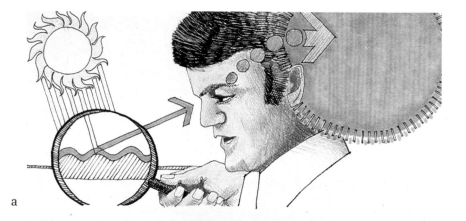

a

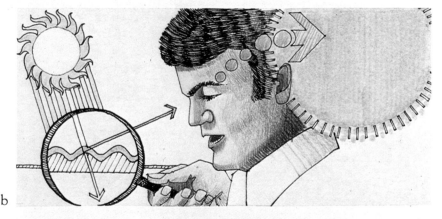

b

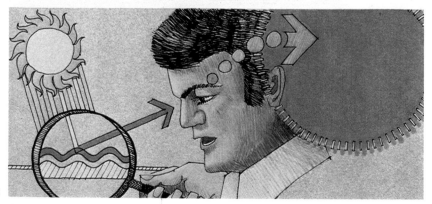

c

How the Marker/Colored-pencil Method Works

Colored pencil is applied over a marker "base" for any or all of the following reasons: to alter the color of the marker base, to make a surface appear illuminated, or to give the effect of subtle texture with line patterns.

Marker and Paper

If an area of paper is covered with a transparent marker coating, the resultant color will be a *blend* of the paper color and the marker color. The marker color will appear most brilliant on white paper since a maximum amount of light will reflect from the paper's surface *through* the marker coating to the viewer's eye (C1–5a). On yellow tracing paper the color will appear lighter and more washed out and will change depending on the color of the surface (C1–5b). On toned paper the same marker coating will appear less brilliant, depending on the lightness or darkness of the tone, since less light will reflect from the paper's surface (C1–5c).

Colored Pencil and Paper

Colored pencils leave a semiopaque coating on the paper's surface. When used very lightly (C1–6a), the paper will still show between the minute spots of pencil deposit, since the pencil has coated only

C1–5. These three illustrations show the result of applying a *Salmon* marker to common papers. The papers are "magnified" by the viewer to show the marker coating; the waves represent the paper's grain or texture. The light reflects from the paper through the marker coat to the viewer's eyes. The top illustration shows the marker color at its most brilliant on white paper. When yellow tracing paper is used, as in the center illustration, the result is more washed out, since some of the light passes through the paper. Note also how the hue has shifted toward yellow-red due to the paper color. The bottom illustration shows the same marker used on black-line print paper, which has a darker than usual background, resulting in a darker, more muted color. The hue has again shifted somewhat, this time toward red-purple, since the black-line print paper is actually slightly purple in color.

the highest grain of the surface. The result is a visual mixture of paper and pencil.

When used with more pressure, the pencil will eventually squash the grain and thoroughly coat the paper, resulting in a solid, brilliant color (C1-6b). Note, however, that, even when applied with pressure, the resulting pencil color will be partially influenced by the color and tone of the paper beneath it.

When light-colored pencils (such as *White*, *Flesh*, and *Light Violet*) are used on *toned* papers, the resulting color seems to glow. This is because the lightness and brilliance of the colors appear even greater in *contrast* to the dull-toned surface. A similar phenomenon occurs when light-colored pencils are applied to yellow tracing paper and placed over a darker surface. An even greater apparent brilliance is created when the drawing is placed almost parallel to the direction of the light. *The use of light-colored pencils over a toned or marker surface is an especially effective way of making a surface appear illuminated.* This technique is used throughout the book.

Colored Pencil Over Marker

From the above discussion the effect of colored pencil applied over a marker base should be clear. Light reflects from the colored-pencil deposit, while the marker *simultaneously* shows through the minute particles. The result is a *visual mixture of the two* (C1-6c)—a third color! The visual mix of separate colors is not new to color-work. Georges Seurat and other neoimpressionist painters placed spots and lines of pure hue in close proximity to one another, thus forming medial mixtures when viewed from even a short distance.

C 1-6. The top illustration shows the result of applying an *Aquamarine* colored pencil lightly to white paper. The light reflects from the colored-pencil coating, which covers only the peaks of the paper grain, and from the paper visible between these peaks. The result is a visual mixture of pencil and paper, which yields a tinted version of the pencil color. The center illustration shows the colored pencil applied with full pressure, thoroughly coating the paper and resulting in a solid brilliant color. The bottom illustration shows the result of applying the *Aquamarine* pencil over a *Golden Tan* marker. The result is again a visual mixture—but of the marker and pencil colors! Since these two colors are complementary, a dull, grayish color results.

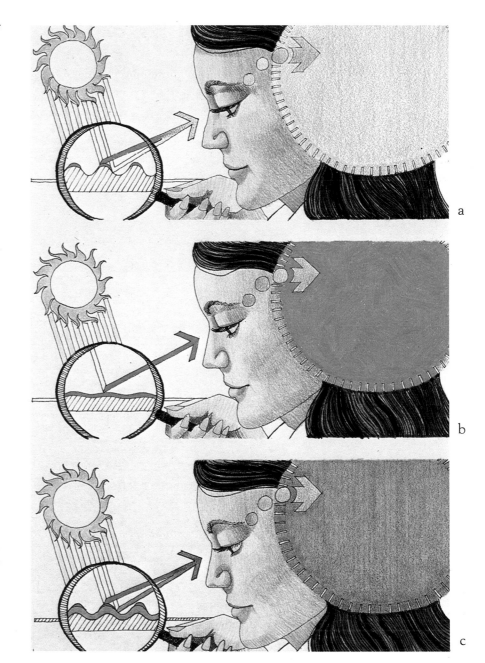

a

b

c

2 Techniques and Effects

This chapter introduces you to a basic set of techniques that will assist you in creating your color drawings. They are essentially tips and shortcuts used to produce the effects of light, shade and shadow, building materials, and textures in color. These techniques are used throughout the book; further examples are shown in Chapter 3.

Papers

Toned Paper

Toned papers offer some distinct advantages for marker and colored-pencil drawing that are not afforded by white papers. First, toned paper will make the marker colors seem less brilliant—an advantage, since the majority of marker colors are too brilliant for the type of drawing described in this book and must be toned down. Second, in contrast to the toned paper light-colored pencils seem even lighter. This becomes advantageous in effecting illuminated surfaces, a task easily accomplished even without a marker base. A third advantage of toned papers is time efficiency. If time does not permit the application of color to the entire drawing, a smaller portion, perhaps the center of interest, can be colored. On toned paper the colored area will retain its impact without becoming diluted in a sea of white.

The application of color only to the center of interest or focal point of a drawing, gradually fading the color as the drawing expands outward, is in fact compatible with our perception of color in the environment (C2–1). The color receptors in our eyes, the cones, are located in the fovea, which is in the center of our field of vision. If you fix your gaze upon one area within a room, the color is more intense in the center of your vision, while the periphery appears relatively colorless!

C2–1. This drawing illustrates the use of color only in the center of interest. From that area it is gradually faded by lessening the pressure on the colored pencils, also resulting in a more time-efficient drawing. The table was done with a *Sand* marker base, with *Cream*, *Burnt Ochre*, and *Orange* pencils applied over it. The vertical streaks in the tabletop simulate reflections from the windows (made with *White* pencil)—an important but easy touch for shiny surfaces. The exposed brick wall, doors, and rug were washed with *Light Blue* pencil (the same was used for the plate rims and napkins) to reduce the brilliance of their original colors. To obtain the ultrawhite reflections on the faucet, white opaque ink was applied with a ruling pen. (To draw chrome, see C3–46.)

The papers already in use in the design professions are ideal for the marker/colored-pencil method of color application. Diazo prints and yellow tracing paper are probably the most widely used and can be considered toned papers. Upon completion of a line drawing on drawing vellum (such as Clearprint) or Mylar, a diazo print may be run at a *faster than usual* speed, resulting in a toned background. Color may then be applied to the print with the marker/colored-pencil method. An advantage of this process is that, if the color drawing is unsatisfactory, you need only to run another print of the original drawing rather than begin another drawing from scratch.

Most blueprint shops stock the standard print-paper colors—black, blue, and brown—though other colors such as red and green are also available. The paper colors can be chosen to be compatible with a scheme of hues. For example, blue-line print paper might be used for a drawing that employs a cool-hue scheme, which perhaps encompasses greens, blues, and purples. The blue-line paper suits the cool-hue scheme, since its hue is itself used in the scheme. Brown-line prints might be used for a warm-hue scheme, as for a drawing that shows a large amount of brick and wood (C2–2).

C2–2. Brown-line diazo-print paper, run at a faster than usual speed through the print machine, provides a very compatible drawing surface for the marker/colored-pencil method. It was selected for this drawing because its color is suitable for those to be used for the drawing, providing a unified effect. The sky and ocean were intentionally left colorless to maintain this effect. The drawing was quickly laid out with a Pilot Razor Point pen (though it could just as easily have been drawn on tracing paper, then printed on the brown-line paper), and some perspective errors resulted. These errors were subsequently corrected as the color was applied, due mostly to the opacity of the colored pencil. The process becomes one of simultaneously refining the drawing—and the design itself—while applying the color, making a presentable drawing out of what began as a study.

If more impact is desired, a print-paper color may be chosen that is *complementary* to the scheme of hues used in the drawing—a blue-line print paper with a warm-hue scheme, for example (C3–3).

The gray background provided by black-line print paper is neutral and may be safely used with any hue scheme.

Tracing Paper

Yellow tracing paper is a form of toned paper, and markers and colored pencils may be effectively used with it. It is the paper most often used during the early parts of the design process (C2–4, C2–5), and for that reason one should learn to use color with it comfortably.

C2–3. A predominantly warm hue scheme is employed in this drawing, done on blue-line diazo-print paper, which has a darker than usual background. The warm hues—reds, yellow-reds, and yellows—are used in the foreground, while the background is left the original blue of the print paper. The warm hues tend to advance toward the viewer, while the cool blue seems to recede from the viewer. A feeling of distance or depth can thus be created between foreground and background by playing warm hues against the cool blue-line paper.

C2–4. This drawing represents a design idea drawn quickly and directly in perspective—in color on yellow tracing paper—without prior plans and elevations. The intent was to show the feel of a cluster of housing units stacked above public spaces within a proposed retirement community. The design was refined during the drawing process, resulting in many insights not only into the relationship of the forms to each other and to the whole but also into the relationship among interior and exterior public spaces, private living units, and the vertical and horizontal circulation between the two. Though the design was changed considerably during the process, the original feeling was still present in the final solution.

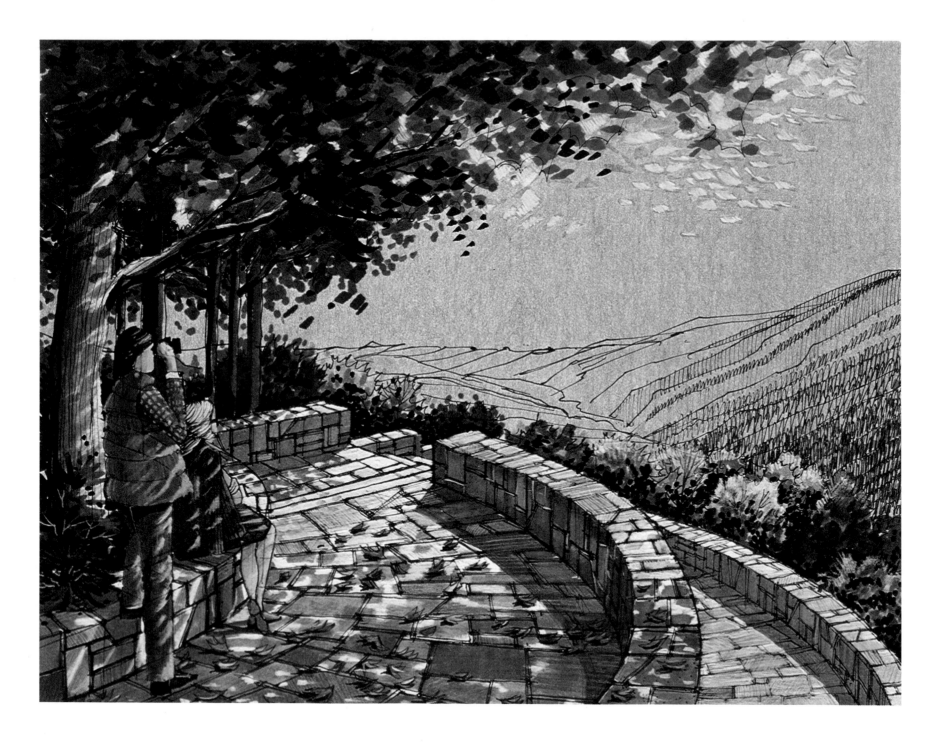

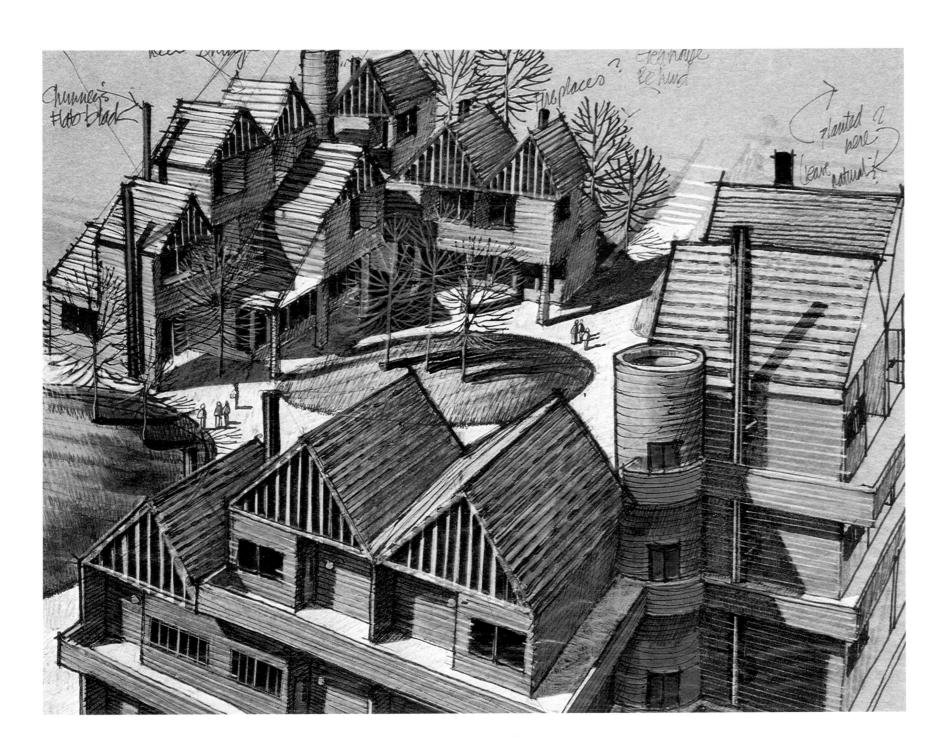

A variety of effects similar to those achieved with print paper may be obtained with yellow tracing paper. Marker colors become muted, and colored pencil almost seems to glow. These effects are most obvious when the paper is mounted on a darker background and displayed at or near a position parallel to the direction of a light source.

White Paper

The marker/colored-pencil method may also be used with white papers. Both the markers and the colored pencils will appear at their most brilliant, and for that reason steps must often be taken to mute the colors, as discussed in the section on mixing basics in Chapter 4.

The handiest type of white paper for color drawing is diazo-print paper. A black-line print of a line drawing with little or no background will provide a white copy of the original drawing but no toning, since the print machine is running at a slower-than-usual speed. For more finished renderings Strathmore Bristol, a 100%-rag paper, is one of the best papers available for use with markers and colored pencils. I have attained the best results with the 2-ply, vellum surface. The markers bleed very little, and the colored pencils can be applied smoothly, since the paper has a fine grain. One disadvantage is that the original drawing must be drawn directly on the final rendering surface. This is most conveniently done by tracing a preliminary drawing onto the Strathmore paper with the aid of a light table.

All the papers mentioned above have been used in this book to show the results that can be expected from each.

C2–5. These drawings, done on yellow tracing paper, are a few of the rough, quick studies for a design project involving the recycling of a large unused building into a food market, cinemas, restaurant, and retail shops. The linework for this drawing was done with a Sharpie, and the color was applied with marker and colored pencil. Note that, even in this initial study phase, the effects of light are included in the drawing—shadows were applied with marker and highlights with colored pencil.

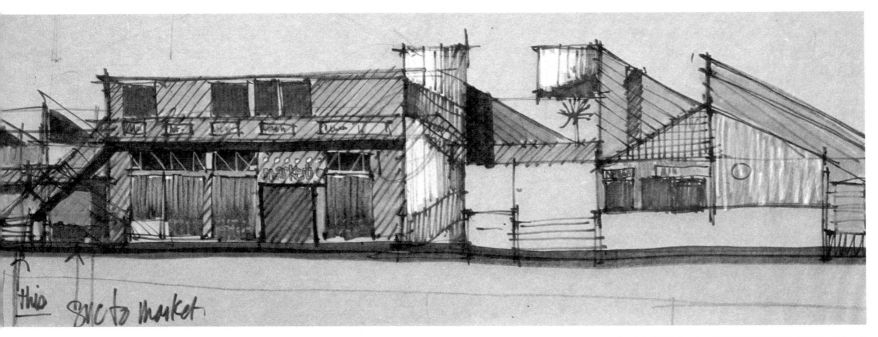

this svc to market

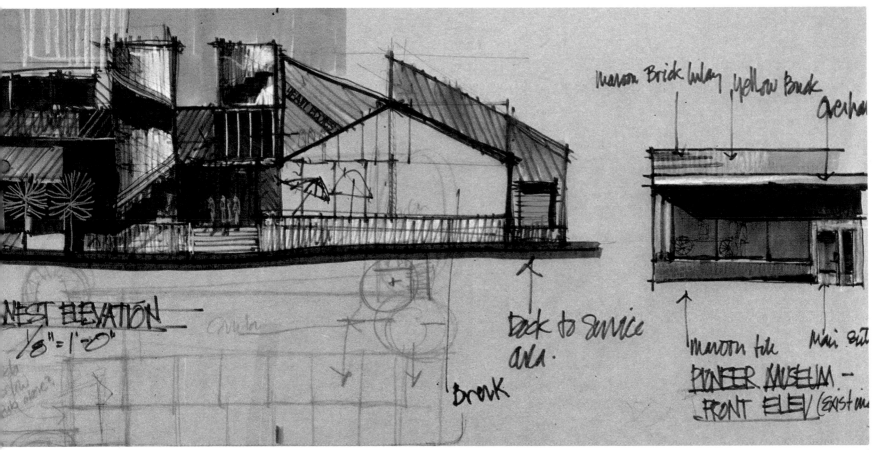

WEST ELEVATION
⅛" = 1'-0"

back to service area.

Break

maroon Brick inlay yellow Brick overhang

maroon tile Main entry
PIONEER MUSEUM —
FRONT ELEV (existing)

Abstract Material Indications

The indication of materials on the exterior surface of a building, in interior spaces, and in the landscape can seem an insurmountable, time-consuming task, suggesting infinite detail. "Draw *all* those bricks?" you might ask. "The leaves on this tree will take me forever!" Indeed, the drawing might easily take "forever" if all the detail is put in, with little added effect in comparison to the time spent.

In this regard two points should be remembered. First, it is advisable to indicate in the drawing only those visual qualities needed to sufficiently *suggest* the material. Second, when drawing materials in this abstract manner, the qualities of the material, such as its texture, should be communicated with *simple* strokes of the marker and colored pencil. Complicated or elaborate strokes are time-consuming, and it is not expected that your drawings be photographs but rather honest *suggestions* of the finished design.

What this means, then, is to present only the most obvious qualities of a material—its color, its illumination, and its most conspicuous texture. When you look at photographs while squinting or slightly crossing your eyes (C2–6, C2–8), you will see these qualities. Your drawings should show these obvious qualities in drawn form, using simple, quickly accomplished strokes (C2–7, C2–9).

The closer the view of the material in the drawing, the more obvious the material *unit* will be, and it should be drawn in accordingly (C2–10).

C2–6. In this photograph of an arched brick doorway the color of the brick, the shadow shapes, and the horizontal mortar joints (since they are continuous) are the most obvious material qualities. Try squinting or slightly crossing your eyes while drawing materials from life—then draw only the most obvious qualities. You will soon find that just about any material can be drawn quickly.

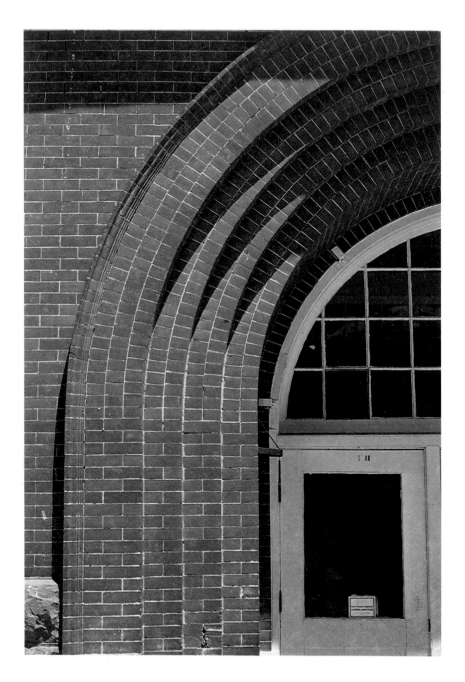

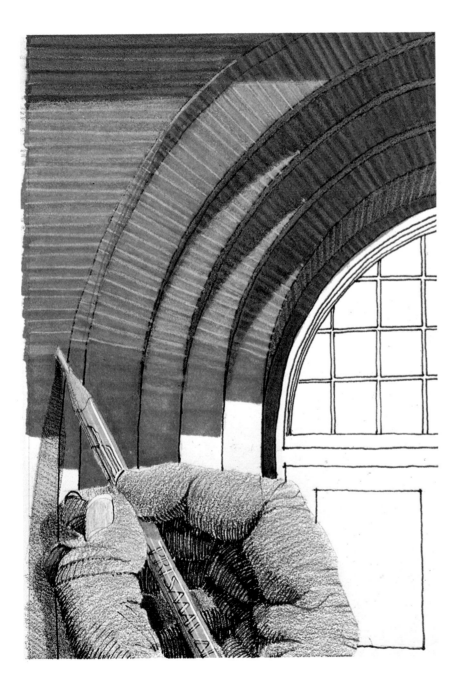

C2–7. This corresponding drawing of the brick archway is a representation of the obvious qualities revealed in the photograph. The marker base gives the brick its approximate color, with the shadows applied with a darker brown marker. This color is then refined with colored pencils, which are applied over the marker along the horizontal direction of the bricks. The horizontal mortar-joint lines were emphasized with *White* pencil.

C2–8. Plant materials can also be abstracted and still retain their loose, leafy quality. Rather than seeing this deciduous tree as a vast number of individual leaves try blurring your vision (by squinting or slightly crossing your eyes) and viewing it as a collection of textured masses that react to light in the same way as do all rounded forms—lightest facing the light source, gradually darkening as the surface turns away from the light. These textured masses are composed of individual leaves, which form groups or clumps.

C2–9. In this drawing the most obvious light effects, colors, and texture are again indicated, resulting in an easy and successful suggestion of a deciduous tree. The pointed tip of the marker was used in a pointillist or stippling fashion to build up the leaf masses. Rather than using only a single marker color, however, a variety of values of olive-green marker, including black, give the tree the necessary depth.

C2–10. Note in this drawing how each brick is shown in the closest column. At the corners of this column, which appear in profile, a profile edge has been created to further relate information about the column material. As the brick recedes into the distance, the drawing techniques become more simple, more abstract—as shown in the two next closest columns. The brick texture in the distance is only hinted, with the slightest indication of horizontal linework.

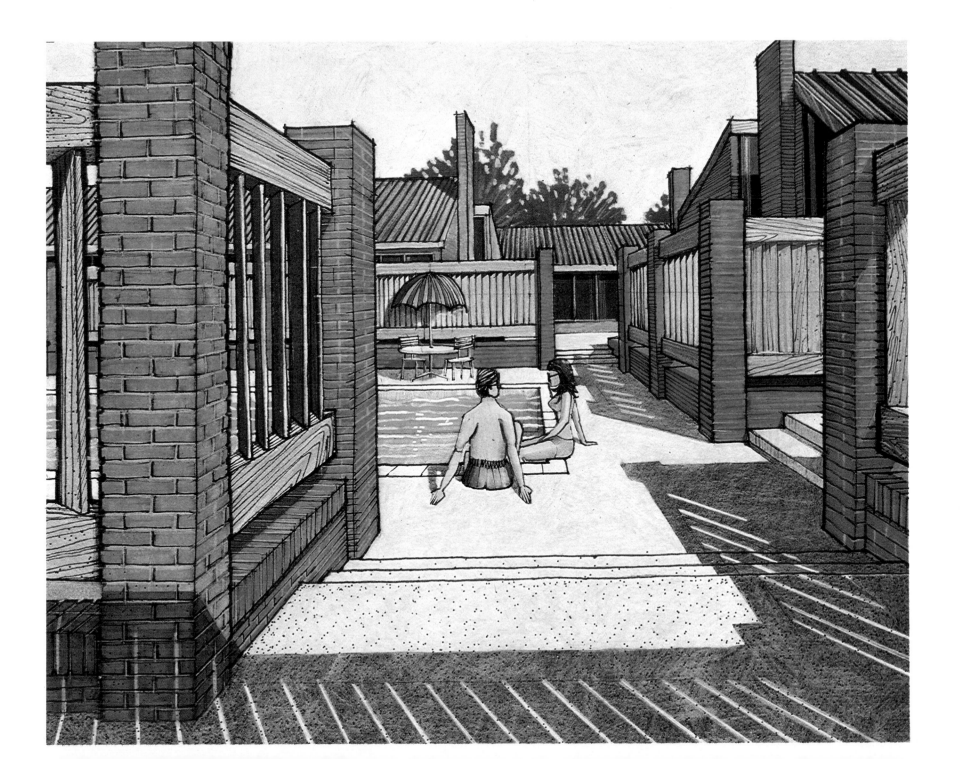

Light, Shade, and Shadow

Wash

One of the most obvious advantages of using colored pencil with marker is the ease with which a surface in a drawing can be made to appear illuminated (C2-11, C2-12). The lightest-colored pencils, included in the palettes mentioned in Chapter 1, are used to partially cover or wash a marker base coat. The pencils most commonly used to create light washes are *Flesh, Cream, Sand, Canary Yellow, Light Blue, Light Violet, Warm Grey Very Light,* and *White.* The pencils are used with varying degrees of pressure, depending on the lightness required. Stroking the pencil evenly and consistently at a diagonal angle in relation to the plane of the surface will usually help to keep the pencil marks from interfering with any texture or material-unit indications.

Graded Wash

A wash with changing degrees of lightness over the same surface, accomplished by varying the pressure on the pencil, is called a graded wash. Graded wash can be seen in most watercolor and airbrush work and is an effective color-drawing tool for a number of purposes.

First, it is used to differentiate surfaces that might otherwise be hard to distinguish from one another with subtle but effective contrasts of gradation (C2-13). The use of such a gradual change in value to produce contrast in changing or interrupted surfaces is also known as value opposition.

Graded washes are also used to depict varying degrees of illumination on large surfaces, such as sloping roofs and high-rise buildings. As we scan these large surfaces (C2-14), the angle between the sun and our sight line changes, usually producing a corresponding gradation in the value of the surface.

C2-11. The first steps in a study of the entry area for a children's day-care center show how the marker base is applied over a quick freehand line drawing done with a Pilot Razor Point pen on black-line print paper. It's a good idea to execute as many of the light and shadow effects as possible during the marker stage. All shadows are put in with marker, including the graded value on the grass bank in the middle right of the picture. This initial step shows the marker application by itself so that you can compare the drawing stages before and after the pencil washes are added. I usually prefer to complete an area of the drawing first, using both the marker and the colored pencil, since this builds my satisfaction and confidence in the drawing more quickly. I decided to eliminate the figures behind the foreground tree after completing the line drawing and did so simply by coloring over them—a handy technique for rough studies like this one.

C2-12. To complete the study, light colored pencils were used to create the effects of sunlight and, on the plant materials, texture. *Sand* and *Cream* pencils were used for the wood fascia, a mixture of *White* over *Light Blue* for the sky, and a light coat of *Flesh* over *White* for the board-formed concrete walls and walk area. *Canary Yellow* and *White* pencils were used over a *Pale Olive* marker to create a sunlit effect on the trees and foreground shrubs, while the grass and flanking juniper shrubs were given a textured coat of *Cream* pencil for the same reason. Colored pencils were also used to effect the glazed-brick sun-logo inlay on the wall by the entry door.

C2-13. This loose study shows the effects of north light in the lobby of a proposed small office complex. Note the graded pencil washes on the walls, floor, and the structural members in the foreground ceiling. The hue scheme is near-complementary: yellow-red and purple-blue, with the purple-blue dominant. The intense white highlight on the chrome duct was added with white opaque ink and a ruling pen. The glass doors on the right show the reflected exterior, drawn with colored pencils.

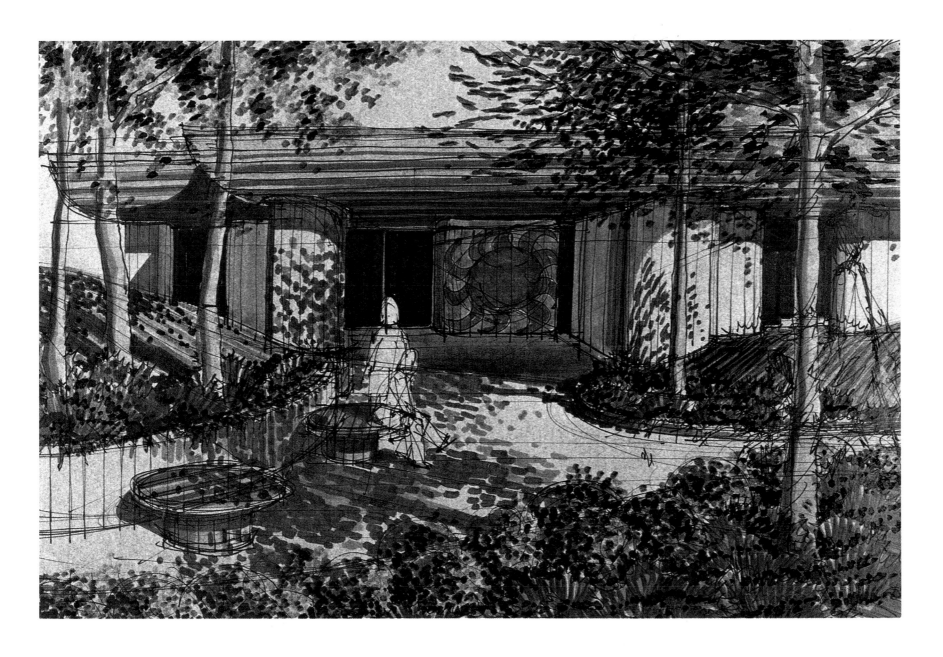

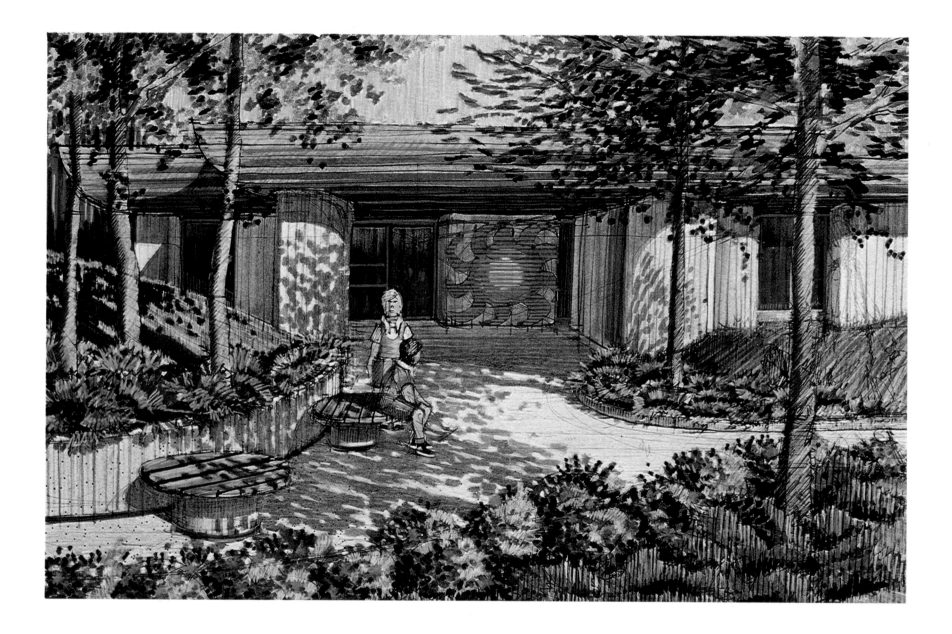

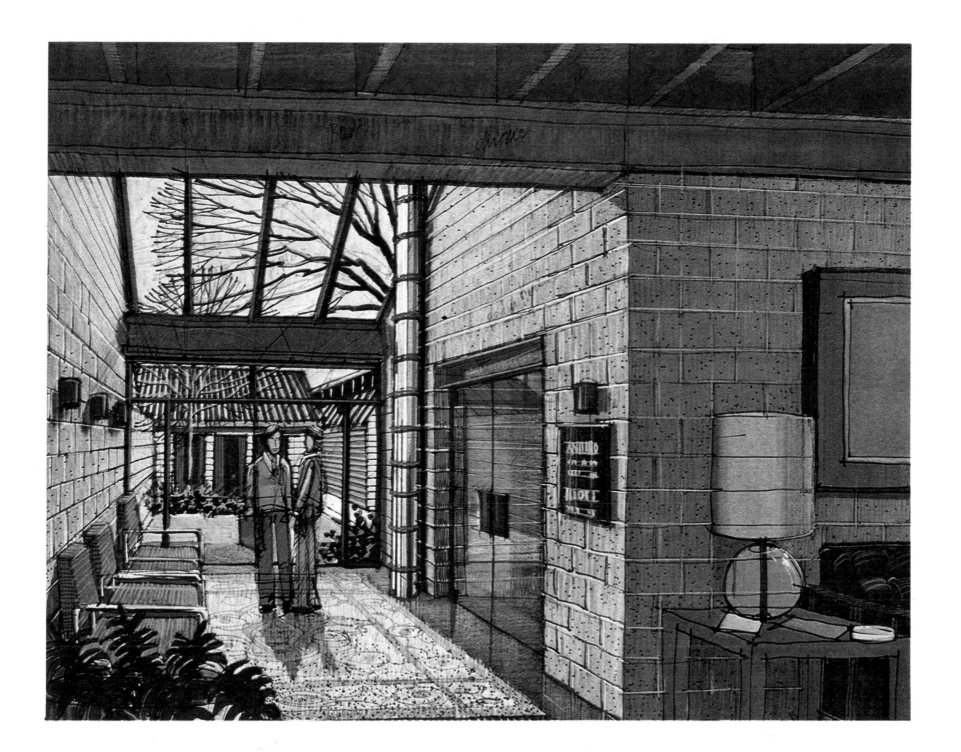

C2–14. This highrise-building scheme for downtown Denver shows extensive but subtle use of graded wash. For such complex building surfaces the marker base was applied first, then the graded pencil washes, ignoring the windows for the time being. Once the graded washes were in place, the windows were drawn with a black Markette marker over the pencil. Though I usually discourage the use of broad-tipped marker over colored pencil, in this rare case it made the drawing much easier. The graded wash on the foreground clock tower contrasts strongly with the background. The tower is lightest at the top to stand out against the darker building behind it. As your eye moves down the tower, you can see it gradually darken to contrast with the lighter paving surface of the plaza below. The colors of the main parts of each building section depict natural, unpainted materials. The smallest section, closest to the viewer, is covered in a locally obtained pinkish stone facing. The two middle sections are both brick, each of the same hue but differing in value. The tallest section is CORTEN steel, left to weather to its familiar rust color. The horizontal strips and exposed columns, both concrete, might be painted or otherwise colored during the mixing process. Though they vary in both color and material, the units composing this scheme relate to each other, since all parts are very close in hue. There is also an orderly progression of value, with the lowest building section lightest in value and the large section darkest. The elevator towers are finished with reflective glass except for the high, vertical sections, which allow views to and from each elevator car. These reflective finishes allow further repetition of the building colors and also provide complementary accents by reflecting the sky color as well. The reflections in the windows of the building make it seem much more alive—and they are easy to draw. (see Chapter 3). A complementary blue pencil, mixed with *White* pencil, was used to create the reflections and the color of the buildings in the background.

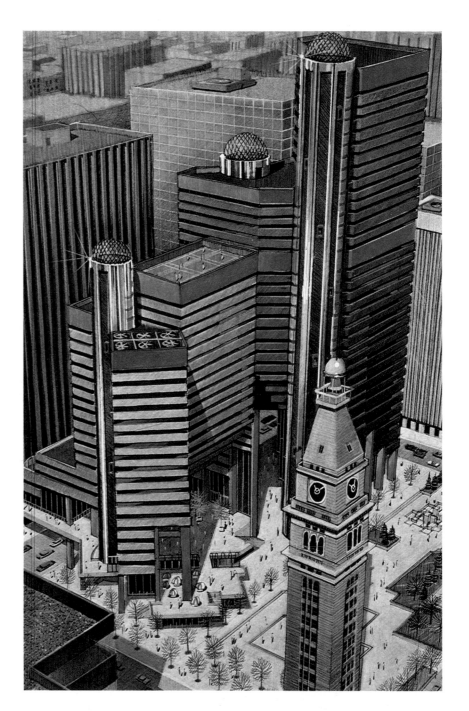

A graded wash will also relieve the monotony of a large surface with no color or texture variations. A variation in intensity will subtly make the drawing more dynamic, since the value is constantly changing as the viewer's eye scans the drawing. Note how often such a gradation occurs on the various surfaces in your own environment!

Flavoring

Flavoring is the application of a *subtle* wash of color, using little pressure on the colored pencil, to a surface that is either illuminated, shaded, or shadowed (C2–15). It is frequently used on what would otherwise be a stark gray, pure white, or pure black area to avoid the unreal and often deadening effects that colorless values can have on a drawing.

Flavoring is very common in renderings and paintings done in such brush media as tempera, watercolor, and acrylic. Grays are formed by mixing two complementary colors (as opposed to commercial premixed paint), which results in lively, chromatic grays, each with its own subtle flavor. Similar results can be achieved with markers and colored pencils simply by flavoring a gray-marker base with a colored pencil or by combining complementary markers and colored pencils (see the section on chroma in Chapter 4). Flavoring may also be used on the colored surface of a finished drawing to change its color slightly or, as discussed later in the book, to distribute the colors already used in order to unify the composition (C2–15, C2–16).

Note how often the white, gray, and even black surfaces in color photographs actually carry a flavor of color—a subtlety that can add immensely to the unified effect (C2–17). This may be due in part to the fact that *every colored object reflects its color onto its surroundings,* however faintly (C2–18). Paul Cézanne used a comparable technique of modulation in his paintings.

C2–15. This drawing is an early study of a building form (C2–16) done on yellow tracing paper. It is useful for communicating the *feeling* of a building—both to the designer and to the client.

C2–16. This drawing shows the building (C2–15) at the end of the design process. It was drawn on blue-line diazo-print paper, which has a darker than usual background. The concrete building forms were done in *White* pencil over a *Cool Gray #3* marker base (shadow areas were done in a *Cool Gray #7* marker base). A *Flesh* pencil was used to subtly flavor the concrete. If you look closely, you can see how the colors are distributed through the drawing. The *Light Blue* and *Copenhagen Blue* pencils used for the sky also flavor the shade and shadow areas and the grass. The *Flesh* pencil highlights the *Terra Cotta*-pencil roof. This drawing employs a triadic-hue scheme (red/green-yellow/purple-blue). Graded washes were used for the roof and sky.

C2–17. In this remodel design drawing of a living space old schoolhouse windows are recycled as a two-story window wall capped by a semicircular antique-stained-glass window. Notice that the white walls are flavored due to the reflection onto them of the intensely sunlit objects within the room. *Flesh, Orange, Sand,* and *Apple Green* pencils were initially applied lightly in varying amounts to the walls and sloping ceiling, and a white pencil wash was applied overall. Note also how the flavoring helps to distribute the color within the drawing. Instead of using a gray or black pencil for shaded recesses an *Indigo Blue* pencil was used.

C2–18. This loose drawing serves the designer as a color, lighting, and layout study—all in one. It also demonstrates the use of flavoring to show how objects and surfaces reflect their color onto other objects and surfaces. The wood counter colors are reflected (using colored pencil) onto the back wall, cupboard doors, teakettle, and pots stored overhead. Even the tomatoes reflect their color onto the side of the salad bowl. These may be small touches, but they do much to unify the drawing. The overhead shelves and objects appear to be uplit from below due to the light reflecting from the counter surface. It is not necessary for the perspective to be completely accurate in an early study. An approximation suffices at this stage in the design process. Note here how the construction lines running to the vanishing point are all but hidden by the color. The paper used for this illustration is Strathmore Bristol, 2-ply, medium finish.

C2–15

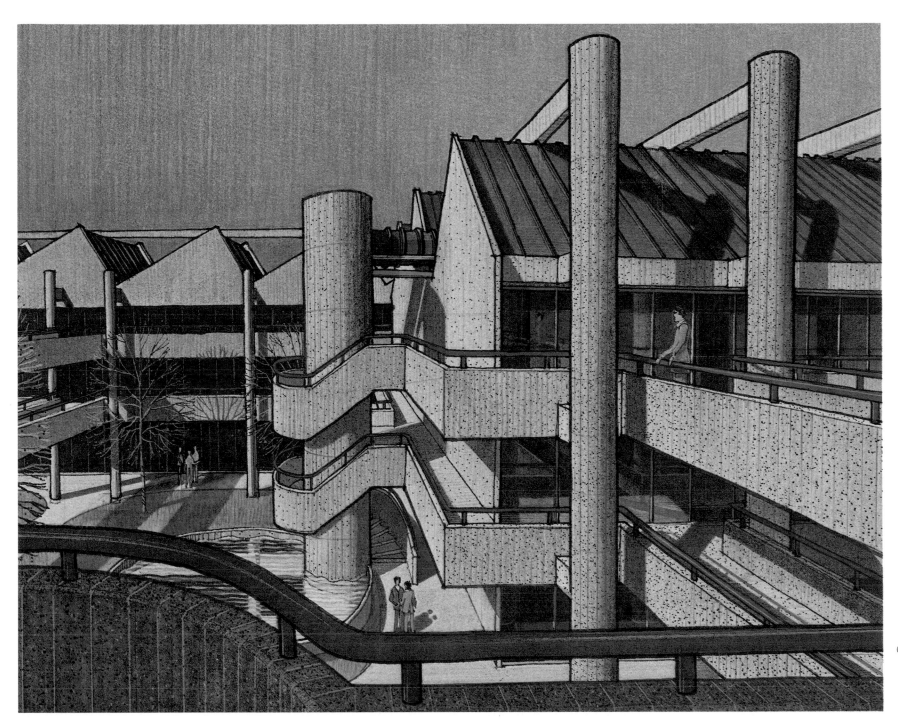

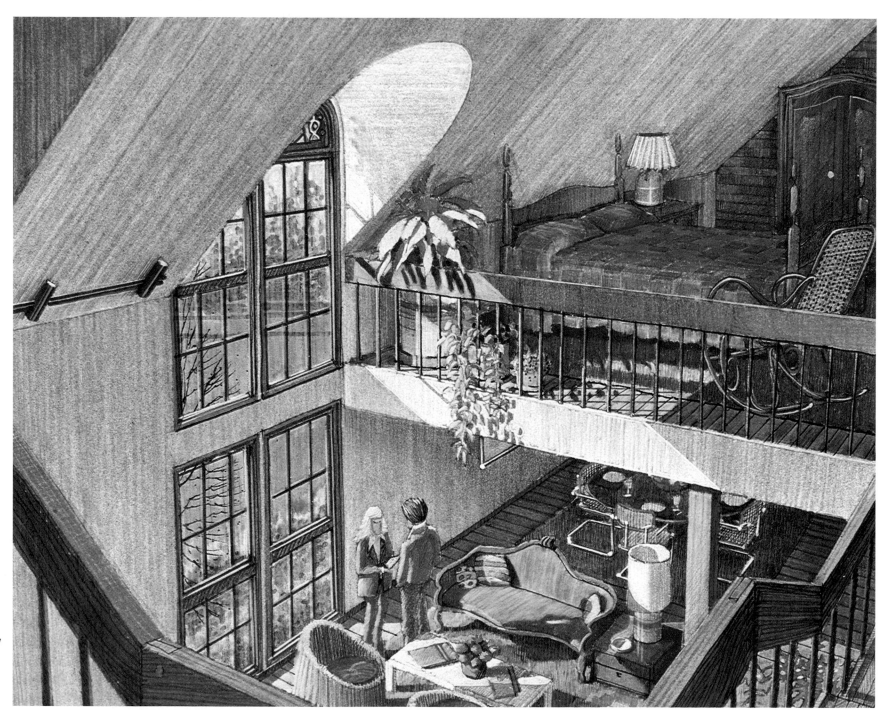

C2–17

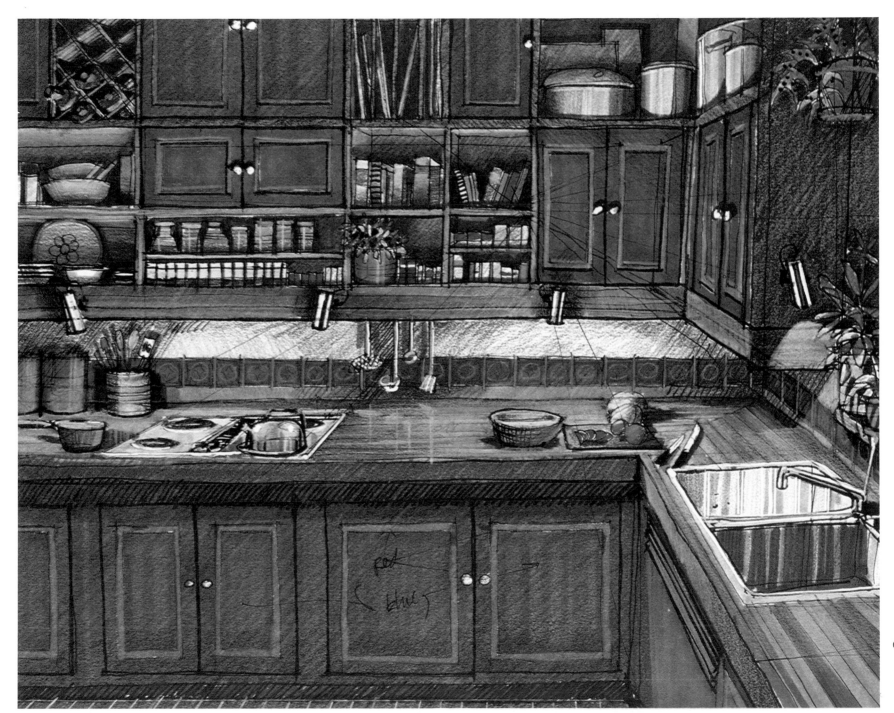

C2–18

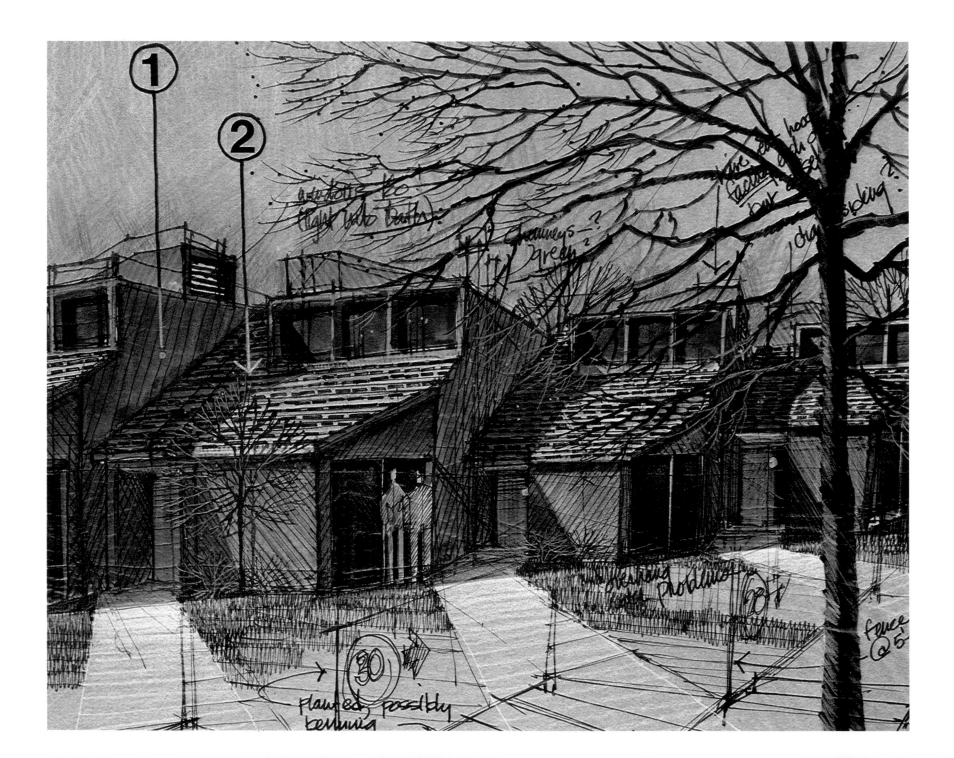

Form

The absence of direct light, indicated by shade and shadow, is essential not only to a finished, persuasive drawing but also to drawings done during the design process as well, since *light, shade, and shadow are as much design materials as are brick or wood.* Along with the phenomenon of perspective, shade and shadow are necessary ingredients for revealing space and form in a drawing. They give a view an infinitely more "real" and three-dimensional appearance.

Shaded surfaces face in the opposite direction to the light source, while shadow denotes the absence of light on a surface that would otherwise be illuminated, due to an intervening object (C2-19). Both shade and shadow result from the absence of direct light and appear as a single phenomenon. The degree of apparent lightness or darkness varies in direct relation to the lightness or darkness of the surfaces upon which the shadows occur. A shadow falling on a light surface, such as a sidewalk, will appear lighter than a shadow falling on a darker surface, such as grass.

Color

We usually think of the shaded and shadowed portions of a surface simply as being darker than their sunlit counterparts. There is, however, another aspect of shade and shadow. The color of the shade and shadow will seem to maintain approximately the same *chroma* (strength) as the sunlit portion of the same surface, with only the *value* (lightness) appearing lower! Shade and shadow, therefore, are not black or gray, as they are sometimes indicated in drawings.

C2-19. This early design study shows a group of attached townhouses. The initial linework was done in fountain pen on yellow tracing paper, and marker and colored pencil were used to effect material colors, light, shade, and shadow. Additional linework was added to depict trees, shingles, and wood siding. Design-school and professional renderings often give the impression that architectural drawings must be tight and slow, with every line in place. This is unfortunate, since many students come to avoid perspective drawing when exploring their design ideas. As you can see here, there are many errors—distorted perspective, incorrect shade and shadow construction, and so forth—but the *feel* of the design is quite obvious through the maze of linework *due to the use of color media.*
[1] shade [2] shadow

Two ways of indicating shade and shadow are most appropriate to the marker/colored-pencil method. First, a shade or shadow may be indicated by applying a darker-value gray marker over the colored-marker base or vice versa (C2-20, C2-21). It may sometimes be necessary to use black marker to indicate a shadow area, most probably

C2-20. This initial drawing of an idea for a solar-heated education facility utilizes a variety of gray markers to show shade and shadow. (The drawing is done on brown-line print paper with a darker than usual background.) The markers used were all cool grays—*Cool Gray #3* for the lightest shadows, *Cool Gray #5* for the stone walls, *Cool Gray #7* for the various foreground shadows, and *Cool Gray #9* for the darkest shadows. Marker shadows can be applied at any stage before the colored pencil is added. Note that the foreground shadows (between you and the building entry) are somewhat darker, even though they fall on the light concrete walkway. This creates a sense of depth by providing a darker foreground—a technique used in many renderings, drawings, and paintings. Don't worry if the marker bleeds or runs into adjoining areas. The shadows may be trimmed when the colored pencil is applied to their neighboring sunlit surfaces. The initial value of the shade and shadow, like those you see here, is only an educated guess. Rely on your intuition and experience during the final steps to judge their lightness or darkness and strength of chroma.

C2-21. In the final stage you can see the results of the initial shadow preparation. For example, the shadow on the grassy bank has approximately the same hue and chroma as its corresponding sunlit area but is *darker.* Note that the shadows also have texture (see C2-25). Both sunlit and shadow areas of the bank were covered with *Yellow Ocher* marker, then with *Sand* pencil using a grass-texture stroke. As it still didn't seem to be sufficiently dark, a Pilot Razor Point pen was applied over the shadow area, repeating the same stroke. The shadows on the walkway were lightly covered with *White* pencil, while more pressure was applied to the sunlit areas. These shadows were flavored with *Indigo Blue* and *Violet* pencils. In this final state note how the foreground was kept generally darker to create the illusion of space or distance. The middle ground—the major part of the building shown—is generally medium in value, while the background, the mountains and sky, is lighter in value. The sky was colored with a mixture of *Light Blue*, *Light Green*, and *Light Violet* pencils and then washed with a *White* pencil. The use of these colors helps to tie the sky into the rest of the drawing, done with *Olive Green*, *Violet*, *Light Violet*, *Light Blue*, and *Indigo Blue* pencils. The reflections on the solar-collector panels were determined by experimenting with a small mirror. They were drawn by first applying a *Black* marker to the surface, then, using lighter pressure, the same colored pencils that were used for the reflected objects themselves. The dividing lines between each panel were executed last—after the reflections with a Sharpie felt-tipped pen. A *White* pencil line was drawn on top of each Sharpie line.

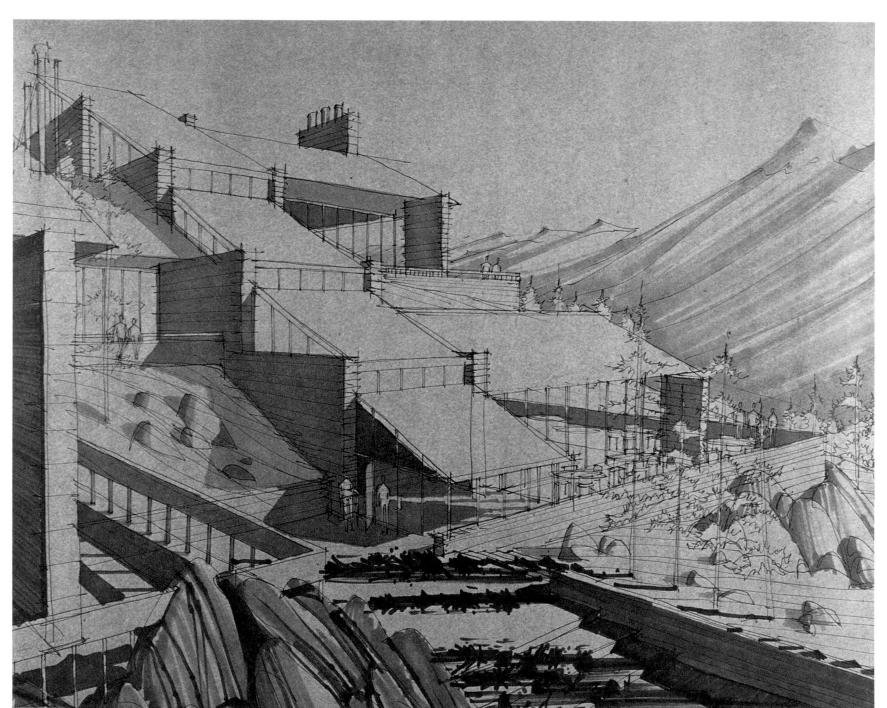

C2-20

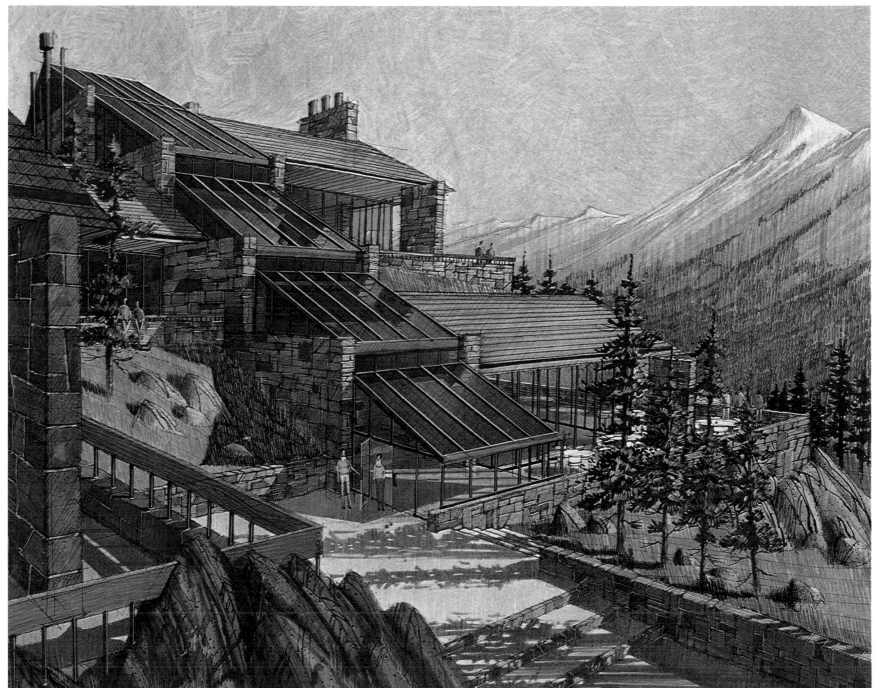

on surfaces done in low-value colors. After the marker is applied to the shade and shadow areas, the appropriate colored pencil is applied over both the sunlit and the shaded areas to give their respective colors approximately equal chromas. Avoid using dark-colored pencils by themselves (without a marker base) to indicate shade and shadow areas (except for diffuse shadows, discussed later in this chapter), since they will often produce unwanted streaked or grainy effects.

A second way of indicating shade and shadow is to use a darker version of the marker color used for the surface base. If a *Sand* marker is used as the base color, for example, a *Burnt Umber* marker might be selected for the shade and shadow area. The colors of both markers have about the same chroma (brilliance), while the *Burnt Umber* is darker in value (lightness). If you make the shade and shadow areas too dark, they can be lightened if necessary simply by applying the colored pencil used for washing the lighted areas of the same surface.

There is a third way of working with shade and shadow colors, especially those that occur on white or nearly white surfaces, such as sidewalks, snow, or building exteriors. The gray-marker base used for these shadows is flavored with colored pencils in the blue-to-purple hue range (C2–22). These colors include *Slate Gray, True Blue, Ultramarine, Copenhagen Blue, Indigo Blue, Blue Violet,* and *Violet.* Your choice of pencil colors for flavoring shadows will of course depend on the colors used in the rest of the drawing, but flavoring gray shadows with any color will add vitality to the entire drawing.

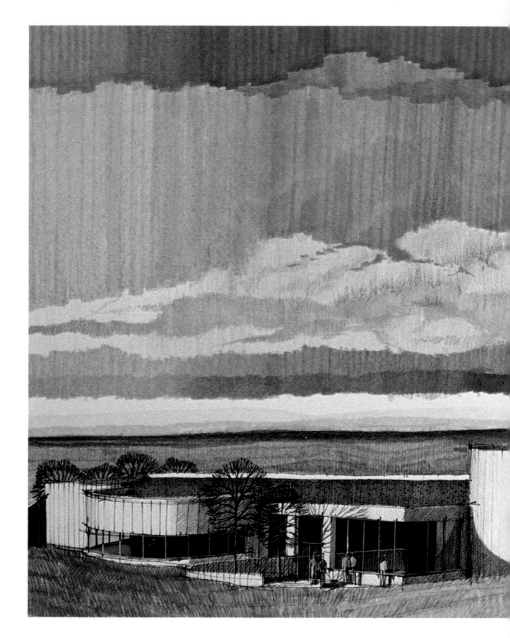

C2–22. This study for an electronics-assembly plant settled into the Colorado prairie demonstrates the use of flavored shadows in the purple-blue range. After shade and shadow were applied with gray markers, a *Copenhagen Blue* pencil was used to flavor them. To add more interest to the drawing, the sunlit surfaces of the building were also flavored with *Pink* and *Orange* pencils, creating a more dramatic setting-sun effect and, by utilizing near-complementary colors (*Pink* and *Orange/Copenhagen Blue*), making the forms appear more full and rounded. The *Pink, Orange,* and *Copenhagen Blue* pencils were also used (with a series of gray markers) to depict the clouds of the approaching storm, tying the building into its environment. The repetition of colors helps to unify a drawing.

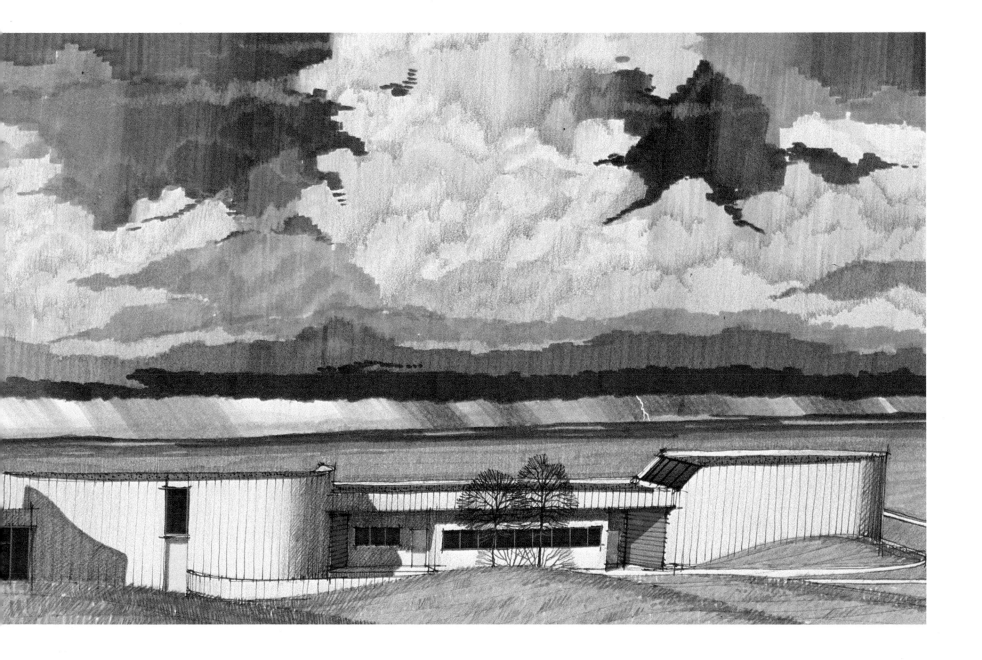

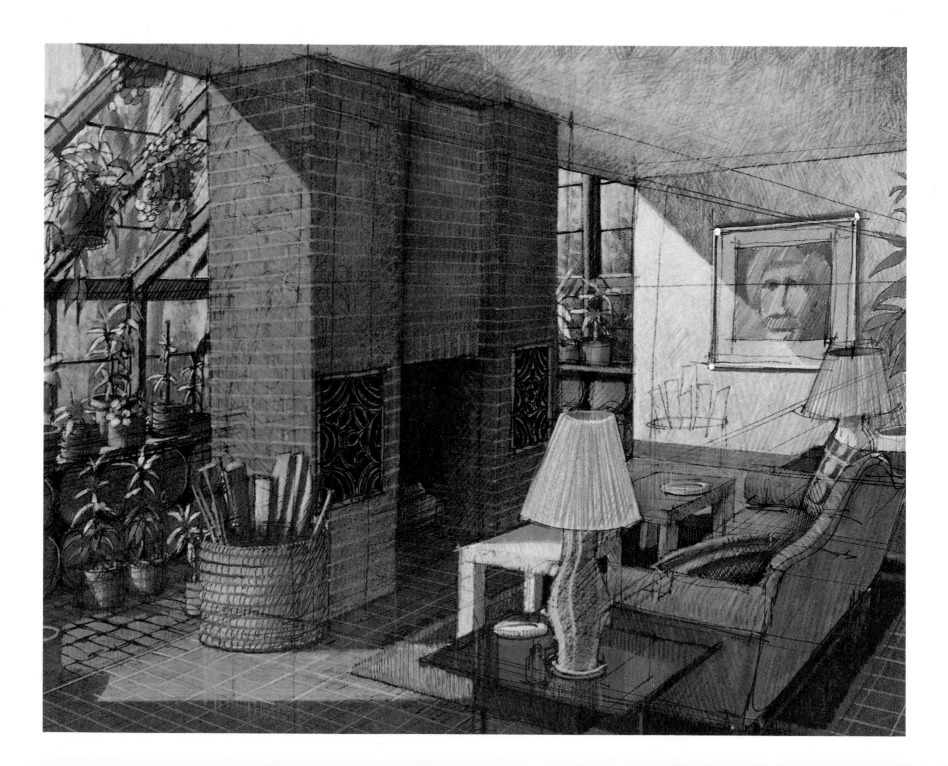

Edges

Boundary Emphasis

An important aspect of shade and shadow indication is the treatment of the boundary where light and shadow meet. This boundary should have the highest contrast possible while still appearing realistic. This can be achieved with the value opposition possible with graded washes. The illuminated area should become brighter as it nears this boundary, while the shadow area should become darker. The subtle but effective contrast that results makes the illuminated area appear brighter than it actually is, while the shadow area appears darker. An especially useful application of boundary emphasis is in drawing a room with both sunlit and shaded portions (C2–23).

Distinctness

In your drawing work you are concerned with *distinct* and *indistinct* shadow edges. Distinct edges are caused by casting edges that are themselves distinct and relatively close to the surface upon which their shadow is cast and by a focused or intense light source such as the sun.

Indistinct or diffuse shadow edges are usually caused by diffused light sources. In a drawing diffuse light probably comes from one of two sources: indoor lights, which are ordinarily soft and diffused either by reflection or by lampshades and light covers; and general reflected light (C2–24). Although they receive no direct light, objects in the shaded areas of a sunlit drawing will cast diffuse shadows due to reflected light and ambient skylight.

C2–23. Shown here is a loose study drawn directly from imagination on brown-line print paper with a Pilot Razor Point felt-tipped pen. The color was added directly over the rough layout. Note how the shadow is drawn on the far wall. It is darker at its boundary, then gradually lightens as your eye travels to the right. The sunlight on that wall (created by applying *White* pencil) is brightest at the light-shadow boundary. Rather than using gray pencils or markers to create the shade and shadows on the white wall and ceiling colored pencils were mixed to form a more lively, interesting gray. These pencils—*Terra Cotta*, *Indigo Blue*, and *Olive Green*—form an approximate triad on the color wheel and thus, when mixed, visually cancel each other, since they were applied in roughly equal amounts (using a random cross-hatch stroke). *White* pencil was then applied to the ceiling to create the effect of reflected light.

The Receiving Surface

Value

The surface upon which a shadow falls will influence the shadow in more than color alone. As mentioned previously, the value (degree of lightness or darkness) of a shadow will be lighter on a light surface and darker on a dark surface. Further, the more distant an object, the lighter the shadows on its surface.

Texture

When a shadow falls on a roughly textured surface, such as grass, shrubbery, or cobblestones, it will assume the texture of that surface (C2–25).

C2–24. A study drawing of an attic living space (complete with hot tub) can be used to show how various kinds of shadow edges occur. Shadows with distinct edges, like those cast on the floor behind the hot-tub occupant, are caused by direct sunlight. The shadows with diffuse edges on the ceiling are cast by the beams, due to the general reflected light from the floor and the window. Other diffuse shadows in the foreground are caused by the hanging light over the table. The table shadow on the floor, for example, was created by first applying *Burnt Umber* marker to the paper. *Indigo Blue* pencil was heavily applied directly under the table, then graded with lighter pressure toward the shadow's edge. The diffuse edge was made by extending the *Indigo Blue* pencil slightly past the shadow edge into the illuminated part of the floor, and the *Sand* pencil, used for the illuminated part of the floor, slightly into the shadow. The result is a blurred, indistinct edge. This drawing was done on black-line diazo-print paper, which has a darker than usual background.

C2–25. Consider the value, texture, and transparency of your shadows when using color media. The shadows falling upon these aggregated concrete surfaces were drawn with a *Cool Gray #5* marker over which was applied a flavoring of *Burnt Ochre* and *Cream* pencils. The *Cream* pencil was applied more heavily to the sunlit areas, making the shadows appear darker by contrast. More stippling was applied in the shadows than in the sunlit portions to give the shadows a transparent effect. The wood siding in shadow was given a light grain (with *Sand* pencil), while the sunlit wood was given a dark grain (with a Pilot Razor Point pen). The texture of the sunlit surface again remains apparent in shadow, creating a sufficiently transparent effect. The shadows on the concrete floor are lighter in value, since the concrete itself is light. The shadow area of the larger plant was first drawn with a *Black* marker, while an *Olive* marker formed the base for the sunlit portion. *Apple Green* pencil was then applied to the black shadowed part, while *Sand* and *White* pencils were used on the sunlit leaves.

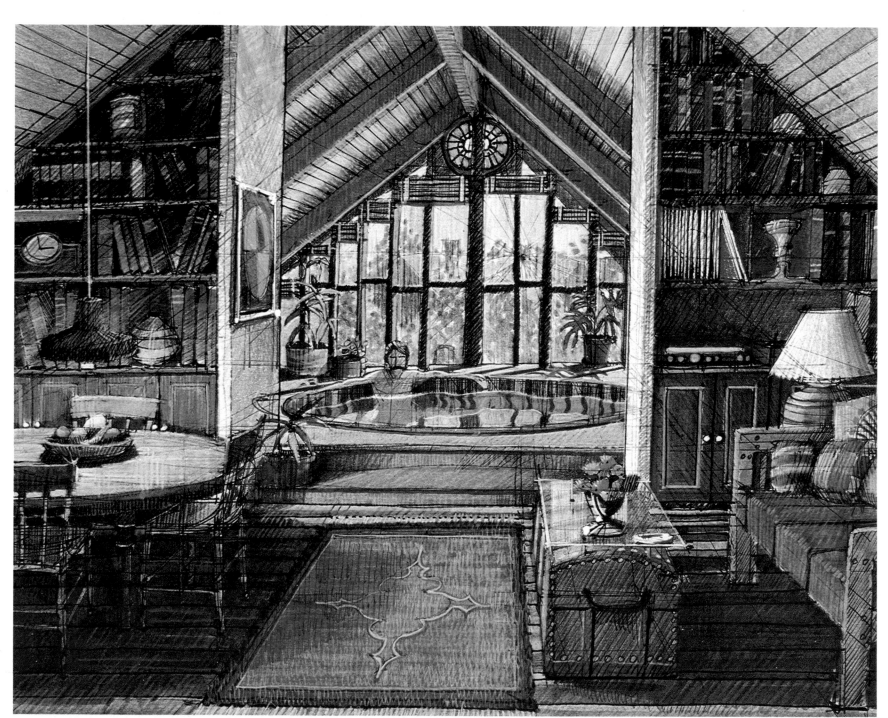

C2–24

C2–25

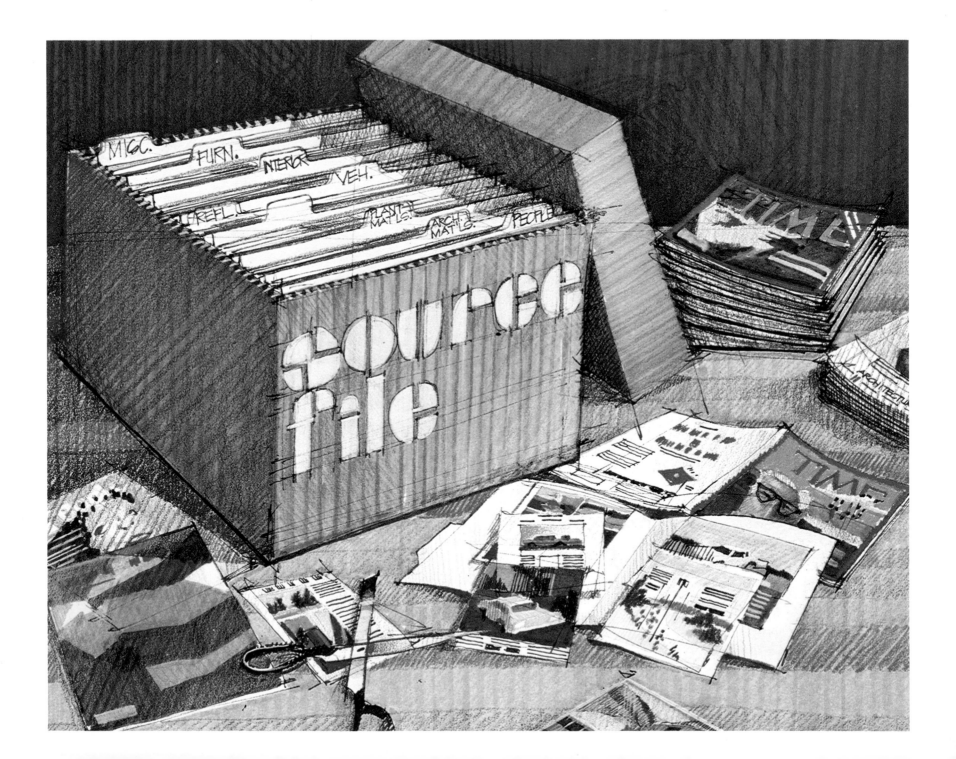

Transparency

Hand in hand with texture is the transparency of shade and shadow. If steps are not taken to make them appear transparent, they will often look as if they had been painted on their surfaces. The transparency of shade and shadow is easily accomplished in a drawing by one or both of the following ways. First, a fountain pen can be used to emphasize the texture and material units of a surface by making them slightly darker and more obvious than they appear in the illuminated portions of the drawing. The second way is the opposite of the first. A light-colored pencil, the same as that used for the light wash, can be used to indicate the texture in the shadow.

The Source File

In addition to the portfolio of materials given in Chapter 3 a good way to have many different kinds of objects and materials available for color-drawing reference is to organize a source file (C2–26). This is a categorized file of color-photograph clippings from magazines, catalogs, and even newspapers that will save you countless hours of "reinventing" people and support objects to put into your drawings. Their forms, colors, lighting, and textures will be at your fingertips for those occasions when time will not allow you to leave your drawing table to, say, visit a particular stone wall 10 miles away or spend hours leafing through magazines to find out just what an oriental-rug design looks like.

C2–26. Keep a source file as a reference for the form, color, light, and texture of frequently drawn objects. A simple cardboard box works quite well as a file, with inexpensive manila folders serving as dividers.

Your source file can be divided into the following basic categories, with additions or deletions depending on the kind of drawing that you do:
(1) people—sitting, standing, walking, leaning
(2) architectural materials
(3) plant materials and landscape elements
(4) reflections—water, glass, chrome
(5) vehicles—automobiles, trucks, vans, buses, motorcycles, bicycles
(6) interiors
(7) furniture—tables, chairs, sofas, lamps, televisions, bathrooms
(8) miscellaneous—boats, hot-dog carts, trolley cars, bulldozers, umbrella tables, dogs, cats, and the like

Permanence of Materials

The colors of both markers and diazo-print paper can fade or shift slightly. Some marker colors have good permanence, while others, especially those in the blue-to-purple-blue range, will fade and shift slightly in color over a year or two. Ultraviolet light will also cause a shift in color. Print papers will fade when exposed to light, especially direct sunlight, which can have a noticeable effect within a few hours.

To avoid these changes, keep your drawings covered and store them in a dark place when not in use. If you intend to display them for long periods (more than a few weeks), keep them away from strong light—direct sunlight in particular—and cover them with clear plastic or glass that contains ultraviolet screening agents.

3 A Portfolio of Materials

This chapter exhibits a step-by-step process for drawing basic materials common to architecture, landscape architecture, and interior design with the marker/colored-pencil techniques and effects discussed in Chapters 1, 2, and 4. It is intended that this chapter be used as a desktop drawing reference, and it has been arranged with this in mind.

Many of the drawings were done quickly and loosely, while others were given a more careful, deliberate, rendered style for purposes of clarity. Only close-range and middle-range versions of most materials are shown, since distant materials are usually seen only as areas of color with few other distinguishing characteristics.

The materials illustrated are drawn on both toned and white papers. The toned papers are all diazo-print papers, including black-line, blue-line, and brown-line varieties, which were run at a faster than usual speed through the print machine to obtain a toned background. Most of the line layouts for the drawings were done with a Pilot Razor Point pen, while others were done in pencil when more appropriate. Another approach utilizing diazo-print paper is to do the line drawing on drawing vellum (such as Clearprint 1000H) with a thin-line 0.5mm mechanical pencil and then to make a toned-background print. This approach was not used for the drawings in this chapter due to the extra step involved. The white paper used in this chapter is 2-ply Strathmore Bristol with a medium or vellum finish. When using markers on this paper, you will note that the colors must often be muted, usually by adding a gray marker over the base marker.

The progressions illustrated in this chapter are by no means the only progressions. It is rather offered as an introduction to the process of drawing with markers and colored pencils, a process that you will hopefully experiment with and expand upon. The markers mentioned below are AD markers (see Appendix A for cross-referencing information). The colored pencils are Prismacolor.

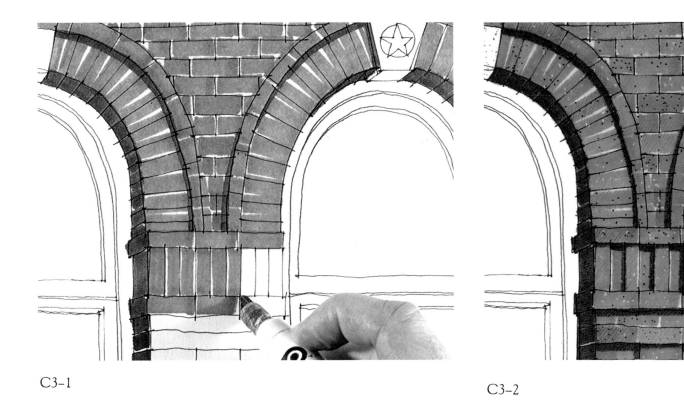

C3–1 C3–2

Masonry

C3–1, C3–2. BRICK, close range. The technique shown here is good for larger-scale drawings, such as this window-detail study, but is inefficient for large areas of brick or brick shown in sharply vanishing perspective.

(1) Apply marker base. Use a *Brick Red* marker, stroking the length of each brick. Let the paper show between each brick to suggest mortar. Use a *Burnt Umber* marker for shade and shadows.

(2) Reduce chroma if necessary. Since the drawing is done on white paper, the *Brick Red* marker appears too strong in chroma. Apply a *Cool Gray #3* marker over the brick and mortar to reduce the chroma.

(3) Add texture. Fountain pen and *white* pencil were used to stipple the brick. Twist the pencil as it strikes the page in order to leave a mark. The following may be added to create further interest, as time permits: (a) flavor various bricks with *Orange, Flesh,* and *Peacock Green* pencils (shown); (b) *Peacock Green* pencil may be added to the shade and shadow to reduce their chroma and add the interest of complementary color.

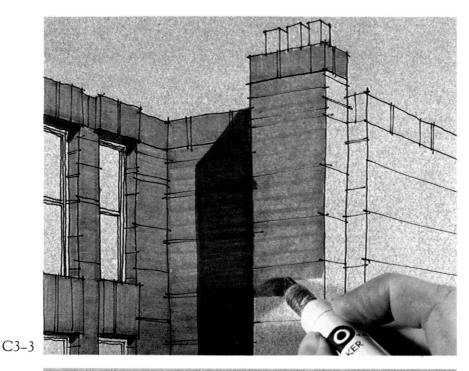

C3–3

C3–4

C3–3, C3–4. BRICK, middle range. Middle-range brick is an abstract version of close-range brick and the type that you will probably draw most.

(1) Apply marker base. Stroke the *Brick Red* marker in the direction of the horizontal mortar joints. Note the "help lines" that run toward the vanishing points: they are used to keep the marker and pencil strokes in correct perspective. Apply *Burnt Umber* marker to the shade and shadow areas.

(2) Apply colored pencil. Add the *Flesh* pencil, stroking in the direction of the horizontal mortar joints and using the "help lines" to guide your strokes. These strokes were added lightly to the shadow area as well, giving it a needed sense of transparency. To further define the direction of the wall planes, *Light Flesh* pencil was applied to the planes facing the sun most directly, making them lighter in value.

C3–5. BRICK, paving surface.

(1) Apply marker base. Stroke toward the far vanishing point of the drawing, using a *Brick Red* marker. Since this drawing is done on white paper, the marker color should be reduced in chroma. This can be done by applying a light-gray marker or a light marker in a complementary color over the *Brick Red*, as in this case, in which a *Willow Green* marker was used for the purpose.

(2) Add shadows. A *Burnt Umber* marker was used for the large part of the shadow, while a *Burnt Umber* pencil was used for the tree-branch shadows, since the marker was too large for that purpose.

(3) Draw in the mortar joints. Use a *White* pencil and a straightedge to draw the continuous mortar joints that run toward the far vanishing point. Note how these lines become closer together in the distance. Add a few short mortar joints to the closest bricks, which run to the close vanishing point. Let these fade out in the distance simply by using less pressure on the pencil.

C3-6. CONCRETE, smooth finish. Smooth-finish concrete often has characteristic markings that should be included in drawings—seams and holes caused by formwork, spiral tube markings on columns, and chamfered edges.

(1) Apply marker base. Since this diazo-print paper is so dark, no marker was applied to the sunlit surfaces. On lighter-toned papers *Cool Gray #3* marker is applied to the sunlit surfaces. *Cool Gray #7* marker was applied to the shade and shadow areas.

(2) Brighten sunlit areas with pencil. *Warm Grey Very Light* pencil was added to the sunlit surfaces in a smooth wash. *White* pencil was used to highlight the chamfered edges that face the sun.

(3) Flavor sunlit, shade, and shadow areas. *Flesh* pencil was used to flavor the sunlit areas, while *Blue Violet* and *Flesh* pencils were used over the shade and shadow areas.

(4) Add texture. Fountain pen was used to stipple the light areas, and *White* pencil was used in the dark areas. Remember to twist the pencil each time it strikes the page in order to make a mark. Only the most obvious texture is shown in the background.

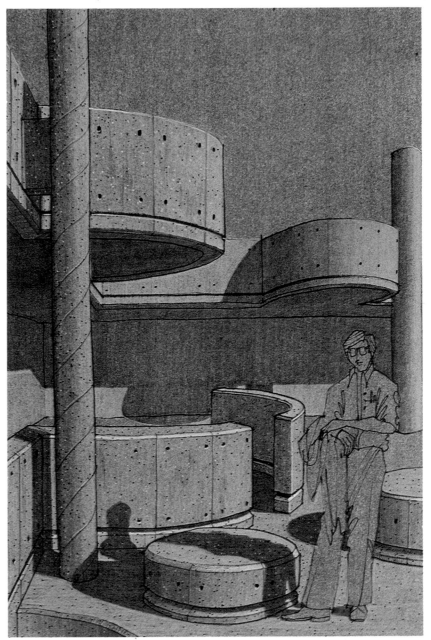

C3-6

C3-5

C3–7

C3–8

C3-7, C3-8. CONCRETE, board-formed.

(1) Apply marker base. *Cool Gray #1, Cool Gray #3, Cool Gray #5,* and *Cool Gray #7* markers were used to draw the illuminated and shaded areas of concrete. The markers were stroked along the help lines as shown. Note how the marker strokes suggest board-formed concrete.

(2) Enhance texture. *Warm Grey Light* and *Warm Grey Medium* pencils were used lightly over the marker base, stroking in the direction of the help lines. A wide, flat point was used.

(3) Flavor colors. Since concrete is rarely perceived as neutral gray in color, it should be flavored with colored pencils, repeating the colors used elsewhere in the drawing. *Flesh* pencil was used here to flavor the illuminated surfaces, while *Blue Violet* pencil was used on the shaded surfaces.

(4) Add stippling. The foreground was stippled for further texture, using a *White* pencil on top of a fountain pen. The pencil was twisted as it touched the paper.

C3-9, C3-10. CONCRETE, bush-hammered. The finish on the concrete surfaces shown here is typical of many different effects that can be achieved by using a simple pencil stroke that *resembles* the texture of the actual material. The concrete shown here is tinted but could just as easily have been drawn with the gray markers and pencils used in the previous illustrations.

(1) Apply marker base. *Sand* marker was applied to the sunlit surfaces, *Burnt Umber* marker to the shadow.

(2) Add pencil texture. Alternating dotted lines were applied in vertical rows, using *Cream* and *Burnt Umber* pencils on the sunlit portions of the surfaces. *Sand* pencil alone was applied in the same manner to the shadow areas.

(3) Stipple closest (foreground) surfaces with fountain pen.

(4) Texture background surfaces. Simple straight lines were used to texture the background surfaces. *Burnt Umber* pencil was used on the sunlit portions, *Sand* pencil in the shade. (Note: Since the colors seemed a bit too strong in chroma when this study was completed, all surfaces were flavored with *Light Blue* pencil to reduce the chroma.)

C3-9

C3-10

C3–11, C3–12. **CONCRETE, aggregate finish.**

(1) Apply marker base. *Sand* marker was used on the sunlit portions of the surfaces, *Burnt Umber* marker on the shadows. The marker colors used may change, depending on the aggregate color desired.

(2) Add pencil, using a texture stroke. A *Cream* pencil is used to create a random-cross-hatch stroke (inset). The same stroke, using the same pencil, was continued into the shadow, except that *less pressure* was applied. With the same *Cream* pencil a simple, smooth stroke is applied to the background, since the texture becomes less obvious with distance.

C3–12

C3–11

(3) Flavor surfaces. Flavor the sunlit surfaces with a *Burnt Ocher* pencil. Note how this flavoring was applied in graded washes to help distinguish one surface from another. Although it is not necessary, *Copenhagen Blue* pencil was used to add the interest of complementary color to the shadow-area flavoring.

(4) Apply stippling. Fountain pen was used to stipple both sunlit and shadowed surfaces in the foreground, with *White* pencil added to further stipple the shadow areas. The pencil was twisted each time it touched the page. The background surfaces were stippled with the smaller Pilot Razor Point. Use an old pen for this task, as you will quickly ruin the point of a new one. The joints between each panel were added last.

C3-13, C3-14. CONCRETE BLOCK, close range.

(1) Apply marker base. *Cool Gray #3* marker was applied to the sunlit surfaces, while *Cool Gray #7* marker was applied to the shade and shadow areas. The markers were stroked in the direction of the horizontal mortar joints.

(2) Add horizontal mortar joints. A straightedge is used to apply the *White* pencil for the horizontal mortar joints. The pencil is turned as it moves to maintain a constant line thickness. Heavy hand pressure is used in the sunlit areas, lighter in the shade and shadow. Make sure that the horizontal mortar joints are aligned with the proper vanishing points.

C3-14

C3-13

(3) Add vertical mortar joints, using the straightedge.

(4) Flavor sunlit areas. The sunlit areas were flavored with a *Flesh* pencil. Though not shown, the shadows could have been enhanced by flavoring them with a bluish pencil, such as *Copenhagen Blue*.

(5) Add final touches. Using a Pilot Razor Point, the thin, L-shaped shadows were added to each block freehand. The sunlit areas were stippled with an old Pilot Razor Point, while the shadows were stippled with *White* pencil.

C3–15, C3–16. CONCRETE BLOCK, middle range.

(1) Apply marker base. The shaded walls were toned with *Cool Gray #5* marker, stroked in the direction of the horizontal mortar joints. No marker base was used for the sunlit areas, since the diazo-print paper already has such a dark background.

(2) Add horizontal mortar joints. The horizontal mortar joints are created with a *White* pencil, using a straightedge. The pencil is rotated as it is moved, maintaining a line of consistent thickness. More pressure is used on the pencil in sunlit areas, less in shaded areas.

C3–16

C3–15

(3) Flavor surfaces. The walls were flavored with a *Flesh* pencil. Graded washes were then applied with a *White* pencil to create the effects of reflected light, especially on wall surfaces facing the window.

(4) Add finishing touches. Though not absolutely necessary, a few vertical mortar joints and some stippling were added to the closest surfaces with a *White* pencil.

C3-17, C3-18. STONE, coursed.

(1) Shade surfaces with gray markers. *Cool Gray #1* marker was applied to surfaces in direct sunlight, *Cool Gray #3* marker to surfaces in middle light (directly facing the viewer), and *Cool Gray #5* to surfaces in shade and shadow.

(2) Apply colored-marker base. *Ice Blue* and *Sand* markers were applied randomly to the surfaces as shown. *Light Ivy* marker was then evenly applied to all surfaces. Note that many marker colors can be used to draw stone, depending on the color desired.

(3) Outline stone shapes. The shapes of the stone were drawn as shown on the curving wall beside the stairs. The help lines are used to keep the stones in correct perspective.

C3-18

C3-17

(4) Highlight with colored pencil. *White* pencil was applied to the surfaces in direct sunlight, varying the direction of the pencil strokes for each stone. *Warm Grey Very Light* pencil was used on the stones in middle light (directly facing the viewer), again using the same variation in stroke direction. *Burnt Ocher* and *Light Blue* pencils are added to a few of the stones on these same surfaces.

(5) Add stippling. A Pilot Razor Point was used to stipple the stone in both sunlight and shade. A *White* pencil was added to the shaded stone.

C3–19

C3–20

C3-19, C3-20. **STONE, cut.** The cut stone depicted here is a greenish granite. Other stone colors can be drawn, depending upon the marker and pencil colors chosen.

(1) Apply marker base. *Cool Gray #5* marker was used for the shadows, while *Cool Gray #3* marker was used to soften the edges of the vertical shadows on the columns. *Light Ivy* marker was then applied as shown to both sunlit and shadow areas of the stone.

(2) Apply color and texture. A *Light Blue* pencil with a sharp point was applied to each stone in both sunlight and shade. The strokes used for each stone are perpendicular to those used for neighboring stones. *Flesh* pencil was applied lightly to each stone in the same manner. Both of these pencils were applied as smooth washes to the background stones.

(3) Add highlights. *White* pencil was applied to the sunlit stones, with more pressure used for some stones and less for others.

(4) Add stippling. Stippling was added to the foreground stone with an old Pilot Razor Point.

C3-21, C3-22. **FLAGSTONE.** Two kinds of common flagstone are shown here:

 [1] sandstone [2] slate

(1) Apply marker base. For sandstone *Sand* and *Flesh* markers were utilized as base colors, with *Cool Gray #7* marker applied over them to indicate shadows. For slate *Slate Green* and *Cool Gray #5* markers provided the base colors, while *Cool Gray #7* marker was used for the shadows.

(2) Develop stone colors with pencil. For sandstone *Flesh, Tuscan Red, Terra Cotta,* and *Burnt Ocher* pencils were used to randomly flavor various stones. For slate *Terra Cotta* pencil was used to flavor some of the stones, both in sunlight and in shadow.

(3) Add highlights. For both slate and sandstone all stones in sunlight were washed with *White* pencil.

(4) Apply finishing touches. For sandstone *White* pencil was added to mortar joints. Fountain pen was used to put small, thin shadows on the sides of stones facing away from sun. Foreground stones were stippled with an old Pilot Razor Point. For slate *White* pencil was used to draw in the mortar joints. Fountain pen was used to add small, thin shadows on the sides of stones facing away from the sun. No stippling was applied.

C3-21

C3-22

C3-23, C3-24. TILE ROOFING or SPANISH TILE, close range.

(1) Apply marker base. *Brick Red* marker is applied as shown to the tiles. *Burnt Umber* marker was added over it to create the shadow.

(2) Add colored pencil. Stroking along the length of the tiles, *Flesh* pencil was applied to those in sunlight, while *Terra Cotta* pencil was added to those in shadow. *White* pencil was used to highlight each tile.

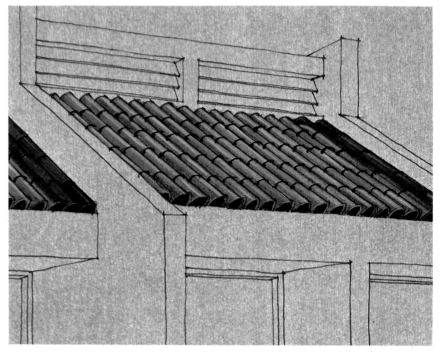

C3-24

C3-23

(3) Apply finishing touches. Fountain pen was used to blacken the end opening of each bottom tile and to draw in the dark overlapping edge of the other tiles. *Orange*, *Tuscan Red*, *Indigo Blue*, and *Burnt Ochre* pencils were used to flavor various tiles.

C3–25, C3–26. TILE ROOFING or SPANISH TILE, middle range.

(1) Apply marker base. *Brick Red* marker is applied to the roof surfaces as shown. Since the drawing is done on white paper, *Cool Gray #3* marker is added to the *Brick Red*. Note the difference in relation to the three roofs already colored with the marker base. *Burnt Umber* marker was used for shadows.

(2) Add colored pencil. A *Flesh*-pencil wash was applied to the sunlit parts of the roofs, and a *Terra Cotta* pencil was added to the shadows. *White* pencil highlights were added, with the help of a straightedge, along the length of the roof surfaces, using the help lines (C3–25).

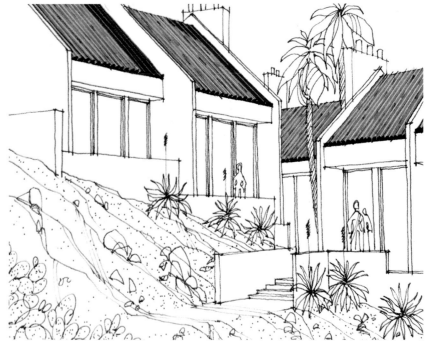

C3–26

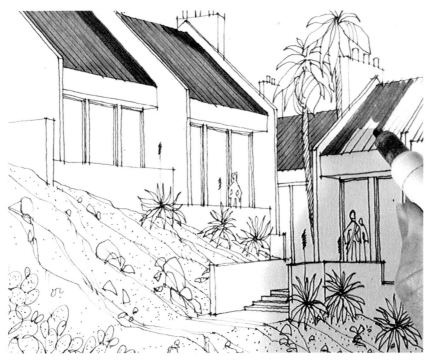

C3–25

(3) Apply finishing touches. A few dashes of *Burnt Ocher* and *Indigo Blue* pencils were added to each roof to suggest odd-colored tiles. Fountain pen was used to darken the openings on the front rows of tiles.

C3–27, C3–28. **QUARRY TILE.** Quarry tile can be obtained in a variety of shapes and sizes and can be set either in dark grout or in the light grout shown in this illustration.

(1) Apply marker base. *Brick Red* marker was first applied to the floor surface.

(2) Create diffuse shadows with marker. The shadows were initially drawn in with a *Cool Gray #5* marker. *Cool Gray #7* marker was added to create the darkest areas. *Cool Gray #3* marker was scrubbed along the shadow edges to make them indistinct or diffuse.

(3) Apply colored pencil. *Terra Cotta* pencil was applied to the shadow areas to make their chroma closer to that of the rest of the floor. *White* pencil and a straightedge were used to form the grout lines, which run to the vanishing points of the drawing.

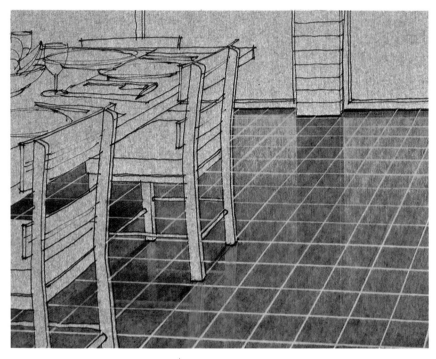

C3–28

C3–27

(4) Add reflections. *White* pencil was used to create the window reflections, while *Sand* pencil was used for the chair-leg reflections. The colors of object reflections will of course depend on the colors of those objects. Note how the reflections are most obvious nearest their source, fading away as they drop into the floor surface.

C3–29, C3–30. **STUCCO.**

(1) Apply marker to shadow areas. *Cool Gray #5* marker was used to apply the shadows to the columns. The sunlit surfaces were left untouched.

(2) Add pencil, using random-cross-hatch stroke. A *White* pencil is applied with a curved random-cross-hatch stroke (inset). More pressure is used on the pencil in sunlit areas, less in shadow areas. A less textured stroke is on the background forms.

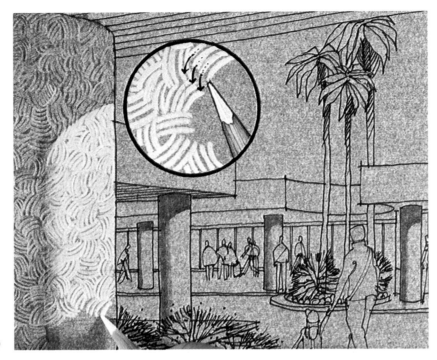

C3–29

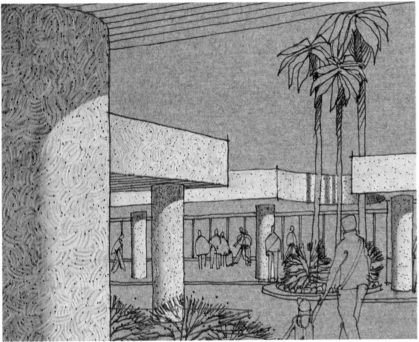

C3–30

(3) Add finishing touches. *Blue Violet* pencil was used to flavor the shadows, though other bluish pencils might also be used. If the stucco is more yellow red, such as that found in New Mexico, use a *Flesh* pencil to flavor the sunlit surfaces. Fountain pen was used to stipple the foreground forms, while an old Pilot Razor Point was used to create smaller textural dots on the background forms.

Wood

C2–31, C3–32. **WOOD, new (left) and weathered (right).**
(1) Apply marker base. For new wood *Sand* marker was applied to the sunlit surfaces, while *Burnt Umber* marker was added to areas in shade and shadow. For weathered wood *Cool Gray #3* marker was applied to the sunlit surfaces, and *Cool Gray #7* marker to the areas in shade and shadow.
(2) Develop colors with pencil. For new wood *Cream* pencil was applied to the sunlit areas, using more pressure on the pencil for surfaces most directly facing the sun. *Sand* pencil was applied in a streaky manner to the sunlit surfaces. A light *Sand* pencil wash was applied to the shadow area. Note that all colored pencils were applied along the direction of the wood grain. For weathered wood both *Sand* and *Flesh* flavorings were applied to all surfaces in a streaky manner (again following the grain). A *White*-pencil wash was then applied only to the sunlit areas.
(3) Add wood grain, color irregularities, and stippling. For new wood the wood grain was drawn with a Pilot Razor Point. *Burnt Ocher* and *Flesh* pencils were than randomly streaked between some of the lines. Stippling was added sparsely with an old Pilot Razor Point. For weathered wood wood-grain lines were added with a Pilot Razor Point, with extra lines in the shadow area to give it sufficient transparency. *Burnt Ocher*, *Light Blue*, and *Black* pencils were streaked lightly between these lines at random. A fountain pen was used to add stippling.

C3–31

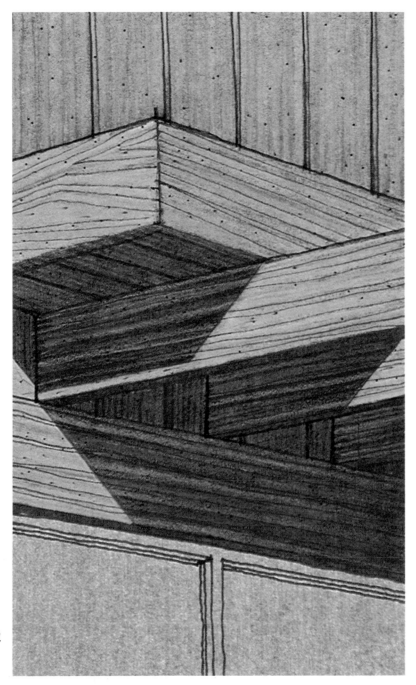
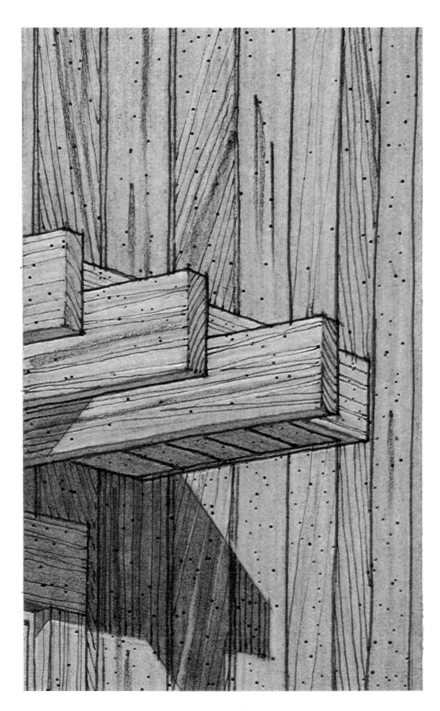

C3–32

C3–33, C3–34. **WOOD SHINGLES, close range.**

(1) Apply marker base. *Sand* marker is applied to the sunlit surfaces, while *Burnt Umber* marker is used to create the shadows. Note that the broad side of the marker tip is used to make short vertical strokes between each row of help lines. To create weathered shingles, use the same colors as for weathered wood (C3–31).

(2) Create illumination effects and develop shingle colors. *Cream* pencil was applied to the sunlit areas, while *Sand* pencil was lightly added to the shadows. The pressure applied to these pencils was varied to create a more irregular appearance. *Burnt Umber* pencil was used to grade the rounded balconies into shadow. Touches of *Burnt Ocher* and *Light Blue* pencil were added to various shingles.

C3–34

C3–33

(3) Enhance shingle-butt shadows and add cracks. The horizontal lines between each row of shingles (butt shadows) were darkened with a fountain pen. The vertical cracks were added with a Pilot Razor Point except in shadow, where they were made even darker with a fountain pen.

C3-35, C3-36. **WOOD SHINGLES, middle range.**
(1) Apply marker base. *Sand* marker was applied to the sunlit surfaces, while *Burnt Umber* marker was used for the shadows.
(2) Develop texture and color. Using a cross-hatch stroke, *Cream* pencil is applied to the lightest surfaces. *Sand* pencil was applied, using the same cross-hatch stroke, to less intensely lit surfaces. *Sand* pencil was also used to lightly apply the cross-hatch texture to the shadows. A light wash of *Flesh* pencil was then applied to all surfaces.
(3) Add shingle-butt shadows and finishing touches. Thin, horizontal lines were applied to the roofs and walls, suggesting rows of shingle-butt shadows. Short horizontal dashes were added with *Burnt Ocher* pencil.

C3-36

C3-35

C3-37

C3-38

C3-37, C3-38. WOOD FLOORING.

(1) Apply marker base. *Sand, Kraft Brown,* and occasional strokes of *Redwood* markers are used as the base colors, following the penciled help lines.

(2) Develop wood colors with pencil. *Sand* and *Cream* pencils were applied randomly in horizontal streaks, following the help lines. A light *Flesh*-pencil wash was then evenly applied over the entire wood-floor surface.

(3) Add diffuse shadows and reflections. A *Burnt Umber* pencil was used to add the diffuse shadows under the table and chairs. The window reflections were added with *White* pencil, making them most obvious nearest their source.

Metals

C3-39, C3-40. STEEL (unpainted), new and rusted.

(1) Apply marker base. For new steel *Cool Gray #3* marker is applied to the sunlit surfaces, while *Cool Gray #7* marker is applied to the areas in shade and shadow. For rusted steel *Redwood* marker is applied to some of the sunlit areas, and *Burnt Umber* marker is used for shadows.

(2) Develop color and illumination effects. For new steel a light wash of *Light Blue* pencil is applied over both sunlit and shadowed areas. Streaks of *Burnt Ocher* pencil are added to sunlit and shadow areas. A *White* pencil wash is then applied to sunlit surfaces. For rusted steel a wash of *White* pencil is applied over sunlit areas. *Burnt Umber* pencil is used to draw in the shadows cast by the standing seams.

(3) Add finishing touches. For new steel a light flavoring of *Canary Yellow* pencil is applied in a few areas. For rusted steel a graded wash of *Burnt Umber* pencil is applied to the down side of the horizontal roof seams. A light wash of *Burnt Ocher* pencil is applied to the rest of the roof surface. Flavorings of *Tuscan Red* pencil are added over the darker areas of the roof.

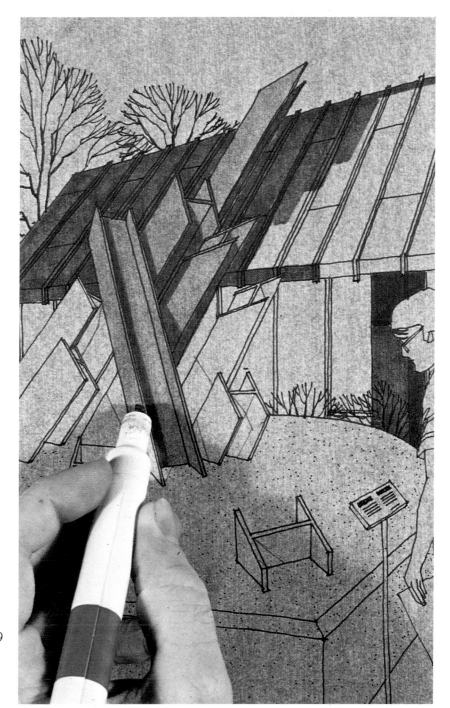

C3-39

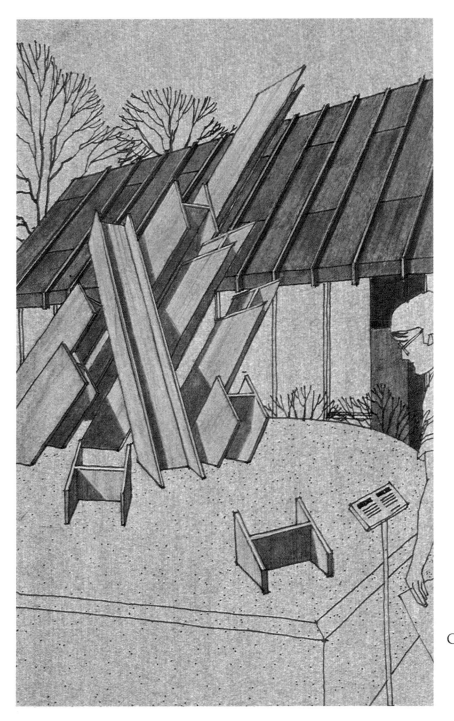

C3-40

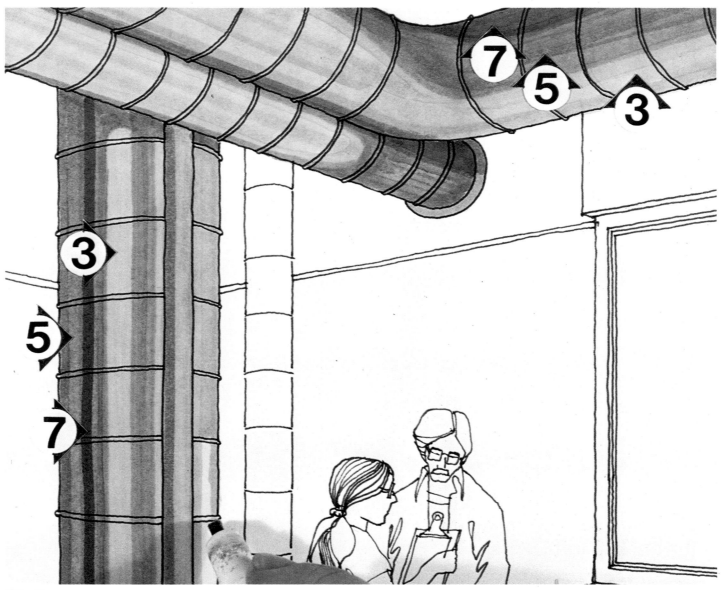

C3–41

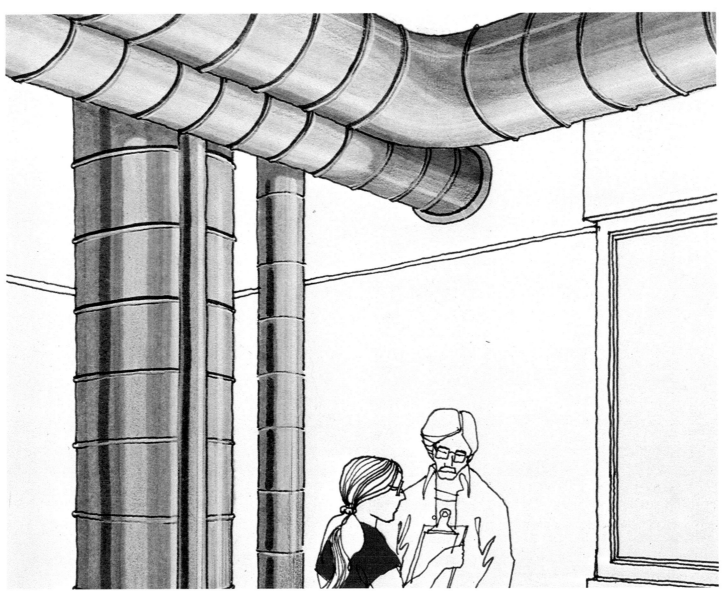

C3-42

C3–41, C3–42. ALUMINUM AND GALVANIZED STEEL. Unfinished aluminum and new galvanized steel are similar enough in appearance to be drawn with the same techniques. The light source here is the window on the extreme right.

It is important to be aware of the light source(s) when drawing reflective metals such as aluminum, galvanized steel, chrome, and polished copper. The highlights, or brightest areas, are caused by the reflection of the light source and occur on rounded forms *somewhere between the part of the surface that directly faces the light source and the part of the same surface that directly faces you, the viewer.* The light sources often occur outside the picture area and must be imagined. Notice how some reflective metals, such as aluminum and/or galvanized steel, have diffuse reflections with soft, blurry edges, especially in comparison to a surface such as chrome, in which the edges of the reflections are very crisp and distinct.

(1) Apply marker base. *Cool Gray #3* marker [3] was applied to the lightest areas, *Cool Gray #5* marker [5] to the medium areas, and *Cool Gray #7* marker [7] to the darkest areas and to those in shadow. The boundaries between these markers were scrubbed with a *Cool Gray #1* marker to make them more diffuse.

(2) Add highlights. Highlights running lengthwise along the ducts were added with *White* pencil and a straightedge. They were made most intense at their center by applying a heavier pressure on the pencil. The highlights were then made more diffuse by applying *White* pencil with less pressure on either side of the brightest highlights. *White*-pencil highlights were also added to minor protrusions, such as the transverse ribs on the ducts.

(3) Add details and finishing touches. Since colors near these metals will be faintly reflected by them, *Scarlet Lake* pencil was used to draw the reflections of the woman's red dress. *Light Blue* pencil was used to flavor the darker areas of the ducts, giving the metals a more characteristic bluish tinge.

C3–43, C3–44, C3–45. COPPER AND COPPER-BASED METALS. Shown here are the beginning steps for drawing polished-copper sheeting, a bronze statue, and a brass spittoon.

(1) Apply marker base. For copper use a *Redwood* marker; for brass, a *Golden Ocher* marker; for bronze, a *Dark Olive* marker.

(2) Add colored pencil. For copper *White* pencil was first applied to the light globes themselves, then used to draw their reflections in the copper. A graded wash of *Flesh* pencil, followed by a graded wash of *White* pencil, was applied to the copper to create the effects of illumination. For brass the first stages of the highlights were added with *White* pencil to the appropriate surfaces and edges. For bronze *Light Green* pencil is lightly applied to the parts of the surfaces thought to be most directly affected by the rain and sun to suggest oxidized copper.

(3) Add highlights and lowlights. For copper the wiggly white lines were first drawn in, using *White* pencil, and followed by straight white lines on the rounded surfaces of the forms. To one side or the other of these wiggly white lines small graded washes of *White* pencil were applied. On the slightly wrinkled surface of the copper these can be thought of as "hills" that reflect light. In between these hills darker "valleys" were then added with *Burnt Umber* and *Orange* pencils. The valleys are darker because they reflect little or no light. Light washes of *Pink*, *Light Green*, and *Apple Green* pencils were randomly added to various parts of the copper. For brass touches of white opaque ink were added with a ruling pen to create small, intense highlights. For bronze *Burnt Umber* pencil was used to create the lowlights (dark areas) on the statue. *White* pencil was applied to surfaces directly facing the overhead lighting.

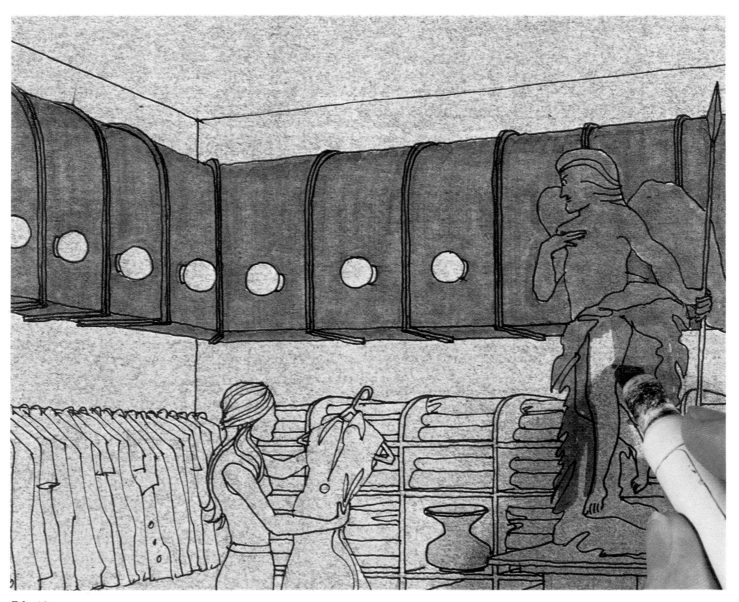

C3-43

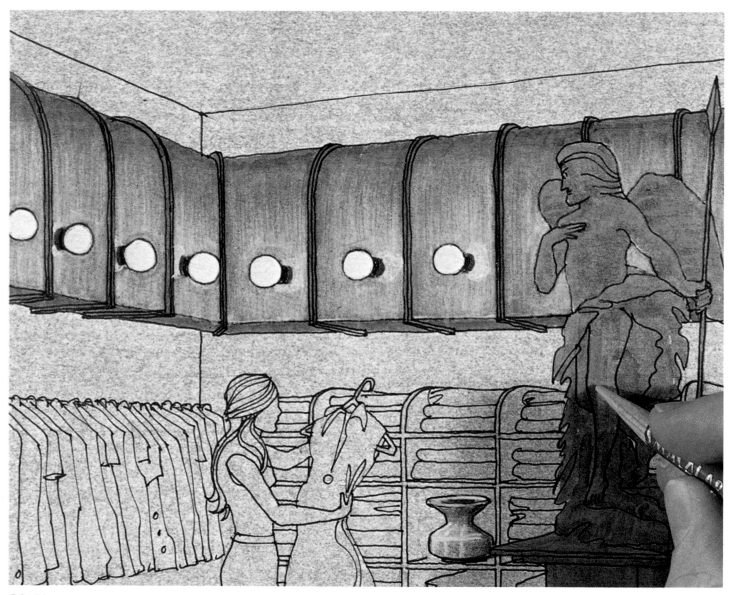

C3-44

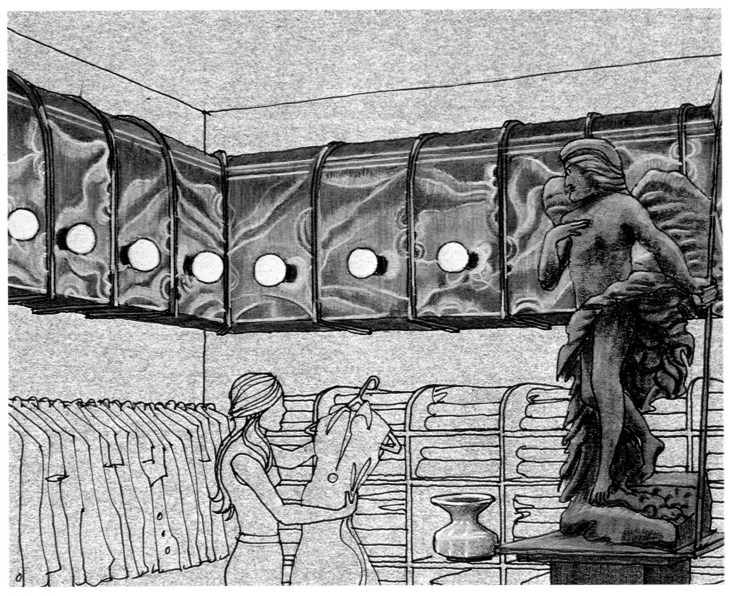

C3-45

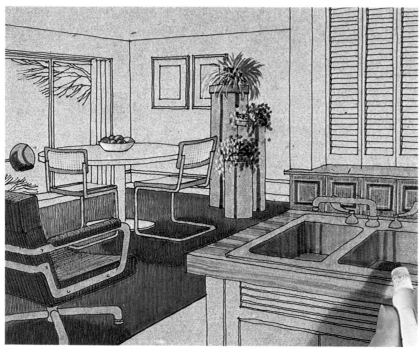

C3-46

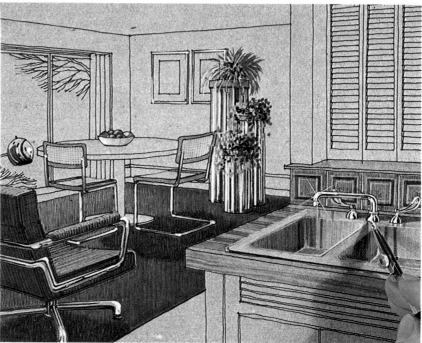

C3-48

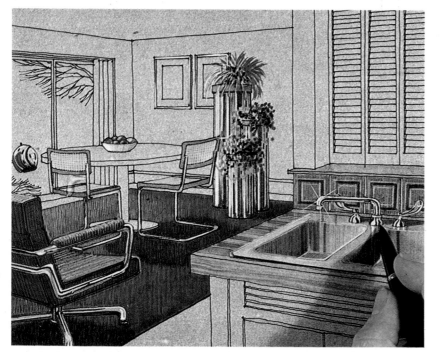

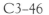

C3-47

C3-46, C3-47, C3-48, C3-49. **CHROME.** When drawing chrome, it might be helpful to keep the following points in mind: first, reflections in chrome have very distinct rather than blurry edges. Second, the reflections range from black to very bright, white highlights. Finally, chrome reflects the colors of its surroundings rather vividly, so it's important to include such colors in your chrome drawing. It's usually easier to draw the chrome last in a drawing so that you will know which colors will be reflected. Further clues for drawing chrome can be found in the color photographs in your source file, magazines, and books.

(1) Apply marker base. *Cool Gray #3* marker was applied first to all surfaces, including the stainless-steel sink. *Cool Gray #5* marker was used for the sink bottoms, while *Cool Gray #7* marker was applied to the left sides of the sinks. *Cool Gray #9* marker was used to add the darkest streaks on the sinks, planters, and reading lamp.

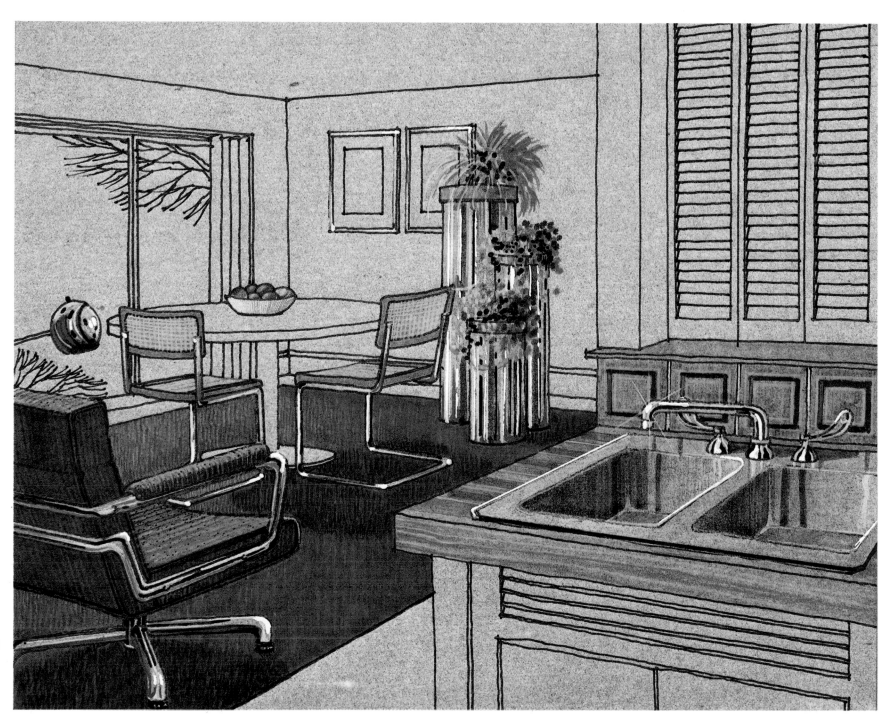

C3–49

(2) Add colored pencil and ink. For the sink *White* pencil was used to apply graded washes. *Apple Green* pencil was used to add the reflected tile color beside the faucet. For the faucet *White* pencil was applied first, with the strokes conforming to the shape of the faucet lengthwise. Black lines, running in the same direction, are added with a fountain pen. The sparkle was added with *White* pencil (though a bit corny, it *does* help to indicate chrome). For the planters *White* pencil was added first, using a straightedge. *Apple Green, Olive Green, Violet, Burnt Ocher, Sand, Canary Yellow,* and *Scarlet Lake* pencils were applied in small amounts between the white vertical lines. Black lines were then added with a fountain pen. For the foreground chair and the reading light the same procedure was followed as for the planters, except that only *Burnt Ocher* and *Violet* pencils were added between the white lines. For the dining chairs and picture frames streaks of *White* pencil were added in various places. Touches of black ink were added to the chair legs with a fountain pen.

(3) Apply highlights with white opaque ink. Though this step is not absolutely necessary, it will significantly improve the appearance of a chrome drawing. Here it was added frugally, using a ruling pen. If you want to remove dried white ink, simply chip it off with the tip of a knife.

Interior Materials

C3–50, C3–51. **FINISHED WOODS: oak, mahogany, walnut.** Illustrated here are the beginnings of an oak chair, a mahogany dresser, and a walnut grandfather clock.

(1) Apply marker base. Apply the marker base by stroking in the direction of the wood grain. For oak use *Sand* marker. For mahogany *Burnt Umber* marker was applied to the front and top. *Cool Gray #9* marker followed by *Burnt Umber* marker was used for the side in shade. *Golden Ocher* marker followed by *Cool Gray #3* marker was used for the brass hardware. For walnut *Burnt Umber* marker was used on surfaces in normal light, with *Cool Gray #9* marker followed by *Burnt Umber* marker for areas in shade and shadow.

(2) Develop wood colors with pencil. For oak *Orange* pencil was used to flavor all surfaces. For mahogany *Scarlet Lake* pencil was used to flavor all surfaces. For walnut *Sand* pencil was used to flavor only the lighted surfaces.

(3) Add highlights and lowlights. Highlights were added to small shapes and surfaces that reflect an imaginary light source, while lowlights were applied to small shapes and surfaces that would definitely be in shade and shadow—facing away from the same light source. *White* pencil was used for the highlights on all three pieces of furniture, while *Burnt Umber* pencil was used to create the lowlights. *Burnt Umber* pencil was also used to create the wood grain on the oak chair, while fountain pen was added to the lowlights on the grandfather clock.

C3–50

C3–51

C3-52, C3-53. **GRASSES.** Shown here are the beginning drawing stages of a few of the many contemporary furniture items made from grasses:

[1] bamboo window blinds
[2] cane seat and chair backrest
[3] sisal rug
[4] rattan-wicker trunk
[5] bound-grass basket
[6] woven-rattan chair

(1) Initial steps. For the bamboo window blinds the view through the window was drawn first (see C3-62). For the cane seat and backrest objects seen through them and backrest were initially drawn. Frames and armrests were added. For the sisal rug an approximately 12″ grid was drawn on the floor, with diagonals added to each square. *Beige* marker base was applied. *Cool Gray #3*, *Cool Gray #5*, and *Cool Gray #7* markers were used to create diffuse shadows. For the rattan-wicker trunk *Kraft Brown* marker was applied to lighter surfaces, with *Burnt Umber* marker used for shaded surfaces. For the bound-grass basket *Sand* marker is applied to the lighter sides and *Kraft Brown* marker to the rest of the surface in shade. For the woven-rattan chair *Beige* marker is applied to lighter areas, *Kraft Brown* marker to areas in shade.

C3-53

C3-52

(2) Develop color and illumination with pencil. For the bamboo window blinds draw the horizontal slats with a *Sand* pencil and a straightedge. With the darker *Burnt Umber* pencil draw over the *Sand* pencil lines in front of the glass area only so that the blinds contrast with the brighter exterior view. For the cane seat and backrest *Olive Green* pencil was used to add color to the leaves behind the backrest. A *Sand* pencil with a sharp point was applied in a cross-hatch pattern to both seat and backrest. For the sisal rug a *Burnt Ocher* pencil wash was applied to the entire rug. Over that *Cream* pencil lines were added to the triangles formed by the diagonals of each square. For the rattan-wicker trunk *Sand* pencil lines were added, following the direction of the weave, to both light and shade areas. For the bound-grass basket *Sand* pencil lines were applied, using rounded vertical strokes. Patches of *Burnt Umber* pencil were added, and *Cream* pencil was used for highlights. For the woven-rattan chair vertical strokes were added with *Cream* pencil.

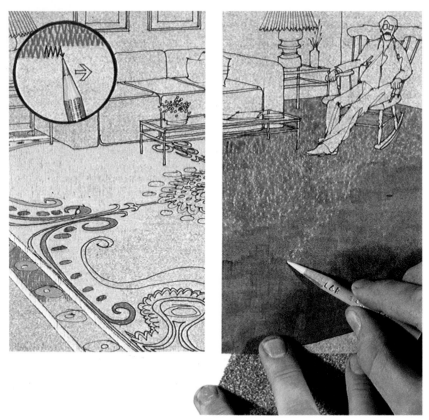

C3-54

C3-55

(3) Add finishing touches. The furniture items are complete, except for the following. For the bamboo window blinds drawcords and vertical binders are added with *White* pencil and a straightedge. For the sisal rug Pilot Razor Point lines are added to areas in shadow. For the rattan-wicker trunk highlights are added with *Cream* pencil. A Pilot Razor Point is used to apply dark lines, following the direction of the weave.

C3-54, C3-55. RUGS AND CARPETS.

(1) Apply initial color. For the patterned rug *Sand, Burnt Ocher, Violet, Olive Green, Non-Photo Blue,* and *White* pencils were used to apply color, using a short up-and-down stroke (inset) to create texture. No marker base was used. For the plain carpet *Redwood* marker was used as the base, with *Sand* pencil applied over it. Sandpaper was slipped under the drawing paper (diazo-print paper) to provide the grainy texture. (This technique works best when a light pencil is used over a darker marker and vice versa.)

(2) Add color refinements and diffuse shadows. For the patterned rug *White* pencil was applied over the entire rug to mute its colors (weaken their chroma), since they seemed too intense. *Burnt Umber* pencil was used to create the diffuse shadows under the tables, using the same up-and-down stroke. For the plain carpet *Violet* pencil was added with the sandpaper still in place, again using the side of the pencil point. *Burnt Umber* pencil was used for the diffuse shadows, and *White* pencil for highlights. Note the resultant graded value over the entire carpet.

C3-56, C3-57. LEATHERY MATERIALS.

Leathery materials are distinguished from other interior materials in that their surfaces are reflective, with crisp though slightly diffuse highlights. Shown here are three common colors of leathery materials.

(1) Apply marker base, stroking in the direction of the folds. For the sofa use *Burnt Umber* marker; for the chair, *Burnt Umber* marker with *Maroon* marker superimposed; for the ottoman, *Black* marker.

C3-56

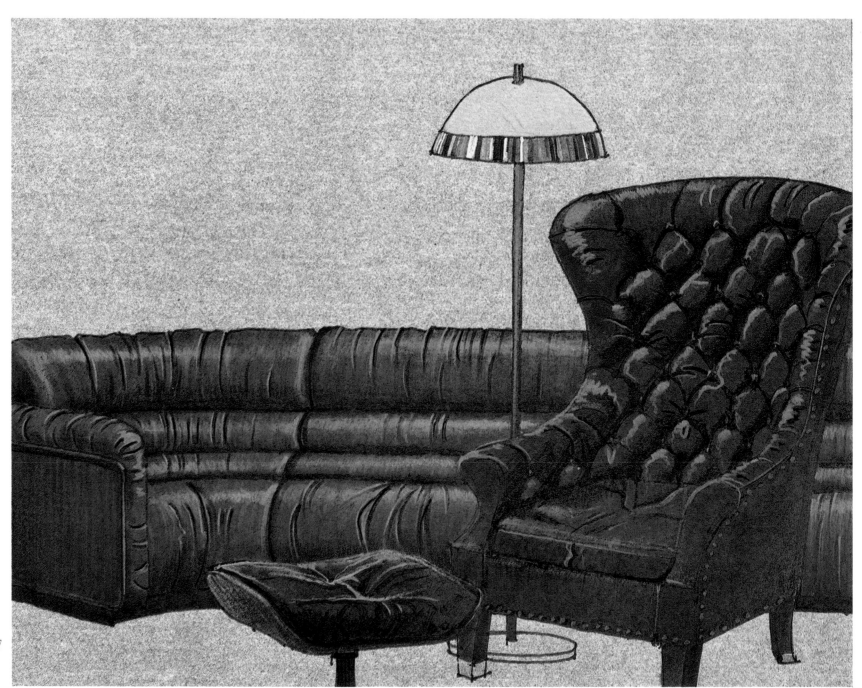

C3-57

(2) Add highlights. For the sofa *Cream* pencil was used to make the horizontal highlights that run along its length. *White* pencil was used over *Cream* pencil to create the most intense horizontal highlights. For the chair *White* pencil was used to create the wiggly highlights on each of the rounded forms and applied to the sides of forms facing the light. For the ottoman *White* pencil was used for highlights.

(3) Add lowlights and creases. For the sofa *Burnt Umber* pencil was used to apply short, vertical, curved streaks to the rounded forms. A streak of *White* pencil was applied immediately beside the dark one, indicating the part of the crease facing the light. A Pilot Razor Point was used over the *Burnt Umber* streak to make it even darker. *Burnt Umber* pencil was also used to make the shadow areas between the rounded forms. For the chair *Black* pencil was applied to the darkest areas between the rounded forms. For the ottoman *Black* pencil was applied to the portions of the forms that face away from the light source and to the tops of the rounded forms to add creases.

C3-58, C3-59. **SOFT, BRUSHED FABRICS.** Fabrics of this type diffuse light over their surfaces, creating soft-edged highlights and lowlights.

(1) Apply marker base. For the sofa *Dark Olive* marker was applied, stroking in the direction of the folds. For the chair *Light Ivy* marker was used; for the ottoman, *Sand* marker.

(2) Develop color and texture with pencil. For the sofa *Cream* pencil was used for highlights, while *Burnt Umber* pencil was utilized for shading. *Cream* pencil was applied as a wash over the entire sofa to soften the overall contrast. For the chair *Dark Green, Burnt Umber,* and *Olive Green* pencils were mixed to form a graded wash that was applied over the chair's surface. Flat, broad pencil points were used to obtain a soft, slightly textured effect. For the ottoman (shown with corduroy upholstery) *Burnt Umber* pencil was applied on the shaded side. *Burnt Ocher* pencil was used on all sides to create the corduroy pattern.

C3-58

C3-59

C3–60

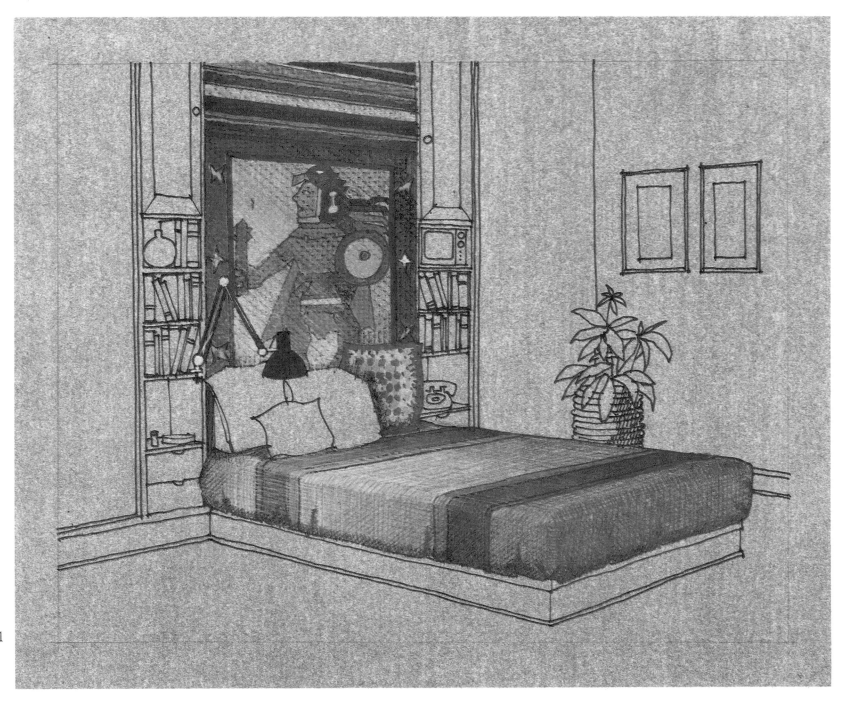

C3–61

C3-60, C3-61. COARSE FABRIC. Fabric with an obvious coarse-woven texture can be drawn using two different techniques. In the first (as for the wall hanging) a piece of common window screen is placed under the paper and drawn over with wide, flat-pointed colored pencils. A second way to illustrate a similar texture is to simply apply colored pencils with pointed tips in a cross-hatch pattern (inset).

(1) Apply marker base.

(2) Develop color, texture, and light simultaneously. For the wall hanging colored pencil was applied. A *White*-pencil wash was applied last to create light effects. For the bedspread *Cream* pencil was applied in a cross-hatch pattern to the lit areas, while *Burnt Umber* pencil was added to darker, shaded areas, also in a cross-hatch pattern. Note the graded values created with the colored pencils to simulate the effects of light. The crocheted pillow was added by simply applying a series of dots with colored pencils. *Black* pencil was used to create the shadow on the pillow.

C3-62, C3-63, C3-64. VIEW THROUGH A WINDOW. When looking from an interior through a window to the view outside, the view should be *lighter in value*, have *less contrast*, and show *less detail* than the interior.

(1) Draw exterior view. *Pale Olive, Olive, Dark Olive,* and *Cool Gray* #9 markers were used to stipple tree forms and create sunlight-washed grass. *Non-Photo Blue* pencil was washed lightly on the sky, while *Canary Yellow* pencil was used to highlight trees and grass. Apply the color directly over the window muntins, since they will be drawn in later.

(2) Apply *White* pencil wash. *White* pencil is applied to the entire view to make it lighter, with more pressure applied to the sky and less to the rest of the view. As before, draw right over the muntins.

(3) Draw in the window muntins and frame. *Redwood* marker was applied to the muntins (drawing right over the exterior view) and frame. *Burnt Umber* pencil was then applied over the muntins to make them an even darker brown, establishing even greater contrast with the exterior view. *White*-pencil highlights were added with a straightedge to the muntins and frame.

C3-65, C3-66. BATHROOM FIXTURES.

(1) Apply base color to the fixtures. *White* pencil was applied to the fixtures, using the most pressure on surfaces facing the light source. If the fixtures are colored, add marker base first, then use *White* pencil to create illuminated surfaces and highlights.

(2) Add reflected colors and shading. *Terra Cotta* and *Sand* pencils were used as flavoring in appropriate places to create the reflected colors of nearby surfaces. For the *White* fixtures shown here a *Copenhagen Blue* pencil was used to draw in the shade and shadow. For colored fixtures draw in the shade and shadow with a darker pencil of the same (or nearly the same) color.

(3) Accent highlights with white opaque ink. A ruling pen was used to add the highlights shown here.

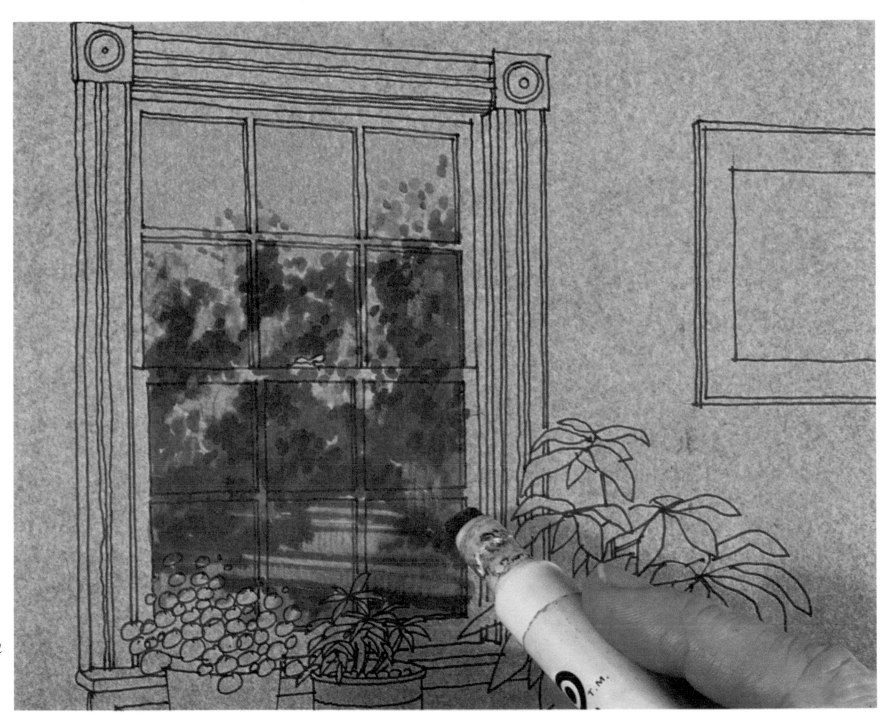

C3-62

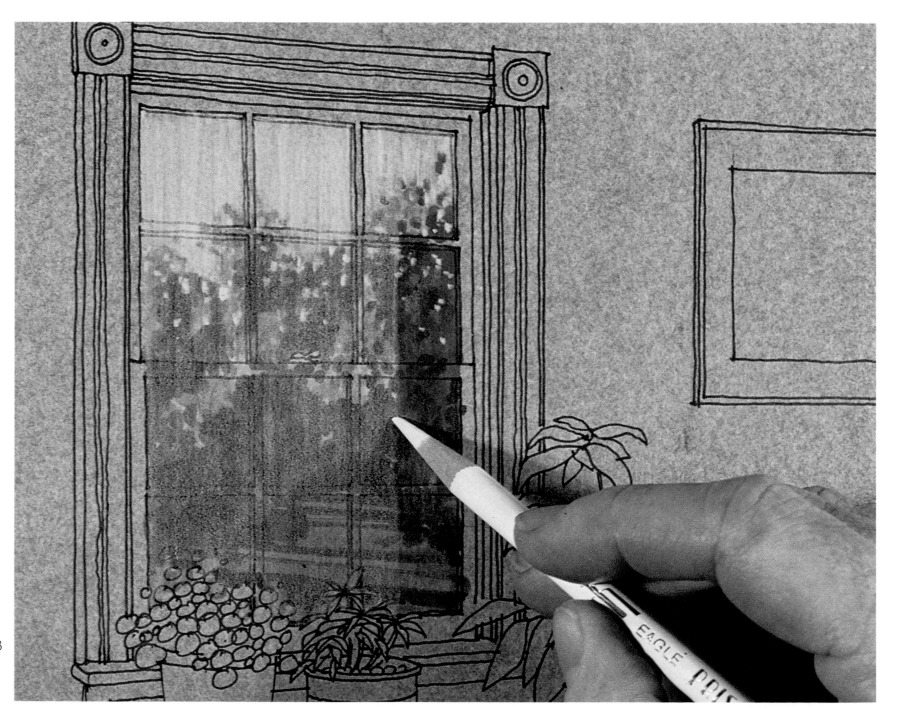

C3–63

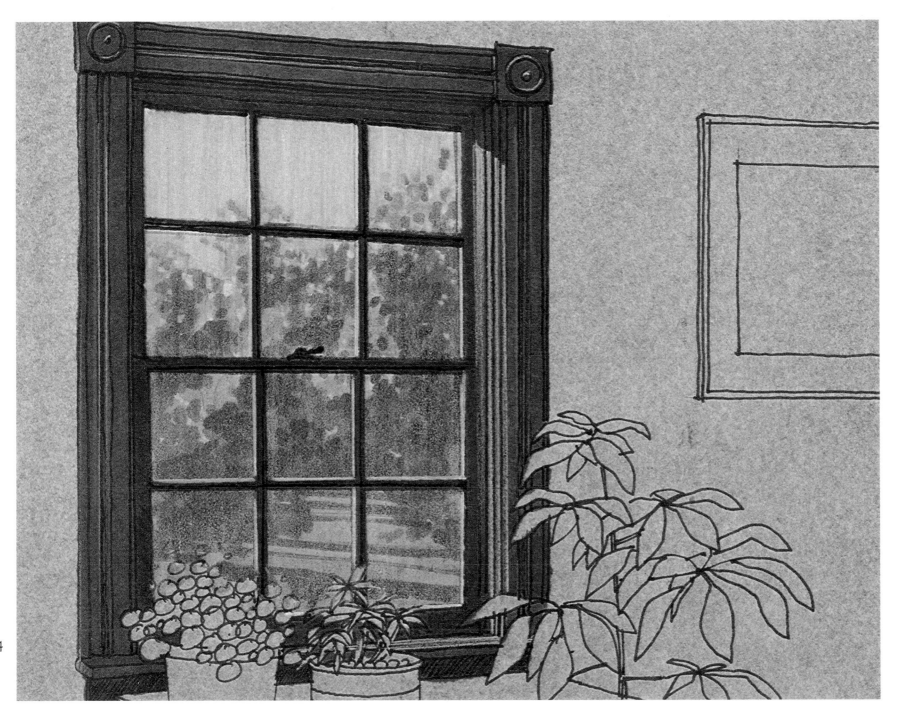

C3–64

C3–65

C3–66

C3-67

C3-68

C3–67, C3–68. DRAPES AND CURTAINS. The drapes on the left are opaque, while the curtains on the right are semitransparent. **(1) Apply marker shadows and exterior color.** For the drapes *Cool Gray #7* marker was applied to the shadows created by the folds. For the curtains *Cool Gray #7* marker was used to show the window frames and the shadows created by the folds. Note that shadows were omitted in curtain areas lying in front of the window glass. Colored marker is applied to the part of the view seen between the curtains (see also C3–64), while gray markers were applied to the part of the view seen *through* the curtains. **(2) Develop colors with pencil.** For the drapes *White* pencil was added in vertical strokes to both lighted and shadow areas of the folds, with more pressure applied to the lighted parts. *Copenhagen Blue* pencil was used to flavor the shaded parts of the folds. For the curtains *White* pencil was applied in the same manner as for the drapes. It was also used to wash the part of the exterior view seen *between* the curtains (see C3–63). *Olive Green* and *Canary Yellow* pencils were used to lightly flavor the part of the view seen *through* the curtains. *Copenhagen Blue* pencil was used to flavor the parts of the curtain folds in shadow.

Automobiles

C3–69, C3–70, C3–71. AUTOMOBILES, close range. Close-range automobiles can be effectively drawn when creating surfaces that fall into the following categories if a sharp, crisp distinction is kept between these surfaces. *Highlights*, caused when the metallic surfaces turn in such a way as to reflect the light source (usually the sun), are brightest on chrome. *Bright areas*—surfaces that face the light source—are usually the roof, hood, and trunk. *Middle areas*—which are somewhat darker and at an angle to the light source—include the sides of the doors and fenders. *Dark areas*—surfaces in shade, facing away from light source—are still reflective. *Shadow areas* include the interior, upper parts of tires, wheel wells, grill, and the ever-present (usually diffuse) shadow under the car. Magazine advertisements provide valuable examples of the above categories and can be used as references when drawing automobiles.

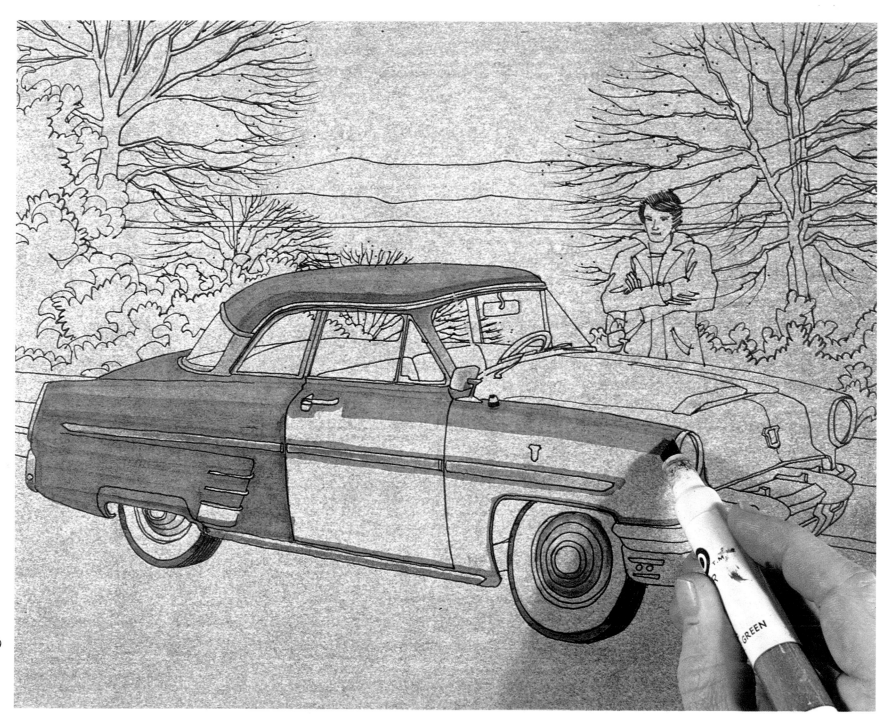

C3–69

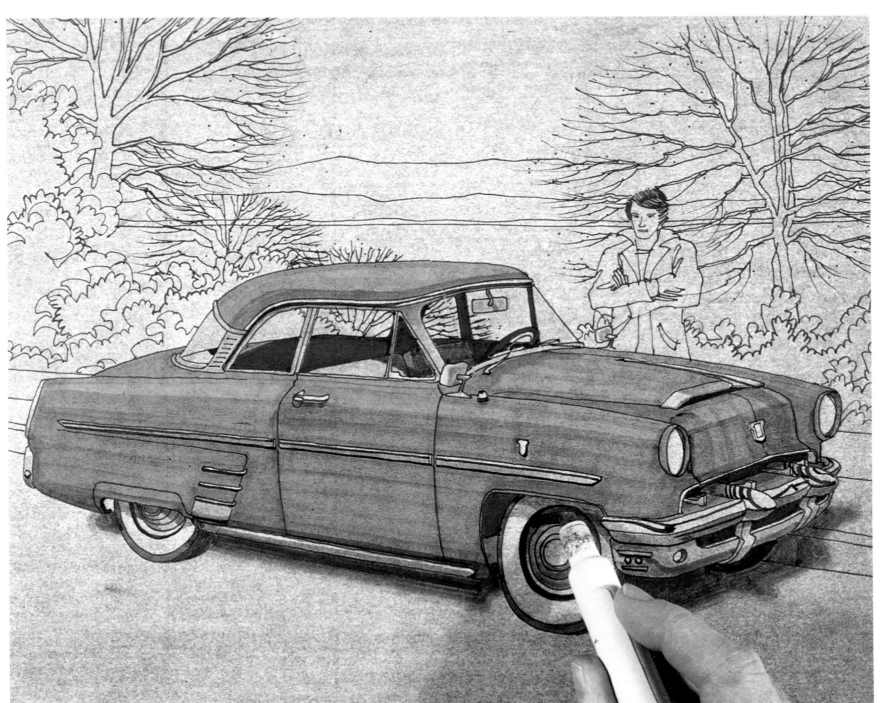

C3-70

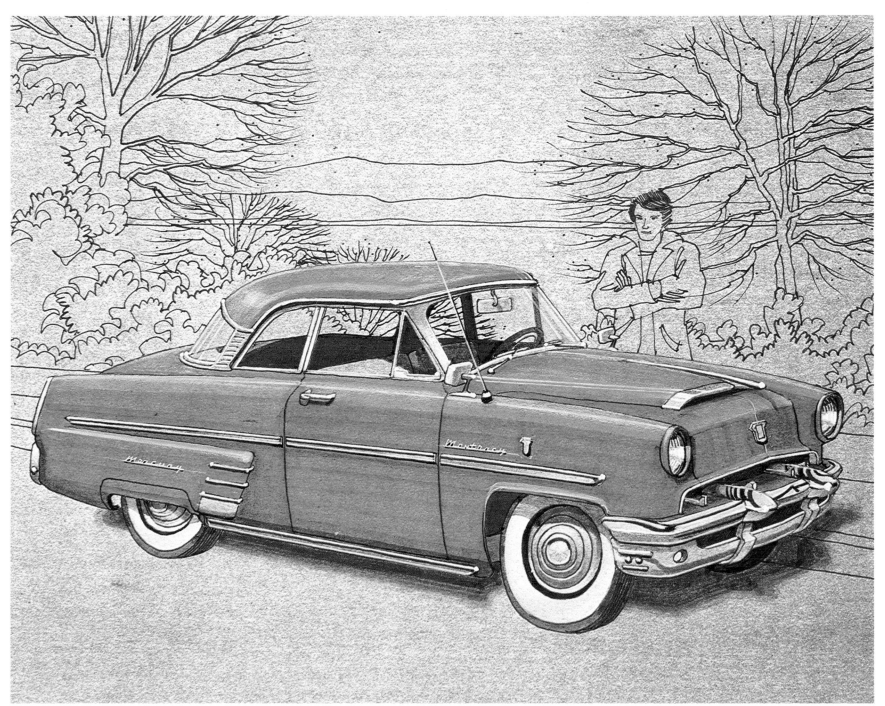

C3–71

(1) Apply marker base. *Cool Gray #3*, *Cool Gray #5*, and *Cool Gray #7* markers were used for the chrome; *Cool Gray #7* and *Cool Gray #9* markers were applied to the tires; and *Forest Green* marker was used on the body. This marker was applied with horizontal strokes in the same direction as for the highlights and the bright area.

(2) Add windshield, shadows, and dark areas. *Cool Gray #1* marker was used to slightly tint the windshield. Shadows on wheels were applied with *Cool Gray #5* and *Cool Gray #7* markers, while *Cool Gray #9* marker was used to make the shadow under the car; *Cool Gray #7* and *Cool Gray #3* markers were used to make its edge more diffuse. A Markette marker and fountain pen were used to darken the interior, wheel wells, under the hood ornament, and grill. Fountain-pen shadows were also added beneath small chrome items.

(3) Add highlights and bright areas. *Non-Photo Blue* pencil, with *White* pencil applied over it, was added to front and rear windows and to surfaces that directly face the sky overhead. The curved surfaces on the car body that turn to face the sun were flavored with *True Green* and *White* pencils. *White* pencil was also applied, using a straightedge, to the chrome edges facing the sun and to the whitewalls on the tires. The chrome bumper was flavored with *True Green* and *Non-Photo Blue* pencils. *White* pencil was then applied heavily to bumper surfaces facing the sky. White opaque-ink highlights were added last, using a ruling pen, to chrome edges and corners that would directly reflect the sunlight, creating a sparkle.

C3–72, C3–73, C3–74. **AUTOMOBILES, middle range.** Drawing cars at middle range is not difficult if you begin with simple boxes. Stage [1] shows the box framework in perspective at approximately the same size as that of an automobile. (This size estimate was made by simply drawing a scale figure next to where the car was to be drawn.) In stage [2] the outlines of the car are penciled in, avoiding too much detail. Magazine photos of automobiles are a big help at this stage. Stage [3] shows the car traced with a Pilot Razor Point and the pencil lines erased, ready for the marker base, as shown in [4]. When drawing parking lots full of cars, only one row of cars need be drawn. The rest of the cars can be *suggested* by drawing only simple roofs and windshields.

(1) Apply marker base.

(2) Apply shade and shadow and tone windows. *Cool Gray #5* marker was used for the tires and to shade the sides of the cars on the right. Fountain pen was used on the grille areas, the interiors, and for the shadows under the cars. *Cool Gray #3* marker was used to tone the windows.

(3) Add highlights. Each car received a light wash of colored pencil as close as possible to its base marker color. When the white highlights were added, the colors stayed rich and did not bleach out, as they would have without the pencil washes. The *White* pencil, used for highlighting, was most heavily applied to surfaces that directly face the sun.

C3-72

C3–73

C3-74

Landscape Materials

C3–75, C3–76, C3–77. BARE DECIDUOUS TREES, foreground. Foreground trees are often used to frame a view to the middle ground or center of interest of a drawing and are thus usually to one side of the drawing. The entire canopy of the tree will probably not be included within the limits of the drawing, since it is so close to the viewer.

(1) Draw background first. Once the layout of the tree is completed, draw in the background, complete with color, avoiding only the large branches of the foreground tree. Note that the outer edge of the tree canopy is lightly outlined to assure an irregular shape.

(2) Apply marker base to tree. *Cool Gray #3* marker is applied to the sunlit sides of the branches and trunks, while *Cool Gray #9* marker is added to the sides in shade.

C3–76

C3–75

(3) Add medium and fine branches. Medium-thickness branches were added with a Markette marker, and the fine branching with a fountain pen, drawn directly over the background.

(4) Add tree shadow. *Burnt Umber* marker was used to draw the shadow of the trunk and main branches. *Burnt Umber* pencil was then used to add the thin branches to the shadow and to texture the shadow. Notice how the shadow conforms to the shape of the land.

(5) Apply highlights and finishing touches. *Cream* pencil was used to highlight the trunk and main branches. *Burnt Umber* pencil was applied to the shaded sides of the trunk and main branches and to the branch shadows on the trunk. Fountain pen was used to stipple the trunk, adding texture.

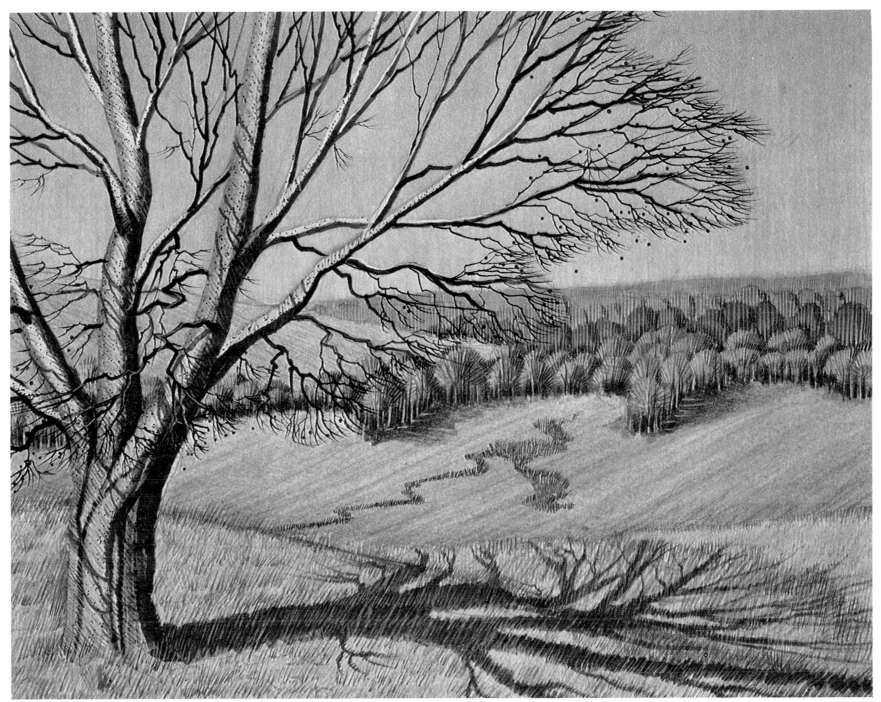

C3-77

C3-78

C3-79

C3-78, C3-79. BARE DECIDUOUS TREES, middle range. Middle-range bare deciduous trees are often used when trees must be shown in front of a building in a drawing, since the building can still be seen through the trees. Due to the middle range these trees will usually be seen in their entirety in a drawing. Note that the trees' canopy outlines are drawn lightly and serve as a guide for the branching lengths.

(1) Draw background first. The background was drawn first, avoiding only the trunks of the few closest trees. The tree shadows were also added at this point, using a *Cool Gray #7* marker.

(2) Add trunks and branching to trees. The trunks and main branches are drawn in with a *Cool Gray #7* marker. The medium branches were drawn with a Markette marker, while a fountain pen was used for the fine branching of the canopy edges. As the trees become more distant, thinner line media are used to draw the branching. On the last tree, for example, a fountain pen was used for the trunk and a Pilot Razor Point for the branching. Each tree canopy received a light wash of *Burnt Ocher* pencil to add color and to make it appear more full. Stippling was added to the closest trees with a Sharpie and a *Burnt Ocher* pencil.

(3) Apply highlights. *White* pencil was used to highlight the sunlit sides of the trunks and main branches.

C3-80. BARE DECIDUOUS TREES AND SHRUBS in front of dark backgrounds. When planning to draw bare trees or shrubs in front of dark values, such as shadows, windows, or darkened skies, use a light-value colored pencil to draw in the plant materials after everything else in the drawing has been completed. *Cream* pencil was used here to draw the part of the foreground shrub in front of the dark wall, while *Warm Grey Very Light* pencil was used to draw the trees on the right. This technique works best when there is a minimum of colored pencil on the dark surfaces over which you are drawing the tree or shrub.

C3–80

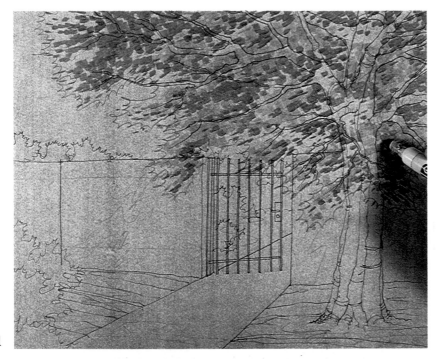

C3–81

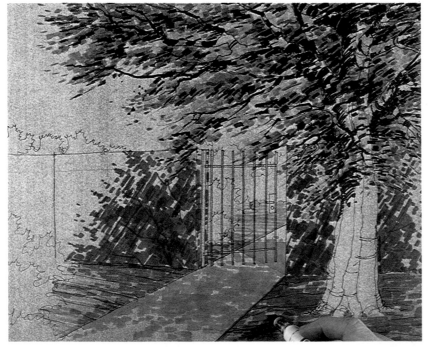

C3–82

C3–81, C3–82, C3–83. DECIDUOUS TREES IN FOLIAGE, close range. As with close-range bare deciduous trees, close-range trees in foliage are also not shown in their entirety in a drawing. Notice that the larger branches are drawn in first and darkened in later steps.

(1) Draw foliage with marker. *Pale Olive* and *Olive* markers were used to begin the application of foliage, stroking diagonally with the broad side of the marker tip. (Autumn foliage colors can be drawn with such markers as *Rust, Golden Tan,* and *Goldenrod.*) The outline of the tree canopy was delineated with a thin pencil line to serve as a guideline and will be erased when the foliage is completed. *Dark Olive* and *Cool Gray #9* markers were added, completing the foliage. Markette marker was applied to the smaller branching in a series of *broken,* not continuous, lines, since the view of the branches is interrupted by the leaf clusters.

(2) Begin shadows with marker. After the marker base for the grass was applied, *Dark Olive* marker was added in a series of close *horizontal* strokes. This same stroking was used to apply *Cool Gray #5* marker for the sidewalk shadows. *Burnt Umber* marker was applied with a *diagonal* stroke to the brick wall.

(3) Add highlights, details, and finishing touches. For the foliage *Canary Yellow* pencil, with *White* pencil applied over it, was added over the *Pale Olive* marker. *Light Blue* pencil, with *White* pencil over it, was used to create the sky. Note the many bits of sky showing through the foliage. For the trunk *Cool Gray #5* marker was used to make the shadows. *Cream* pencil, with *White* pencil applied over it, was used to draw the sunlit areas between the shadows. *Burnt Ocher* pencil was then used to flavor the entire trunk. Additional texture was added by stroking a Pilot Razor Point diagonally over the shadows, with a fountain pen used for stippling. The grass marker shadows received a wash of *Olive Green* pencil. Over that, a Pilot Razor Point was stroked on vertically to add an even darker texture. *Cream* pencil, also stroked vertically, was used for the sunlit grass areas. *Apple Green*-pencil flavoring was added over the *Cream* pencil. *Flesh* pencil was used to flavor the marker shadows on the brick wall, while a heavier wash of *Flesh* and *White* pencil was used in the sunlit areas. The mortar joints were done with *White* pencil and a

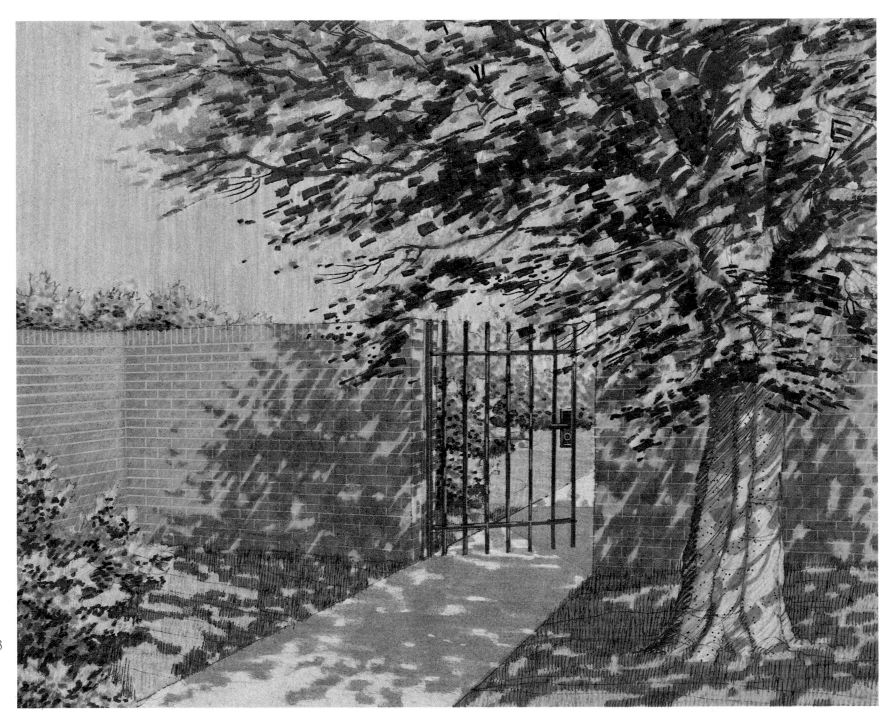

C3–83

straightedge, giving the shadow a transparent quality. *Copenhagen Blue* pencil was used to flavor the marker shadows on the sidewalk. *White* pencil, with a *Flesh*-pencil flavoring, was used to wash the sunlit areas.

C3-84, C3-85, C3-86. DECIDUOUS TREES IN FOLIAGE, middle range. As with bare middle-range deciduous trees, leafy middle-range deciduous trees are also usually seen in their entirety in a drawing.

(1) Apply marker base to foliage. *Pale Olive* marker (for sunlit foliage), *Olive* marker (for foliage in middle light), and *Dark Olive* marker (for foliage in shadow) were applied, using the points of the markers in stippling fashion. Note that the lines of the buildings still show through the foliage in places and act as a guide when applying color to surfaces behind the trees, a necessary step to make the trees appear sufficiently loose and leafy.

(2) Begin shadows, using marker. Using the appropriate markers, the shadows cast by the trees were added. *Horizontal* strokes were used for shadows on the ground, *vertical* strokes for shadows on walls facing the sun, and *diagonal* strokes for surfaces (including people) perpendicular to the direction of the sunlight.

(3) Add color to surfaces behind trees. To small areas seen through the foliage (i.e., not touched by the marker base) the appropriate colored pencils were applied to show the building's colors and the sky.

(4) Apply highlights, details, and finishing touches. A mixture of *Canary Yellow* and *Cream* pencils was applied over the *Pale Olive* marker used to depict the sunlit foliage. Branches were then added with a Markette marker and a fountain pen, using intermittent strokes. *Cool Gray #9* marker was used to stipple in even darker areas of the leaf masses. The appropriate colored pencils were used to highlight the sunlit surfaces and lowlight the shadows in the same manner as for close-range deciduous tree in foliage (C3-83).

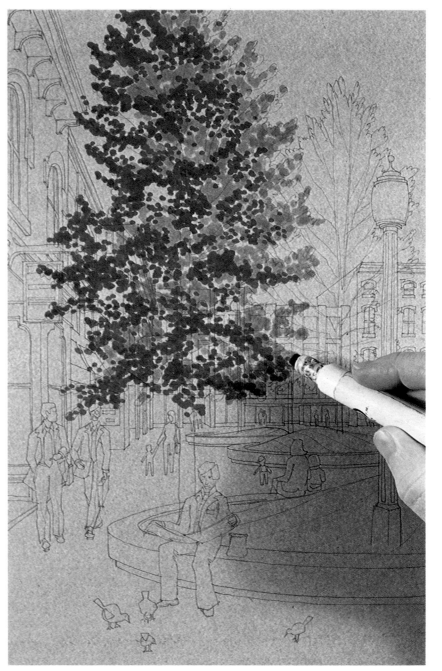

C3-84

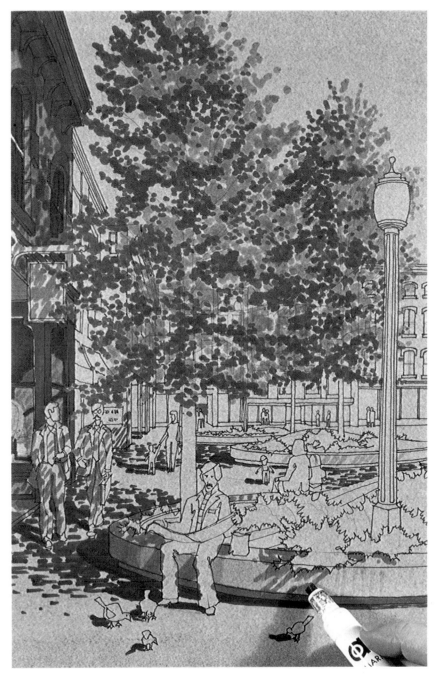

C3–85

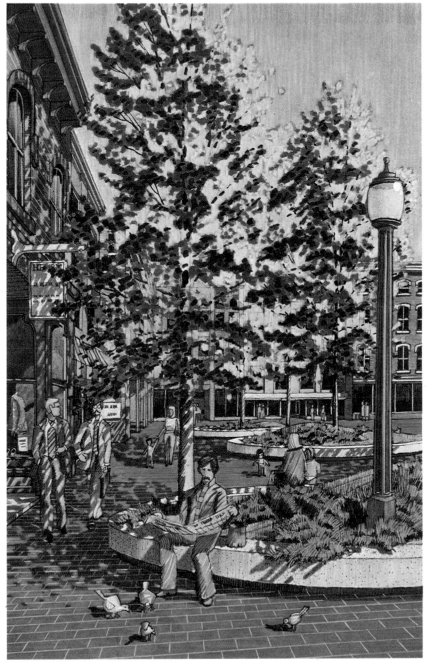

C3–86

C3-87

C3-88

C3-87, C3-88. DECIDUOUS TREES IN FOLIAGE, distant.
(1) Apply marker base. *Pale Olive* and *Olive* markers were applied to the tree forms with the point of the marker tip in stippling fashion. *Dark Olive* marker was applied in the same way to create the darkest areas of the tree foliage and also used for the shadows beneath the trees, added with a horizontal stroke. The distant hill was made with a *Slate Green* marker. Notice how the lower parts of the closest trees are filled in with marker, with no white showing through, indicating the distant hill behind them.
(2) Apply highlights, shadows, and finishing touches. *Cream* pencil was applied to highlight the *Pale Olive* marker base on the foliage. *Cool Gray #9* marker was added to make the bottoms of the tree canopies even darker. *Light Violet*-pencil flavoring was then applied over the trees to weaken the chroma of their colors. For the very far distant trees and hill *Light Violet*, *Non-Photo Blue*, *White*, and *Warm Grey Very Light* pencil washes were added to reduce the chroma and increase the value of the colors, making them recede into the distance.

C3-89, C3-90. SHRUBS. The shrubs shown here are generalized indications and not intended to represent any specific type. Specific shrubs could be drawn with these techniques, however, by imitating their habit, size, and coloration.
(1) Apply marker base. Shrubs of various colors are shown here, each with a marker base applied with the point of the marker tip in stipple fashion:
 [1] *Chrome Green* and *Light Olive* markers
 [2] *Slate Green* and *Cool Gray #7* markers
 [3] *Pale Olive* and *Olive* markers
Cool Gray #9 marker was stippled on all the shrubs to create the darkest areas. *Dark Olive* marker was used to indicate shadows on the grass.
(2) Create highlights, shadows, and contrasts. For shrub [1] *Apple Green* pencil was applied to its sunlit areas, with *Cream* pencil added on top. *Pink* pencil was used to create the flowers. A graded-pencil wash was applied to the fence behind, allowing the shrub to stand out by contrast. The sunlit leaves on shrub [2] were colored with

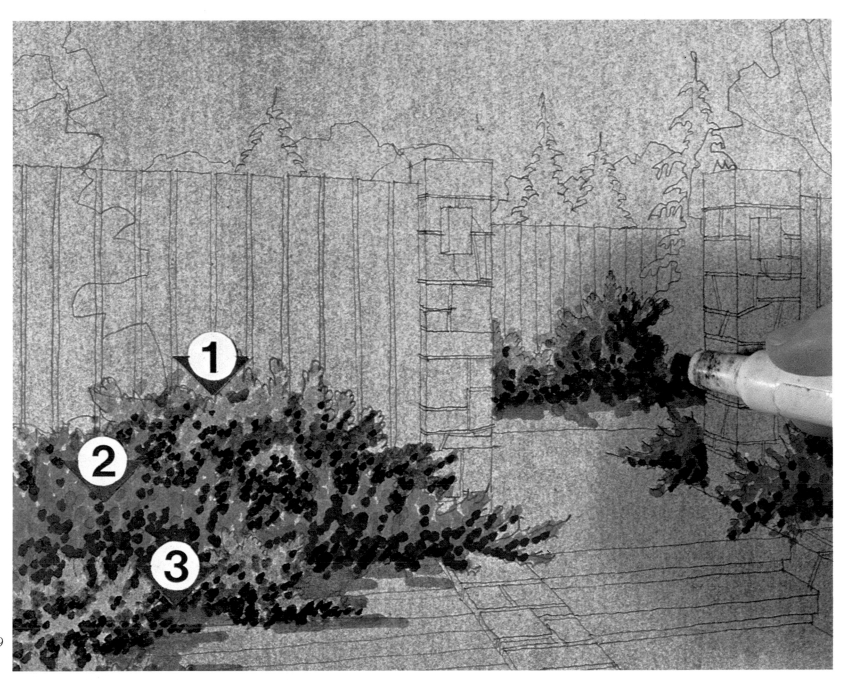

C3–89

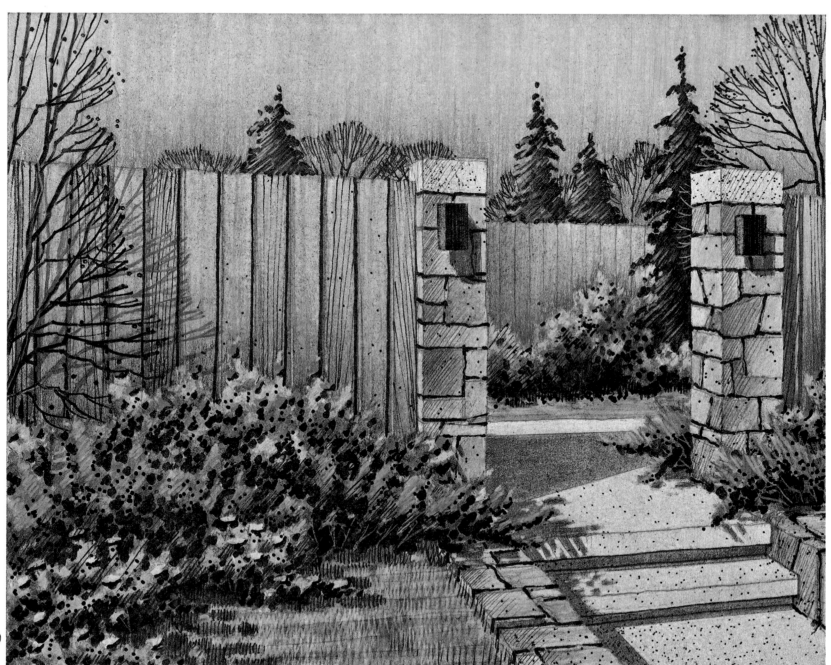

C3–90

Olive Green pencil, with *Cream* pencil again applied to lighten the color. *Blue Violet* pencil was applied to the shaded parts. *Warm Grey Very Light* pencil was used to draw the branching underneath. Shrub [3]was treated to a *Sand* pencil on its lightest foliage, also with *Cream* pencil applied over it. *White* pencil was used for the blossoms. A Pilot Razor Point was stroked vertically to texture the shrub shadows on the grass.

(3) Stipple for texture. A Sharpie was used to stipple the shrubs in order to add further texture.

C3-91, C3-92, C3-93. **EVERGREEN TREES.** The evergreen trees illustrated in this sequence of steps are typical of the many kinds of evergreens found throughout the world. Tree [1] is a sprucelike tree. By using the stroke shown in the inset you can, by varying the form, draw trees similar in form to that of the spruce (genus *Picea*), such as the hemlock (*Tsuga*), fir (*Pseudotsuga* and *Abies*), larch (*Larix*), and cedar (*Cedrus*). Tree [2] shows a pinelike tree, and the stroke (inset) can be used for drawing the many types of pines (*Pinus*). Tree [3] is a cypresslike tree (*Chamaecyparis*), and the stroke used to draw it may be applied to similar tree forms, such as the juniper (*Juniperus*) and the yew (*Taxus*).

(1) Apply marker base to foliage. For the sprucelike tree *Slate Green* marker was applied, using the stroke shown in the inset and stippling the marker to create a Colorado Blue Spruce (*Picea pungens glauca*) tree form. For the pinelike tree *Cool Gray #7* marker was applied, using the stroke shown in the inset. For best results use a marker that is slightly on the dry side to create the feathered edge at the end of the stroke. For the cypresslike tree *Slate Green* marker was applied, using the stroke shown in the inset.

(2) Develop color, shading, and trunks with marker. For the sprucelike tree *Cool Gray #9* marker was stippled on the underside of the foliage masses and used to darken the tips of the masses on the shaded side of the tree. For the pinelike tree *Olive* marker was applied over the *Cool Gray #7* marker base. *Cool Gray #9* marker was used on the underside of the foliage masses to develop their shading. The trunks are drawn with *Redwood* marker, using *Cool Gray #9* marker to shade. For the cypresslike tree *Olive* marker was applied over the *Slate Green*-marker base, using the same stroke as shown in the inset. *Cool Gray #9* marker is stippled over the shaded sides of the trees, gradually reducing the density of the stippling toward the sunlit sides.

(3) Add background and immediate ground planes, working carefully around tree forms. Add highlights and final touches. For the sprucelike tree *Olive Green* pencil was used to wash the entire tree, with *White* pencil applied to the sunlit foliage masses in an upward stroke. Touches of *Burnt Ocher* pencil were added to indicate dead foliage. For the pinelike tree *Sand* pencil was used to highlight the sunlit tops of the foliage masses, while *Olive Green* pencil was added to the shaded areas to bring out their color. Fountain pen was used to add a needlelike texture to the shaded sides of the foliage masses. Touches of *Burnt Ocher* pencil were added to represent dead foliage. *Cream* and *White* pencils were used to highlight the sunlit parts of the trunks, while *Burnt Umber* and *Violet* pencils were added over the shaded areas. For the cypresslike tree *Sand* and *Cream* pencils were applied to highlight the sunlit areas, creating small, fan-shaped patterns with straight lines.

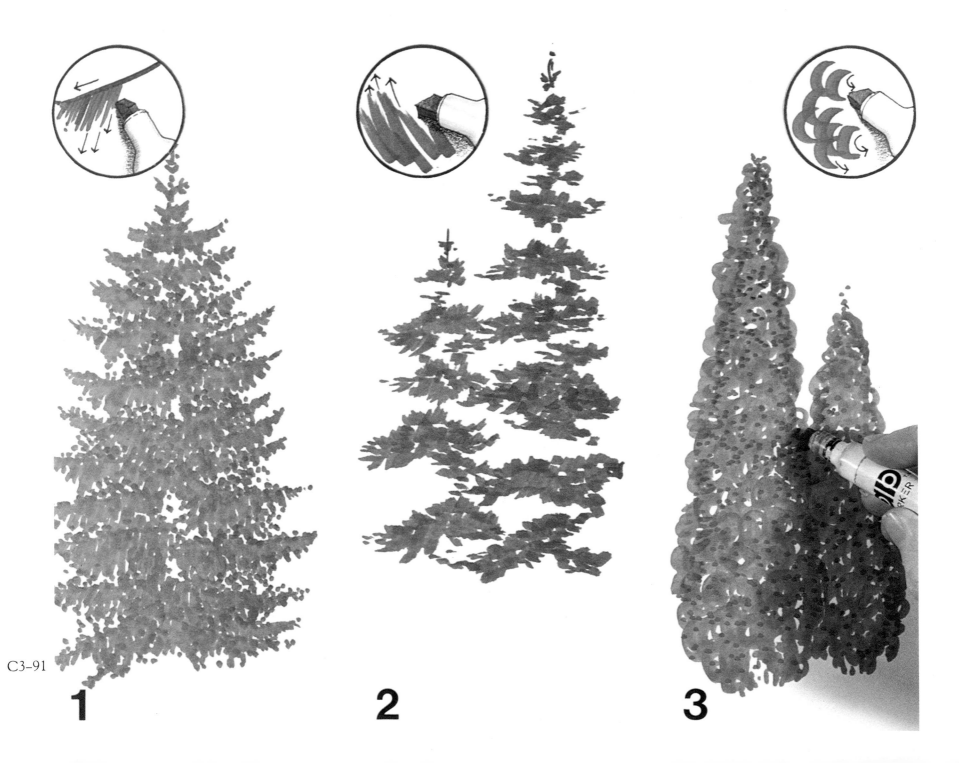

C3-91

1

2

3

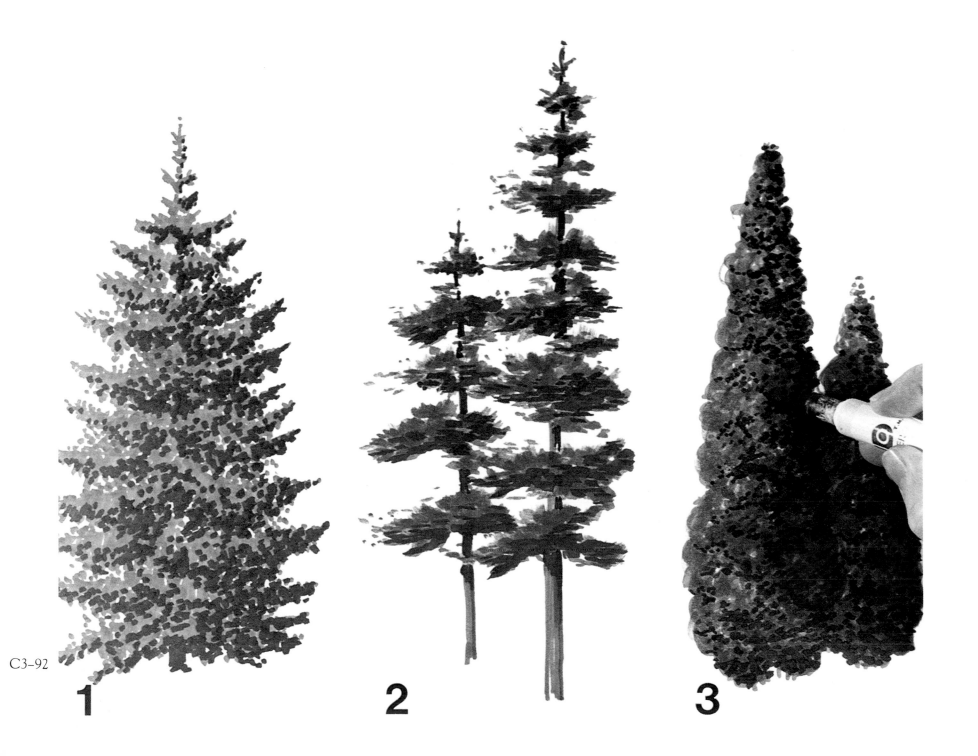

C3-92

1

2

3

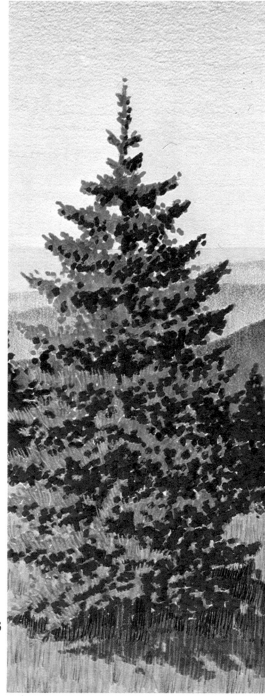
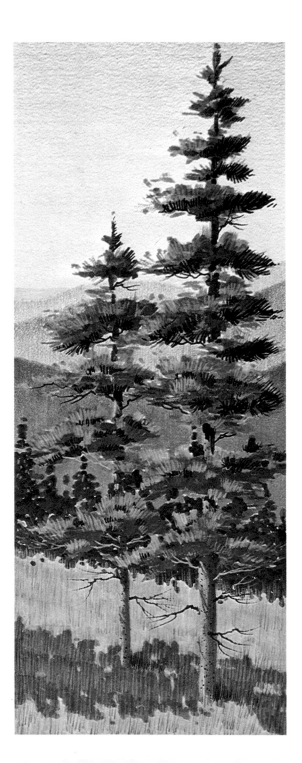
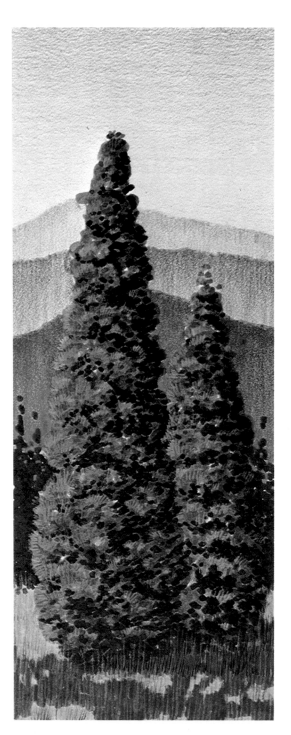

C3–93

C3-94, C3-95. MIDDLE-RANGE AND DISTANT EVER-GREEN TREES.

(1) Draw middle-range trees first. A Sharpie was used to draw the middle-ground trees, using a simple slanted stroke over a trunk line. On the opposite side of each tree the stroke was slanted in the opposite direction (inset). The closer trees, on the left and extreme right, were created by stippling a *Cool Gray #9* marker over a trunk line. These trees are left dark since they often appear as such in the landscape.

(2) Add trunks. *Warm Grey Very Light* pencil was used to draw the trunks of the trees, using intermittent lines.

(3) Draw distant evergreen trees. Once the middle-ground evergreens were drawn, an *Olive* marker was used to add the distant trees by repeatedly flicking the marker upward, producing an evergreen-like shape with a wider bottom and narrower top. The point of the marker tip was used to make these shapes. Fountain pen was then applied, using the same stroke to suggest both tree-mass texture and shading. More of these lines were added at the crest of the hill to contrast more strongly with the mountain behind. *Sand* pencil was also added, again using the same stroke, to create a low-sun-illumination effect on the trees. Note the *Non-Photo Blue* pencil immediately behind the middle-ground trees, which creates more contrast with the distant tree mass.

C3-96, C3-97. EVERGREEN SHRUBS. Juniper and pine shrubs, two typical evergreen-shrub types, are illustrated in this series of drawing steps.

(1) Apply marker base. *Slate Green* marker was applied to the junipers with the point of the marker tip and flicked in a series of fanlike patterns. The pines on the right were drawn with the *broad* side of an *Olive* marker tip, again flicking the tip upward from the center of the shrub.

(2) Add highlights, texture, and shading. The junipers to the side and rear of the fountain are shown in their summer-foliage color. *Cream* pencil, with *White* pencil over it, was applied to the sunlit sides of each shrub, flicking the pencil upward to maintain the spiky habit of the foliage masses. On the shaded sides *Terra Cotta* pencil was added to dull the somewhat intense marker color (and to repeat the brick color). Fountain pen was used to create dark areas in each shrub, again flicking upward with the stroke, and to stipple the shrubs for additional texture. The junipers in front of the fountain at the bottom middle of the drawing are shown in their winter-foliage color, similar to that of an andorra juniper (*Juniperus horizontalis plumosa*). They were drawn by washing each shrub with *Terra Cotta* and *Light Violet* pencils, with *White* pencil flicked upward on the sunlit sides. Fountain pen was used to create the darkest texture and for stippling. The pine shrubs on the right are similar to the mugo pine (*Pinus mugo mughis*). The sunlit needles were highlighted by flicking *Sand* and *White* pencils outward from the curved vertical branches (drawn with fountain pen), while the dark, shaded needles were drawn with fountain pen, using the same stroke.

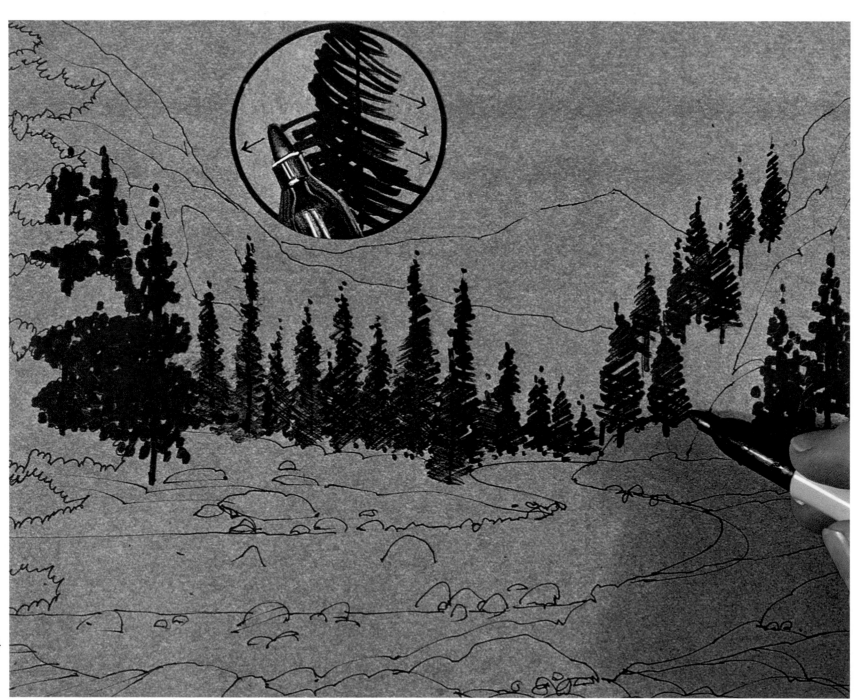

C3–94

C3–95

C3–96

C3-97

C3–98, C3–99, C3–100. **PLANTS OF ARID REGIONS.** The plants illustrated here are common to desert ecologies, such as that of the American Southwest. Their common and Latin names are:

[1] joshua tree (*Yucca brevifolia*)
[2] california fan palm (*Washingtonia filifera*)
[3] mexican fan palm (*Washingtonia robusta*)
[4] ocotillo (*Fouquieria splendens*)
[5] saguaro (*Carnegiea gigantea*).
[6] curveleaf yucca (*Yucca recurvifolia*)
[7] barrel cactus (*Echinocactus acanthodes*)
[8] century plant (*Aguave americana*)
[9] prickly-pear cactus (*Opuntia gosseliniana santa-rita*)
[10] blue palo-verde tree (*Cercidium floridum*)
[11] date palm (*Phoenix dactylifera*)
[12] sago palm (*Cycas revoluta*).

(1) Apply marker base. For the [1] joshua tree apply *Willow Green* marker to trunks and heads, *Sand* marker to trunks; for the [2] california fan palm, *Olive Green*, *Sand*, and *Kraft Brown* markers to leaves, *Beige* marker to trunk; for the [3] mexican fan palm, *Olive Green* marker to leaves, *Beige* marker to trunks, *Burnt Umber* marker to show cut marks below leaves; for the [4] ocotillo, [5] saguaro, [6] yucca, and [7] barrel cactus, *Willow Green* marker; for the [8] century plant, *Slate Green* marker; for the [9] prickly-pear cactus and [10] palo-verde tree, *Willow Green* marker; for the [11] date palm, *Olive Green*, *Sand*, and *Kraft Brown* markers to leaves, *Beige* and *Burnt Umber* marker to trunk; for the [12] sago palm, *Olive Green* marker.

(2) Add shade and shadow with marker. For the [1] joshua tree apply *Dark Olive* marker to shaded needles on the head and to the trunk, *Cool Gray #9* for extra dark accents; for the [2] california fan palm, *Burnt Umber* marker to shaded sides of leaves and trunk, *Sand* marker to the trunk to make the transition between shaded and sunlit sides; for the [3] mexican fan palm, *Dark Olive* and *Cool Gray #9* markers to shaded sides of leaves, *Burnt Umber* and *Sand* markers to shaded sides of trunk; for the [4] ocotillo, touches of *Dark Olive* marker to base of plant; for the [5] saguaro, [6] yucca, and [7] barrel cactus, *Dark Olive* marker to shaded side; the [8] century plant was

left untouched; for the [9] prickly-pear cactus and [10] palo-verde tree, *Dark Olive* marker to shaded side; for the [11] date palm, *Burnt Umber* marker to shaded leaves and trunk; the [12] sago palm was left untouched and is complete at this point. *Burnt Umber* marker was used to apply plant shadows on the ground.

(3) Add background, highlights, and details. At this point in the process it is advisable to draw the background, including the sky, before adding further detail to the plants. Once the background has been drawn, details such as small branching and leaf tips can be drawn right over it. The highlights and details were added as follows. For the [1] joshua tree *Sand*, *Light Violet*, and *Apple Green* pencils were used to flavor the leaves. *White* pencil was added for highlights, and fountain pen used on shaded sides of leaf clusters. *Sand* pencil was applied to the sunlit side of the trunk, while *Burnt Umber* pencil was used on the shaded sides. *Violet* pencil was used to flavor the shaded side of the trunk, with fountain pen added over it to further darken it. For the [2] california fan palm *Sand* and *Cream* pencils were added to the sunlit sides of the leaves and trunk, while *Burnt Umber* and *Violet* pencils, along with fountain pen, were applied to the shaded sides. For the [3] mexican fan palm *Olive* pencil was used to wash the leaves, and *Cream* pencil was added for highlights. *Violet* pencil was used to lightly wash the shaded side of the trunk. For the [4] ocotillo used to lightly wash the shaded side of the trunk. For the 4 ocotillo *Cream* pencil was used to highlight the sunlit sides of the stems, and *Black* and *Violet* pencils were applied to the shaded sides. *Scarlet Lake* pencil was used for flowers. Short, horizontal strokes of a Pilot Razor Point were used to add spines. For the [5] saguaro *Sand* and *Cream* pencils were applied to sunlit sides of trunks, while *Violet* pencil was used to flavor the shaded sides. *White* and *Canary Yellow* pencils were used for flowers. Fountain pen was used for vertical furrows and stippling. For the [6] yucca *Peacock Green* pencil was added to all leaves. *Indigo Blue* pencil was applied to the shaded leaves. *White* pencil was used to highlight both leaves and flowers. Fountain pen was used to apply dark shading to leaves. For the [7] barrel cactus *Sand* and *Cream* pencils were used to highlight the top of the plant. *Cream* pencil was also used on the sunlit side, *Burnt Umber* pencil to the shaded side and furrows. *Violet* pencil was added near the bottom of

C3-98

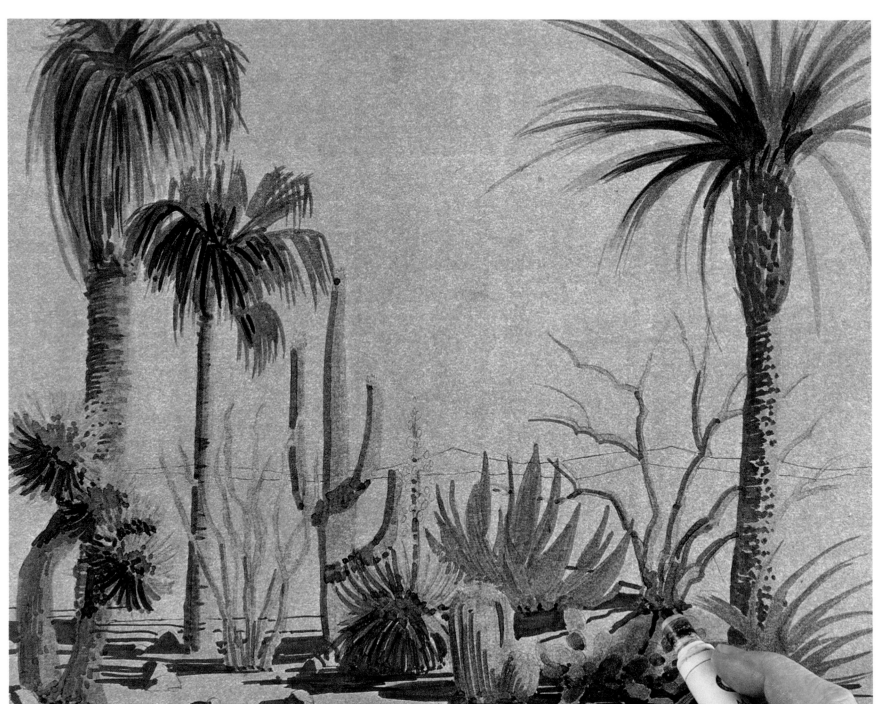

C3-99

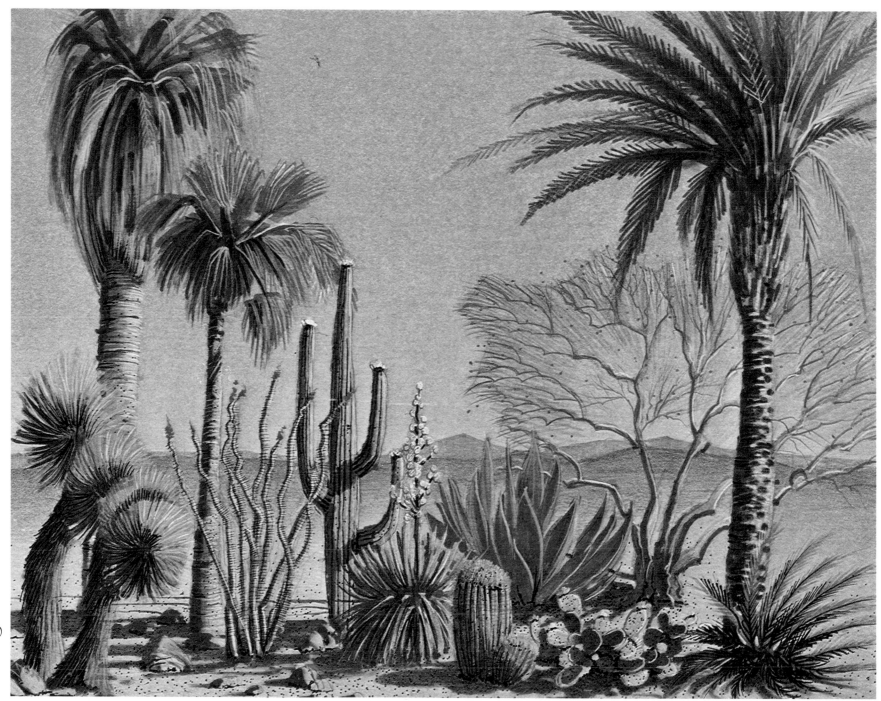

C3–101

C3–102

the cactus, *Magenta* pencil near the top. Fountain pen was added to furrows and used for stippling. For the [8] century plant *Olive* pencil was used to wash all leaves. *White* pencil was added for highlights. For the [9] prickly-pear cactus *Sand* and *Cream* pencils were used for highlighting. *Yellow Orange* and *Cream* pencils were used to draw flowers. Fountain pen was used to create dark areas and for stippling. For the [10] palo-verde tree *Peacock Green* pencil was used to draw the thin branches, while *Peacock Green* and *Olive Green* pencils were used to draw in the fine branching. *Violet* pencil was used to flavor the left sides of the tree canopy and the trunk. Cream pencil was used to highlight the right side of the tree canopy, branching, and trunk. For the [11] date palm *Cream, Sand, Olive Green,* and *Burnt Umber* pencils were used to articulate leaves. *Cream* pencil was used to highlight the trunk, while *Burnt Umber* and *Violet* pencils were added to the shaded side of the trunk.

C3–101, C3–102. LAWN GRASS.

(1) Apply marker base. *Light Olive* and *Sand* markers were applied to the grass areas in sunlight, while *Dark Olive* marker was used to create the shadows. Note that the markers were applied parallel to the help lines, which were added to indicate the contour of the ground. Leaf litter, created with small dashes of *Kraft Brown* and *Burnt Umber* markers, has collected most densely in the nooks and crannies of the rocks.

(2) Apply texture and highlights. A Pilot Razor Point was applied to the shadow areas, using an up-and-down vertical stroke and moving parallel to the help lines. After a *Canary Yellow*-pencil flavoring was added to the sunlit areas, *Cream* pencil was applied to the foreground sunlit areas, again using the up-and-down stroke and following the help lines. This textural stroke was faded out toward the background and gradually replaced with a sweeping stroke of the *Cream* pencil, following the help lines. *Light Violet* pencil was used to flavor the background grass, fading it into the distance. *Olive Green* pencil was used to flavor both sunlit and shadow areas, using large up-and-down strokes. The dead leaves were accented with *Burnt Ocher* and *Sand* pencils, and tiny shadows were placed under each leaf with a fountain pen.

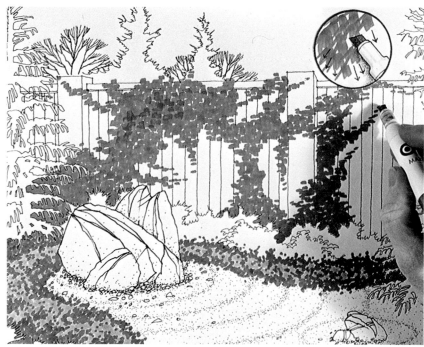

C3–103

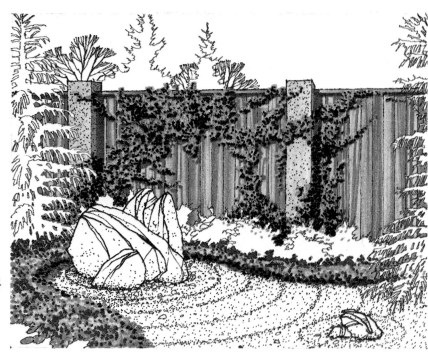

C3–104

C3–103, C3–104. GROUND COVERS AND CLIMBERS. The ground cover shown here is a general representation, while the climbing vine suggests a member of the ivy family, such as english ivy (*Hedera helix*). Shown in the inset is the beginning marker stroke used to suggest a climber such as the virginia creeper (*Parthenocissus quinquefolia*).

(1) Apply marker base. For the ground cover *Olive* and *Pale Olive* markers were applied in stipple fashion. For the climber the narrow, flat edge of the *Olive*-marker tip was applied to the fence.

(2) Add highlights and shadow areas. For the ground cover *Cream* pencil was applied in spots over the *Pale Olive*-marker areas. *Cool Gray #9* marker was stippled in areas to create darker holes in the foliage mass. It was stippled more heavily in the area where the foliage meets the ground. For the climber *Grass Green* pencil was used to wash the foliage, making its color more like that of ivy. *Cream* pencil was applied in spots as highlights. *Cool Gray #9* marker was applied in stipple fashion to create holes and texture. *Burnt Umber* marker was used to draw the shadows of the ivy on the fence. For the redwood fence *Sand* and *Kraft Brown* markers were alternated randomly on each board as a base. *Burnt Umber* and *Cream* pencils were streaked over the marker. Streaks of *Light Blue* pencil were added to give the wood a more weathered look.

C3–105, C3–106, C3–107. BERMS AND BANKS.

(1) Make line drawing. To begin a drawing of berms or banks, the ridges should be drawn first, using a gradually sloping contoured line. These lines should be drawn light enough so as not to show in the final drawing.

(2) Add help lines and apply marker base. Thin help lines run approximately perpendicular to the axes of the berms, curving smoothly and gently. Since the forms are grass-covered, *Light Olive* and *Sand* markers were applied, following the help lines. *Dark Olive* marker is added to indicate tree shadows, which originate to the right of the drawing. Note how the shadows conform to the terrain.

C3-105

C3-107

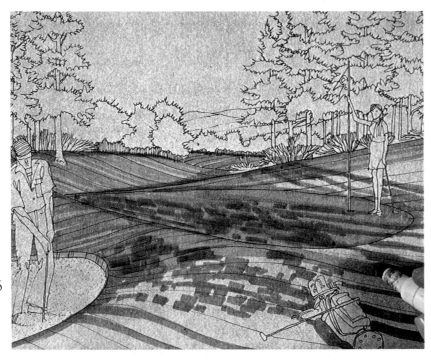

C3-106

(3) Add highlights, shading, and texture. The same techniques were used to finish the drawing as for lawn grass (C3–102). *Olive Green* pencil was used to darken the hollow in the distance, while *Cream* pencil was used on the hillside. The resultant graded value gives a sense of volume to the landforms and distinguishes between them.

C3–108, C3–109. **URBAN BACKGROUNDS.** As distance increases in the drawing of an urban background, the *value contrast should decrease; the values of the colors should be made lighter; the chromas of the colors should become weaker; the hues should become more bluish; and less detail should be shown on the buildings.*

(1) Apply marker base. Since most colors in the urban landscape are weak in chroma, gray markers were used as the base. Beginning with *Cool Gray #7* as the darkest marker in the foreground (touches

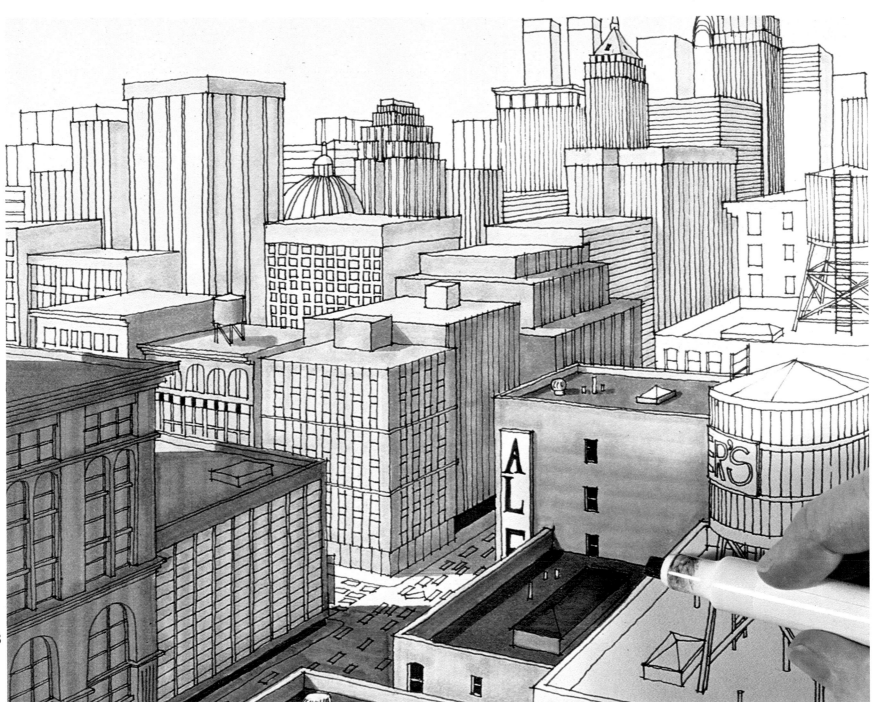

C3–108

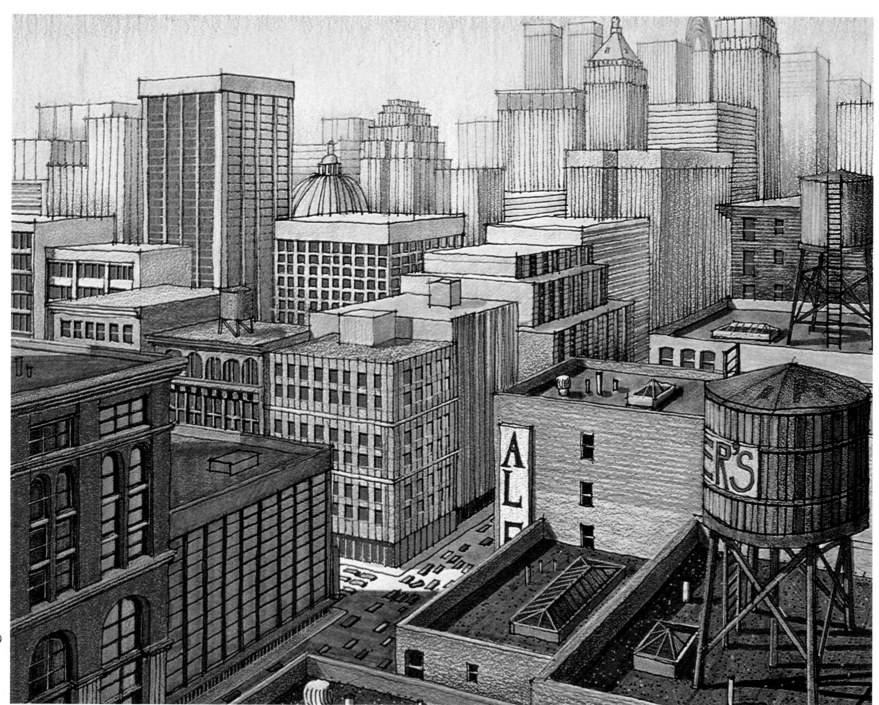

C3–109

of *Cool Gray #9* and *Black* markers were also used), lighter gray markers were successively applied as the distance increased.

(2) Flavor walls of buildings with colored pencils. The walls of the closest buildings were flavored with warm-hued colored pencils (*Terra Cotta, Flesh, Sand, Orange, Sienna Brown, Burnt Ocher, Burnt Umber,* and *Light Flesh*), and *White* pencil was added for highlights. The buildings in the middle to far distance were flavored with *Light Flesh* pencil on their sunlit sides and *Light Blue* pencil on their shaded sides. The most distant buildings were washed with *White* pencil to increase color value and decrease chroma. The entire distant part of the drawing, buildings included, was flavored with *Sand* and *Cream* pencils to create the ever-present, unfortunate effects of air pollution.

(3) Add window treatments. Fountain pen was applied to the windows on the sunlit sides of the closest buildings. *Cold Grey Medium* pencil was added to windows on buildings further in the distance. A mixture of *Light Blue* and *White* pencils was used to create the effects of reflected skylight on the shaded sides of the closest buildings. Note how this effect is brightest in one corner of the building and gradually diminishes toward the opposite corner. After these treatments were applied to the windows, fountain pen and a Pilot Razor Point were used to add the muntins, frames, and shaded recesses.

C3–110, C3–111, C3–112. **RURAL BACKGROUNDS.** As with urban backgrounds, the chroma of the colors becomes weaker, the values higher, and apparent texture diminishes as distance increases. The hues seen in rural backgrounds, however, often form a clockwise progresssion around the color wheel from green-yellows in the foreground to purple-blue or purple in the far distance.

(1) Apply marker base to foreground. *Cool Gray #9, Cool Gray #7,* and *Cool Gray #5* markers were used to create a dark foreground massing of trees, which creates a more dramatic sense of distance through value contrast. *Burnt Umber* and *Nubian Brown* markers were used on the buildings.

C3–110

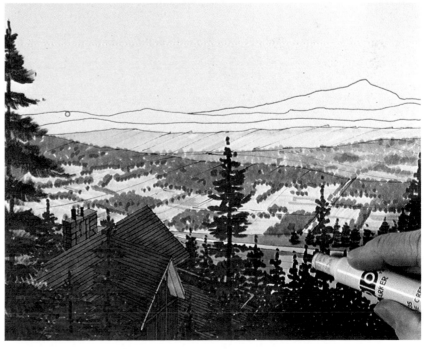

C3–111

(2) Add help lines; create distant trees and fields with marker. Help lines were added to create distant fields, roads, and land contours. *Cool Gray #5*, marker was used in stipple fashion to draw the trees on the first ridge (in the middle of the drawing). Shade and shadows were added with a *Cool Gray #7* marker. *Light Ivy* and *Beige* markers were applied to the fields, along with occasional touches of *Pale Olive* marker. *Chrome Green* marker is applied to the close hillside. The trees on the hill beyond the first ridge were stippled in with a *Cool Gray #3* marker. *Cool Gray #1* marker was used on the further hillside.

(3) Add colored pencil. *Grass Green* pencil was used to wash the closest trees, which were then textured with fountain pen. The trees on the first ridge were flavored with *Grass Green* pencil. *Grass Green* and *Peacock Green* pencils were used to flavor the trees on the next ridge (over the *Cool Gray #4* marker). *Peacock Green* pencil was

lightly applied over the *Cool Gray #1* marker on the following ridge. Beyond it a light mixture of *Peacock Green* and *Non-Photo Blue* pencils was used, progressing to *Non-Photo Blue* and *Light Blue* pencils. *Light Blue* and *Light Violet* pencils were used to flavor the most distant mountain. The sky is a mixture of *Light Blue*, *Copenhagen Blue*, and *Apple Green* pencils, with *White* pencil used most heavily at the horizon.

(4) Add final touches. *Light Violet* pencil was used to lightly wash distant areas in which the greens seemed too strong in chroma. The trees on the first ridge were stippled with fountain pen for added texture. *Green Bice* pencil was used to flavor the lawn on the closest hill.

C3–113, C3–114, C3–115. **ROCKS AND ROCK OUTCROPS.** Rocks can be effectively drawn by drawing their shaded and shadow areas with crisp, definite edges. Older, more worn rocks have more rounded surfaces, and the transition from a sunlit surface to one in shade will be more gradual. Deposits of soil are often found in pockets and small crevasses, from which *grasses and small shrubs* often grow. The *bottoms of rocks usually appear flat* rather than round, since soil collects around them over time. *Rock litter is usually found* scattered around larger rocks—smaller rocks that have broken away from the larger rocks. Rocks are often composed of minglings of a variety of colors, small areas of which are sometimes quite intense.

(1) Apply marker shadows. *Cool Gray #9* marker was used to draw in the darkest shadows and the largest fissures in the rocks. *Cool Gray #7* marker was used for the lighter shadows.

(2) Apply colored-marker base, mingling colors. A variety of marker colors can be used to draw rocks. *Beige* marker was loosely applied here, leaving many areas untouched. *Flesh* marker was used to fill in these areas, and *Willow Green* marker was randomly applied over all the rocks. *Kraft Brown* marker was applied over the shadow areas; *Sand* marker, with touches of *Light Olive* marker, to the grass areas.

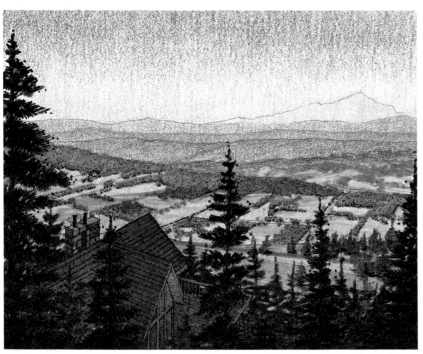

C3–112

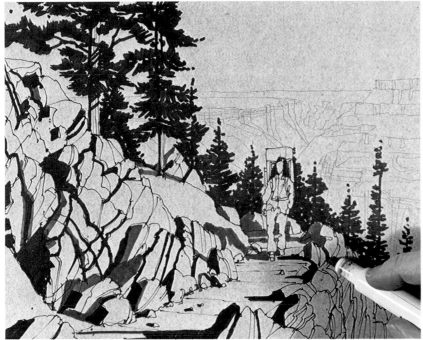

C3-113

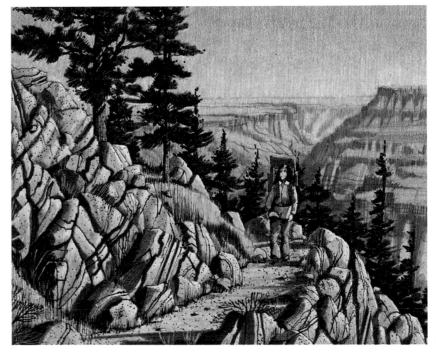

C3-115

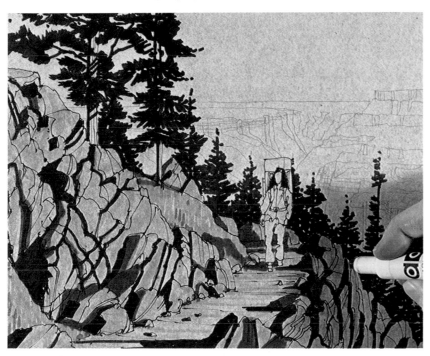

C3-114

(3) **Add highlights and shadows with pencil.** A *Flesh*-pencil wash was applied to all the rock surfaces. *Light Flesh* pencil was used for highlights, while *Burnt Ocher* and *Burnt Umber* pencils were applied to the shaded areas and large fissures. Touches of *Tuscan Red*, *Olive Green*, *Violet*, and *Light Blue* pencils were applied as flavorings to various areas.

(4) **Add smaller fissures, cracks, and stipple texture.** Fountain pen and a Pilot Razor Point were used to retrace the smaller fissures and cracks (C3-114) and to add new ones. Fountain pen was used to create additional texture through stippling.

C3–116, C3–117, C3–118. **SKIES AND CLOUDS.** When drawing clear skies, I usually avoid marker base (due to its streakiness) and work instead with such pencil colors as *Light Blue, Non-Photo Blue, Copenhagen Blue, Light Violet,* and *Light Green.* These colors can be used singly or mixed, depending on the sky color desired. *White*-pencil wash is usually applied over the pencil colors, using more pressure near the horizon to make it the lightest part of the sky. To suggest an approaching storm, a progression of gray markers can be blended and then flavored with the sky-colored pencils (see also C3–80).

(1) Fill in background. For the clear sky (left) an even wash of *Light Blue* pencil was applied over the entire sky area. For the cloudy sky (right) the marker background (optional) was added using *Cool Gray #7, Cool Gray #5, Cool Gray #3,* and *Cool Gray #1* markers after the cloud forms were lightly drawn. The underside and dark areas of the clouds were drawn with *Cool Gray #3, Cool Gray #5,* and *Cool Gray #7* markers. The sunlit sides of the cloud forms were drawn with a *Pink* pencil.

C3–117

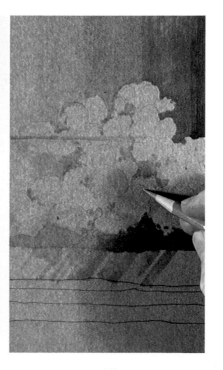

C3–116

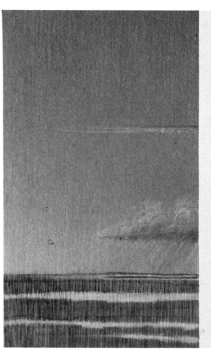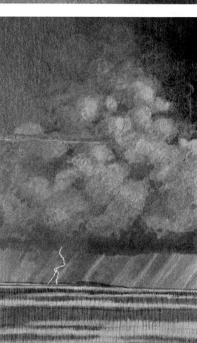

C3–118

(2) Add pencil. For the clear sky add *White*-pencil wash to the horizon, grading it into the sky above. For the cloudy sky the marker background was flavored with *Copenhagen Blue* pencil. A *White*-pencil wash was applied, using a circular motion, to the sunlit side of the cloud forms and graded into the shaded side. *White* pencil was also added between the sheets of rain beneath the cloud.

(3) Add finishing details. For the clear sky *Copenhagen Blue* pencil was used to add a graded wash, darkest at the top of the drawing and fading out at about the middle. The result is a sky-dome effect rather than a flat sky with a single value. For the cloudy sky *Copenhagen Blue* pencil was added to the dark sides of the cloud forms. *White* pencil was used as a wash, thus softening the entire dome.

Reflective Materials

Reflections are often either ignored completely or poorly handled in design drawing. Much of our environment is comprised of reflective surfaces—glass, water, mirrors, furniture, metals—which add vitality not only to our environment but also to the drawings that represent it. As such the environmental designer can hardly afford to ignore them. Briefly explained, reflections occur as far into the reflective surface as the object reflected is separated from it. (For more information on reflection placement see *Design Drawing* by William Kirby Lockard and *Design Graphics* by C. Leslie Martin.) Drawings of reflective surfaces are most successful *when the object being reflected is also shown*, creating a cause-and-effect relationship. I draw the reflective surfaces *last* in a drawing. In that way I know exactly what must be reflected. *Avoid outlining the reflections* of objects so that they may be more easily distinguished from the object itself. The colors of reflections are the same as those of the objects reflected, except that *they have a lower value and weaker chroma* than the objects themselves (except for mirrors, which reflect exactly). Shadows falling on a reflective surface are not seen on it but rather fall on the objects and surfaces seen *through* the reflective surface. For example, a shadow falling on the water in a pool will not be seen on the water but instead on the bottom and/or sides of the pool.

C3–119, C3–120, C3–121, C3–122. **REFLECTIONS IN WINDOWS.**

(1) Draw everything except window. Color was added to everything except the window surface and the objects seen through it. The trees and shrubs will be drawn in *after* the reflections, since a portion of their branching will be drawn in front of the window.

(2) Apply marker to everything seen through window. Only marker should be applied at this stage. *Cool Gray #9* marker was used to darken the interior behind the objects seen in the window.

(3) Draw reflections with colored pencil. *White* pencil can be used to lightly lay out the reflections, drawing right over the objects seen *through* the window. Use colored pencil to add color to the reflections, applying it lightly and smoothly. The white outlines of the reflections should be obscured as the coloring takes place. Use a light enough pressure on the pencils so that the objects *in* the window can still be seen when the reflection is complete. To avoid confusion, draw the reflections of objects *closest* to the window first, then progressively work away from the window. The objects shown here were drawn in this order: underside of awnings, stone forming left window cut, pedestrians, green car on left, streetlight, brown car on right (shown in layout stage).

(4) Add reflected background if necessary. After the reflections of the objects seen in the drawing were drawn, a simple background reflection was added, since the environment was an urban one. *Terra Cotta*, *Sienna Brown*, *Raw Umber*, and *Burnt Umber* pencils were used for the buildings, while *Non-Photo Blue* and *White* pencils were used for the sky.

(5) Add trees and shrubs, their reflections, and finishing touches. The tree reflections were drawn over the other reflections, using a *Cold Grey Medium* pencil with touches of *White* pencil on the sunlit sides. The shrub reflections were then added, followed by the trees and shrubs themselves. The items *in* the windows (such as manikins) were then reoutlined with a Pilot Razor Point so that they would appear more solid than the reflections.

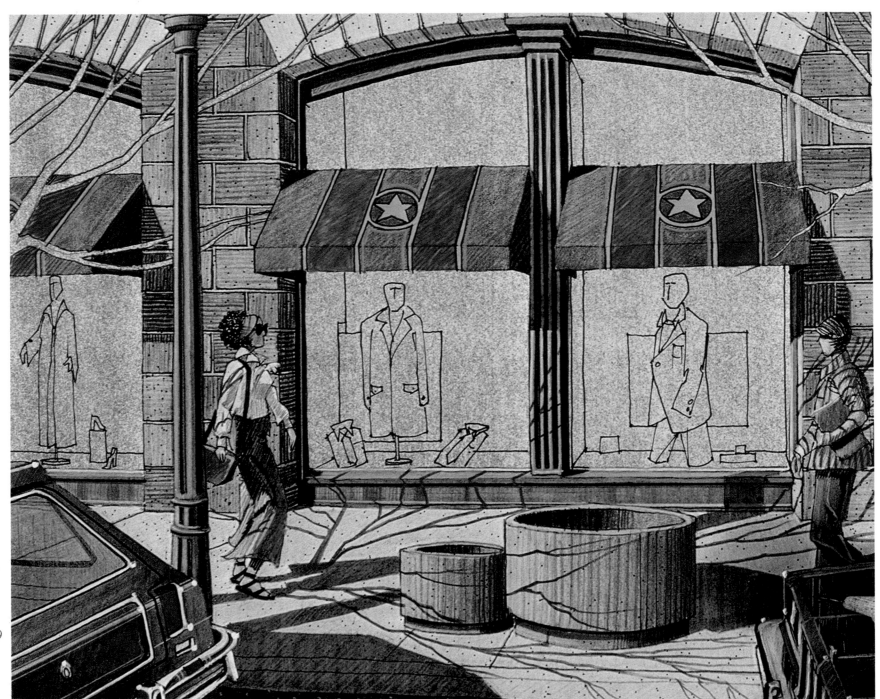

C3–119

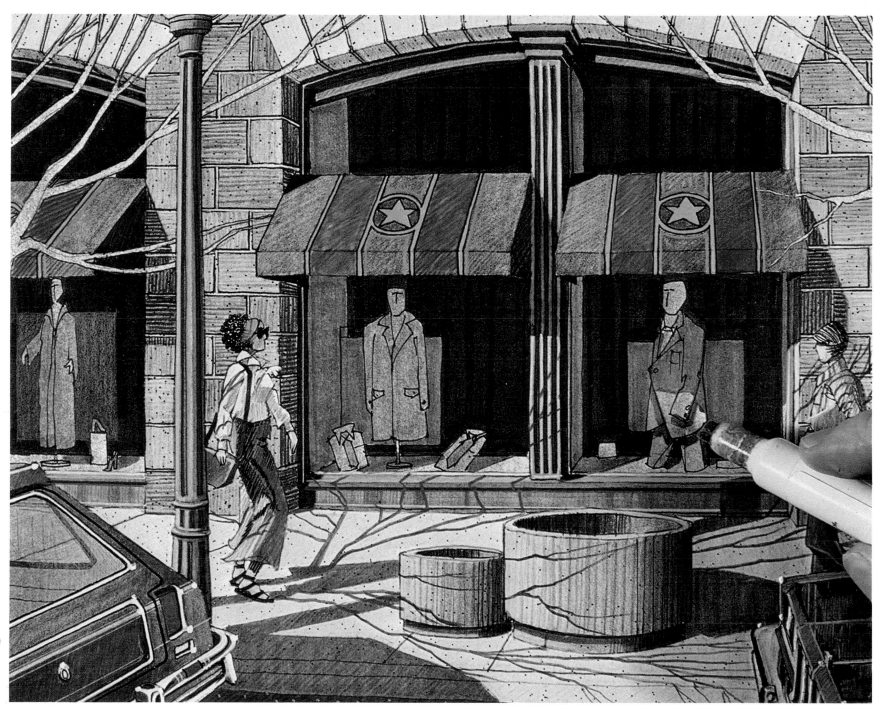

C3-120

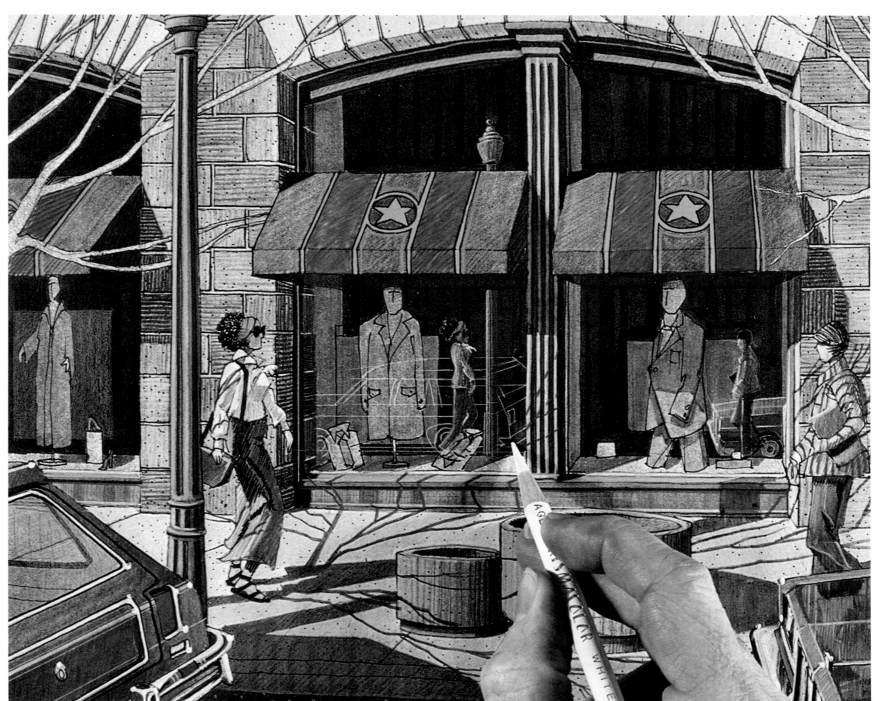

C3–121

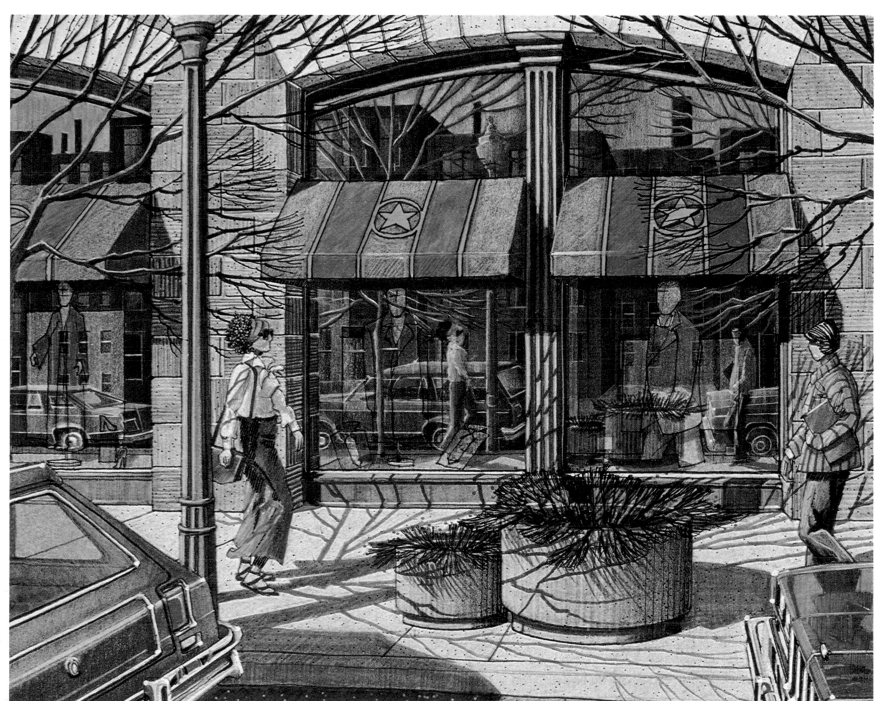

C3–122

C3–123, C3–124, C3–125, C3–126. **REFLECTIONS IN WIN-DOWS OF LARGE BUILDINGS.** The reflections in windows of large buildings usually have three components: the reflection of the sky, the reflection of the building itself, and the reflection of neighboring buildings. In most highrise buildings the fluorescent lighting can be seen through the windows even in daylight!

(1) Apply color to wall surfaces only. *Goldenrod* marker is applied to the sunlit areas of the walls, while *Cool Gray #5* marker, with *Goldenrod* marker over it, was added to the areas in shade and shadow. *Cool Gray #5* and *Cool Gray #3* markers were applied to the shade and shadow areas of the concrete elements.

(2) Add marker to windows and draw outlines of reflections. *Cool Gray #7* marker was applied to the windows in sunlight, while lighter-value *Cool Gray #5* and *Cool Gray #3* markers were added to windows in shade, since they will reflect the bright sky. Note that the markers used to depict shade are graded from light to dark. Corner windows were made lighter in value, since lighter values can be seen through them. *Non-Photo Blue* pencil was used to lightly draw the outlines of the building's own reflections, while *White* pencil was used to lightly outline the reflections of neighboring buildings, thus avoiding confusion between the two kinds of reflections. When neighboring buildings are not seen in the drawing, their reflections should be made up, as seen in the windows on the sunlit side of the building.

(3) Add color to reflections. To avoid confusion, the color was first added to the reflections of the building itself, using *Canary Yellow* and *Cold Grey Medium* pencils. On the shaded side the reflection of the pinkish building was drawn in with *Flesh* and *Sand* pencils, using *Cold Grey Medium* pencil for the windows. This reflection is light, since it is of a sunlit building face. The reflections on the sunlit face were drawn by first applying *Cool Gray #9* marker, then adding flavorings of *Non-Photo Blue* and *Terra Cotta* pencils over it. These reflections are dark, since they are of the shaded sides of neighboring buildings. *Non-Photo Blue* and *White* pencils were used to draw the reflection of the sky. They were applied heavily to the shaded side, since its reflection of skylight is relatively brighter. *Non-Photo Blue* pencil alone was applied to the sky reflected in the sunlit windows of the building.

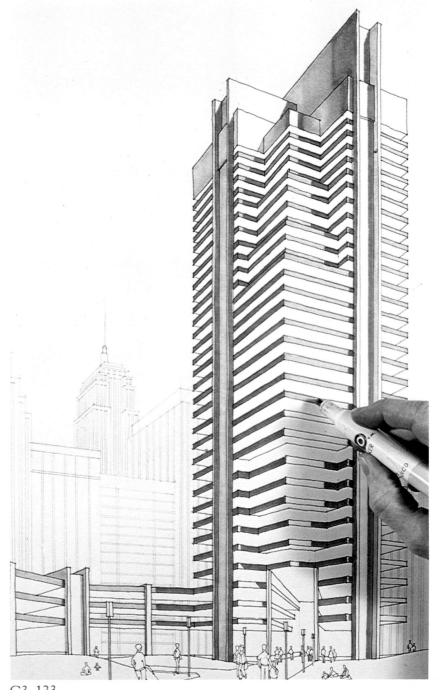

C3–123

C3–124

C3–125

C3-126

(4) Add fluorescent lights and window mullions. *White* pencil was used, with a straightedge aligned with the left vanishing point of the drawing, to create the dashed lines representing fluorescent lights seen through the windows. Note that these dashed lines are drawn right over the reflections. The window mullions were drawn with *True Green* pencil on the sunlit windows and a black Pilot Razor Point on windows in shade and shadow. Pilot Razor Point lines were also added to the shaded side of each sunlit mullion.

C3-127, C3-128, C3-129. **GLASS TABLETOPS.**
(1) Draw table surroundings first.
(2) Draw objects on table and surfaces beneath it. When drawing the undersurfaces, no colored pencil was used on floor surfaces seen directly through the tabletop. When the reflections are drawn in the tabletop, they will thus remain crisp rather than becoming muddied by mixing with other colored pencils. *Willow Green* marker was applied to the tabletop after the floor surfaces seen through it were drawn in with marker.
(3) Draw reflections with colored pencil and add finishing touches. The reflections were drawn with the same colored pencils used to draw the objects reflected. No outlines are used on the reflections. To avoid confusion, the reflections of objects resting on the table were drawn, since they will block or partially block reflections of objects above or behind them in the room. The reflections of objects above or behind, such as the brick of the fireplace and the window, were then drawn in. For that extra (though not absolutely necessary) touch white opaque ink was applied to the two far edges of the table, using a ruling pen, since the edges weren't sufficiently visible. The two closer edges were defined with *Black* and *White* pencil, applied with a straightedge. Touches of white opaque ink were added to the corners of the table and to the two wineglasses.

C3–127

C3–128

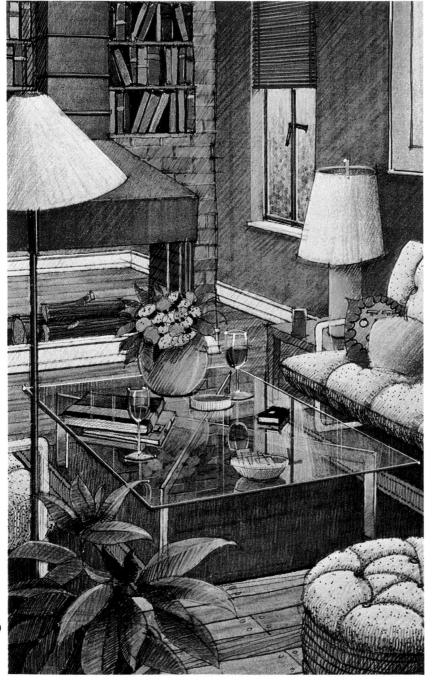

C3-129

C3–130, C3–131, C3–132, C3–133. **STILL WATER.**
(1) **Draw everything except water.** The only element excluded is foreground vegetation, since it must be drawn over the drawing of the water's surface.

(2) **Draw in water color and outline reflections.** *Olive* marker was used to apply the marker base to the water, stroking horizontally. A medium-value marker color should be used for the marker base so that both dark and light reflections will show, though the hue of the marker color may range from a blue, green, or brown to a gray. *White* pencil was used to draw the outlines of the reflections. After they were initially drawn with straight lines to ensure accuracy, they were then altered to indicate the slight movement of the water.

(3) **Draw reflections with colored pencil.** The reflections are drawn with the same colored pencils that were used to draw the objects themselves. Using a light to medium hand pressure on the pencils, the colors of the reflections should have a slightly lower value and weaker chroma than that of the objects reflected, due to the *Olive* marker base. The reflections were lightly flavored with an *Olive Green* pencil to add the effect of the greenish water.

(4) **Draw in sky reflection.** *White* pencil was used to add the sky reflection, stroking horizontally with a slightly up-and-down line. The reflection was made brighter toward the horizon, as the angle of the view becomes more oblique. *Light Violet* and *Non-Photo Blue* pencils were used to flavor the sky reflection.

C3-130

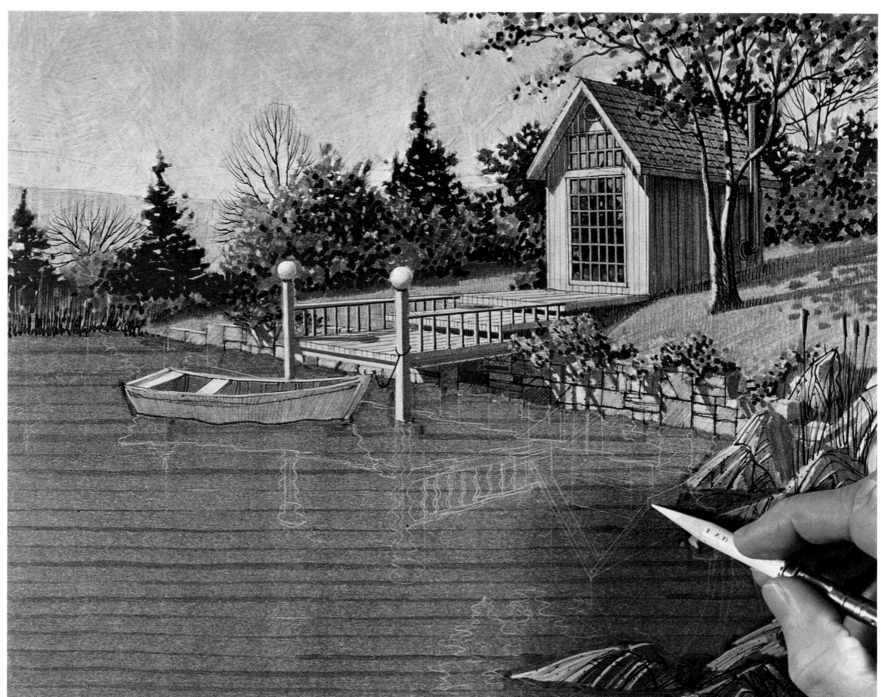

C3–131

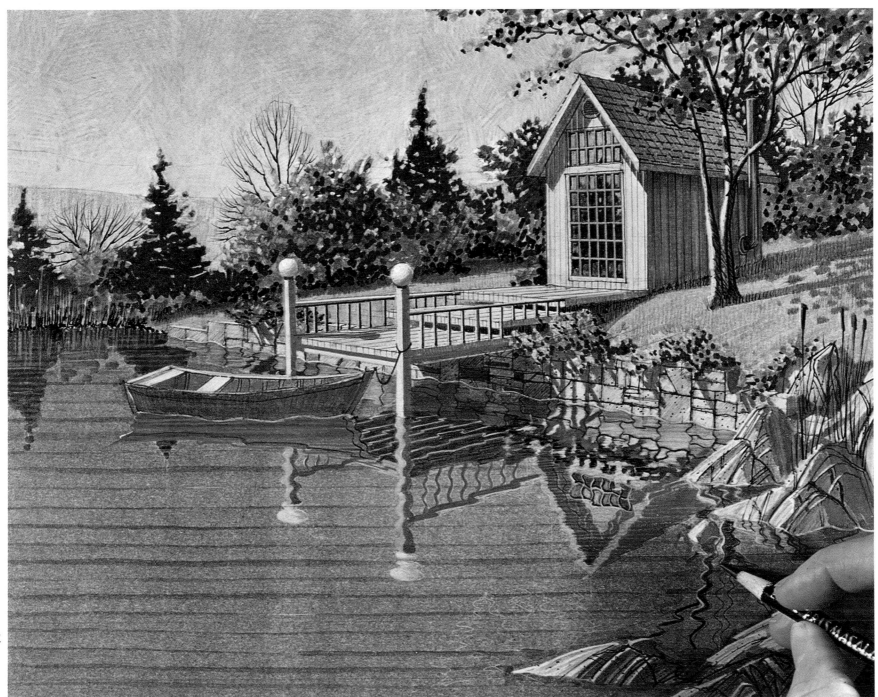

C3-132

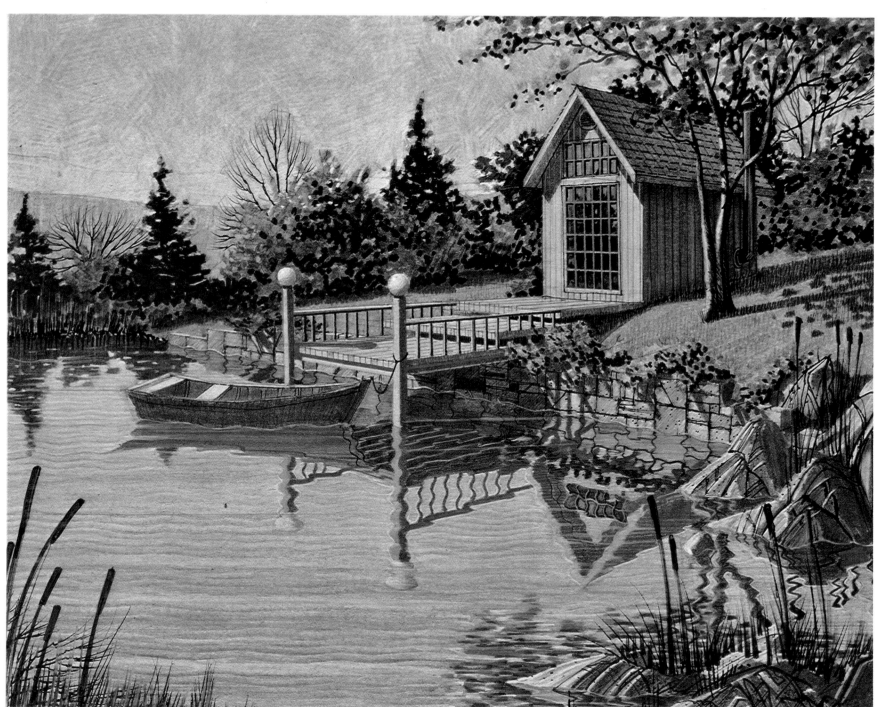

C3–133

C3-134, C3-135, C3-136, C3-137. **MOVING WATER.**

(1) Draw surroundings first. Space was left for both the water jet and the waterfall.

(2) Draw water jet and waterfall. *White* pencil was used to draw the water forms, using photographs of moving water (from a source file) as guides. *Warm Grey Light* pencil was added to the shaded sides of the water forms. *Non-Photo Blue* pencil (one of the pencils used to draw the sky) was then used to flavor the water forms, indicating the reflected sky.

(3) Draw pool surface and splashing water. *Slate Green* marker was used as a base for the water color in the pool and drawn carefully around the falling "strings" of water. *Copenhagen Blue* and *Peacock Green* pencils, utilized elsewhere in the drawing as well, were used to flavor the marker color. *White* pencil was used to create the effect of the splashing water, flicking the pencil upward in short strokes. *Non-Photo Blue* pencil was used to flavor this splashing water. Reflections were added to the less disturbed parts of the water's surface with *Light Flesh* and *Burnt Umber* pencils. *White* pencil was again used to add ripples to the less disturbed portions of the water's surface.

(4) Add white opaque-ink highlights. For the smoother water in the less disturbed areas of the pool and the waterfall *lines* of white ink were applied with a ruling pen, while for the more disturbed water, as in the water jet and splashing water, *dots* of white opaque ink were applied.

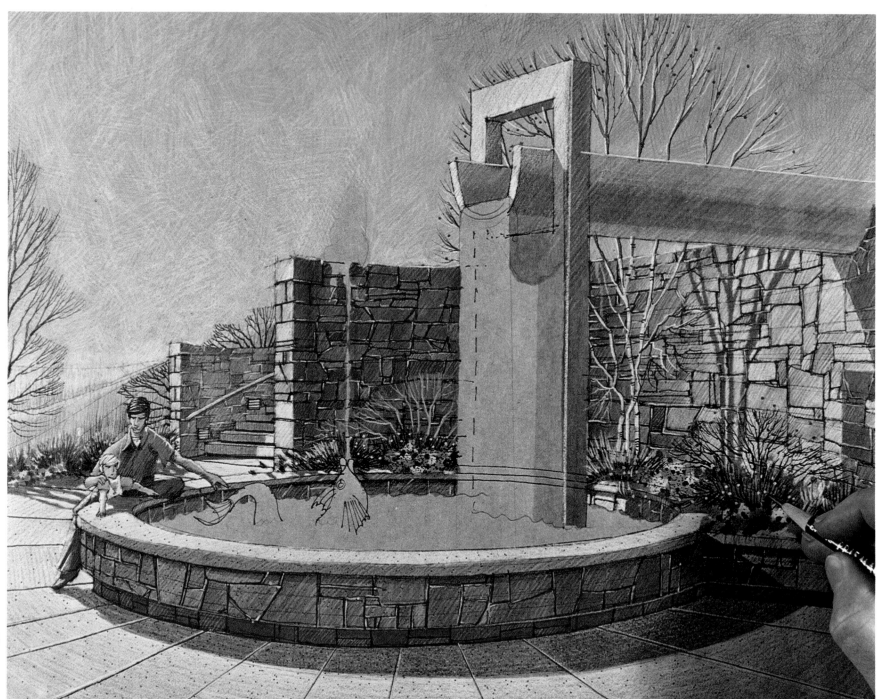

C3-134

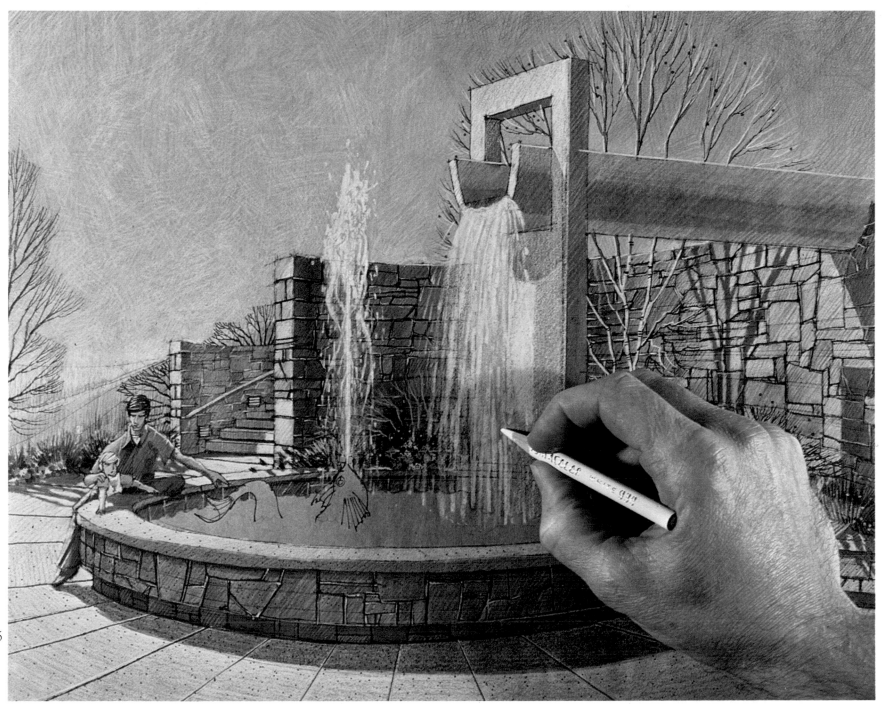

C3–135

C3–136

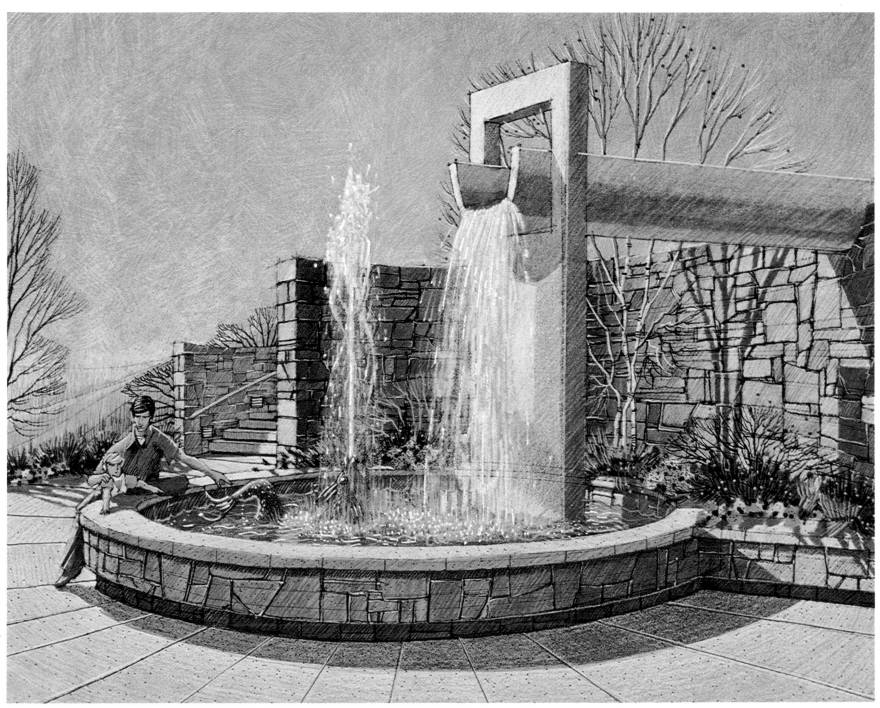

C3–137

TWO
The Harmony of Colors

One of the most elusive concepts for designers who deal with color is that of color harmony—combinations of colors that are aesthetically pleasing. People who have little or no experience in colorwork often find that their attempts at combining colors end in failure, only to increase their discouragement and discomfort. Survey readings on the subject of color merely yield further frustration when the writer defines color harmony *only* as "colors which seem pleasant together." Most designers don't know *why* some color compositions seem pleasing to them, while others are somehow dissonant. As a result of this widespread lack of knowledge many in the design professions are either shackled to the stab-in-the-dark method of combining colors or forced to rely on the same few safe, tired combinations that they have been using for years. This is the antithesis of the word "design."

Good color has the unique ability to impart the feeling intended by the designer, an emotional message expressing the quality of the design—restful, exotic, dramatic, elegant, exciting. But a designer in pursuit of fine color must not only be aware of his expressive intent.

He must also possess the technical skills necessary to make it a reality—in whatever medium he chooses. Designers of environments see their work realized in many media, but most rely on drawing as the medium for initially visualizing their ideas.

This book can only begin to make you aware of the expressive power of color. Good color, color harmony, is based on *order*, and one of the underlying sources of order in all the arts—music, dance, sculpture, painting, design—consists of the *principles of composition*.

This part of the book is an investigation, based on the principles of composition, into *one* approach to color harmony. It begins by defining the terms necessary for a discussion of color and by explaining how to mix colored pencils and markers to achieve the hues and other color dimensions you desire. Techniques of color composition are discussed and illustrated, and particular hue arrangements are examined. The last chapter presents a step-by-step procedure for creating your own color compositions.

Secrets of color theory? Why call those principles secrets which all artists must know and all should have been taught?—Eugène Delacroix.

Definitions and Mixing Basics 4

The Three Dimensions of Color: Hue, Value, and Chroma

We can rely on the three basic dimensions—length, width, and depth—to describe a form or a space. A color also has three variable dimensions that must be used to describe it.

First, a color may be described in terms of its hue—its name—such as red, blue, or green. *The hue is the name of a color.* You are probably aware that the words "hue" and "color" are often used interchangeably, but it is more accurate to use the word "hue," which is only *one* of the *three* dimensions of color.

Second, *a color may vary in lightness or darkness, a dimension called the value of the color.* A red might be a high-value red (a light red) or a low-value red (a dark red). The value of a color is determined by comparing the color to a varying scale of grays, with white at the top and black at the bottom, called a *value scale.* To find the value of a swatch of color, place it beside a value scale and squint your eyes. The squinting reduces your impression of hue, making the value of the particular color swatch more obvious (C4–1).

Third, *a color may vary in its strength, or chroma.* Chroma is also referred to as the purity or saturation of a color. A strong-chroma red would be very bright and pure, while a weak-chroma red is dull and grayish (C4–2).

Any color may be accurately described in terms of all three of its dimensions. For example, field grass in a winter landscape may be described as a medium-high-value, weak-chroma yellow, while the brick on a wall might be a medium-value, medium-weak-chroma red. Note that the value and chroma for any hue *coexist* so that a range of chromas for a color can occur at a given value.

If all the possible combinations of value and chroma for a particular hue were arranged in an organized fashion, the result would be what is known as a hue chart (C4–3, C4–4). Hue charts are valuable aids in locating a hue with a particular value and chroma.

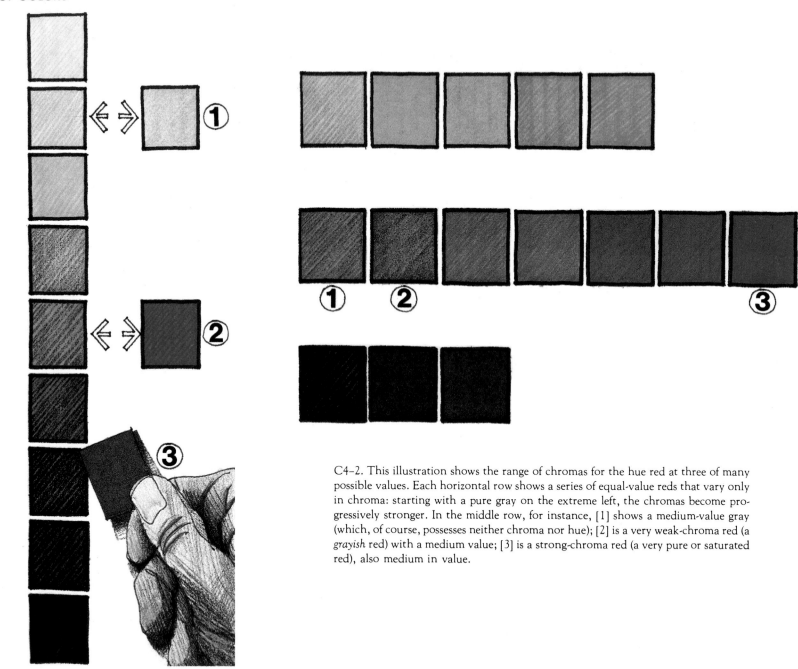

C4–2. This illustration shows the range of chromas for the hue red at three of many possible values. Each horizontal row shows a series of equal-value reds that vary only in chroma: starting with a pure gray on the extreme left, the chromas become progressively stronger. In the middle row, for instance, [1] shows a medium-value gray (which, of course, possesses neither chroma nor hue); [2] is a very weak-chroma red (a *grayish* red) with a medium value; [3] is a strong-chroma red (a very pure or saturated red), also medium in value.

C4–1. By squinting your eyes when looking at this illustration the values of the colors become more obvious: [1] is a high-value red, [2] a medium-value red, and [3] a low-value red.

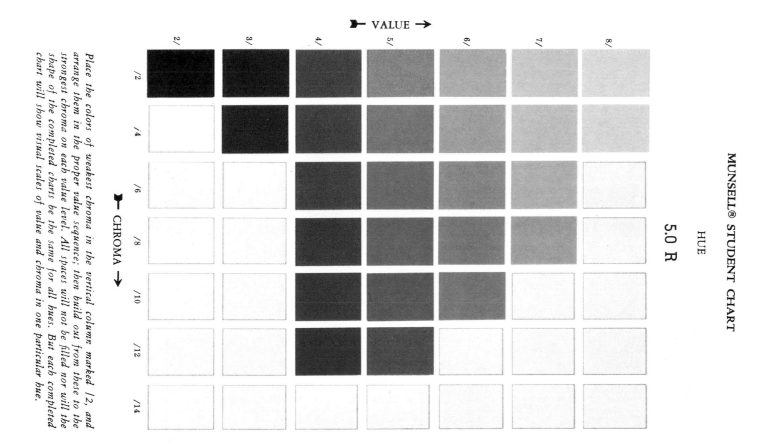

►— VALUE —►

◄— CHROMA —►

MUNSELL® STUDENT CHART

HUE

5.0 R

Place the colors of weakest chroma in the vertical column marked /2, and arrange them in the proper value sequence; then build out from these to the strongest chroma on each value level. All spaces will not be filled nor will the shape of the completed charts be the same for all hues. But each completed chart will show visual scales of value and chroma in one particular hue.

C4–3. Munsell Student Chart (courtesy of Munsell Color). This chart, of the Munsell hue *Red*, shows the possible ranges of value and chroma for this particular hue. These ranges can be expanded (or shrunk), depending on the color media used to make the hue chart. The value of the color chips changes in the vertical direction—becoming lower or darker in value toward the bottom of the chart and higher or lighter in value toward the top of the chart. The chroma of the color chips varies in the horizontal direction—becoming weakest or grayest toward the left and stronger or more saturated toward the right. In any given *vertical* row of color chips on a hue chart the value of the colors varies but their chroma remains the same. Likewise, in any *horizontal* row of color chips the values of the colors stay the same but their chroma varies. You may ask why the color chips are arranged as they are in a particular hue chart. This is because each hue reaches its strongest chroma at a particular level of value, known as its spectrum value. As you see in the hue chart shown here, horizontal rows 4 and 5 seem to be equal in chroma. If the chart were more finely divided, another row between rows 4 and 5 would carry the strongest chroma.

VERY LOW VALUE · LOW VALUE · MEDIUM LOW VALUE · MEDIUM VALUE · MEDIUM HIGH VALUE · HIGH VALUE · VERY HIGH VALUE

VERY WEAK CHROMA
WEAK CHROMA
MEDIUM WEAK CHROMA
MEDIUM CHROMA
MEDIUM STRONG CHROMA
STRONG CHROMA
VERY STRONG CHROMA

MUNSELL® STUDENT CHART

HUE

5.0 R

An inexpensive student set of 10 hue charts, one for each of the five principal hues (red, yellow, green, blue, and purple) and intermediate hues (yellow-red, green-yellow, blue-green, purple-blue, and red-purple) in the Munsell system, is available from Munsell Color. (Munsell Color does not intend these Student Sets to be taken as *standards*, since they are not reproduced with the same strict quality controls as are their standard sets and may thus vary slightly from set to set. For more information write to Munsell Color, 2441 N. Calvert St., Baltimore, MD 21218, or call (301) 243-2171.) The charts are also helpful in identifying the relative value and chroma of a hue, a necessary skill for colorwork.

C4-4. Munsell Student Chart (courtesy of Munsell Color). To describe a particular color, the Munsell System of color notation uses the initial of the hue acccompanied by a fraction made up of two numbers, which indicates the value and chroma of the color. Notice on the hue chart that the numbers on the left, which run vertically (2/, 4/, 6/, etc.), indicate the degree of value. The numbers running horizontally along the bottom of the chart (/2, /4, /6, etc.) indicate the degree of chroma. The diagonal lines that accompany each number indicate to which side of the fraction the number belongs. A particular red might be specified as "R 6/4," meaning a color with a red hue, a value of 6, and a chroma of 4. Though the Munsell notation is quite compact and explicit, colors described in terms of it do not immediately come to mind unless one is familiar with the use of the notation. In this book colors are described less accurately but more descriptively—for example, instead of the R 6/4 mentioned above, the same red is called "a medium-high-value, weak-chroma" red.

The Munsell System of Color

There are many color systems in existence today, each of which arranges the three dimensions of color in a somewhat different way; the Ostwald system, the German Standard Color System (DIN 6164), and the Kuppers system are a few examples. For our purposes, however, the Munsell System is one of the most appropriate because it organizes colors visually. This is important, since colors must also be arranged in terms of how they are *seen* together rather than only by the mixture laws governing paint pigments.

The Munsell system is based upon the following phenomenon of perception: if you stare at a spot of strong-chroma yellow for a few minutes, then turn your gaze to a neutral-gray surface, you will see an afterimage of purple-blue. The purple-blue is the hue that your *eye* perceives as the visual opposite of the yellow. In the same manner the opposites can be determined for the four other principal hues in the Munsell System—green, blue, purple, and red. In the system there is a total of 10 hues—5 principal hues and 5 visually opposite or intermediate hues: red-purple, yellow-red, green-yellow, blue-green, and purple-blue. They are most usefully arranged in a hue circle, commonly called a *color wheel*, with the visual opposites (known as complements) diametrically opposing each other (C4–5).

While adjacent hues on a color wheel actually blend imperceptibly into each other, most color systems utilize systematic divisions of hue, as in the Munsell system. More finely divided color wheels are available from Munsell, which divide each of the principal and intermediate hues into 10 subhues, producing a 100-hue color wheel.

Red, yellow-red, yellow, and green-yellow are generally referred to as *warm hues*, while purple, purple-blue, blue, and blue-green are known as *cool hues*. Red-purple and green lie on a loosely defined warm-cool border and can potentially be used with either group. Identifying colors with temperatures may seem at first to be a strange phenomenon but can probably be attributed to natural phenomena: fire is yellow-red and warm, while snow, ice, and shadows are cool and often seem bluish.

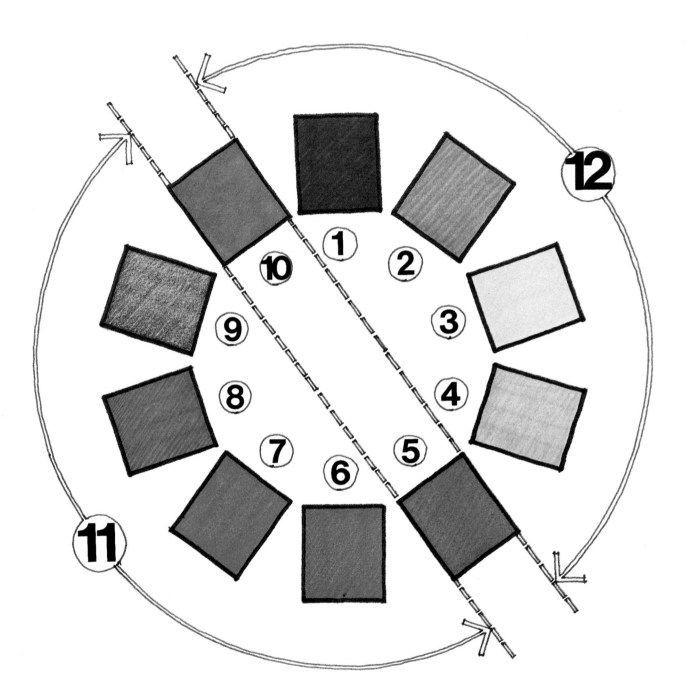

C4–5

The Color Solid

The interrelationships among the three dimensions of the 10 Munsell hues are illustrated on a three-dimensional version of the color wheel known as the *color solid*.

The color solid can be understood by imagining a sphere divided into 10 slices like those of an orange, each of which represents one of the 10 hues (C4–6). The slices are arranged around a central core, the black-to-white value scale, which has neither hue nor chroma. Each slice is thus a hue chart showing the range of value and chroma for each hue, with the surface of the sphere representing the strongest chroma possible for the hue at the various degrees of value. The weakest chromas are next to the neutral-value scale. If the sphere is cut horizontally, leaving the value scale intact, the color wheel reappears and includes the chroma variations of the hues, which are weak at the core and stronger at the edge (C4–7).

The color solid shown here is a simplified representative model that illustrates the three-dimensional character of colors and their relationships. An actual color solid, such as the Munsell Color Tree (C4–8), is not a perfectly round sphere with all colors neatly ar-

ranged within it. While it does demonstrate the same general relationships among colors as does the simplified model, the Munsell Color Tree has an uneven shape, since the different hues have different strongest chromas, which are attained at different values. This phenomena is known as spectrum value.

Spectrum Value

If you refer to the vertical slice taken from the color solid (C4–6), you will notice that the hue yellow-red reaches its strongest chroma at value 6. This is not true for all hues, as each reaches its strongest chroma at a different value. Compare the hue chart of yellow-red with that of, say, blue, which reaches its highest chroma at value 4 (C4–9).

The value at which each hue reaches its strongest chroma is called its spectrum value, or natural order of colors. The spectrum value is the *inherent* value of a hue, its approximate value as it would appear if a black-and-white photograph were taken of it at its strongest chroma. The spectrum values of the various hues can play a significant part in color harmony, as you shall see.

C4-5. The basic 10-hue Munsell color wheel shows the 5 principal hues and the 5 visually opposite intermediate hues, all of which appear at strong chroma:
Red
[1]
Red Purple [10]
Purple [9]
Purple Blue [8]
Blue [7]
[6]
Blue Green
[2] Yellow Red
[3] Yellow
[4] Green Yellow
[5] Green
On the wheel [11] shows the range of cool hues, while [12] shows the range of warm hues. Green and Red Purple form the transition between the warm and cool hues and can be used with either group in a color composition.

C4-6. A color solid is shown intact in drawing [1], with a typical slice, yellow-red (indicated by dotted lines), about to be removed. In drawing [2] the yellow-red slice is partially removed. Note how the values are lighter at the top and gradually become darker toward the bottom and that the chroma is strongest toward the outer surface of the sphere and weakest or grayest toward the neutral core. In drawing [3] a yellow-red hue chart, similar to the one found in the Munsell Student Set, is superimposed over the dotted outline of the slice from the color solid. As you can see, actual hue charts do not conform to the circular outline of the ideal color solid, since the strongest chromas of the various hues occur at different distances (on the chroma scale) from the neutral core. A Munsell Student Set includes 10 of these color charts, which are equivalent to a basic color solid.

C4-7. Drawing [1] shows a color solid about to be cut horizontally through its middle at the dotted line. Drawing [2] illustrates how the solid might look with the top half removed, leaving the neutral core. Looking down at this bottom half in drawing [3], you see the color wheel, with all the hues at the same medium value. Notice how the chromas of these colors become weaker toward the neutral core.

C4-8. The Munsell Color Tree (courtesy of Munsell Color).

C4-6

C4-7

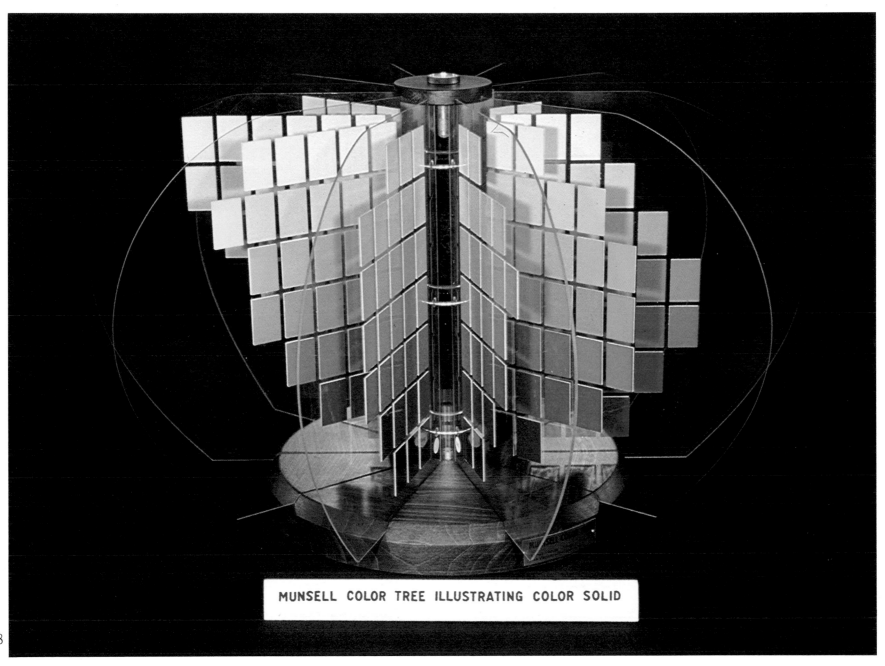

MUNSELL COLOR TREE ILLUSTRATING COLOR SOLID

MUNSELL® STUDENT CHART

HUE

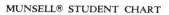

5.0 YR

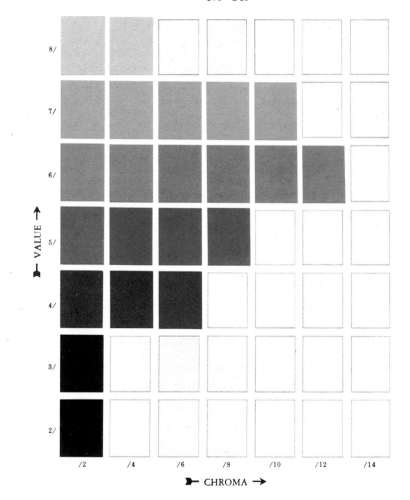

MUNSELL® STUDENT CHART

HUE

5.0 B

C4–9

Mixing Basics

A color system based upon visual perception, such as the Munsell System, has a slightly different color-wheel organization than does that of a system based upon the actual mixing of color media, such as paints. Complementary hues, for example, shift somewhat from system to system. Blue-green is opposite red in the Munsell system, but true green is opposite red in most paint-mixing systems. Since this fact is relatively unimportant for the purposes of this book, the Munsell system will serve as a standard for mixing marker and colored-pencil media.

With the marker/colored-pencil system you can vary the dimensions of colors in a number of different ways, producing virtually any variation that you want.

C4-9. The yellow-red hue chart on the left (courtesy of Munsell Color) shows that yellow-red reaches its strongest chroma at a medium-high value (Munsell value 6), while the blue hue chart on the right shows that blue attains its strongest chroma at a medium-low value (Munsell value 4). This is due to the inherent value of a particular hue at its strongest chroma, called its spectrum value. Note also that some hues extend further from the neutral core and have stronger chromas than other hues. This is due to the nature of the color medium used to make the hue charts. Charts made with other color media may be able to achieve stronger chromas. This is why the strongest-chroma colors that you can produce with markers and colored pencils may be significantly different in value than the spectrum values shown in the Munsell hue charts.

Hue

The hue of a marker base can be varied in the following ways.

1. A second marker hue can be applied over the base marker (C4-10). Care must be taken in using this method over large areas, as the resulting effect can sometimes be streaky or gummy.
2. Colored pencil can be carefully applied over the base-marker hue to produce the color desired (C4-11). One, two, and sometimes more pencil hues can be used, as the situation requires. The value and chroma of the resultant color will have the average dimensions of the marker and colored pencils used. Experience will tell you how much pressure to apply with the pencil so that the desired amount of marker hue shows through.

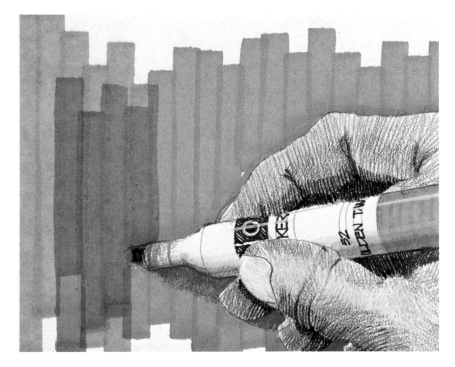

C4-10. A marker color can be altered by applying another marker over it, resulting in a color that is between the two on the color wheel. Here a *Golden Tan* marker is applied over a *Sea Green* marker, resulting in a dull green-yellow.

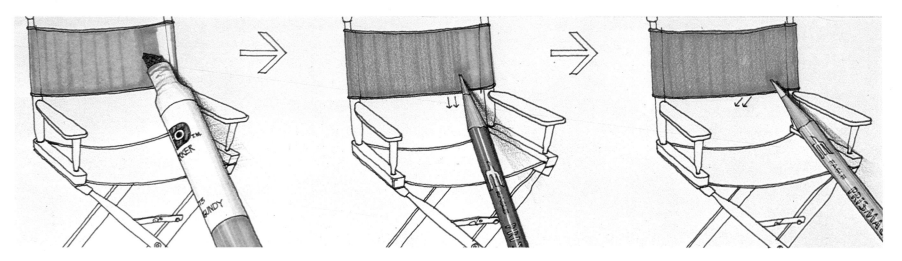

C4–11. This illustration shows how markers and colored pencils can be mixed to produce a desired color. The first step on the left shows the marker base (*Pale Burgundy*), over which an *Orange* pencil is stroked vertically. In the last step a *Canary Yellow* pencil is applied, changing the direction of the stroke to produce a more even, less streaky result. A light to medium pressure on the pencils is usually best for producing subtle changes in color.

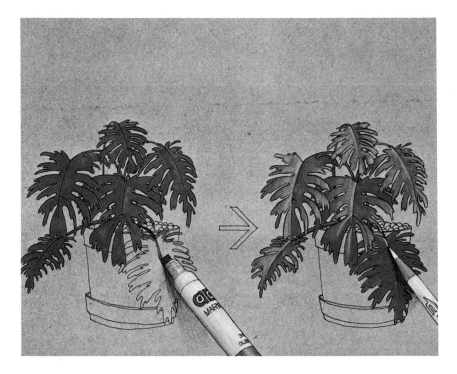

Value

The apparent value of a marker-base color can be altered in three ways.

1. White colored pencil can be applied over the marker-base color, producing a *tint* of the base color (C4–12). This is often used to make a surface appear illuminated.
2. Black colored pencil applied over a marker base will produce a *shade* of the marker color (C4–13). This pencil must be used carefully, as it can produce a sooty effect, especially when applied over light-value markers or other colored pencils. It is often used to make colors appear as if they were in shadow or shade.
3. You may simply change to a lighter- or darker-value marker, if available, provided that it is approximately the same hue (C4–14). (See Appendix B for help in the selection of these markers.)

C4–12. The *White* pencil produces a tint of the *Olive* marker base, making it appear illuminated. This drawing is done on brown-line diazo-print paper with a darker than usual background.

C4–13. The *Black* pencil, applied over marker, produces a shade of the marker color. Here it is used to create indistinct or diffuse shadows—a technique that works well with dark marker colors but creates a sooty effect over light colors, such as that of the lampshade.

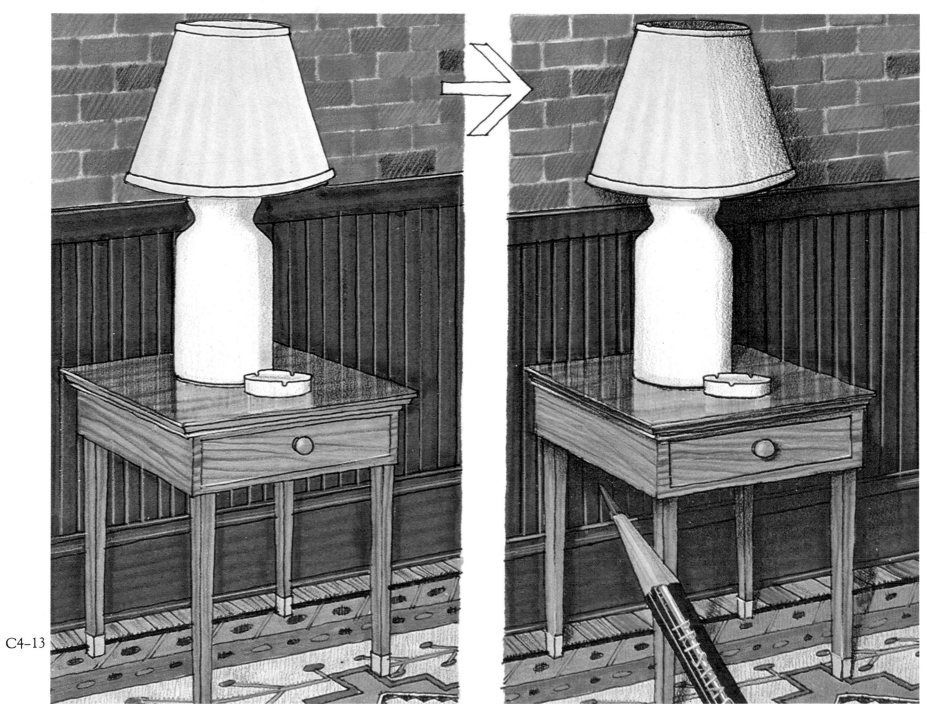

C4-13

C4–14

Chroma

The chroma of a marker color can be altered in the following ways.

1. Chroma may be reduced by applying gray colored pencil over the marker color, producing a *tone* of the original color (C4–15). The chroma becomes weaker as more gray is added, since less of the original marker shows through. Remember that the resulting color will begin to assume the value of the gray pencil if the pencil differs in value from the marker base. Since both a warm-gray and a cool-gray pencil series is available, either might be used. The warm grays have a slightly reddish cast, while the cool grays are somewhat bluish in cast. A cool-gray pencil applied over a marker in the warm-hue range, such as the Golden Tan, will yield a more neutral chroma reduction, as will a warm-gray pencil applied over a cool marker hue.

2. A weakening of chroma can also be effected by applying a *complementary-colored* pencil over the marker (C4–16). This technique should be used when the complementary hue is also used elsewhere in the drawing to avoid dissonance.

3. A weakening of chroma also occurs when the value of a marker base is altered with white or black colored pencil (C4–12, C4–13).

4. The chroma of a marker color can be strengthened as well—either by applying a stronger-chroma colored pencil of the same hue or simply by choosing a stronger marker in that hue! Because of its purity colored pencil is often used by itself for areas of strong chroma in a drawing.

C4–15. As distance increases, the chroma of colors becomes weaker. One way to create this effect is to use gray pencil over distant colors, as in this drawing, in which a *Cool Grey Very Light* pencil is applied over the marker colors of the distant landforms and vegetation. The pencil was applied with most pressure on the distant mountains, with less pressure applied as the landforms approach the viewer.

C4–14. This study illustrates the use of markers that are approximately the same in hue but differ in value. The sunlit portion of the wall, for example, was drawn with a *Purple Sage* marker base, while the rest of the wall was drawn with a *Plum* marker. The illuminated side of the plant basket has a *Sand* marker base, while the side in shade employs a *Burnt Umber* marker. The trees seen through the window were drawn with *Pale Olive*, *Olive*, and *Dark Olive* markers, creating the effects of light and shadow.

C4–16. These two quick studies are identical, except that the bottom contains more muted colors, due to the mixing of complements, giving it a more realistic, less cartoonish appearance. These muted colors were created by applying a complementary pencil color over a marker color. *Peacock Green* pencil (a blue-green), for example, was lightly applied to areas of *Brick Red* marker, while *Terra Cotta* pencil (a reddish yellow-red like that of the brick) was added over the *Slate Green* marker (a blue-green) used for the shrubbery. This exchange of colors not only weakens the chromas in a drawing but also repeats and distributes the colors.

C4-16

C4-17

Weak-chroma Colors

Weak-chroma colors are used extensively in design drawing, more so than medium-to-strong chroma colors. As mentioned above, the chroma of a marker color may be weakened by applying gray pencil over it, but for very weak chromas or large areas of a weak-chroma color this becomes impractical. *A weak-chroma color may be effectively created by applying a light coat—a flavoring—of colored pencil over a gray marker of the desired value* (C4–17). This not only greatly reduces the amount of work involved in creating a weak-chroma color (if it is not available as a marker—and few are), but the chances of streaking are also reduced.

Identifying Hue, Value, and Chroma

Arranging colors into harmonious compositions depends directly upon the designer's ability to identify the hue, value, and chroma of a color accurately in terms of its relationship to other colors.

C4–17. The first step (top) of this mostly weak-chroma drawing shows the application of cool-gray markers. A *Cool Gray #5* marker was used on the ocean, while *Cool Gray #7* marker was applied to the sofa, chair back, and shadows. *Cool Gray #3* marker was used for the distant landforms. The second step (bottom) shows the result of applying various colored-pencil flavorings over the gray marker in order to obtain the desired weak-chroma colors. The paper used for this drawing is black-line diazo-print paper with a darker than usual background.

He or she must know, for example, that two colors may have the same hue even though they may be quite different in value and chroma. Or he or she may have to know that colors are alike in chroma regardless of their hue and value variation. Though it takes practice to master this skill, it is definitely attainable; and, once acquired, your ability to compose drawings with harmonious color relationships is greatly increased. (This is discussed in more detail in Chapter 5.)

One exercise for developing this skill is to pick colors from nature and consciously label their hue, value, and chroma. The sky at a certain time of day may become a high-value, weak-chroma purple-blue, or the grass might be described as a medium-value, medium-chroma green-yellow. Appendix B will aid in further developing this skill. It shows AD markers and Prismacolor pencils arranged, *as they would appear on a good-quality white drawing paper*, according to the Munsell system. The arrangements are visually approximate and not intended to be accurate reproductions of Munsell hue charts, which can be ordered directly from Munsell Color. Different marker brands are cross-referenced with AD markers in Appendix A.

5 How Colors Relate

In this chapter my intent is to help the beginner in colorwork learn how to arrange colors into a composition. Basic principles are explained, which can be used to evaluate colorwork in progress. This discussion is not meant to provide a foolproof formula for creating color compositions but rather a point of departure from which the designer can gain the necessary experience and confidence to ultimately rely upon his own intuition.

As designers we must know *how* colors can be combined into a unified composition. But just what is a color composition? *A color composition is an arrangement of colors that is intended to be seen together as a whole.*

The design of a room or other interior space, for example, is a color composition (whether deliberate or not), as is the perspective drawing used to represent that color composition before it is a reality! Exteriors of buildings—whether painted, made of natural materials, or both—are color compositions, though until very recently few seem to have been intentional. Floor-plan and site-plan presentation drawings can be color compositions that communicate information unattainable from a black-and-white drawing and can exist as mosaics of color that are beautiful in their own right. Weavings, fabrics, graphics, and paintings are all arrangements that can be appreciated as a unit—a composition—of color.

Fashion trends can become established as substitutes for conscious thought and feeling when dealing with color in design work. In order to break out of such ruts, it is useful to understand basic guidelines upon which to formulate fresh and inspired approaches to color composition. These guidelines, each of which is best experienced rather than simply memorized, are common to all the creative arts. They are known as *principles of composition* and, according to Ellinger in *Color Structure and Design* (page 3), they "establish the conditions under which sensory stimuli may most effectively be presented." They are classically applied to two- and three-dimensional design, but they also apply to the arrangement of *each* of the three dimensions of color—hue, value, and chroma.

Three composition principles centrally affect our color-composition decisions—*dominance, contrast,* and *repetition.* Each is defined and discussed here.

Dominance

Each of the three dimensions of color has its own range of possibilities. There is a range of 10 basic hues on the Munsell color wheel, a range of values from very light to very dark, and a range of chromas from very weak, or grayish, to very strong, or vibrant.

In designing a color composition it becomes necessary to place limits on these ranges of possibilities. Some or all the three dimensions of the colors in a given composition might have limits placed upon them. Which dimension or dimensions to limit and to what extent are a large determinant in your emotional response to the composition. (There are obviously other sources of emotional content in a composition, such as subject matter and forms. They are ignored in this discussion for the sake of clarity.)

For example, you will probably receive one impression from a composition that is mostly limited to red and yellow-red hues, mostly medium values, and mostly very strong chromas (C5–1) and an entirely different one from a composition consisting of many different (unlimited) hues, mostly high values, and weak chromas.

Those *limited* areas within the *possible* ranges of hues, values, and chromas constitute the *dominant* hues, values, and chromas of the given composition. This is not to say that other hues, values, and chromas cannot be present in the composition, because there can and often must be others, as will be discussed later. It can nonetheless be noted that, of the color dimensions that you *do* decide to limit, *dominance is established when your choice within that dimension's scale of possibilities predominates—that is, occupies noticeably more space in the composition,* while comparatively smaller areas are occupied by other contrasting choices.

If a color dimension is left unlimited—say, for example, value (C5–2)—then there is no one *obvious,* or dominant, value in the composition. You would instead see colors ranging from very light to very dark. The more color dimensions left unlimited, the less *obviously* unified (in terms of color) the composition is, since there are fewer common threads with which to tie it together.

A dominant element—the hue red, for example—may exist as a number of smaller, unattached areas rather than as one large area (C5–3). A number of colors, each red in hue, may be distributed throughout the composition and still occupy a significantly greater area than that of other hues.

Dominant Hues

In attempting to unify a composition and create a particular mood, it is usually a good idea to limit the number of hues to no more than four, with three, two, and even one hue often sufficing quite nicely (see Chapter 6).

If a group (more than two) of hues is used in a composition, one should assume the dominant role, with the remaining hues *successively reduced* in amount. If you choose the analogous group of red-purple, purple, and purple-blue as a hue scheme, for example, purple-blue might play the dominant role, while the remaining areas might be filled in mostly with red-purple and only a few touches of purple (C6–7).

C5–1. In the composition on the left red and yellow-red hues (though of the two the yellow-red predominates), medium values, and very strong chromas dominate. Compare your reaction to this composition on the left to the one on the right. Though it uses the same arrangement of shapes, it contains five different hues, mostly high (light) values, and weak chromas.

C5–2. In this composition no one value (or limited range of values) dominates. There are rather many different values, ranging from very light to very dark. With a wide range of values the hues and chromas were limited in order to unify the composition. Neighboring green, blue-green, and blue hues were used (with only touches of yellow and red-purple), while the chromas were limited to weak (though small areas of stronger chromas were added for interest).

C5–3. A dominant element, such as the hue red in this illustration, need not be present in one large, continuous area but may consist of a number of smaller, unattached areas. In terms of total area, however, there is more red than purple-blue and gray combined.

C5-1

C5-2

C5–3

Dominant Value

The values of the colors used in a composition should be limited in such a way that one value or a closely related group of values clearly occupies more space than other contrasting values.

When the dominant value is obvious, the composition is said to have a particular value key. A drawing that utilizes a high or light dominant value is said to be high-key and, depending on the viewer, may impart such emotional or sensual qualities as airiness, light-heartedness, or delicacy. A low-key composition may evoke such responses as somberness, dignity, soberness, or heaviness (C5-4). Middle-key compositions suggest neutrality and do not have—or indeed may not need—the decisive emotional impact of either high- or low-key compositions.

Chroma Dominance

As with hue and value, one chroma or a closely related group of chromas should clearly dominate a composition. Most color drawings (and the subsequent designs based on them) do not favor strong chromas, as they tend to be overstimulating when experienced on a long-term basis. Since an environment must be inhabited, medium- to weak-chroma colors have consistently proven more satisfying, with strong-chroma colors used as accents or punctuations. On the other hand, compositions designed to capture and hold your attention for a short period—commercial graphics, posters, and advertising—as well as various works of art often utilize strong-chroma dominance.

C5-4. Above is a high-key composition, while below is a low-key composition.

Contrast

While the establishment of hue, value, and chroma dominance helps create the mood and unity of a composition, it may be rather dull if there are no subordinate elements to oppose this dominance and establish tension.

This opposition, called *contrast*, depends on a *distinguishable difference between two parts of the same color dimension*. Contrast is essential to good color composition, as it prevents the boredom caused by uniformity. Dark versus light, dull versus bright—these opposing forces help create a balance within the composition and give it a sparkle.

The reason why "this approximate balance [via contrast] is desired," Albert Munsell concluded in *A Color Notation*, "may be shown by reference to our behavior, as to temperatures, quality of smoothness and roughness, degrees of light and dark, proportions of work and rest" (page 32). Indeed, some colorists have constructed entire systems of color use in terms of contrast. Johannes Itten, an eminent Bauhaus instructor in the early 1920s, maintained in *The Art of Color* that contrasts "constitute the fundamental resource of color design" (page 35).

There can be contrasting or opposing groups of hues, values, and chromas. The *degree* of contrast again depends on the intended mood or emotional impact of the composition. Subtle contrasts will impart a quite different feeling from strong, obvious contrasts. You may also want to vary the degree of contrast, with subtle oppositions in one color dimension and stronger ones in another. You might choose strong value contrast and subtle hue and chroma contrast, for example (C5–5).

C5–5. This composition exhibits subtle hue and chroma contrast and strong value contrast: the hues are analogous on the color wheel—yellow and yellow-red—the chromas have been kept in the medium-weak to weak range; while the values of the colors range from the very dark browns (yellow-reds) at the four corners to very light pale yellow under the left eye.

Hue Contrast

All hues that are distinguishably different from one another are in essence contrasting. The further apart two hues are on the color wheel, the more they contrast. Side-by-side or analogous hues contrast subtly, while opposite or complementary hues contrast strongly (C5–6).

Contrast schemes that utilize opposite or near-opposite hues simultaneously form *warm-cool contrasts*. Our tendency to perceive warm hues as advancing and cool hues as receding may thus be utilized in your color compositions if circumstances permit.

Value Contrast

Contrasts in the values of colors exist when the values used are distinguishably different. If there is more than one subordinate value in a color composition, each will contrast with the dominant value and with each other as well (C5-7).

In perspective design drawings this contrast usually occurs automatically when the shade, shadow, and highlights are added. For a preview drawing of a color study for an environmental design—say, a building facade or an interior scheme—avoid shade, shadow, and highlights, since in most environments the light is constantly changing. The shade, shadow, and highlights may be added to a presentation or persuasive drawing of the scheme to show how the composition might look at a particular moment in time.

Chroma Contrast

Interest may also be supplied to a color composition by adding contrasts in chroma—chromas that are discernibly different from the dominant chroma. The contrasts may again be subtle or strong, depending upon the intended mood (C5-8). As with value contrast, a number of different chromas will obviously contrast with the dominant chroma and with each other.

Chromatic contrast can also be achieved between colors and noncolors—neutral white, black, and grays.

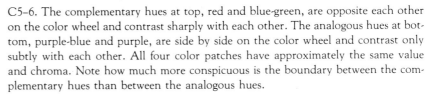

C5-6. The complementary hues at top, red and blue-green, are opposite each other on the color wheel and contrast sharply with each other. The analogous hues at bottom, purple-blue and purple, are side by side on the color wheel and contrast only subtly with each other. All four color patches have approximately the same value and chroma. Note how much more conspicuous is the boundary between the complementary hues than between the analogous hues.

C5-7. At top subtle value contrast; at bottom strong value contrast. The hue and chroma of the colors are approximately the same.

C5-8. At top subtle chroma contrast. The patch on the left is slightly more grayish than the one on the right. At bottom strong chroma contrast. The patch on the left is considerably more grayed than its neighbor on the right. All four patches are approximately the same in hue and value.

C5-6

C5–7

C5–8

Contrast Limitations

One of the most common shortcomings in a color composition is the use of wide, unrestrained variations within the three color dimensions—*too much of too many kinds of contrast.*

The usual result is a quality of busyness—or even chaos—since too much variation or contrast is happening simultaneously, thus diluting the expressive direction of the composition. Care must be taken to set limits on the amount of contrast within each of the three dimensions of color. Your expressive intentions will help you to determine which color dimension or dimensions should be restrained and, of those that you *do* choose to contrast, how much or how little should be used.

Johannes Itten advises in *The Art of Color* that, "when a composition is to be done in the pure style of a particular contrast [hue, value, or chroma], all other, incidental contrast must be used with restraint, if at all" (page 33). If, for example, my expressive intent in designing a kitchen is to make it warm and earthy, I might limit the hues to naturals such as red and yellow-red, restrain the chromas to medium-weak, and utilize a full range of values of these colors to provide the interest of contrast (C5–9). In this way the composition is given "the pure style of a particular contrast."

Repetition

The principle of repetition, already implicit in the discussion of dominance and limitation, may be seen as the thread that weaves the composition into a coherent, unified whole. One way in which repetition can be incorporated is to relate subordinate areas to one or more of the dominant elements. (*The subordinate areas of a given color dimension in a composition are those that do not possess the dominating limits placed on that dimension. If the dominant value were low, for example, then colors with high or medium values would be subordinate.*) *If each subordinate area repeats the dominant characteristic of two of the color dimensions, the composition becomes obviously unified.*

If a color composition has a dominant red hue, a dominant medium in value and weak in chroma (C5–10). Though it is not always possible for every subordinate area to repeat the dominant characteristic of *two* color dimensions, some link to the rest of the composition can be established if each repeats the dominant part of at least *one* of the color dimensions.

A related way to create repetition with markers and colored pencils is to select only a *limited* number of markers and pencils (other than neutrals) and to allow only their possible mixtures to suffice for the entire composition (C5–11). In this way repetition becomes almost unavoidable.

Repetition may similarly be established or furthered in a finished or nearly finished drawing by adding a pencil color used in one part of the composition on top of colors used in other parts of the composition with a very light to medium hand pressure, depending on the desired amount of color shift. This helps create color balance and unifies the drawing through repetition (as in C5–10). Further examples of this technique can be seen in most of the drawings in this book.

C5–9. Value contrast is shown in this kitchen abstraction; little contrast occurs in the other color dimensions. A full range of values was used—from very light to very dark—while the hues were limited to the analogous red and yellow-red, and the chroma was restrained to the medium-weak range.

C5–10. The dominant aspects of the three color dimensions in this illustration are red hue, medium value, and weak chroma. The blue-green areas are tied into the composition by their medium values and weak chromas. Though *most* of the areas of the composition adhere to the dominant aspects mentioned above, note the *contrasting* areas of hue, value, and chroma, which add interest and surprise through their *difference* from these dominant aspects. To achieve the weak chromas, the *Blush* pencil, used in many of the red areas, was applied lightly over most of the blue-green areas. Likewise, the *Light Green* pencil was used to weaken the chroma of many of the red areas. Color distribution helps to balance and unify the drawing through repetition.

C5–9

C5–10

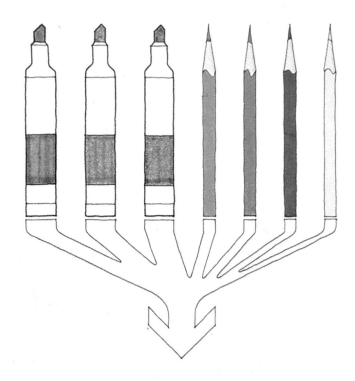

Strong-chroma Colors

A useful point to remember when incorporating repetition into a color composition is that, as a color approaches its strongest chroma, it offers fewer choices of value. When a color reaches its strongest chroma, it has a certain inherent value. (See the section on spectrum value in Chapter 4.) A yellow, for example, will always possess a *high* value at its strongest chroma, (C5–12), for it is impossible to achieve a *low*-value, strong-chroma yellow!

This phenomenon becomes important if you want to use significant areas of strong-chroma colors in your composition. If you want these colors to repeat the dominant value of the composition, your choice becomes limited. A strong-chroma purple, for example, would be too low in value to fit into a high-key (light-value) composition, while a strong-chroma yellow or green-yellow would have a high enough value to repeat the dominant value (C5–13).

C5–11. In this quick tree-grouping study only a *few* markers and colored pencils were used (not including a gray and a black marker), and their various mixtures sufficed for the colors of the composition. It was therefore necessary to repeat the pencil and marker colors throughout the drawing.

C5–12. The hue chart on the left demonstrates that yellow reaches its strongest chroma at a high value, while purple-blue, shown in the chart on the right, reaches its strongest chroma at a considerably lower, darker value. It would be as impossible for the yellow to achieve a strong chroma at a *low* value as it would be for the purple-blue to reach a strong chroma at a *high* value!

C5–13. The strong-chroma yellow fits into this dominantly high-value (high-key) composition, since it exists as a high-value color when at a strong chroma.

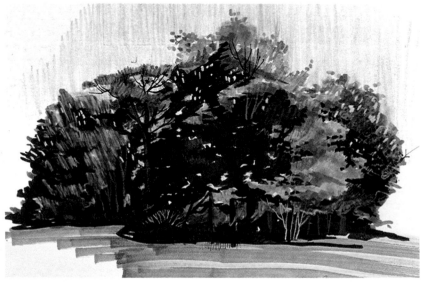

C5–11

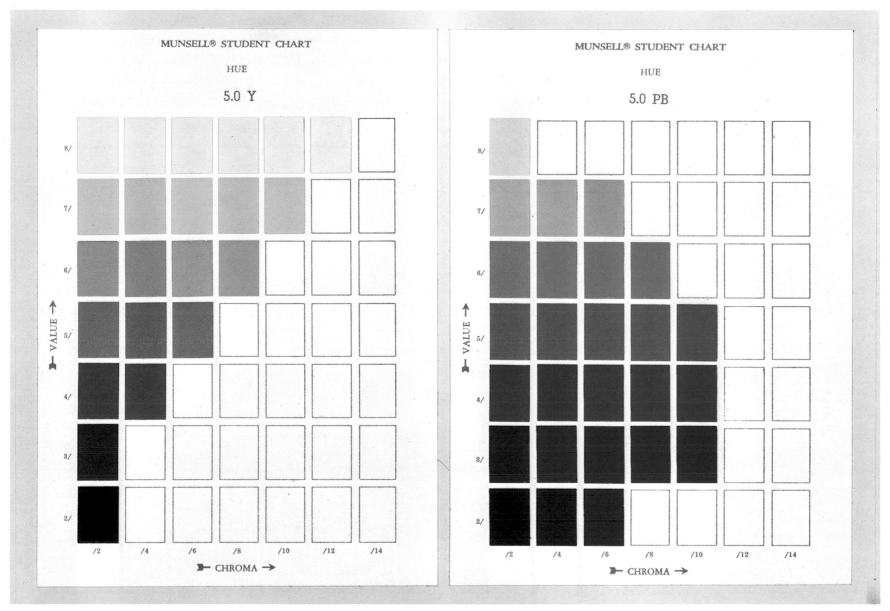

MUNSELL® STUDENT CHART

HUE

5.0 Y

VALUE →

CHROMA →

MUNSELL® STUDENT CHART

HUE

5.0 PB

VALUE →

CHROMA →

C5–12

C5–13

Hue Schemes 6

A discussion of color harmony can be divided into two parts: *How* colors can be combined into a composition and *which* hues might be used for this purpose.

Hues are chosen for a composition from a variety of hue arrangements on the color wheel (and the color solid) called hue schemes. Hue schemes have evolved through the centuries out of the consistent choices of many people, most of them painters. They are not intended to be absolute directives for hue choice but rather suggestive *guidelines*. (Most scheme selections involve the use of a color wheel as a reference, and for that purpose a color wheel is provided in Appendix C.)

Some schemes can be selected from a color solid, which contains a color wheel. These delightful schemes are called progressions and are based on the *orderly variation* of spacing between colors, which are located either on a single hue chart or on the solid itself, thus involving a series of charts. Compositions based on progressive schemes are most interesting when the colors selected are adjacent to each other in the same order as on the color solid. This is not always possible for every part of every composition, but appropriate opportunities should be capitalized upon. (An example of a progressive scheme put to use in a practical composition is given later in this chapter.)

Following is a discussion of basic types of schemes. Remember that *most successful compositions are based on the use of a few hues* rather than many, and for this reason (with a few exceptions) the schemes discussed here involve no more than four hues and often less.

189

Site Plan View

SCREEN MOUNDING
—Mounding topped @
6'. Plant materials
include Amelanchier
canadensis, Tsuga can-
adensis, and, Pinus
mugo mughs.

PICK-UP AREA

PARKING FOR 17 CARS
Asphalt topped and
sealed. Spaces 9'x 18'.
Curbed w/ walkway
leading away from pick-
up area.

CONIFER TREES
—Tsuga canadensis (typ.)

PATIOS AGG. CONC.
—Planting space as owner
specified

DECIDUOUS SHADE TREES
—Tilia cordata (typ.)

CONC. WALKWAY

DECID. SHRUBS
Azalea mollis, Rhodo-
dendron maximum

EXISTING OAK
(Quercus alba –
white oak)

STAINED WOOD SHINGLE
WHITE STUCCO

BOATING INFO. KIOSK

DOCK
@ sidewalk level
for row boats.

"BOSS LAKE"

Site Section A-A'

C6–1

Preliminary Cluster Study: Welton Avenue

One Hue with Neutrals

This arrangement is the most basic hue scheme. Any hue on the wheel may be chosen and used with the neutrals—the grays, white, and black. In the resulting composition either the chosen hue *or* the neutrals may dominate. In either case quite different expressions will result (C6–1, C6–2).

This scheme is generally considered to be sophisticated and may be used accordingly—possibly for an office, a demure wall hanging, or perhaps a drawing in which color is not customarily used, as of an illustrative construction detail such as a wall section.

C6–1. This landscape-design study utilizes a one-hue-with-neutrals scheme, with the green-yellow hue dominant. Though the values of the colors are unlimited, the dominant chroma lies in the weak to medium-weak range.

C6–2. These markers and colored pencils were used for the landscape study (C6–1), along with fountain-pen and Pilot Razor Point line media:

Dark Olive [1]	Cool Gray #3 [3]	Cool Gray #5 [5]	Cool Gray #7 [7]	Cool Gray #9 [9]	White [11]
Apple Green [13]	Olive Green [15]				

Monochromatic Schemes

As its name implies, a monochromatic scheme utilizes a single hue throughout a composition. Any variation is provided by contrasts in value or chroma. Monochromatic schemes based on progressions may be chosen from a hue chart. Many progressions are available from a single hue chart.

Monochromatic schemes, like single-hue-and-neutral schemes, may also be considered refined and are used in interiors, many types of wall hangings, and site-plan drawings (C6–3, C6–4, C6–5). Exteriors of recycled buildings are often seen in monochromatic schemes that use both natural and painted materials as their sources of color.

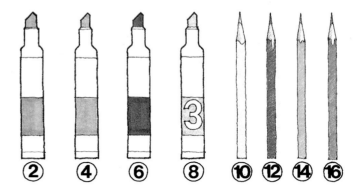

C6–3. The arrows show the paths of the yellow-red progressions used for the parking-garage study (C6–5). Path [1] (chroma constant, value changes) was used on the spiral stairway on the left side of the elevation. This same progression was used on the thinner bands located directly below the widest wall bands. Path [2] (chroma changes, value constant) was used on the widest wall bands. The color at the intersection of paths [1] and [2] was used on the columns, since it was common to both progressions. The arrow [3] points to the accent color used on the railings and window mullions on the first level.

C6–4. These markers and colored pencils were used, in addition to the fountain-pen and Pilot Razor Point line media, in the parking-garage study (C6–5):

| Golden Tan [2] | Sand [4] | Burnt Umber [6] | Cool Gray #3 [8] | Light Flesh [10] | Burnt Ochre [12] |
| Flesh [14] | Orange [16] | | | | |

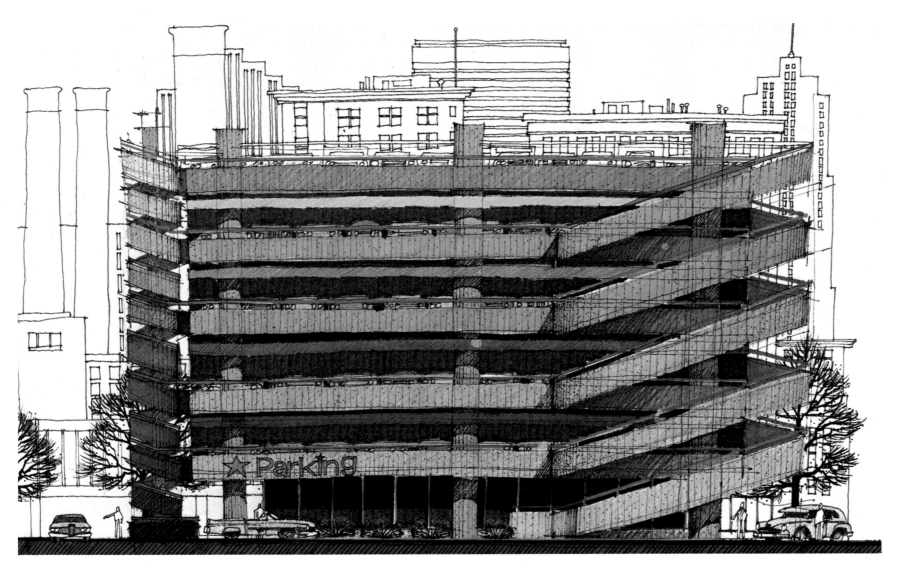

C6–5. This parking-garage elevation study employs a yellow-red monochromatic-hue scheme with color progressions. It was done on Strathmore Bristol, medium-surface, 2-ply thickness.

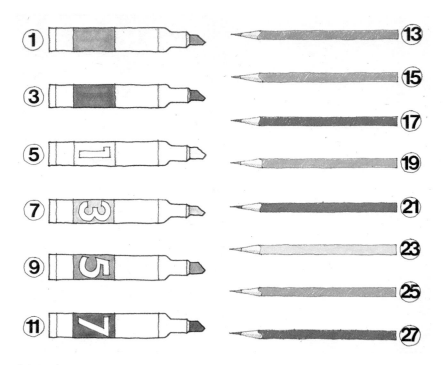

Analogous Schemes

Simple Analogous Scheme

Analogous schemes utilize *neighboring* hues on the color wheel and are common in every area of colorwork. They are often most successful when they are definitely warm or definitely cool, since the use of hues that reach into both the warm and the cool portions of the color wheel creates oppositions in temperature, which can contradict the neighborly intent of the scheme (C6–6, C6–7).

Analogous-with-neutrals Scheme

In this extension of the analogous scheme grays, white, and black are included. Either the neutrals or one of the hues can dominate the composition.

C6–6. These markers and pencils were used for the bathroom study (C6–7), in addition to the Pilot Razor Point:

[1] Pale Burgundy [15] Light Violet
[3] Colonial Blue [17] Violet
[5] Cool Gray #1 [19] Light Blue
[7] Cool Gray #3 [21] Copenhagen Blue
[9] Cool Gray #5 [23] Warm Grey Very Light
[11] Cool Gray #7 [25] Warm Grey Light
[13] Pink [27] Warm Grey Medium

C6–7. The analogous-hue scheme in the bathroom study shown here employs the hues of red-purple, purple, and purple-blue. These hues are used in tapering amounts, with purple-blue dominant, red-purple secondary, and only touches of purple. Progression is used in a traditional interior value arrangement, beginning with a dark floor and progressing to a light ceiling. A light range of value is dominant in this composition. The dominant chroma of the colors lies well within the weak range, with touches of strong-chroma accents in the rug, molding, flowers, and print. Each of the three hues used in one area of the drawing was repeated in other areas. The colors were also repeated by mingling colored pencils in one hue into areas done with another hue. Though the upper walls and ceiling are purple-blue, for example, *Light Violet* pencil was also lightly applied to these areas. The white water closet, sink, and inside bathtub reflect the colors and thus further repeat them in the composition.

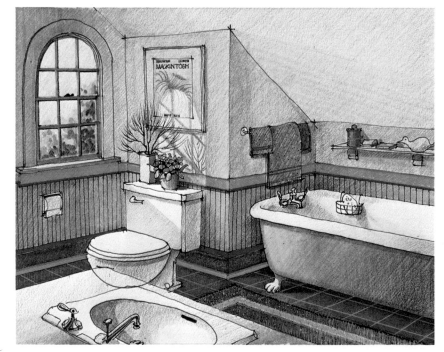

C6–8

C6–9

Analogous-with-complementary-accent Scheme

This scheme utilizes an accent of the hue opposite the center of the analogous group on the color wheel. It is used to set off the analogous scheme, and a strong chroma for the accent color is common. For example, in an analogous scheme of red, yellow-red, and yellow the complementary accent might be a touch of bright blue. The dominant hue should be chosen from the analogous hues. color. The illustration shows this scheme being used for a residential exterior (C6–8, C6–9, C6–10).

The markers and colored pencils chosen for a hue scheme *can be mixed with each other*, according to the mixing basics covered in Chapter 4. Such mixtures can produce many rare and beautiful colors without departing from the scheme.

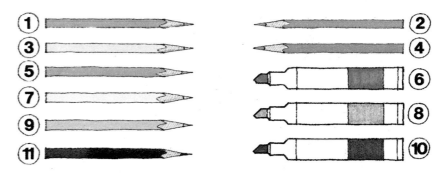

C6–10. These markers and colored pencils (excluding plant materials) were used for the house study (C6–9):

[1]	Blush	Light Green	[2]
[3]	Light Flesh	Non-Photo Blue	[4]
[5]	Flesh	Brick Red	[6]
[7]	Cream	Sand	[8]
[9]	Sand	Burnt Umber	[10]
[11]	Burnt Umber		

C6–8. This photograph shows a house (C6–9) in its existing state—brick and asphalt shingle painted a dull brown and (oxidized) green. About 70 years old, it has much potential as a color composition.

C6–9. This study shows the house as it might look if done in the analogous hues of red, yellow-red, and yellow with a complementary accent of blue. As many natural colors as possible were utilized. The brick was sandblasted to remove the paint. The asphalt shingles on the gables and roof were replaced with wood shingles. The design intent was to keep the colors soft and unobtrusive due to the residential character of the neighborhood. For this reason colors with higher values and medium-weak chromas were used in order to relate to the colors of the natural materials, since they are similar in these two dimensions. Shade and shadow were not included in this study drawing so that an overall impression could be gained rather than one of a particular instant in time.

Analogous Schemes with Progressions

Schemes involving progressions of color are formulated by choosing the three dimensions—hue, value, and chroma—simultaneously. The color solid is helpful in selecting such schemes. Remember that they are based on a regular change in the interval between adjacent (analogous) colors of the solid.

Since a real color solid is quite expensive, you may choose a progression from Appendix B, a Munsell Student Set, or simply your imagination (C6–11, C6–12). Arriving at a progression is not difficult. If, for example, you wanted an analogous progression of four hues that had the same chroma but steadily changed in value, the first step would be to choose the hues—say, purple-blue, blue, blue-green, and green. Then choose the value and chroma of one of the end hues—say, purple-blue at medium chroma and low value. The progression can proceed from this point: blue at medium chroma and medium-low value, blue-green at medium chroma and medium value, and green at medium chroma and medium-high value.

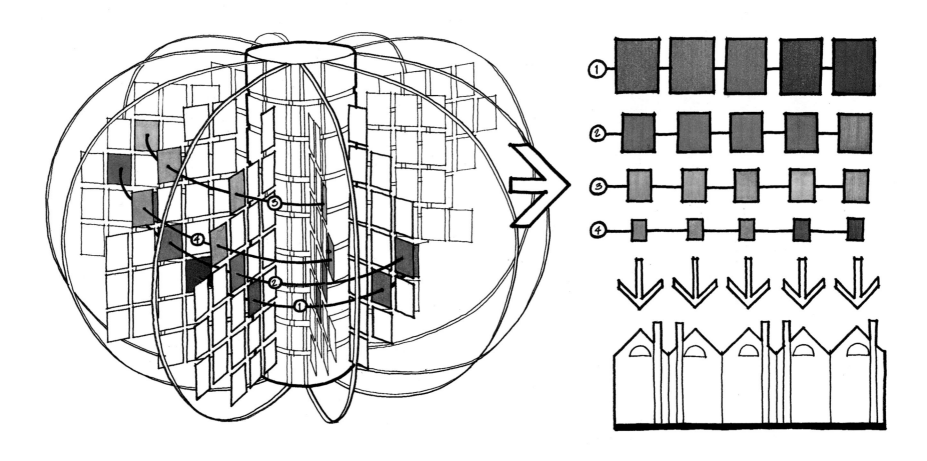

C6–11

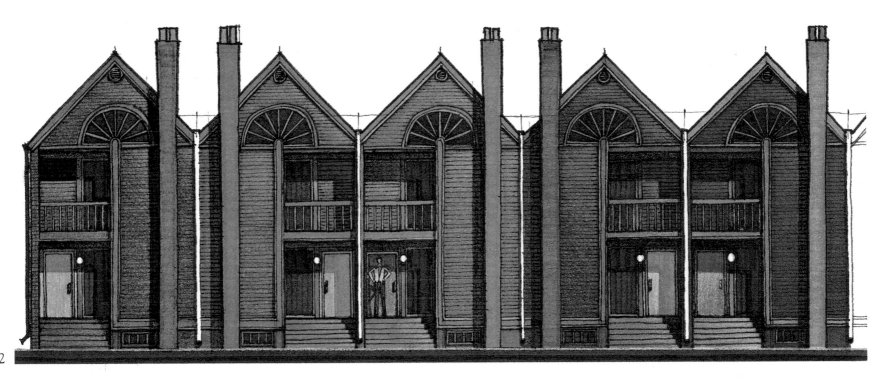

C6–12

C6–11, C6–12. This drawing illustrates how progressions can be taken from an actual color solid (or from a Munsell Student Set of hue charts) and applied to an environmental color composition such as a row of townhouses. The analogous cool hues of green, blue-green, blue, purple-blue, and purple are all used as medium-low-value, weak-chroma colors (progression [1] on the color solid) for the main body of each townhouse unit, beginning with green on the left unit and ending with purple on the extreme right. For the chimney, stairs, and major trim each townhouse unit borrows its righthand neighbor's main body hue, raising its value to medium and its chroma to medium-weak (progression [2] on the color solid). The door hues of each unit are borrowed from the main body hue of its neighbor two units to the right and raised to a medium-high value and a medium chroma (progression [3] on the color solid). The minor trim pieces on each unit are the same color as the door, though the chroma is increased to medium-strong for accent (progression [4] on the color solid).

Complementary Schemes

Complementary hues are diametrically opposite each other on the color wheel. When placed side by side, complementary colors look their most intense. To make a blue look very blue, for example, place its complement, yellow-red, next to it.

Since they oppose each other on the color wheel, complementary colors may be viewed as *contrasting* colors. When interpreted in this way, complementary-color schemes may be expected to form a more vigorous and active color composition in the hue dimension than do those previously discussed. This point might be kept in mind when the expressive intent of the designer leans in that direction. Consider some of the many dramatic complements found in nature: the intense yellow-reds and blues of a sunset, the green-yellow of spring grass together with the low-chroma purples of distant mountains, or the intense, warm hues of wildflowers with the cool, dark greens of their supporting foliage.

Of any pair of complements one hue occurs in the warm-hue range, wise be a direct complement. The colorist Faber Birren has said

appropriately in *Principles of Color* (page 51) that "It is. . . philosophic, if not scientific, to conclude that the human sense of color doesn't want to be bothered with details." This certainly holds true for schemes in which near-complements often serve the expressive purpose of a composition as effectively as does the direct-complement scheme, providing the designer with a wider selection from which to choose (C6–13, C6–14). The near-complement scheme of yellow-red and purple-blue was used for many of the exquisite renderings done in the 1920s.

This phenomenon is known as atmospheric perspective and is readily apparent if you look into the distance at the landscape. Not only do the colors become more purple-blue, but, with each successive layer of distance, the chroma becomes weaker while the values become higher. This is an important fact to remember when trying to effect a feeling of distance in a landscape drawing (see C3–112).

One of the two opposing hues used in a complementary scheme should dominate, or the neutrals can be given the dominant role. If the neutrals—grays, white, and black—are not dominant, they can still be used to provide areas of relief upon which the eye can rest.

Grays may be applied with gray markers and/or gray pencils—or formed by mixing the complementary colors used in the scheme (see Chapter 4). A gray made in this fashion will probably not be a true neutral gray but rather a more lively gray that will lend itself readily to the composition.

C6–13. This life drawing shows only a small portion of the many kilns situated behind the University of Colorado Fine Arts Building. The brick wall behind the kilns receives evening sunlight, which reflects an eerie orange backlight onto the shaded kilns. The hues used are the near-complements of yellow-red and purple-blue, with the yellow-red dominant. The colors are mostly medium in value, while their chromas are left unrestrained, ranging from weak to strong. Much of the dark shading on the pipes and other small areas was drawn in with a fountain pen, using diagonal lines, after the color was applied.

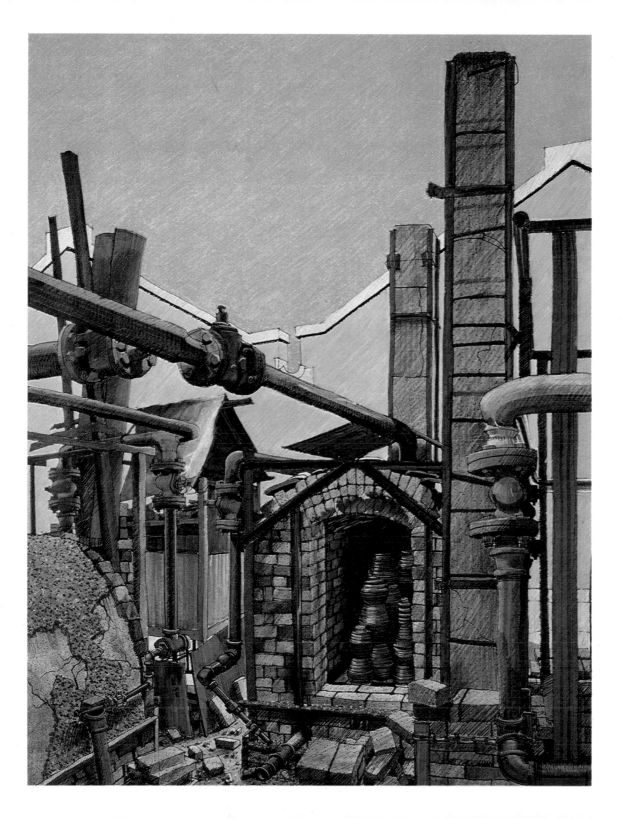

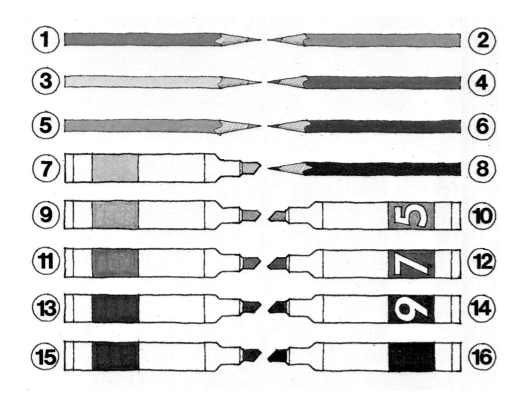

C6–14. These markers and colored pencils were used for the kiln drawing (C6–13):

[1]	Light Blue	Yellow Ochre	[2]
[3]	Light Flesh	Orange	[4]
[5]	Flesh	Burnt Ochre	[6]
[7]	Flesh	Burnt Umber	[8]
[9]	Sand	Cool Gray #5	[10]
[11]	Kraft Brown	Cool Gray #7	[12]
[13]	Burnt Umber	Cool Gray #9	[14]
[15]	Nubian Brown	Black	[16]

Direct-complementary Scheme

This scheme uses hues that are directly opposite each other on the color wheel.

Near-complementary Scheme

A near-complement scheme, as its name suggests, is an arrangement in which one of the hues lies to one side of what would otherwise be a direct complement. The colorist Faber Birren has said appropriately in *Principles of Color* (page 51) that "It is. philosophic, if not scientific, to conclude that the human sense of color doesn't want to be bothered with details." This certainly holds true for schemes in which near-complements often serve the expressive purpose of a composition as effectively as does the direct-complement scheme, providing the designer with a wider selection from which to choose (C6–13, C6–14). The near-complement scheme of yellow-red and purple-blue was used for many of the exquisite renderings done in the 1920s.

The Split-complementary Scheme

This scheme derives from the rationale for the near-complement scheme and is in fact a double near-complement scheme. It utilizes one hue and the two hues that lie on either side of its direct complement, forming a Y shape on the color wheel.

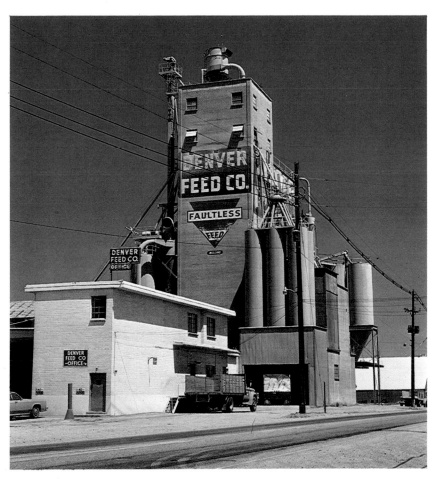

C6–15. This building is located in a rather bleak, colorless, heavy industrial area of Denver. It provides an ideal arrangement of forms with which to work with color composition.

Triad Schemes

One of the most active hue schemes is the triadic scheme, which uses three hues that lie at approximately equal distances from each other on the color wheel, with the lines between them roughly forming an equilaterial triangle. Since the hues sample all portions of the color wheel, they can form one of the most lively, vigorous schemes for a composition (C6–15, C6–16, C6–17).

As when using any other scheme in a composition, one of the three hues should dominate, and one of the remaining two hues should occupy more area than the other.

C6–16. The study drawing shows some possible effects of paint and applied color composition. The hue scheme is an approximate triad—red-purple, yellow, and blue—with the blue dominant and the yellow slightly more prevalent than the red-purple. The low-key value is dominant in the composition, while the chromas of the colors are weak to medium in strength, with some strong chromas as accents. Small areas of other hues, such as the purple and yellow-red stripes, were made by mixing pencils that were part of the triadic palette.

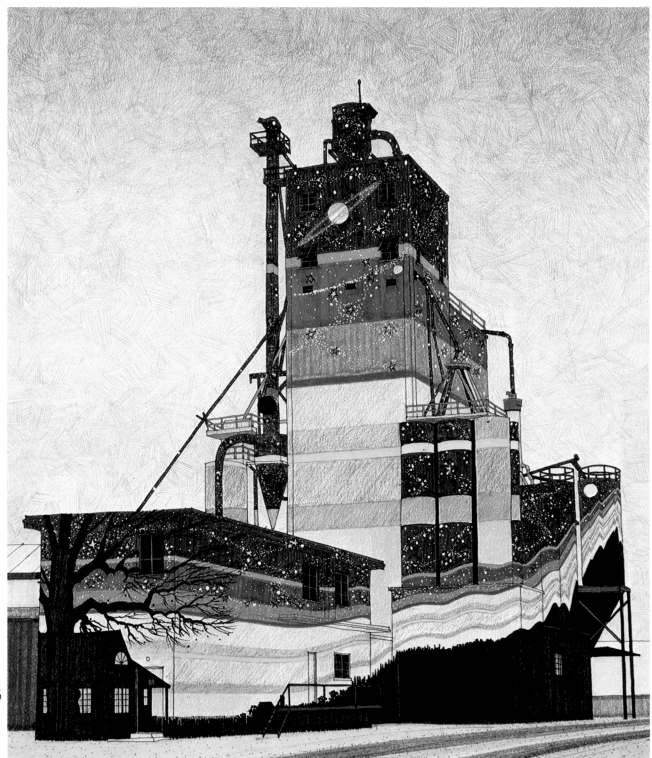

C6–16

Random-hue Schemes

A variety of randomly selected hues may also be used as a scheme, which can result in an exciting and intriguing composition. Since the hue selection is unlimited, however, steps must be taken to avoid chaos. (See also the discussion of contrast in Chapter 5.) This can be accomplished by limiting the area occupied by the hues, by covering most or all of the hues with a flavoring of a single colored pencil, or by limiting the range of the value, chroma, or both of the hues involved. All these steps establish an obvious dominance, keeping the composition unified.

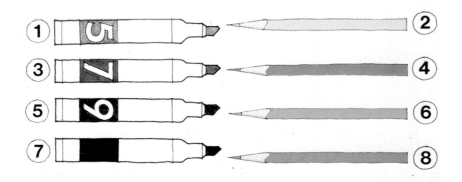

C6–17. These markers and pencils were used to complete the building study (C6–16):

[1]	Cool Gray #5	Canary Yellow	[2]
[3]	Cool Gray #7	Pink	[4]
[5]	Cool Gray #9	Non-Photo Blue	[6]
[7]	Black	True Blue	[8]

Random Hues with Restrained Dimensions

With no limit placed upon the variety of hues in a scheme, restrictions should be placed on the other two dimensions of color in order to provide a counteracting stability within the composition (C6–18, C6–19). A medium-to-weak chroma range usually works best, since our society tends to reject most environmental compositions (such as interiors) with a strong-chroma dominance. The value of the colors can be restricted to either a high, middle, or low range, depending on the expressive intent of the designer.

Random Hues with White

A randomly selected palette of hues can be used with white, provided that the hues occupy only a small proportion of the composition. White allies itself with strong-chroma hues, so small areas of a rainbow of strong-chroma hues are often used with a large area of white. As the chromas of the hues are weakened, they can occupy a larger proportion of the composition, as long as white continues to dominate the scheme.

Random Hues with Dominant Flavor

Although flavoring all the colors in a drawing with a single colored pencil need not be restricted to a random-hue scheme, it works well in this context, since it provides a unifying influence over what would otherwise be a group of disparate hues with little in common.

This scheme is a good one with which to simulate special lighting effects, as in a drawing of a landscape at sunrise or at sunset or perhaps a theater stage bathed in chromatic light.

C6–18. This drawing illustrates the use of a random-hue scheme (with restrained dimensions) for a restaurant interior. There are seven hues in the composition—red, yellow-red, yellow, green-yellow, green, purple-blue, and purple. The red/yellow-red hue range is dominant, while the purple-blue is secondary. The dominant value of the colors was restrained to medium-low, and the dominant chroma was limited to medium-weak. Contrasting accents of high-value colors are provided by the backlighted stained-glass windows, columns, and dishware. Touches of strong-chroma accent colors are also placed throughout the composition. The diffuse shadows and lighting were located so that the light would seem to emanate from the large fireplace on the extreme left side of the drawing.

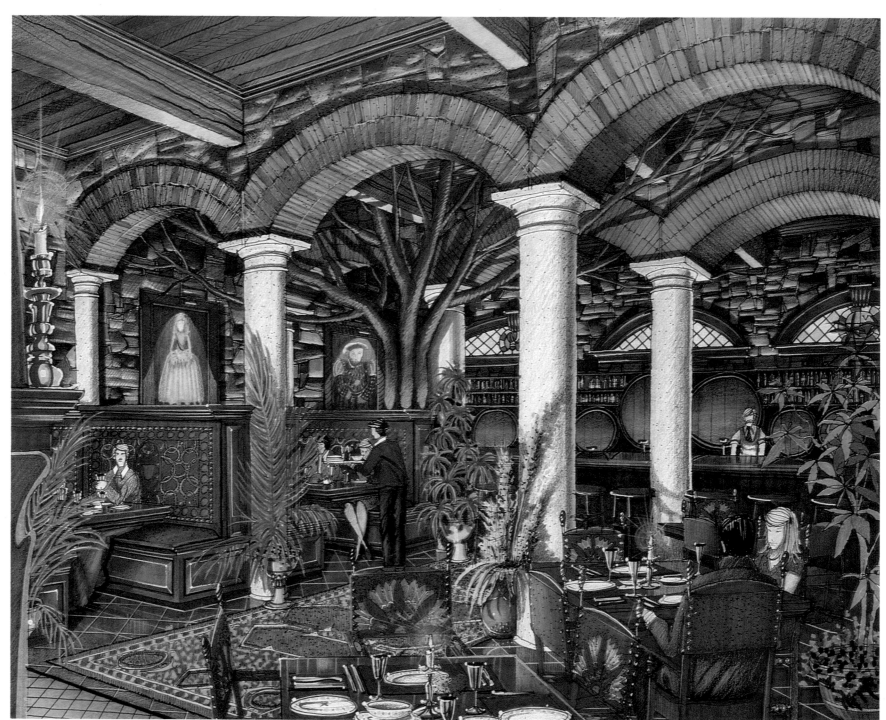

C6–18

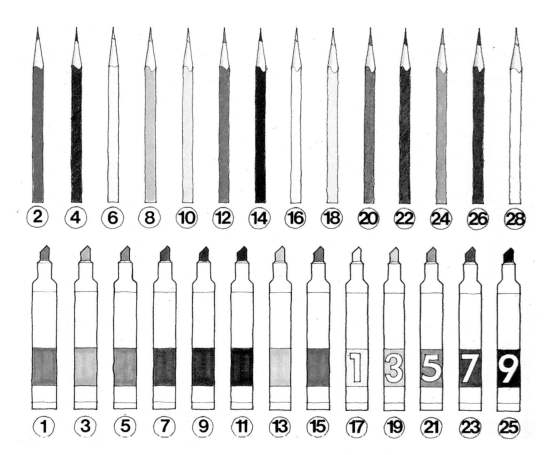

C6–19. These markers and pencils were used for the restaurant interior (C6–18):

Scarlet Lake [2]	Tuscan Red [4]	Light Flesh [6]	Flesh [8]	Sand [10]	Burnt Ochre [12]	Burnt Umber [14]	Cream [16]	Canary Yellow [18]	Olive Green [20]	Dark Green [22]	Light Blue [24]	Indigo Blue [26]	White [28]
Brick Red [1]	Sand [3]	Kraft Brown [5]	Walnut [7]	Burnt Umber [9]	Nubian Brown [11]	Golden Ocher [13]	Colonial Blue [15]	Cool Gray #1 [17]	Cool Gray #3 [19]	Cool Gray #5 [21]	Cool Gray #7 [23]	Cool Gray #9 [25]	

7 An Approach to Color Composition

As you grow more successful in composing color, the process of advancement from your initial confusion and perhaps even discouragement will hopefully be experienced as a challenging puzzle, rewarding you the designer (and your environment) with color compositions that are immensely interesting in their rational complexity.

It should be recognized that an understanding of the principles discussed in the previous chapters is not a ticket to guaranteed success in your colorwork. It rather provides a solid, basic set of tools with which to *intellectually* compose and manipulate color. Though a detailed discussion is beyond the scope of this book, you should be aware, however, that color composition is only *partly* intellectual. Truly beautiful colorwork is also the product of an inspired designer —one who is capable of relating a feeling through his *subjective* as well as objective use of color.

Creating a color composition can often be tedious or tricky without some organized approach. This chapter presents just such an approach in a generalized form. It is intended to be useful in a wide variety of color-design situations, and as such liberties can and should be taken in adapting it to specific circumstances. You may wish to switch certain steps or skip them altogether.

The illustrations and their captions depict an actual design/color-composition process from the initial inspiration to the final result, utilizing this general approach. By combining the general approach with a specific example you will hopefully arrive at a clearer understanding of the approach and of how it can be used.

Feeling or Mood

Once you have prepared a line drawing or other compositional format, pay attention to whatever feeling or mood it seems to suggest to you. Most probably a combination of dispositions will become obvious as you "listen" to your composition: exciting, soft, mysterious, quiet, vibrant, melancholy, cosmic, summery, cold, nervous, open, and so on (7-1).

Each mood that you feel can be characterized by a set of colors that embody it best—for *you*. Each designer has his or her own characteristic use of color, and the more that he or she works with color in a conscious way, the easier it is to create color compositions that accurately reflect his or her personal view of the world.

Begin to experiment with rough, loose color studies of your ideas. If your original composition is of a three-dimensional form or space, such as an interior, it is a good idea to reduce it to its major elements when exploring it in small, quick studies—since the overall impact rather than the detail is relevant at this stage. Use markers and colored pencils that you feel will best impart the desired mood. If deciding on a mood is inappropriate at this point, allow yourself some space to *play* with the color media until you arrive at a promising combination. Keep in mind that the *dominant* hues, values, and chromas that you choose will together carry the mood or disposition of the color composition (C7-1, C7-2, C7-3).

7-1. This initial drawing is a line study from memory of some hollygrape berries whose forms and colors intrigued me. At first the mood that the composition imparted to me was one of quiet composure, due to the soft, cool colors and rounded forms. As I experimented with the basic compositional elements, however, the mood began to change, becoming more dynamic.

C7-1. This drawing was an initial attempt at combining the colors of the berries as I remembered them. Although I liked the colors of the berries themselves, I was dissatisfied with the light-value background that I added afterwards.

C7-2

C7-3

Many general moods have commonly accepted color equivalents. When designing something functional, such as a public environment, you can begin to establish a direction for your color composition by eliminating colors that are *not* appropriate. You probably would not allow dark, weak-chroma colors to dominate a room intended to feel cheerful and airy, for example.

Contrasts in hue, value, and chroma will also help determine the mood of the composition. Strong contrast, especially in the values and chromas of the colors used, tends to be more stimulating and exciting, while subtle contrasts seem to impart a more soothing, quiet atmosphere.

Another source of inspiration for color composition is nature: you may wish to choose a ready-made color combination from the many found naturally or in conjunction with the man-made landscape. You will find such delightful combinations virtually everywhere, from the soft pastels of an evening view in New Mexico—or perhaps a warm and muted hillside patchwork of village and fields in Italy—to the rich, glistening colors of moss-covered stream cobble in Pennsylvania. These colors may be used as observed or perhaps may inspire improvisation. The latter is the case with the illustrations in this chapter.

C7-2. As I experimented, I found that a dark background (in the same yellow-red hue) worked much better, since the berries seemed to be more highly illuminated. Another idea suddenly emerged, which I quickly jotted down to the right, that uses the same triadic-hue scheme—green, yellow-red, and a purple-blue.

C7-3. In evaluating the previous study something still seemed to be missing. Upon adding the leaves, however, the composition began to come alive, and I felt ready to experiment with these colors in a more careful study.

C7-4. I narrowed my choice of color media to this palette of markers and pencils, which fall into a roughly triadic-hue scheme of green, yellow-red, and purple:

Willow Green	True Green	Dark Green	Walnut
[1]	[2]	[3]	[4]
Sand	Sienna Brown	Burnt Umber	Pink
[5]	[6]	[7]	[8]
Purple	Blue Violet		
[9]	[10]		

Marker/Colored-pencil Palette

From your experimentation you can probably determine at this stage which markers and pencils you want to use for the finished composition. You may wish to eliminate some and add others. In any case this is a good point to begin *limiting* your color media, probably to a *few* hues (C7-4).

If you want to select your color media by first arranging a hue scheme (either your own or one discussed in Chapter 6) and need to know which markers and colored pencils are available in the desired hues, consult Appendix B. Remember that almost any combination of markers and colored pencils can be made to work together by utilizing the principle of repetition through flavoring, mingling, and distribution (see Chapter 5). Many mixtures can be created with only a few markers and pencils. The neutrals (black, white, and grays) can also be included in your palette if you need them.

After you have decided which markers and pencils to use and which to eliminate, you may wish to begin the final version of your composition if your experimental studies feel right to you. If you think that further development is necessary, you can refine your idea.

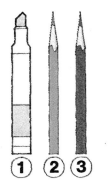

C7-4

C7-5. After selecting the palette this more refined study was made, in which I investigated the abstraction of the berry and leaf forms into more basic geometric shapes. Though I liked the colors and their relationships, the arrangement of these shapes felt uncomfortably static and tense.

7-2. I experimented further with the forms and their arrangement, striking upon the sense of movement that the elongated leaf forms convey here.

7-3. I refined the movement theme further and removed the stem. Upon rotating the page, I found that I preferred horizontal movement to vertical (7-2).

Refinement

Up to this point most of your efforts have probably been directed toward selecting a palette. With that completed, begin to apply your markers and pencils to a more refined study. This study should also be quick and loose and should refine your composition of forms at the same time if necessary. Keep in mind your selected dominant color dimensions but rely on your intuitive sense of what feels right. Leave a more intellectual evaluation, if you need it, to the next stage. As your refined studies develop, you may occasionally find it necessary to reassess your choice of markers and pencils (C7-5, 7-2, 7-3).

Evaluation

When you feel ready to begin the final version of your composition, take some time to evaluate your favorite study or studies. If you are satisfied with them as they are, all that remains is to execute the final, full-sized version of your composition. If, however, your studies still don't seem quite right, you may wish to reconsider some of the points raised in Chapter 5.

(1) Do your studies convey the desired *mood* or spirit?

(2) Are there clearly *dominant* hues, values, and chromas?

(1) Is there sufficient *contrast* to develop the intended mood or disposition? Is there too much contrast?

(4) Does the composition need to be unified through further *repetition?*

If you find that your studies need significant further development, you may wish to continue with additional studies, as they will probably look and feel quite different than your present work. On the other hand, if you need only to make minor changes, they can be noted mentally or on your best existing study and included in your final version of your composition (C7–6).

Once you have arrived at a study that feels right to you, you can begin the final, full-sized composition with confidence. (C7–7).

C7–6

C7–6. I made another quick study, this time bringing together the colors and revised shapes. I reorganized the color relationships as well: yellow-red became the dominant hue, medium-low the dominant value, and medium-weak the dominant chroma. Since the composition suggests such activity, the contrasts are strong in all three color dimensions. After evaluating this study I decided to change a few details: to make the berries more purple, to increase the size of the background somewhat, and to add more green to the contrails behind the berries. With so few changes to make, I simply noted them on the study and added them as I drew the final drawing.

C7–7. The final drawing. It will be used as a poster promoting a conference on solar energy. The original size is 15½″ × 20″.

C7-7

THREE
Architectural Color Drawing

At various points in your design career you have probably found it necessary to produce a finished or persuasive drawing—a set of drawings used for a more formal presentation, usually to a group such as a design jury, school board, governmental council, or bank. Such groups often consist of people who must make decisions about the design but are not directly involved in the design process. They must know what the design will look like when completed. An honest, well-done set of perspective drawings in color not only shows how the forms and spaces will look and feel when complete, but in itself, whether consciously or unconsciously, it will also communicate a sense of competence of the designers.

Beginning — and executing — a finished color drawing is a source of confusion for many people, since they may be unfamiliar with the use of color media or produce this kind of drawing infrequently. Others attempt color drawing but become frustrated after many hours of work to see that the drawing does not "read," the color "somehow doesn't look right," or the entire drawing seems boring, scattered, or chaotic.

In the following pages an organized approach to planning and executing finished architectural color drawings is presented, beginning with a line drawing in pencil and continuing through to the finishing touches. The intent of this approach is to show examples of how to produce a finished color drawing, to show that no mysterious talent need come into play, and to prove that eventually, after you acquire a feel for color drawing, you won't need the steps or this book to guide you. Once you have done a few finished color drawings, you will most likely find that your efficiency, speed, and accuracy have increased quite a bit, making color drawing a more comfortable medium to use during the everyday design process.

8 Exterior Color Drawing

There are two general approaches to a color drawing of a building exterior. In the first the entire drawing—the building and its surroundings—can be considered as a single composition of colors. The finished building will stand a fairly good chance of fitting into and working with the colors of its environment.

The second approach is to view the building exterior as a color composition in its own right, either without regard to its surroundings or in a conscious attempt to *contrast* with them—a contrast that may be subtle or strong. From the designer's point of view a color contrast may be more desirable for a number of reasons than fitting the building into an environment. The designer should recognize, however, that with the second approach the potential of creating color chaos or attracting *too much* attention (as in an amusement park) is greater if he or she does not handle the problem with sensitivity or if he or she is not yet comfortable with colorwork.

With either approach it is advisable to show *some* of the surroundings in color so that the viewer may acquire a broader understanding of the building's color relationship to its environment, whatever that relationship may be.

Though there is really no one best way to execute a finished color drawing, the following may serve as a guide for your own work habits.

Line Drawings and Diazo Prints

A finalized line drawing in perspective, featuring the view of the building that you think most appropriate, should be completed. Unless a particular effect is desired, the building should be dominant—take up the most area—in the drawing (8–1).

If you are drawing a perspective view of a design that is to be built, an arbitrary introduction of elements such as trees and shrubs that will not be planted when the building is constructed is unfair to the viewer—and the client. If scale-giving items cannot be realistically added as *actual* design elements, they can be introduced as clearly movable elements that are not part of the design statement. People and automobiles are often the easiest and sometimes the only way to do this, since they are understood by the viewer to be incidental to the drawing and not part of the design.

The perspective view should be drawn with a single thin (0.5mm) mechanical pencil on a drawing vellum, such as Clearprint, or on a similar high-quality translucent drawing surface, such as Mylar. The linework can be enhanced, if necessary, during the final stages of the color drawing. The use of flimsy tracing papers is discouraged, since, when run through a diazo-print machine, they are often "eaten" by the machine and never seen again.

In addition to your actual-sized line drawing make a quick, small (8½"- x -11") freehand drawing of your building, using the same 0.5mm pencil on a small piece of vellum. This will serve as your study drawing. When these two sheets are completed, have blue-, black-, or brown-line prints made of them. Make one print of the

8–1. This line drawing is the first step in making a color presentation drawing of an office building (with parking underneath) to be built in a wooded environment. The building has been drawn slightly smaller than usual in order to show a sufficient amount of its special setting and its relationship to the setting. Note how the choice of view places a large tree in the foreground to act as a frame for the picture and to promote a sense of depth. The drawing was done with a 0.5mm pencil and 2H lead, on Clearprint 1000H drawing vellum. The original size is 15" × 19".

8–2. A black-line diazo print with a darker than usual background was made from the line drawing (8–1). Its value is high—about value 7 on a Munsell value scale.

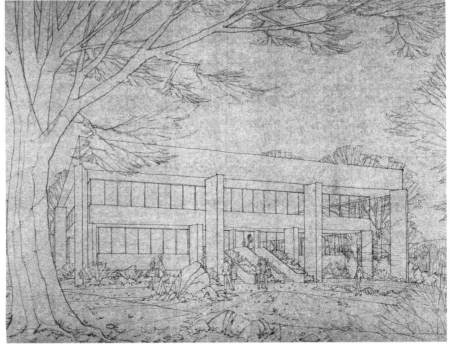

large drawing and three or four of the small drawing to use as studies (8–2, 8–3).

Diazo prints with a medium-tone background provide an excellent, inexpensive drawing surface for marker/colored-pencil techniques, because the marker colors automatically become muted—which is often necessary when using markers on white paper—while the colored pencils seem more vibrant and their deposits less grainy in appearance. The all-or-nothing risk in using conventional drawing surfaces is also removed, since, if you ruin a drawing or decide to start over, you can simply make another print without having to start the drawing over from scratch.

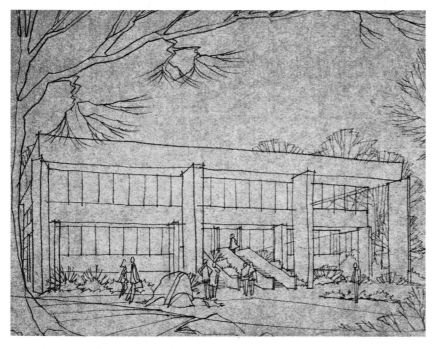

8–3. This is a small 8½"-x-11" black-line print of a quick study drawing that was also done on drawing vellum. A few of these were made at the same time and run at the same machine speed as the print to be used for the final drawing (8–2). They will be used for color studies.

Marker/Colored-pencil Palette

At this point I find it valuable to experiment on a small (8½"-x-11") study print with various markers and colored pencils—some of which I usually have in the back of my mind from the early stages of the design process. Many color possibilities may emerge, and you will probably find that simply by playing with the markers and colored pencils on a study print you can select a palette rather quickly (C8–1). It is helpful to make notes directly on the study print as an aid in remembering the colors you have tried.

When choosing your palette, remember to limit the hues in most cases to only a few, since the uncontrolled use of many hues can lead to color chaos. Though I usually note on the study print which neutral (grays, black, and white) markers and pencils I try, I don't include them in my palette when I am organizing a hue scheme. Appendix B can help you select markers and pencils in your chosen hues.

In a color drawing of an exterior, especially one depicting buildings made of natural, unpainted materials, bear in mind that many of the hues will be given—such as lawn grass, unfinished woods, and skies. Since they can be varied only within certain limits and still remain believable, these given hues will hopefully have an effect on your choice of additional hues. If a designer finds that he is creating an unreal color composition, though maybe a beautiful one, when working with these given hues in order to make the design more appealing, he might want to take a second look *at the design itself* rather than attempting to remedy a lack of appeal through a misleading drawing.

C8–1. I used the small study print at top to arrive at a palette of markers and pencils. I made notes directly on the study in order to keep track of my color selections and other ideas. The hue scheme that evolved from this study is split-complementary—purple-blue, green-yellow, and yellow-red, with purple-blue dominant. The palette of markers and pencils resulting from the study above is shown at bottom. The green-yellows are on the far left: [1] Dark Olive [2] Olive [3] Apple Green. The yellow-reds are in the middle: [4] Sand [5] Sand [6] Flesh [7]Sienna Brown. (The sands are actually yellow reddish yellows but will be used with other markers and pencils to produce the hues of the split-complement scheme.) The purple-blues are on the right: [8] Light Blue [9]Copenhagen Blue.

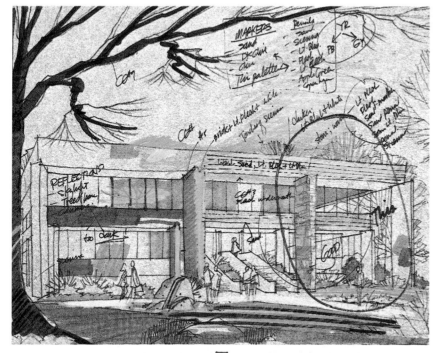

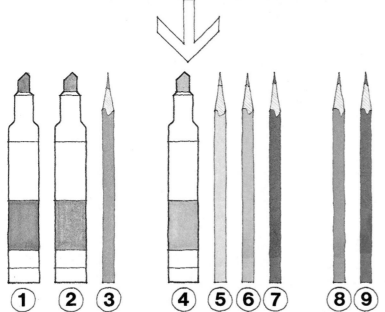

C8-1

On another small study print make a quick, loose study with your chosen palette of markers and colored pencils (C8–2). This study will give you a preview of your drawing with this palette and avoid the risk of working directly on the finished product.

Some considerations to keep in mind when executing this study are the following.

(1) Which hue scheme should I use; is an organized scheme possible or even desirable with the given hues (see Chapter 4)?

(2) How shall I manipulate the three dimensions of color reasonably to arrive at a well-arranged color composition (see Chapter 5)?

(3) Where shall I repeat and distribute colors to tie the composition together (see Chapter 5)?

Evaluation

Step back and evaluate your study. If, upon appraisal, you feel good about your study, go on to consider shadow and reflection location (discussed later in this chapter). If you feel uncomfortable with the study or find certain aspects disturbing, you may want to ask yourself some or all of the following questions.

(1) Does one particular hue stand out as dominant—take up noticeably more area than the other hues in the composition?

(2) Are there major value areas that emphasize or feature the building by means of value contrast?

Most drawings of buildings usually have three spatial components: *foreground*—the space in front of the building; *middleground*—the building itself and the area immediately surrounding it; and *background*—the sky, landforms, buildings, trees, and other features behind the building.

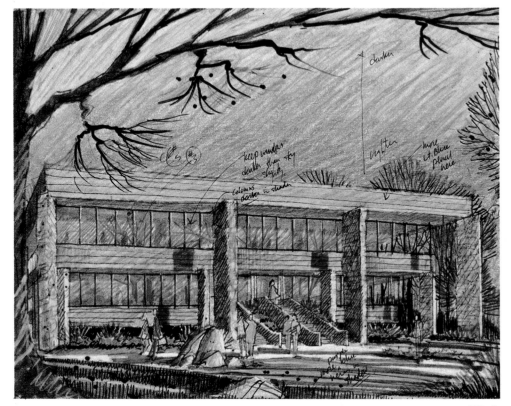

C8–2

C8–2. Using the palette selected, a quick, loose study was made on one of the small study prints. While the purple-blue is dominant in this split-complement-hue scheme, note that the yellow-red is secondary, while the green-yellow is tapered to an even lesser role. A major value arrangement of dark foreground, light middleground (the building), and medium background was experimented with here as an initial consideration. Note the superimposition of pencil colors over other colors, as well as the distribution of colors throughout the study. Upon evaluating the study, I made the following conclusions:

(1) I liked the hue arrangement and decided to keep it as is.

(2) I decided to change the major value arrangement to dark foreground, medium middleground, and light background to make the drawing seem less top-heavy. I also decided to grade the value of the sky—making it light next to the top of the building and gradually darkening it toward the top of the drawing—to make the building stand out and to lessen the somewhat distracting contrast between the dark foreground tree branches and the light sky behind. This contrast seemed to unnecessarily draw attention away from the building.

(3) The shaded sides of the columns should be darkened to appear more three-dimensional.

(4) The chromas of the colors are good and tie the drawing together well. Some *Light Blue* pencil should be added to the wood to reduce its chroma further, making it seem more weathered.

(5) I decided to distribute the purple-blue more widely in the drawing and, in order to further assure its dominance in the composition, to add *Copenhagen Blue* pencil to the dark foreground tree and shadow area. Notes to this effect were made directly on the study, with the changes to be included in the final drawing.

By limiting yourself to a choice of light, medium, or dark as the dominant value of each of these spatial components you can arrive at a major value arrangement that will help feature the building rather than losing it in a sea of similar values. The foreground colors might be dark, the middleground colors medium, and the background colors light in value, for example. There should be smaller areas of value contrast within each of these three spatial components, most notably in the building, but the values of the colors within the spatial components should remain sufficiently limited to generally conform to the major values. Several major value arrangements are possible for a given drawing (C8–3).

C8–3. These four abstract drawings show a few of the major value arrangements possible for the drawing of the building (C8–2). The inevitable smaller areas of value contrast have been downplayed to emphasize major values. The study above, left shows a dark foreground, medium middleground, and light background. This arrangement of major values is widely used and gives a good impression of depth to a drawing of this type. The drawing above, right exhibits a medium foreground, dark middleground, and light background. The study below, left shows a dark foreground, light middleground, and medium background. Note, however, that the windows were kept at a more believable medium value. The drawing below, right exhibits a light foreground, medium middleground, and dark background.

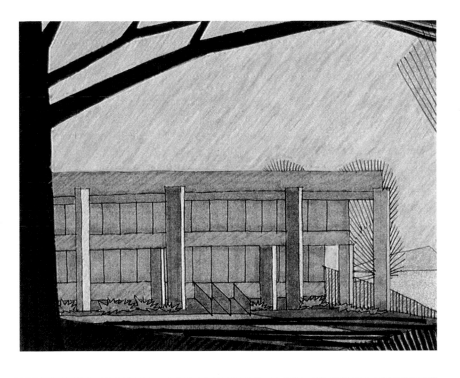

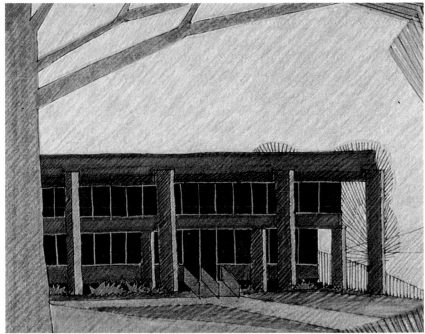

C8–3

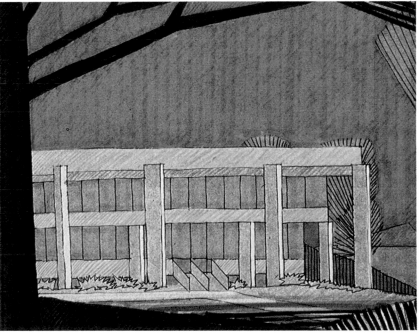

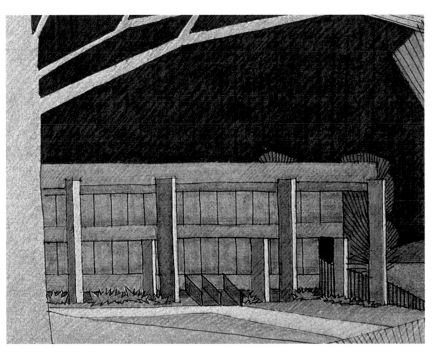

(3) Is there sufficient value contrast within the building?

By giving the values of the colors within the building and its immediate surroundings a *stronger* contrast than occurs in the foreground and background further assurance is provided that the building will not become lost but instead remain the obvious focal point of the drawing. This contrast will also heighten the sense of the building's three-dimensionality.

(4) Do the colors used in the drawing have a dominant chroma (or closely related group of chromas)?

If the building is made of natural materials and drawn in a natural or man-made environment, chroma dominance is usually not a problem, since (if properly drawn) both materials and environment are predominantly medium-weak to very weak in chroma.

If the building is done in other than natural colors—painted, for example—you might consider limiting the amount of foreground and background to be shown in the drawing. In this way the dominant chroma can be assumed by the building's color composition.

(5) Can the drawing be further unified through repetition?

When evaluating your study, consider whether areas of color used in one part can in fact also be used in other parts of the composition. Note whether colored pencils used in certain places in the drawing can be added lightly over colors in other areas.

In the palette study (C8–2) note that the green-yellow used for the grass (*Apple Green* pencil) was also used in the sky; the purple-blue of the sky (*Copenhagen Blue* pencil) in the shade and shadow of the building, lawn, and sidewalk; and the yellow-red of the wood (*Sienna Brown* pencil) distributed into the trees and shrubs throughout the drawing.

Note any changes that you wish to make in the drawing directly on the study to serve as a reminder when you begin the final. These changes can be implemented as you draw the final, though, if many significant changes are to be made, the character of the drawing may be altered considerably. In that case you may wish to do another quick study, including the changes, and then to reevaluate.

Shadows and Reflections

Before beginning to apply color, indicate lightly on the larger, final print where the shadows will fall and where reflections will occur (8–4). Choose a logical sun angle and azimuth that will also make the building look its most interesting. This generally occurs when the majority of the building's surfaces are in sunlight, while fewer parts are in shade and shadow.

Making these shadow and reflection indications before applying the color will save trouble and prevent confusion as the drawing progresses. By lightly toning the shadow areas with pencil they become more noticeable and less easily overlooked. If you have difficulty seeing your pencil lines on your print, either indicate the shadows and reflections with *White* pencil or draw them on the vellum original,

8–4. This closeup of the final print shows how the shadows and reflections are indicated lightly in pencil before the application of color. These pencil lines and tones will not show after the color is applied.

then trace them onto the final print using a light table. Since the areas in shade simply face away from the light source, marking them is usually unnecessary.

Apply the color to the larger, final print (C8-4, C8-5, C8-6, C8-7, C8-8). Use the techniques explained in Chapters 2 and 3 as necessary.

C8-4. The beginning stage of color application on the final print is shown here. The study (C8-2) is kept in view for constant reference. The building is drawn first so that the values of the foreground (dark) and background (light) can be added in relation to the overall medium value of the building. The shaded sides of the columns were done with a *Cool Gray #7* marker base. The *Copenhagen Blue* pencil was also added to the shaded surfaces to make them seem cooler and shadier and to distribute the purple-blue hue in the drawing. Note that the roof was graded darker toward the top with *Sienna Brown* and *Copenhagen Blue* pencils. This subtle technique makes it contrast more emphatically with the light sky.

C8-5. Shown here is the addition of window reflections. After the initial application of a *Cool Gray #7* marker over the entire window surface *Light Blue* and *White* pencils were added to indicate sky reflection. *Flesh, Sienna Brown,* and *Copenhagen Blue* pencils were used to create the column reflections. *Warm Grey Medium* pencil was used to draw the reflected trees. After the reflections were drawn in, fountain pen was used to indicate window frames. *White* pencil was used on the frames for highlights—and to make the frames stand out from the dark reflections. For more information on window reflections see Chapter 3 (C3-119, C3-120, C3-121, C3-122).

C8-6. The addition of the background is shown here. The sky was drawn with *Light Blue, Copenhagen Blue,* and *White* pencils. Note that it is lightest next to the top of the building and gradually darkens toward the top of the drawing. This technique creates more interest than a flat sky and at the same time enhances the contrast between building and sky. The smallest tree branches were covered to save time and in order to draw a more evenly graded sky. They will be added later by simply drawing over the sky with a fountain pen. The background trees and hill were added and intentionally blurred by washing them lightly with a *Warm Grey Very Light* pencil.

C8-7. This drawing shows how to begin the foreground. The shrubs were added with *Olive Green* marker, Pilot Razor Point, and *Sienna Brown* and *Copenhagen Blue* pencils. The people were drawn only with the colored pencils from the palette. Their sunlit sides were illuminated with *White* pencil, while *Copenhagen Blue* and *Black* pencils were added to their shaded sides to give them a more three-dimensional appearance. Tree shadows were streaked across the lawn with *Cool Gray #7* marker. The lawn was drawn in with *Olive Green* marker and *Apple Green, Sand, White,* and *Copenhagen Blue* pencils. *Sienna Brown* was used to draw in the leaves (on the ground) and a small fountain-pen shadow was added under each. The sidewalk was drawn with a *White* pencil; *Flesh* pencil was used to flavor the sunlit portion, and *Copenhagen Blue* pencil to flavor the shadows.

C8-8. The completed drawing. The immediate foreground was drawn by first applying *Cool Gray #7* and *Cool Gray #9* markers to the tree and its immediate area. *Dark Olive* marker was added over the foreground grass, followed by *Apple Green* and *Copenhagen Blue* pencils. *Sand* and *White* pencils were applied to intensify the streaks of sunlight on the ground. Fountain pen and Pilot Razor Point were added to the grass to both darken and texture it. *Copenhagen Blue* pencil was applied to the shaded side of the tree and a light application of *Flesh* and *White* pencils on its sunlit side. The parts of the tree in shade were textured with Pilot Razor Point. *Apple Green* pencil was applied lightly to the sky and in spots to the stone and wood on the building to balance and distribute the color.

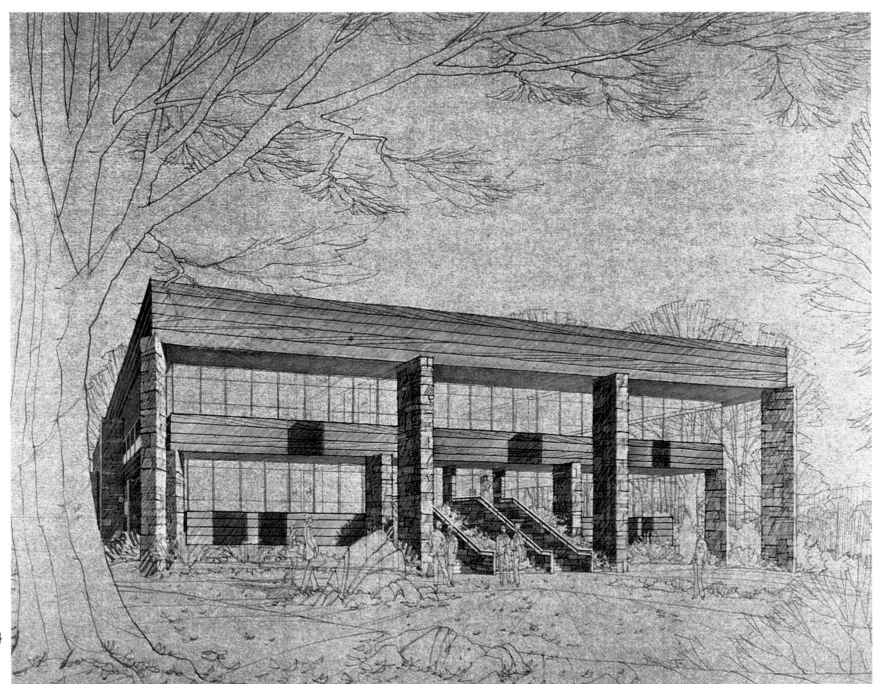

C8–4

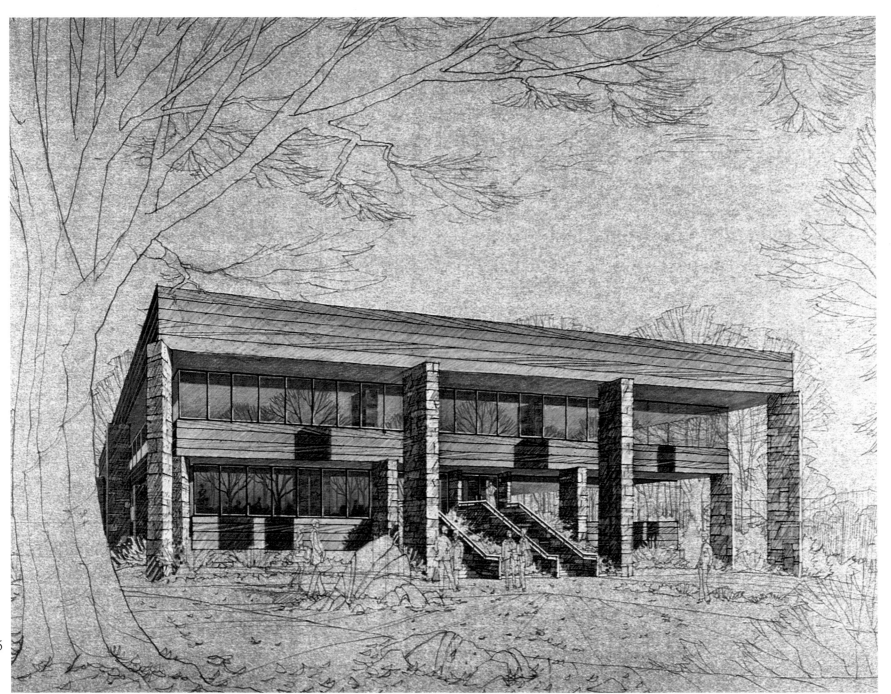

C8–5

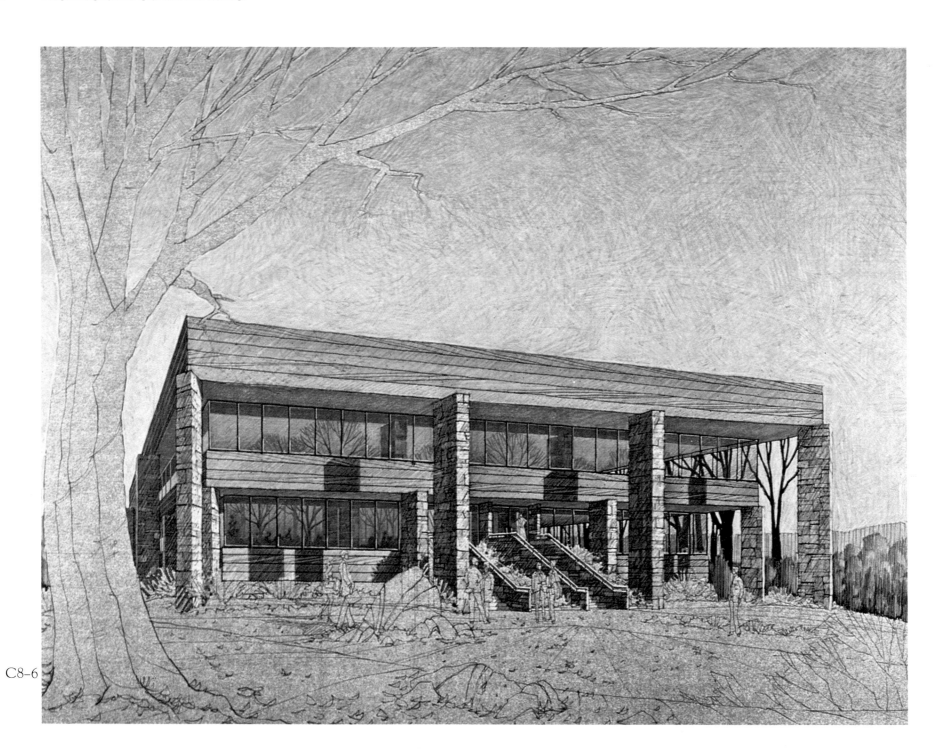

C8–6

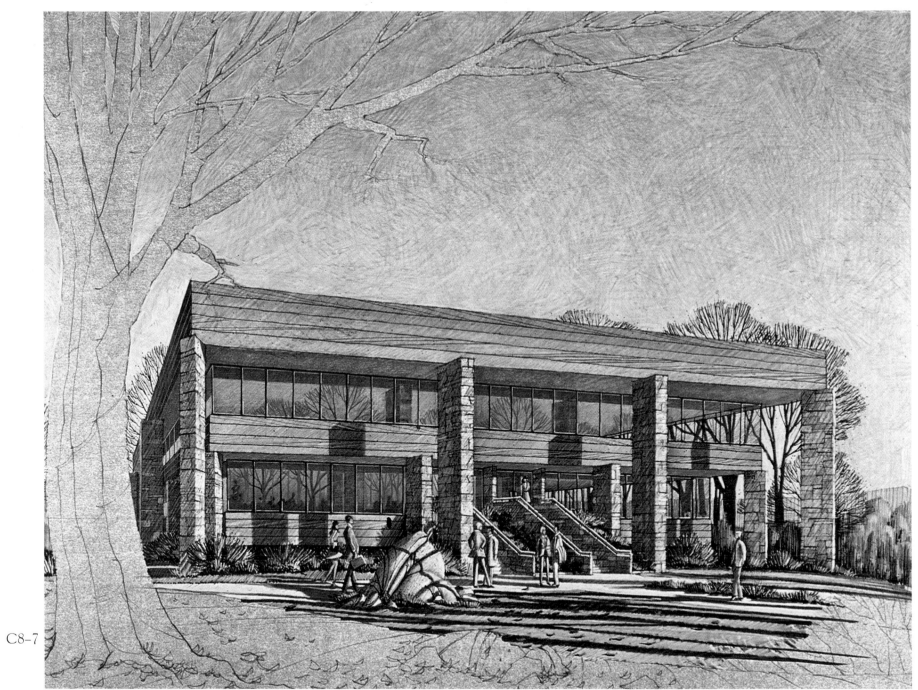

C8-7

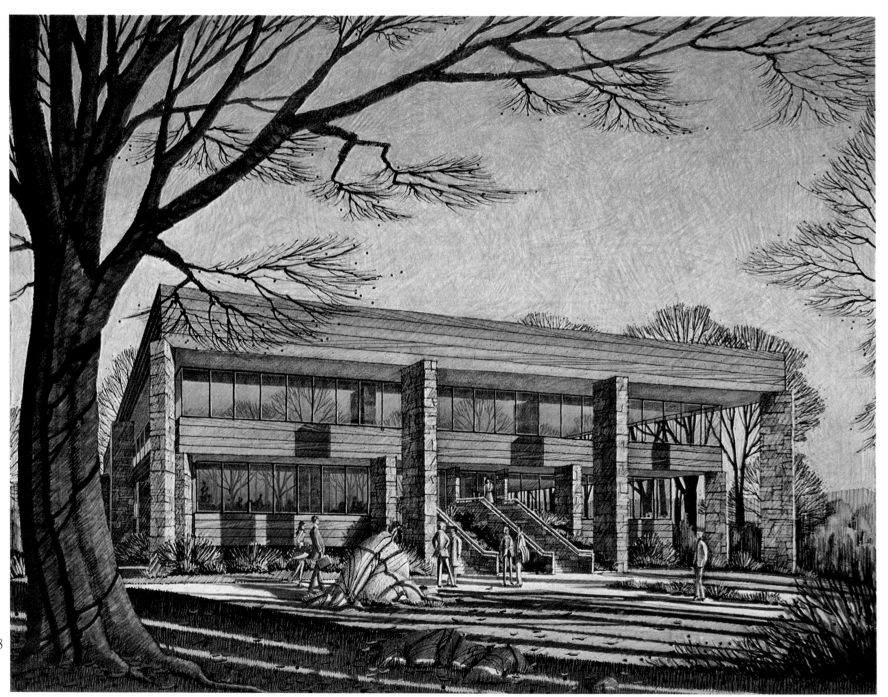

C8–8

Interior Color Drawing 9

A drawing of a building's interior spaces, like any other composition, should follow the principles of color composition. Along with these principles, however, there are other factors that should also be taken into account in deciding on the colors to be used in an interior. Color can affect our judgment of the proportions of a space, influence our perception of size and distance, and focus our attention. Rooms can be made to seem larger or smaller, ceilings higher or lower, and furnishings closer or further than they actually are—by manipulating the three dimensions of color. Our feelings and emotional responses can be subtly triggered by color. A room's color can subconsciously help influence us to be more gregarious or introverted—or perhaps more cheerful or melancholy.

Not everyone can be expected to react, perceptually or emotionally, in the same way to the same arrangements of color, since a person's preference for or rejection of certain colors may be based upon his or her general emotional makeup or his familiarity with the colors used. People who are more emotionally responsive may generally be expected to like more active combinations of color, while those who are more emotionally reserved will probably prefer more subdued rangements of the hues, values, and chromas of the colors in an interior. These conclusions, discussed in the following pages, can be helpful when making decisions concerning interior color composition.

Accompanying the perceptual and emotional aspects of color is a discussion of the relationship of *pattern* to color. It should be kept in mind, however, that, although color and pattern are major aspects of interior design, other considerations must be taken into account but are beyond the scope of this book. Forms, modulation of space, cir-

culation, furnishings, equipment, materials, textures, and lighting also contribute to the perceptual and emotional impressions that we receive from an interior.

In addition to the influence of color on our emotions and perception of space studies done by the National Aeronautics and Space Administration of outer-space environments (Porter and Mikellides, *Color for Architecture*, page 102) have shown that certain colors will conjure pleasant associations with odors and taste: "Pink, lavender, pale yellow, and green hold pleasant associations with odors," while "tints of coral, peach, soft yellow, light green, vermilion, flamingo, pumpkin, and turquoise have pleasant associations with taste." Combinations of these colors might be considered for kitchens and dining areas in homes, schools, and restaurants.

The purpose of providing such a range of information in this chapter rather than only the "how-to" steps for a seductive drawing is to give the serious designer a solid foundation upon which to base his or her color decisions and to reach beyond the constraints of trend and fashion. The evidence of this foundation will first appear in the color drawings that precede the reality of the finished product.

Hue

Just as warm and cool hues contrast on the color wheel, so they contrast in perceptual and emotional content when used in an interior.

Warm Hues

Warm hues tend to subtly influence a person to direct his or her attention outward in a more extroverted fashion than do cool hues and can, among other uses, be utilized in areas intended for social interaction. This effect is especially evident when higher lighting levels and selective use of stronger chromas accompany the use of warm hues. (Note, however, that *all* strong-chroma colors are more stimulating and that warm hues are less stimulating when they possess weak chromas and either high or low values.) Warm hues can be effective when:

(1) you are designing the environment of a room that is to appear smaller, since warm hues seem to advance toward the occupant
(2) you want to focus attention on an object or area within a room—this is most effective when the area surrounding the focal point is cool in hue
(3) you want to raise the apparent temperature, such as in a room on the north side of a building or one that does not receive direct sunlight
(4) you want certain objects in a room, such as furniture, to seem closer or more prominent
(5) little noise is expected, since the hues themselves are more active and noisy than are cool hues
(6) only mild physical exercise is expected, such as in an office, living room, or dining area of a restaurant, since warm hues are generally perceived as stimulating
(7) cool fluorescent lighting is used, as warm hues can help to balance the cool effect of the light.

Cool Hues

Cool hues generally suggest quiet and serenity, directing our impulses away from activity and toward a more restful state. The effect of cool hues can be optimized by using low chromas and providing low illumination within the space. They work well with other cold, reflective surfaces, such as chrome, vinyl, and mirrors. Cool hues can be influential when:

(1) you want to make a room seem larger—cool hues seem to recede and are associated with distance in the landscape
(2) a more introverted, contemplative atmosphere is desired in a space
(3) the room temperature is consistently too warm—the use of cool hues will help make it seem less so
(4) a fair amount of noise is expected, since cool hues have a more quieting influence than do warm hues
(5) substantial physical exercise is anticipated, as in a gymnasium or exercise room

Value

The arrangement of values in a space, along with the dimension of hue, will help determine the character of the space. The conventional value scheme for an interior uses darker ranges of color on the floor to provide a sense of a base or of stability, medium- to high-value colors on the walls, and a very high-value color or white on the ceiling to help reflect light and provide a feeling of spaciousness. These relationships, however, can certainly be altered to create certain perceptual and psychological responses.

High Values

High-value colors are the most cheering and atmospheric and can be effective when used:

(1) on the walls and ceiling to make a room seem more open and spacious
(2) to reduce glare from a window—since glare is caused by excessive contrast, painting a window wall in a light-value color will help reduce glare by reducing the contrast between the window and the wall
(3) to make objects appear larger by making them higher in value than their background
(4) to help lighten a room: a space with high-value walls and ceiling will reflect more light, making the room brighter, which is an especially good treatment for rooms with small windows; if some walls are to remain lower in value for other design reasons, the wall opposite the most windows might be high in value to most effectively brighten the room

Low Values

The emotional effect of low-value colors in interiors can range from quieting to depressing and can be used:

(1) to make a space seem smaller, since dark-value colors on walls usually tend to make them advance—rooms can be made to feel more snug and intimate when walls are treated in this fashion

(2) to make a space feel more expensive or potent (see Porter and Mikellides, *Color For Architecture*)
(3) to make a ceiling appear lower, though this treatment should usually be reserved for ceilings 9′ or higher (an exception might be made for spaces that use downlighting at low illumination levels: for example, a basement pub might employ a dark-value color on a low ceiling quite successfully, provided that the lighting points downward and is at such an intensity that the space appears rather dimly lit so that the ceiling seems to disappear out of sight, like the night sky)

Remember that the decision to use low-value colors on the walls and ceiling of a room should be made only after determining whether enough illumination will be available for comfortable use of the space.

Value Contrast

Value contrasts can do much to alter the apparent proportions of a space. Strong contrasts generally make a room seem smaller and more active, while a room with little value contrast, especially in the higher value ranges, gives a quiet, spacious effect. Consider value contrasts in these ways:

(1) to change the apparent proportions of a room by using both light- and dark-value walls, making the latter seem closer, the former further away
(2) to create an effect of horizontal extension by using light-colored walls with a dark floor and ceiling
(3) to shift emphasis: a room done primarily in dark-value colors will shift the occupant's attention to an adjoining room that employs a lighter range of values (an entranceway or foyer might be dark in value, while neighboring rooms are lighter in value, pulling the visitor into them; a dark color might be used on a window wall to shift emphasis to the lighter outdoor space — possibly a courtyard or entryway)
(4) to emphasize furniture pieces or other objects in a space—strong value contrasts between objects and their background will make the object seem closer and larger and emphasize its outline

(5) as room trim—high-value baseboards, door and window frames, and molding used with low-value walls or vice versa can create interesting effects that will make the room seem smaller and more lively

The way in which a space is illuminated will also affect its apparent size. Low levels of illumination will generally make a room seem larger, while high illumination will reduce its apparent size.

Chroma

Since the stronger-chroma colors are generally felt to be exciting or stimulating, they should be used with restraint in an interior and are customarily reserved for accents. Medium- to weak-chroma colors ordinarily predominate in the color composition of a space, since they are used on the large floor, wall, and ceiling surfaces that serve as background.

Medium to Weak Chromas

Medium to weak chromas are considered restful and calming and seem to retreat in space. They are usually used:

(1) with appropriate hues and values to create an impression of spaciousness in a room—this impression is probably due to unconscious lessons derived from nature, where distant objects such as mountains are weaker in chroma than are closer objects

(2) on all major planes—floor, walls, ceilings, and large pieces of furniture—to create a background for the focal points within a room

Strong Chromas

Strong-chroma colors are more stimulating and attract attention. They seem to advance toward the beholder and are used:

(1) on smaller pieces of furniture and accessories to provide accents within a room

(2) in many smaller areas within a room when white is dominant

(3) to increase the apparent size of a piece of furniture or other object

(4) on walls to decrease the apparent size of a room, since the occupant becomes more aware of the wall surfaces (this effect must be handled carefully, perhaps by including weak-chroma walls and floor in the same room, since the effect can be overpowering)

Chroma Contrasts

The contrast of weak- and strong-chroma colors can be consciously arranged:

(1) to focus attention on a particular area within a room, such as a seating area—an arrangement of stronger-chroma accents makes a room seem less chaotic than a scattered distribution

(2) to make a space appear more active and lively—slight chroma contrast will impart a feeling of calm and stillness, especially if the colors are cool with little contrast in value

(3) to emphasize the shape of an object

Pattern and Color

Those markings, usually repetitive, that are visible by virtue of their contrast with their background are known collectively as pattern. In interior-design work pattern can occur just about anywhere and is usually seen in rugs, floor and wall tiles, furniture and drapery fabrics, weavings, and wallcoverings such as wallpaper. Pattern is also evident in architectural features such as exposed masonry and knotty wood and may as such be taken into account when developing a pattern scheme for an interior space.

The kinds of pattern are infinite. Some of the more usual kinds include checks, stripes, plaids, polkadots, floral designs, hexagons, and repeating designs of all types.

Patterned materials and coverings may be viewed as smaller color compositions within the larger composition of the interior space. Patterned surfaces may contain a variety of hues, values, and chromas; and *one part of each* of these color dimensions will usually dominate the pattern, either by occupying more area than its subordinates or by a visual mixing or averaging process on the part of the observer. Yellow-red, for example, may be the dominant hue that results from a red-and-yellow stripe pattern, since from a distance the eye visually mixes the red and yellow hues to form yellow-red (C9–1). Weak- and strong-chroma colors may be used in a pattern that is visually mixed to produce a dominant average chroma that is medium in strength. The dominant color dimensions—hue, value, and chroma, as perceived by the designer—for each pattern should figure into the overall color composition of the interior.

The number of patterns should be limited in an interior, depending on the amount of variety provided by contrasts in the three dimensions of color. It may be generally assumed that *the less the variation in hue, the more the potential variety in pattern.* A monochromatic color scheme for an interior, for example, might utilize from two to five different patterns in the same room! Conversely, an active color composition employing wide contrasts in hue, value, and chroma may not need much pattern to provide the visual interest.

C9–1. At top an alternating red and yellow stripe pattern is visually mixed by the beholder to form an average impression of yellow-red (called a medial mixture). The high value of the yellow and the medium value of the red also average to a medium-high value. At bottom weak- and strong-chroma blue stripes of the same value are visually mixed by the beholder to form a blue with an average chroma of medium strength.

The Summary Chart

This chart is a summary of the material discussed so far in this chapter. It is provided as an aid in making design decisions and should be used in conjunction with the color principles discussed in Part Two.

The chart presents some of the conditions for creating certain perceptual and emotional impressions within a space. Utilizing the suggestions from all the categories on the chart (hue, value, chroma, and pattern) in trying to create a certain effect may not be possible or even desirable, depending on the designer's intentions.

design intent	to make room temperature seem cooler:	to make room temperature seem warmer:	to make a ceiling seem higher:	to make a ceiling seem lower:	to focus attention on a feature or object:	to hide a feature or object:*	to lighten a dark room:
hues:	cool	warm	cool	warm	warm, contrasting with a cool background, if possible*	same as background	preferably warm
values:	medium range	medium range	high	low	contrasting with its background*	same as background	very high
chromas:	medium to weak range	medium to high range	weak	medium to strong if desirable	strong, if desirable*	same as background	weak
pattern:	limited	variety	none	yes, if desirable*	yes, if desirable*	same as background or surrounding area	limited
notes:				*this will help draw more attention to the ceiling, making it seem lower	*this will help make the object seem closer and larger than it actually is	*or work it in as part of a larger design or graphic	

design intent	to make a room seem more spacious:	to make a room seem smaller, more intimate:	to focus attention on an area within a room:	to make a space seem more peaceful and calm:	to make a space more lively and promote social contact:	to make a room seem larger, use outwardly extended walls:	to make a room seem shorter, use on narrow walls:
hues:	cool	warm	warm in area, cool in background	cool	warm	cool	warm
values:	high	medium to low range	area should contrast with background	any range, little contrast	contrasting	high	lower range
chromas:	weak	medium to strong range	stronger than background	weak, little contrast	strong where desirable, contrasting	weak	stronger range
pattern:	limited	variety	within the area	little, if any	variety	none, if possible	yes, if desirable*
notes:							*or use a large hanging or weaving

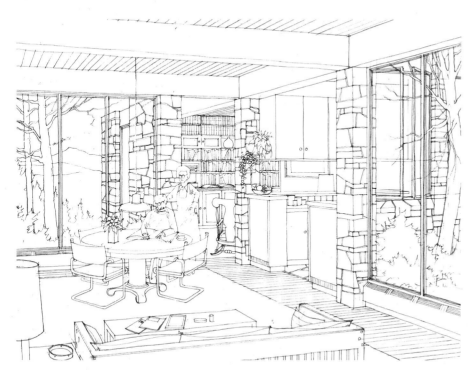

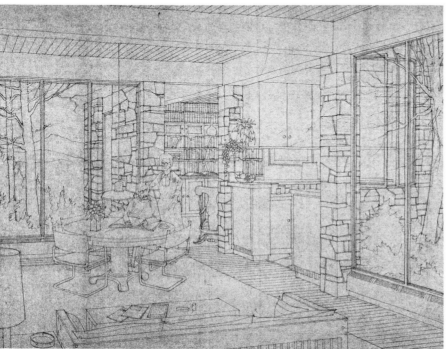

Making the Drawing

The Drawing and the Reality

One problem facing the designer in making a drawing of an interior is that he or she has to consider how a color composition works in the *entire* space, while his drawing may show only a portion of that space. Using the perspective drawing and an accompanying floor plan, he or she should make color decisions relative to the whole space and not just in relation to the drawing at hand. *The color composition of the entire space may or may not yield a drawing that observes the principles of color composition in all ways.* For example, though a particular value may be chosen to dominate in a space, that dominance might not be evident in the view chosen for the color drawing. It is therefore advisable to draw a view of the space that is as representative as possible of the color composition to be used.

There are many ways to design the color composition of an interior. The steps that follow illustrate one method, though they are arranged in an order that at the same time facilitates the *drawing* of an interior view.

Line Drawing

A perspective line drawing should be made of the space that you are designing. Unless you are making a study of a particular area, in choosing a view to draw consider whether it is representative of the entire space. The drawing should ideally present the dominant and subordinate color areas of a room in a view that states fairly accurately the impact of the space when actually completed.

C9–2. Line drawing of the interior done on Clearprint 1000H drawing vellum with a 0.5mm mechanical pencil and a 2H lead. The original size is 15″ × 19″. Note the faint, purplish lines: they are layout lines drawn with a Staedtler Mars Non-Print pencil and, when used lightly, will not reproduce on the diazo print. Nonprint pencils are quite convenient for making notes, guidelines, and layout lines on a vellum or Mylar original to be printed, as the need to erase such markings is eliminated.

9–1. The black-line diazo print made from the interior drawing (C9–2). It is darker than usual and has a high overall value, about value 7 on a Munsell value scale. Note that the nonprint-pencil layout lines did not reproduce.

Using a thin-line pencil (such as a 0.5mm mechanical pencil), draw the interior view, including all planned furniture and accessories, on a good-quality drawing vellum—such as Clearprint 1000H or Mylar—from which a diazo print can be made (C9-2). It is a good idea to include such features as lamps, magazines, ashtrays, plants, and flowers, which will give the space a desirable feeling of detail and sense of scale.

Copy your actual-size drawing in a small (8½" x 11"), quick study drawing on vellum, using the same 0.5mm pencil. When both line drawings are complete, make blue-, black-, or brown-line diazo prints, of the large drawing, to be used for the final (9–1), and three or four copies of the small drawing, to be used as studies (9–2).

9–2. One of the small 8½"-×-11" diazo prints of a quick study drawing of the interior. The drawing, done on a small sheet of Clearprint 1000H drawing vellum, was printed at the same time and at the same print-machine speed as the large print (9–1). Three or four small prints should be made for use as color studies.

If your interior colors are mostly high (light) in value, higher-value prints should be made (by *decreasing* the speed of the print machine). By using a light table, you may alternatively trace your drawing onto a high-quality white drawing paper with a medium finish and a two-ply thickness. Strathmore Bristol is an excellent white paper for marker/colored-pencil techniques. The small studies mentioned above could either be photocopied onto white paper or separately drawn on small pieces of the bristol paper.

Color Studies

Using the small 8½"-x-11" prints created for this purpose, make quick, loose color studies of your ideas, exploring possibilities that you perhaps considered as you designed the space. As you explore various ideas and make these studies, you may wish to keep the following in the back of your mind:

(1) the discussion of some of the uses of color in interiors located in the first part of this chapter and summarized in the chart in the preceding section

(2) the various hue schemes presented in Chapter 6

(3) the explanation of color relationships in Chapter 5

In addition to these considerations there are other ways of arranging colors for an interior space. An existing color composition such as a large painting or multicolored rug is often centrally located in an interior. The colors (or variations) to be used in the remainder of the interior space are then derived from it.

A variation of this idea can be used when redesigning the color arrangement of a space in which certain significant areas of color must remain. If walls, floor, and furniture, for example, contain certain colors, they can be brought together in fabrics, hangings, weavings, rugs, and other accessories added to the space by the designer, unifying it through repetition. If a café has yellow-red walls, green-yellow carpet, and blue chairs, for example, a tablecloth fabric with a pattern that combines these hues might be used to bring the disparate hues together.

(4) The floor, walls, and ceiling typically form the background against which everything else in the space is perceived

These planes, unless they are white, often carry the dominant hue in the space and, to maintain their status as background, are usually weak in chroma. Occasionally, however, a designer may give one of these planes a strong-chroma color for sheer delight, though this use of strong chroma should be attempted with care.

Select the study that you feel is most successful, making notes as needed right on the study to help you remember marker and pencil colors, necessary minor changes, and so forth (C9–3). From this study you can derive your palette of markers and colored pencils, though remember to limit the number of *hues* to a few (C9–4).

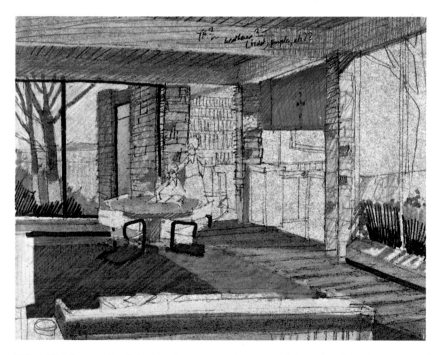

C9–3. The first study of the interior, illustrating some of the color ideas that occurred in designing the space. As it progressed, I became convinced that the cool-hue scheme was inappropriate for the mountainous climate in which the house was located and abandoned the study to begin another in a warmer hue scheme.

After selecting a palette, if you feel that your studies are still in need of refinement or that your palette must be changed significantly, it's a good idea to make yet another study so that the result can be evaluated before beginning the large drawing.

Evaluation

Whether you've made a new study after selecting your palette or decided to use the same one, time should be taken to evaluate your study. If you feel good about it and conclude that it works well, go on to the next section. If, however, you are troubled by the drawing as a whole or perhaps by parts of it, consider the following.

(1) Of the hues used, does one dominate? Are the rest used in tapering amounts?

(2) Does your arrangement of values in the space seem satisfying? Do you have enough value contrast *in the drawing* to illuminate the surfaces sufficiently?

(3) Are the chromas used in the interior weak enough? Are there adequate strong-chroma accents in the room? Are there perhaps *too many* strong-chroma accents?

(4) Can the drawing (and the space as well) be further unified through repetition—can colors that occur in one area be repeated in other areas, helping to balance the composition? Check further to see whether colored pencils used in one area of the drawing might be used over colors in other areas, thus mingling several different colors, distributing them, and unifying the composition.

Make any notes of ideas or minor changes directly on the study to help you remember them. If you decide to make major changes in either your study or your palette, consider doing another study and evaluating it before beginning the large final drawing.

Light, Shadows, and Reflections

A drawing of an interior space is much more interesting—and convincing—if the effects of light are indicated. They should first be explored in your small studies to give yourself a preview that you can evaluate before beginning the larger final drawing.

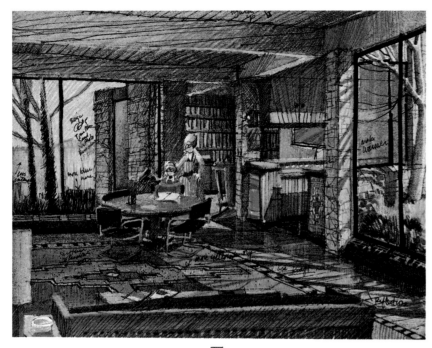

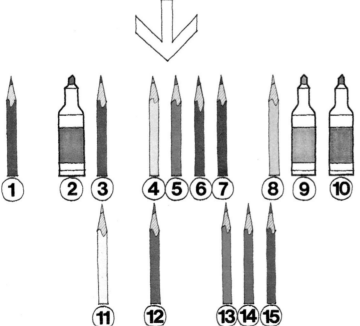

Two kinds of light can often be seen in interiors. Direct light, usually sunlight, will add much to the space's sense of vitality and will create shadows with distinct edges. Diffuse light will create shadows with diffuse edges. Its sources are interior artificial lighting, nonsunlit windows, such as those facing north, and light reflecting from sunlit areas within a room.

C9–4. At top a more satisfactory color arrangement. The hue scheme is warm and not only more fitting to the often cool mountain environment but more intimate in effect—especially necessary with the large windows. The hue scheme is analogous—red, yellow-red, yellow, and green-yellow—with blue as a complementary accent. The yellow-red-to-yellow hue range is dominant, with the red range used to a lesser degree. Blue accents occupy much less space in the composition, while touches of green-yellow occur here and there. The values of the colors were kept in the medium range, while their chromas were limited to the weak range, except for the few strong-chroma accents distributed throughout the space. Note how the rug is used to repeat both the color and the pattern themes of the interior. Not only can all the hues of the scheme be seen in the rug, but it also repeats a rectilinear pattern similar to that of the stone walls and columns. The sunlit effect arouses more interest in the space and conveys a sense of life. At bottom the analogous-with-complementary-accent palette resulting from the study above: the reds are [1] Scarlet Lake [2] Brick Red [3] Terra Cotta (though [2] and [3] are more accurately red-yellow-reds); the yellow-reds are [4] Light Flesh [5] Orange [6] Burnt Ochre [7] Burnt Umber [8] Sand [9] Sand [10] Kraft Brown ([8], [9], and [10] are more accurately yellow-red-yellows that lie between yellow-red and yellow on the color wheel); [11] Cream is a yellow; [12] Olive is a green-yellow; the blues are [13] Non-Photo Blue [14] True Blue [15] Slate Gray. Though a variety of neutrals (black, gray, and white pencils and markers) were used in the study, they are not included in the palette. On evaluating the palette I decided to make a few changes.

(1) I decided that the warm hues should be obviously dominant, with the shaded stone less bluish and more yellow-red.
(2) The ceiling should be lightened and the floor darkened somewhat, making the ceiling seem less heavy and implementing a more traditional room value arrangement. The light appears to work well in the study drawing, though the sunlit areas should be brighter. This can be implemented (on the large final drawing) by lightening the value of the colors in the sunlit areas and darkening the areas just outside these patches of sunlight.
(3) I decided to retain the chroma scheme and the color distribution.
(4) Other small changes noted on the study, to be included in the final drawings, were to make the reflections on the floor more obvious; to make the chromas seen through the left window less strong; to make the rug slightly more yellow-red; to emphasize diffuse light and diffuse shadows resulting from the left window.

Indicate lightly in pencil on your larger final print (or drawing) where the patches of sunlight and shadow will fall (9–3). If you have difficulty indicating the angles and shapes of the patches, you may wish to construct their outlines according to methods presented in various books on architectural graphics (see the Annotated Bibliography).

Since areas of diffuse light and shadow are not easily marked, it is better to simply draw them as accurately as you can on the small study and then to improve and refine them as you do your larger final drawing.

As with diffuse lighting, indicate reflections first on your small study, then improve and refine them in the larger final drawing. (For additional information on reflections see Chapter 3.)

Application of Color

Once you have settled on your palette and have completed a small study that approximates your desired final result, begin applying the color to the final print (C9–5, C9–6, C9–7, C9–8, C9–9). Use the techniques described in Chapters 2 and 3 as you find necessary.

9–3. A detail of the sunlight and shadow patterns drawn lightly in pencil on the final print. The major shade and shadow areas were partially toned with pencil to lessen the confusion as to which side of the lines is in shadow and which is sunlit.

C9-5. The beginning of the color application. The upper part of the drawing was started first so that the drawing hand would not rest on finished portions and possibly smear or stain them during work. The view through the window was drawn first, keeping the foreground dark and progressively lightening it toward the distant mountains. Mixtures of *Olive Green*, *True Blue*, *Non-Photo Blue*, and *Slate Gray* pencils over *Cool Gray #7*, *Cool Gray #5*, and *Cool Gray #3* markers were used to draw the trees and mountains, while *Non-Photo Blue* and *White* pencils were blended in the sky. *Cool Gray #5* and *Cool Gray #7* markers were first applied to the shaded stone wall, followed by light applications of *Sand*, *Burnt Ochre*, *Terra Cotta*, and *Warm Grey Light* pencils. Mortar joints were accented with *Black* and *Warm Grey Light* pencils. The ceiling was drawn in next, using *Kraft Brown* and *Sand* markers, with *Cream*, *Burnt Ochre*, *Burnt Umber*, *Sand*, and touches of *Orange* pencils added. The complementary *Non-Photo Blue* and *True Blue* pencils were applied sporadically to weaken the chroma somewhat and to age the wood. The ceiling was left unfinished so that it can be compared with more of the finished room in case further changes become necessary.

C9-6. The library and kitchen areas were drawn at the same time so that the sunlight in the kitchen and the reflected light in the library window could be drawn in proper relation to each other. These two spaces were also drawn at the same time so that sufficient value contrast could be established between the objects in the kitchen and those behind them in the library. The books on the library bookshelves were colored only with markers and pencils from the palette (including neutrals). The rug, cabinets, and books were treated to a graded wash of *White* pencil to indicate the sunlit effect before any detail (black areas, stripes, small shadows) was added. White highlights (cabinet handles, reflections on the rocking chair) in both the library and the kitchen were added with touches of white opaque ink. The shadows on the kitchen cabinets were made transparent by adding the same wood-grain indications (done with a Pilot Razor Point) to the shadowed parts that appear in the sunlit parts. Other details include the use of a graded wash of *Black* pencil on the stone and wood behind the plants (above the fruit bowl). This not only makes them stand out more but increases their light-blocking effect. A 0.5mm mechanical pencil was used in a cross-hatch pattern over the two weavings after the color was applied to give them an appropriate texture.

C9-7. The view through the righthand window was finished next. The kitchen window was darkened in value not only to make the sunlit wall surrounding it seem brighter by contrast but also to allow the reflections to show in the glass. *Cool Gray #3* marker was applied to the left half of the kitchen window, *Cool Gray #7* marker in the opening, and *Cool Gray #3* marker to the right half. The kitchen cabinets seen through the window were colored with *Sand* marker, the kitchen wall with *Slate Gray* pencil. The reflections on the kitchen windows themselves were also done with colored pencils. With the kitchen windows complete, the tree branches were drawn in front of them with a *Warm Grey Very Light* pencil. The window mullions were then drawn with a black Markette marker and accented with *White*-pencil highlights. The dining table was drawn with the same markers and pencils used to draw the ceiling and cabinet woods. After the colors, including sunlight and shadow, were established, the reflections were added with colored pencil, stroking vertically. As a final touch the wood grain was added with a Pilot Razor Point. The light over the table has an *Olive Green*-pencil base, *Black*-pencil lowlights, and sparing *White*-pencil and white opaque-ink highlights. The chair seats and backs were begun with *Black* marker, but the chrome arms and legs were left until after the rug is completed to determine the appropriate amount of reflection.

C9-8. The completed wood floor and rug. After the marker and pencil were applied to the sunlit and shaded parts of the wood floor, the reflections were drawn in the same manner as those in the dining table. The horizontal board lines were added with a Pilot Razor Point. The design in the rug was drawn first in pencil. *Brick Red* marker was added to the reddish parts, and *Slate Gray*, *Olive Green*, and *Sand* pencils to the rest of the design. *Burnt Umber*, *Terra Cotta*, and *Black* pencils were used to create the graded values of the rug in shade, while *Light Flesh* and *White* pencils were used to highlight the sunlit parts. *White* pencil was added to the rug and floor near the left window to create the effect of reflected, diffuse light. All colored pencils used on the rug were applied with a short up-and-down stroke to create an appropriate texture. The entire rug was finally stippled with a Pilot Razor Point for additional texture. The chrome chair arms and legs were drawn in the techniques described in Chapter 3 (C3-46, C3-47, C3-48, C3-49).

C9-9. The completed drawing. The colors of the foreground sofa, side table, and coffee table were kept dark in value in order to focus attention toward the middle of the drawing. Before completing the ceiling the beam above the left window was darkened with *Burnt Umber* and *Black* pencils to make the sky behind seem brighter by contrast. The wood grain and lines between the ceiling boards were added last.

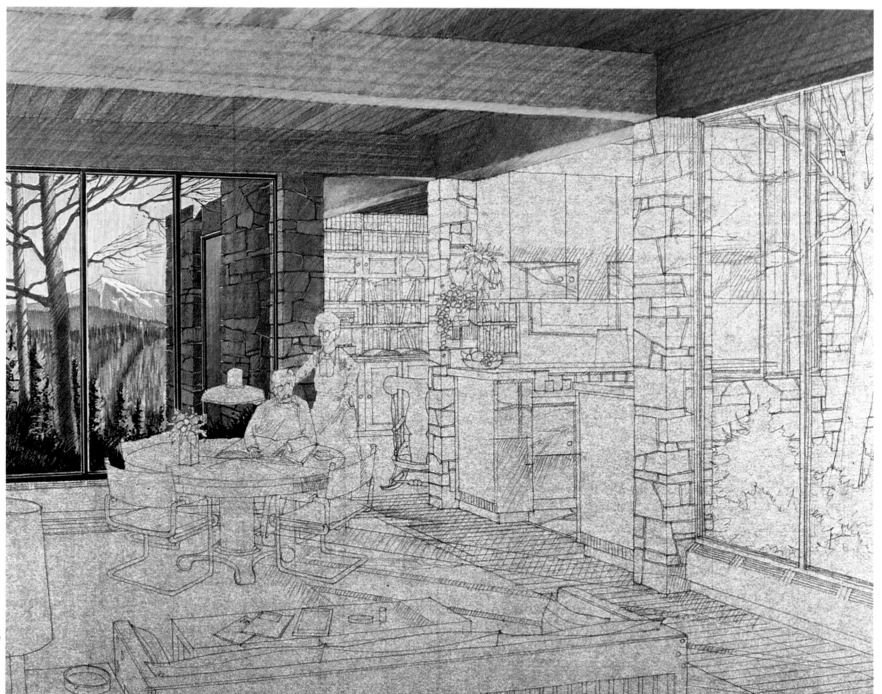

C9-5

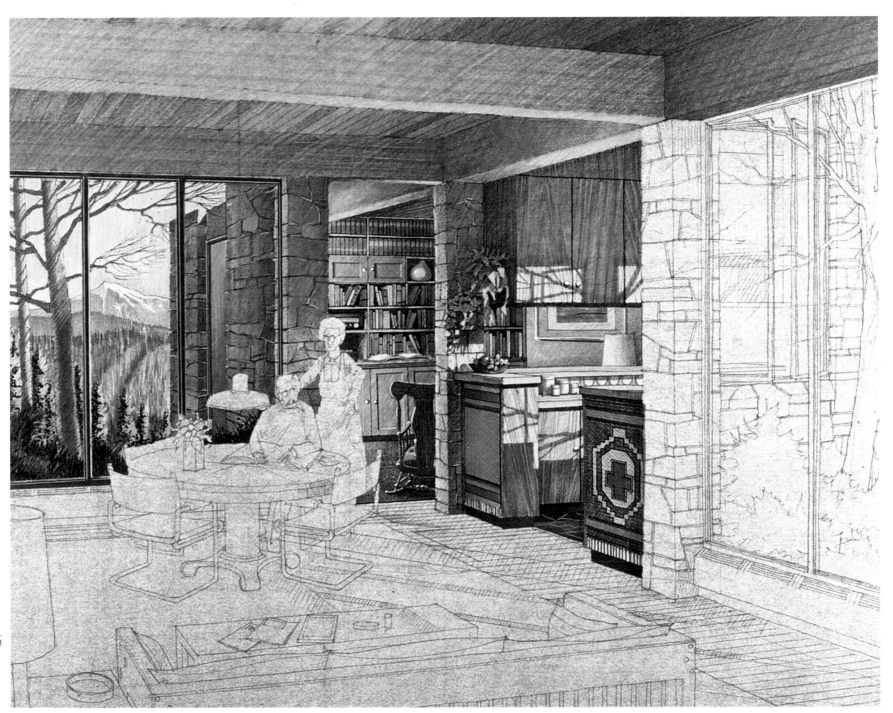

C9-6

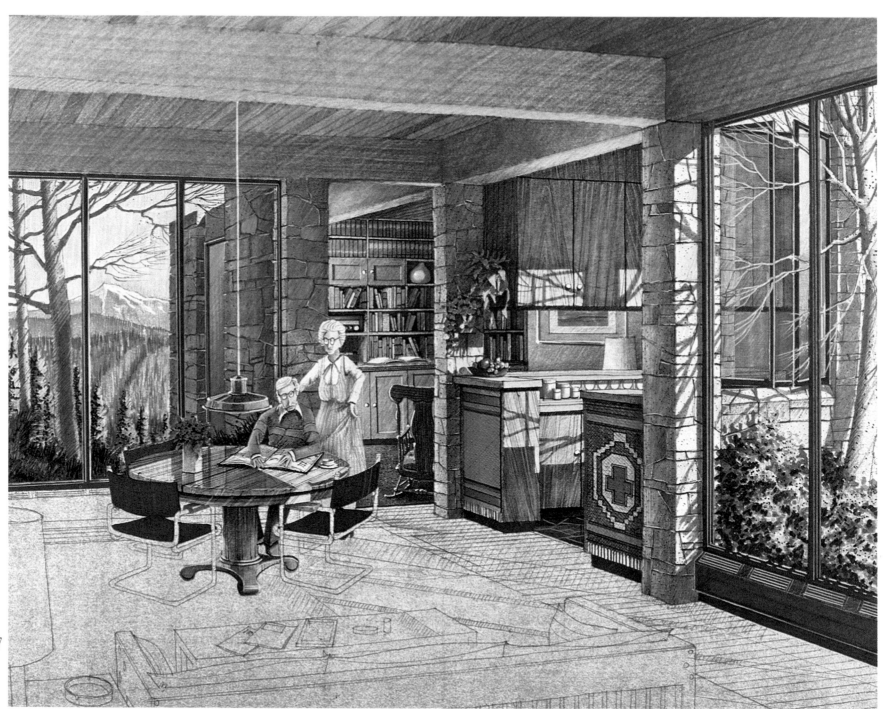

C9-7

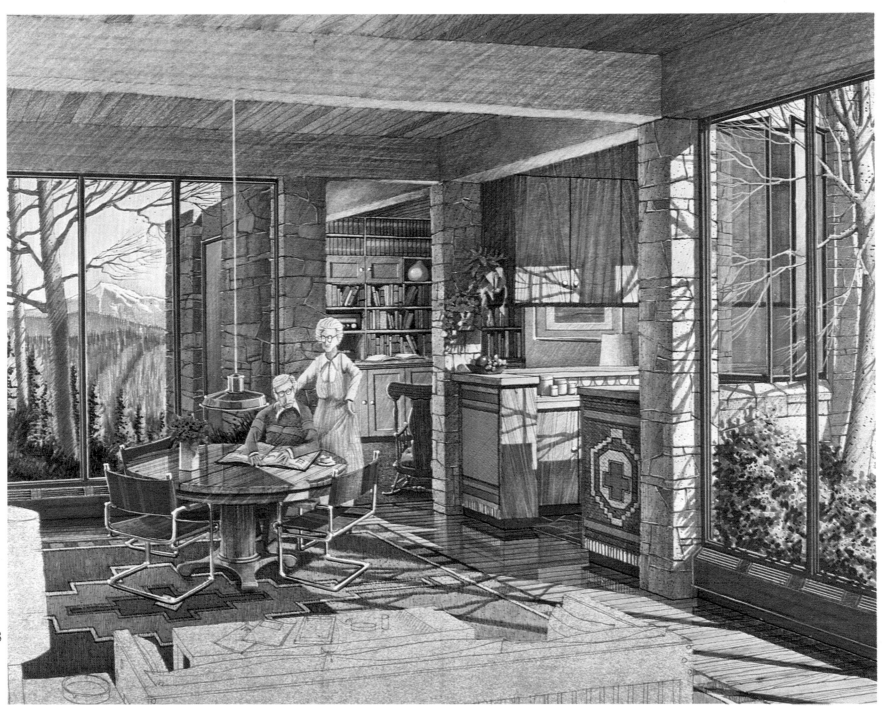

C9–8

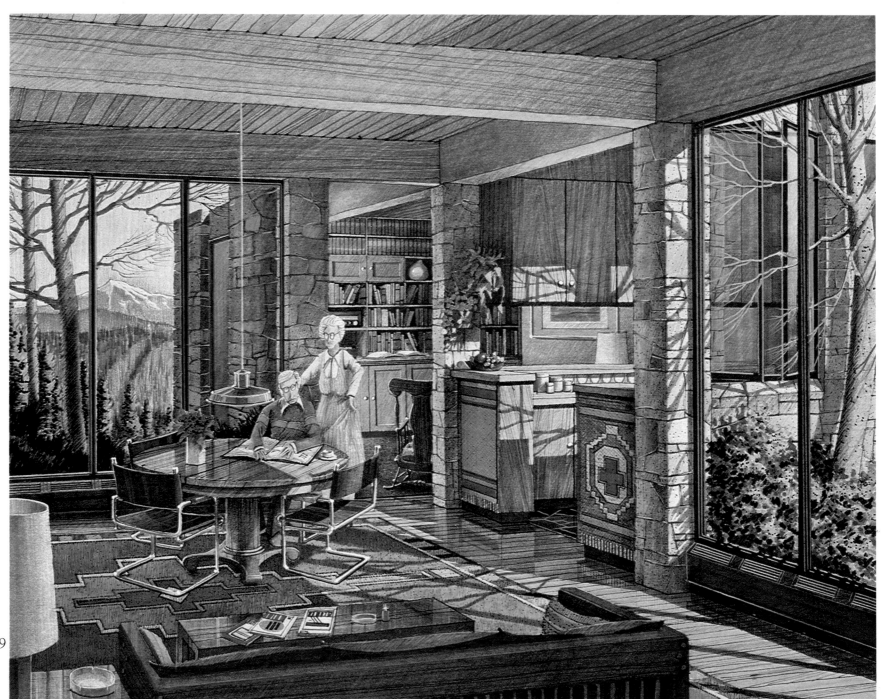

C9–9

A Portfolio of Marker/ Colored-pencil Drawings 10

The drawings in this chapter are done by students and professionals in the environmental-design fields—architecture, landscape architecture, urban design, and interior design. Many of the drawings were spontaneously produced at the initial stages of the design process, while others were drawn at the end after the decision making was finished. Still others were drawn either from life or from fantasy.

In no case was a slide or photograph traced and the drawing simply colored. The drawings were either drawn directly from life or initially set up by "eyeballing" or by using standard perspective-drawing techniques.

C10–1.
Artist: John Copley
Type of drawing: design concept study
Original size: 17″ × 20″
Paper: yellow tracing paper

C10–2.
Artist: John Copley
Type of drawing: design concept study
Original size: 19″ × 21″
Paper: yellow tracing paper

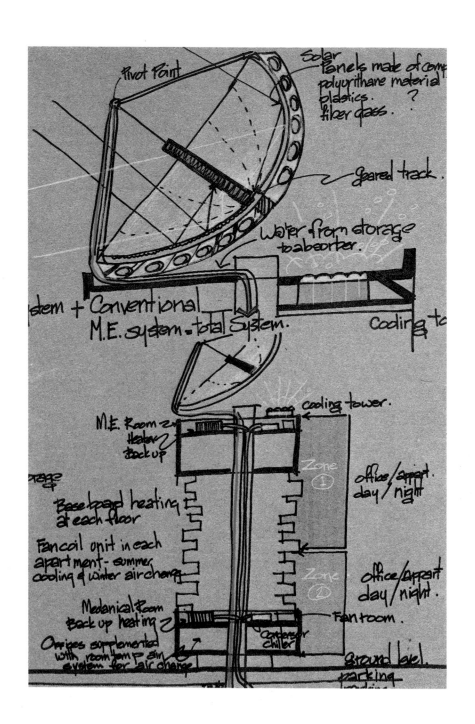

C10–3, C10–4.
Artist: Christopher Belknap
Type of drawing: illustration of a design concept
using a SRTA solar-collection system
Original size: 7″ × 11″, 10″ × 17″, respectively
Paper: black-line diazo-print paper

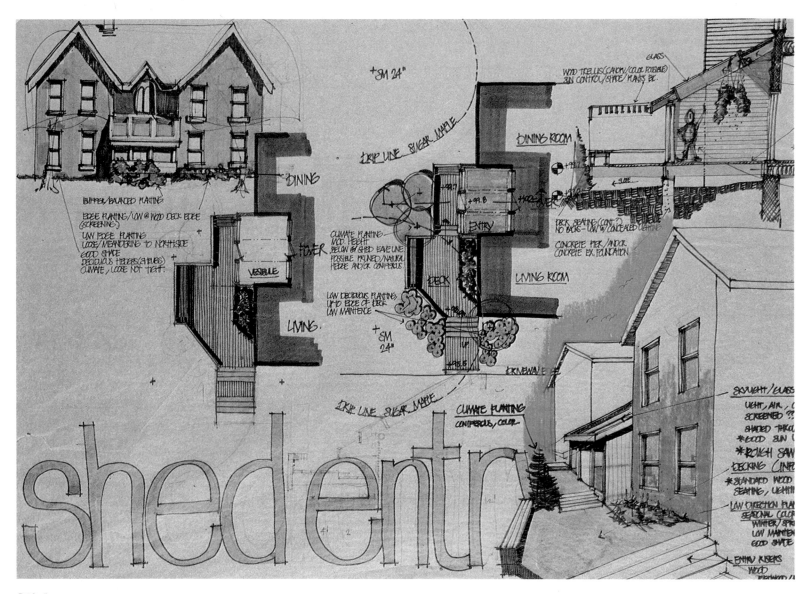

C10–5.
Artist: John Copley
Type of drawing: design study
Original size: 16″ × 23″
Paper: yellow tracing paper

C10–6.
Artists: Mike Doyle (linework), Tom Lyon (color)
Type of drawing: life drawing
Original size: 8″ × 9″
Paper: copy-machine paper

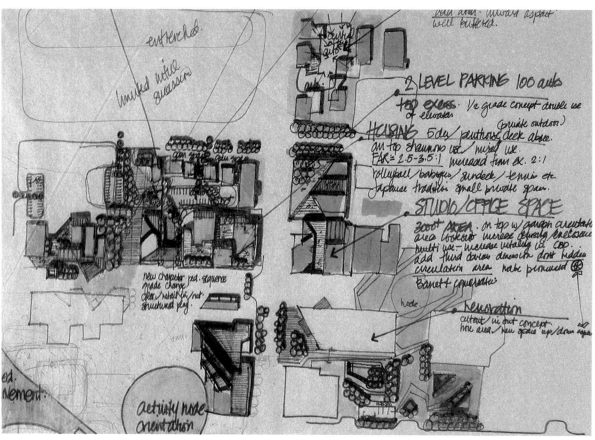

C10–7.
Artist: John Copley
Type of drawing: design concept study
Original size: 11″ × 15″
Paper: yellow tracing paper

C10–8.
Artist: Edward B. Samuel
Type of drawing: life drawing
Original size: 13″ × 17″
Paper: kraft paper

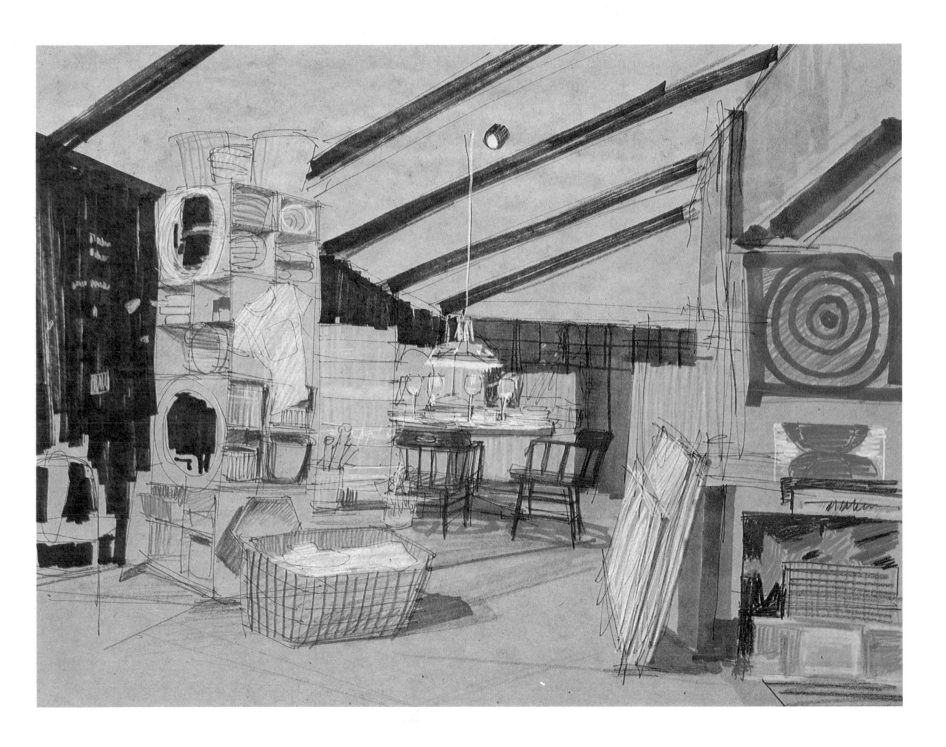

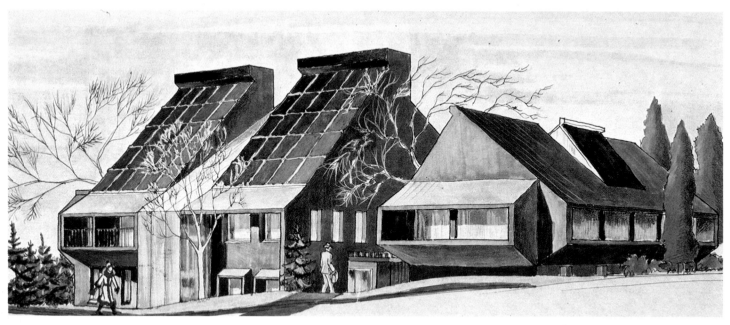

C10–10.
Artist: Margaret Alice Smith
Type of drawing: illustration of a finished design
Original size: 7" × 17"
Paper: blue-line diazo-print paper

C10–9.
Artist: John Copley
Type of drawing: design study
Original size: 15" × 14"
Paper: yellow tracing paper

C10–11.
Artist: Regina M. Grady
Type of drawing: life drawing
Original size: 8" × 8"
Paper: brown-line diazo-print paper

C10-12.
Artist: Edward B. Samuel
Type of drawing: life drawing
Original size: 8″ × 11″
Paper: heavyweight textured illustration paper

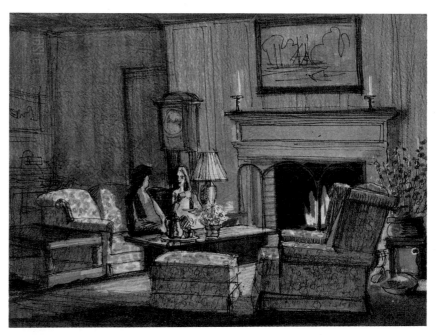

C10-13.
Artist: Lynne Brooks
Type of drawing: life drawing
Original size: 11″ × 12″
Paper: kraft paper

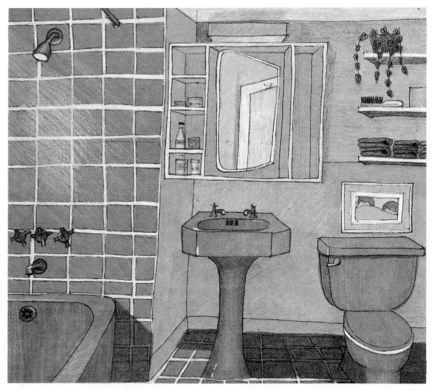

C10–14, C10–15.
Artist: Margaret Alice Smith
Type of drawing: design study for a meditation pavilion
Original size: 8″ × 13″ (each)
Paper: yellow tracing paper

C10–17, C10–18, C10–19.
Artist: Arthur C. Sturz
Type of drawing: illustration of a finished design
Original size: 11″ × 16″, 11″ × 13″, 13″ × 17″, respectively
Paper: black-line diazo-print paper

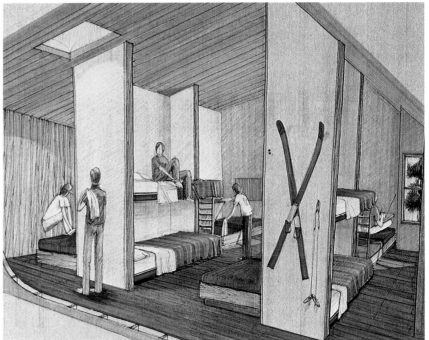

C10–16.
Artist: Ellen C. Burgess
Type of drawing: life drawing
Original size: 9″ × 13″
Paper: Sketchbook paper (Strathmore 400)

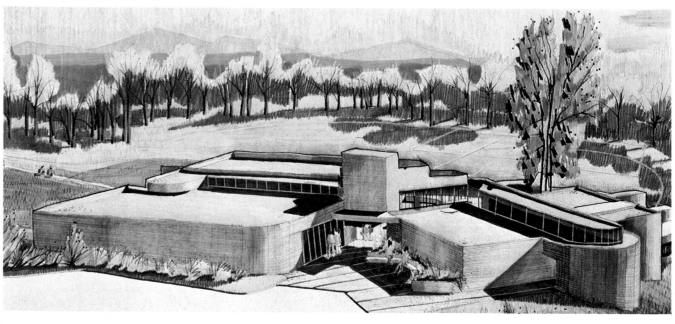

C10–21.
Artist: James Gilbert Johnson
Type of drawing: illustration of a finished design
Original size: 9″ × 21″
Paper: brown-line diazo-print paper

C10–20.
Artist: Cynthia A. Hoover
Type of drawing: life drawing
Original size: 9″ × 10″
Paper: yellow tracing paper

C10–22, C10–23, C10–24.
Artist: Tom Harry
Type of drawing: fantasy design
Original size: 11″ × 29″, 11″ × 21″, 8″ × 9″, respectively
Paper: black-line diazo-print paper

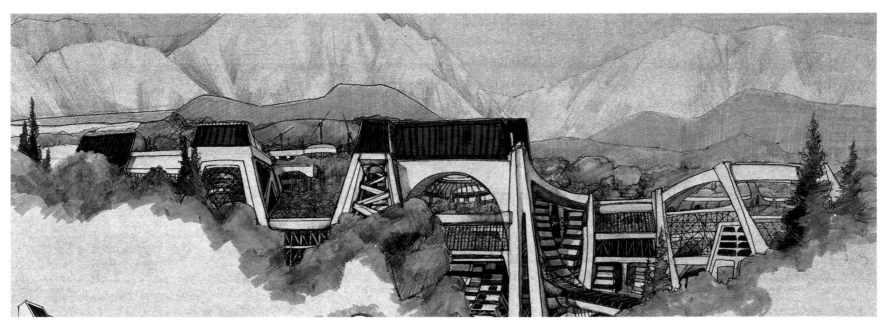

C10–25.
Artist: Tom Lyon
Type of drawing: fantasy design
Original size: 23″ × 33″
Paper: black-line diazo-print paper

C10–26.
Artist: Robert Murphy
Type of drawing: life drawing
Original size: 10″ × 13″
Paper: Crescent textured illustration paper

C10–27.
Artist: David S. Hammel
Type of drawing: life drawing
Original size: 7″ × 12″
Paper: Crescent textured illustration paper

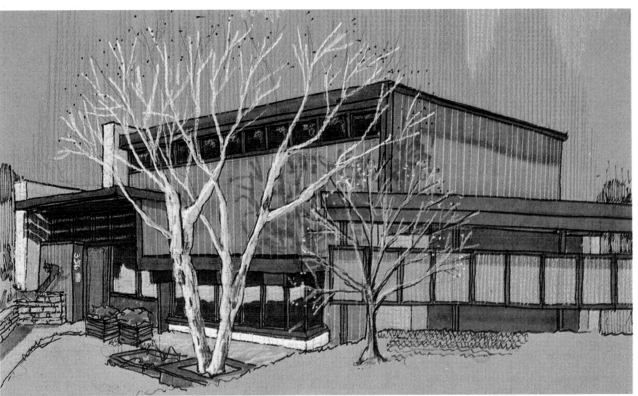

C10–28.
Artist: Brett Richards
Type of drawing: life drawing
Original size: 6″ × 11″
Paper: sketchbook paper (Strathmore 400)

C10–29.
Artist: Margaret Alice Smith
Type of drawing: life drawing
Original size: 8″ × 11″
Paper: sketchbook paper (Strathmore 400)

C10–30.
Artist: Brett Richards
Type of drawing: life drawing
Original size: 9″ × 10″
Paper: sketchbook paper (Strathmore 400)

C10–31.
Artist: Margaret Alice Smith
Type of drawing: life drawing
Original size: 10″ × 11″
Paper: sketchbook paper (Strathmore 400)

C10 32.
Artist: Regina M. Grady
Type of drawing: abstract color composition
Original size: 7″ × 10″
Paper: sketchbook paper (Strathmore 400)

C10–34.
Artist: Bartlett J. Baker, Jr.
Type of drawing: life drawing
Original size: 9″ × 11″
Paper: Strathmore Bristol, medium finish

C10–35.
Artist: Rick Cranmer
Type of drawing: illustration of a finished design
Original size: 18″ × 26″
Paper: brown-line diazo-print paper

C10–33.
Artist: Margaret Alice Smith
Type of drawing: life drawing
Original size: 5″ × 12″
Paper: sketchbook paper (Strathmore 400)

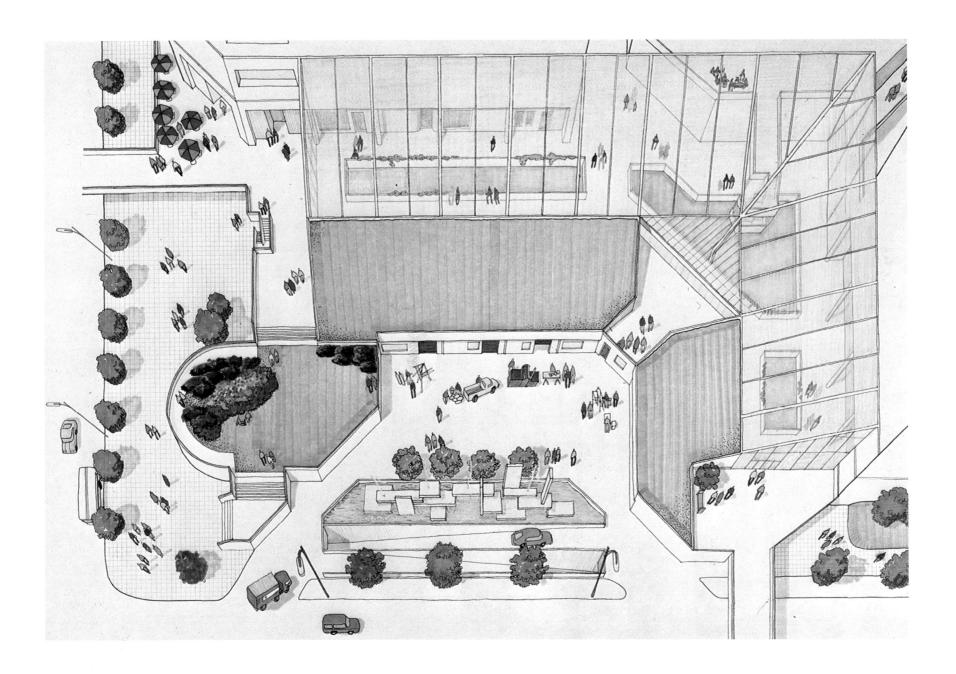

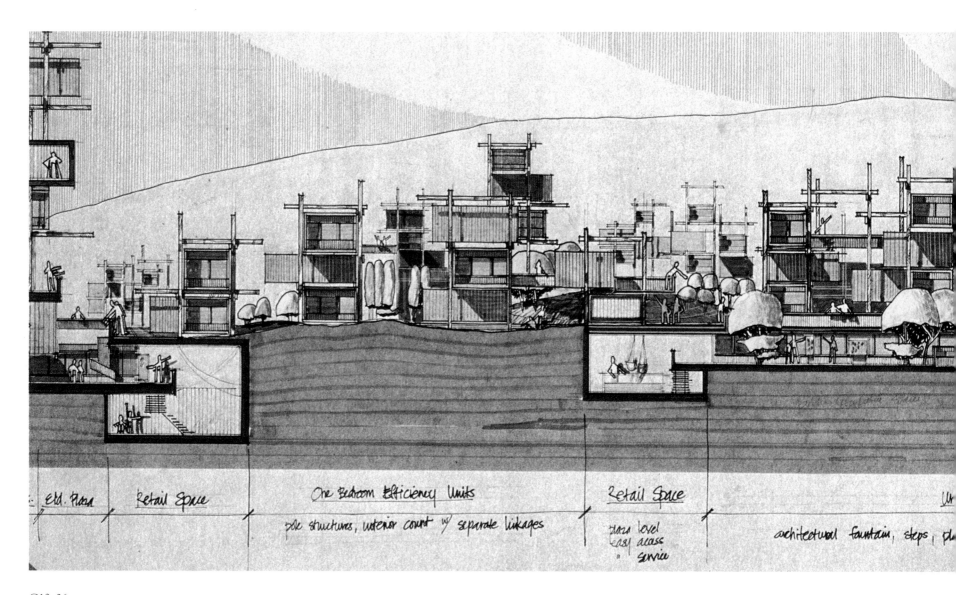

The handwritten labels within the drawing read:

Std. Plaza | Retail Space | One Bedroom Efficiency Units | Retail Space | Un

pole structures, interior court w/ separate linkages

plaza level easy access service

architectural fountain, steps, pl

C10–36.
Artist: John Copley
Type of drawing: illustration of a finished design
Original size: 11″ × 35″
Paper: black-line diazo-print paper

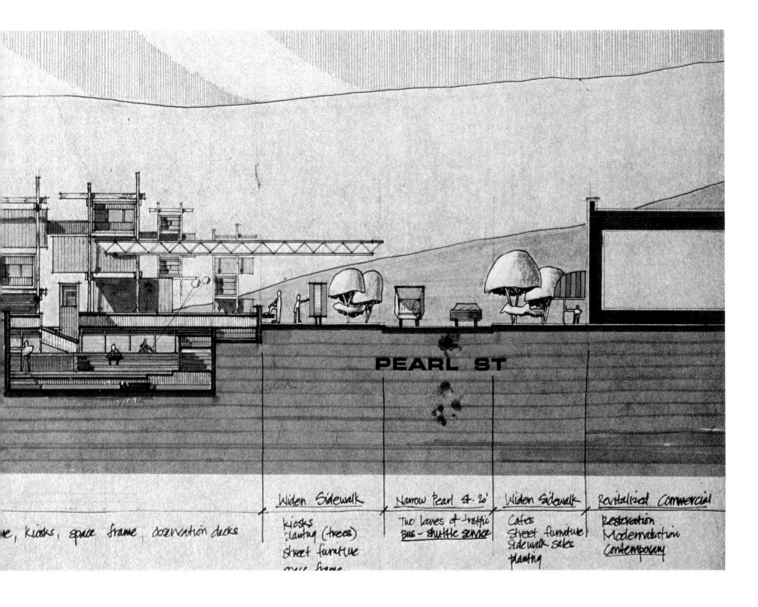

PEARL ST

Widen Sidewalk	Narrow Pearl St. 20'	Widen Sidewalk	Revitalized Commercial

...ve, kiosks, space frame, observation decks

Widen Sidewalk
kiosks
planting (trees)
street furniture
space frame

Narrow Pearl St. 20'
Two lanes of traffic
bus - shuttle service

Widen Sidewalk
Cafes
Street furniture
Sidewalk sales
planting

Revitalized Commercial
Restoration
Modernization
Contemporary

C10–37, C10–38, C10–39, C10–40, C10–41.
Artist: Greg McMenamin
Type of drawing: two studies, three illustrations
of a finished redesign of existing spaces
Original size: 6″ × 7″, 8″ × 11″, 14″ × 18″,
14″ × 18″, 14″ × 18″, respectively
Paper: two sketchbook paper (Strathmore 400),
three black-line diazo-print paper

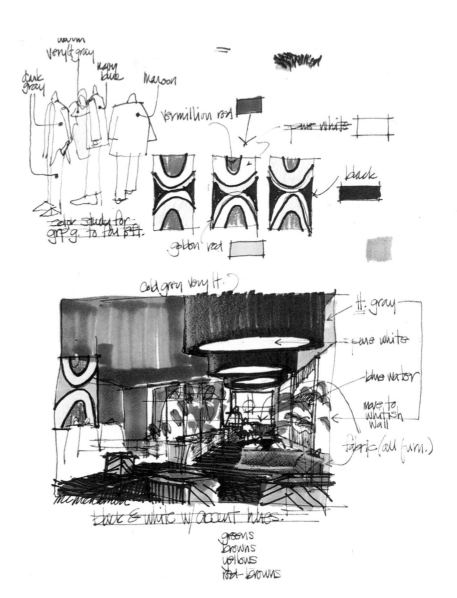

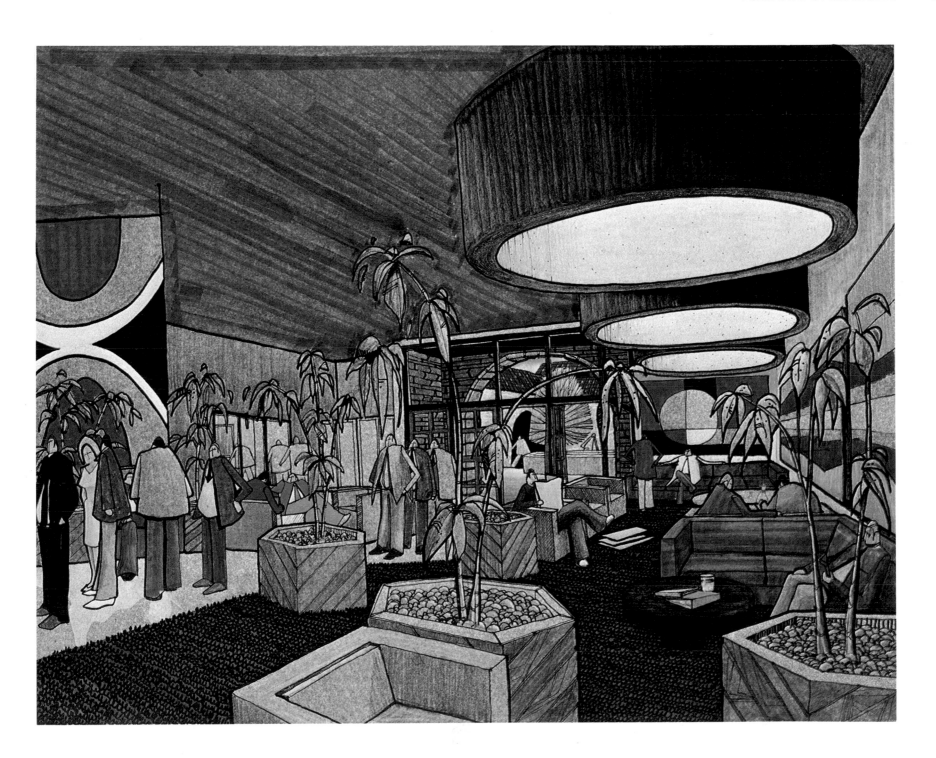

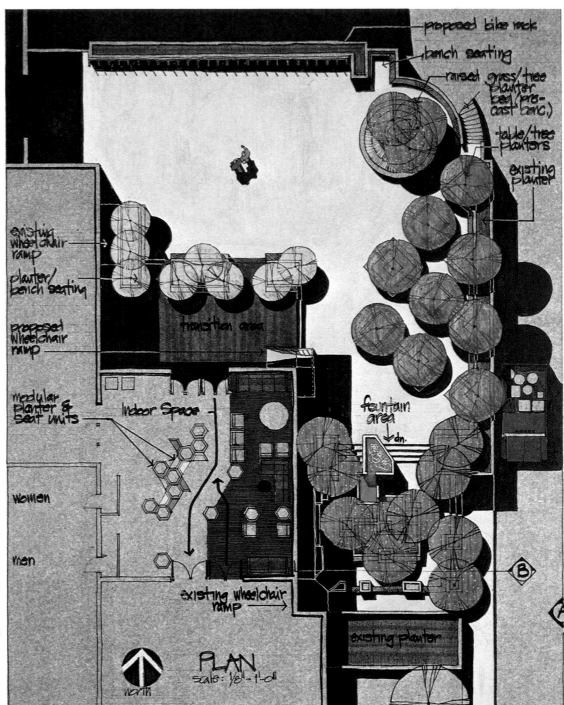

proposed bike rack

bench seating

raised grass/tree planter bed (pre-cast conc.)

table/tree planters

existing planter

existing wheelchair ramp

planter/bench seating

proposed wheelchair ramp

modular planter & seat units

Women

men

Indoor Space

transition area

fountain area

↓dn.

existing wheelchair ramp

existing planter

C10–40

PLAN
scale: 1/8" = 1'-0"

north

B

A

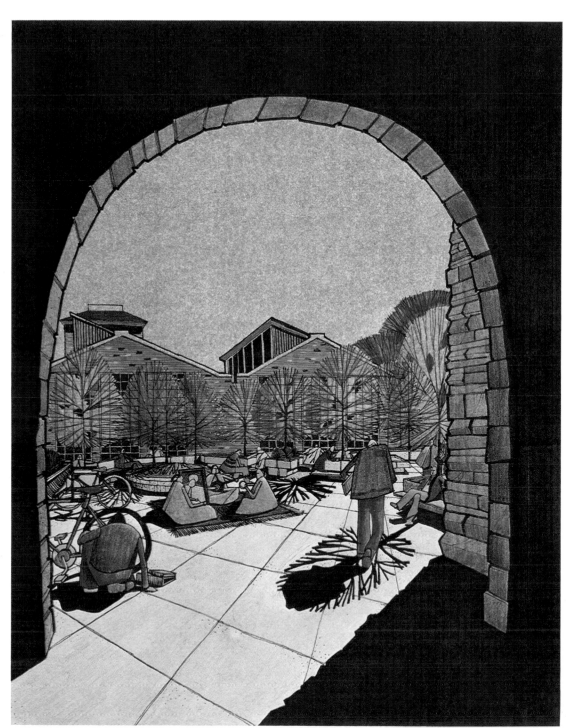

C10-41

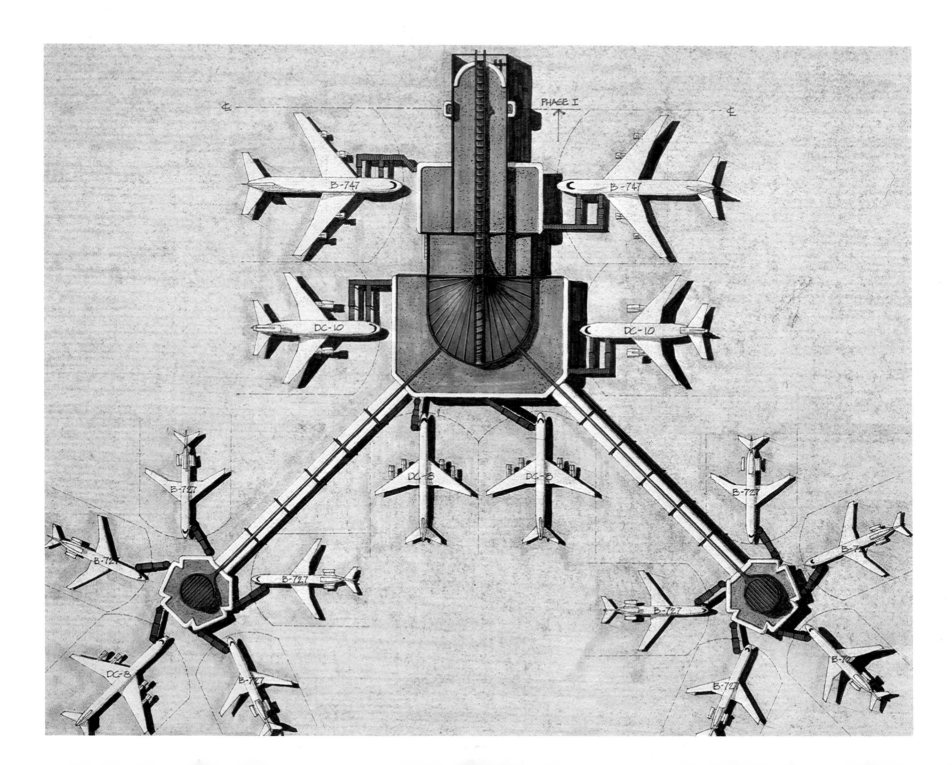

C10–43.
Artist: Rick Cranmer
Type of drawing: fantasy design
Original size: 11″ × 13″
Paper: brown-line diazo-print paper

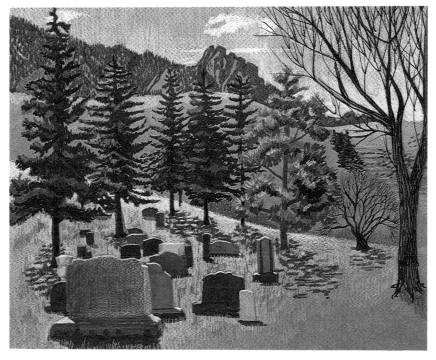

C10–44.
Artist: Margaret Alice Smith
Type of drawing: life drawing
Original size: 13″ × 16″
Paper: Crescent textured illustration paper

C10–42.
Artist: David S. Hammel
Type of drawing: illustration of a finished design
Original size: 20″ × 25″
Paper: diazo-print paper

C10–45.
Artist: BJR Inc., Ann Arbor, Michigan
Type of drawing: illustration of a finished design
for a collector road around the
University Cultural Center, Detroit, Michigan

C10-46.
Artist: BJR Inc., Ann Arbor, Michigan
Type of drawing: illustration of a finished design

C10-47.
Artist: Rick Cranmer
Type of drawing: design study exercise
Original size: 9″ × 13″
Paper: brown-line diazo-print paper

C10–48.
Artist: BJR Inc., Ann Arbor, Michigan
Type of drawing: illustration of a finished design

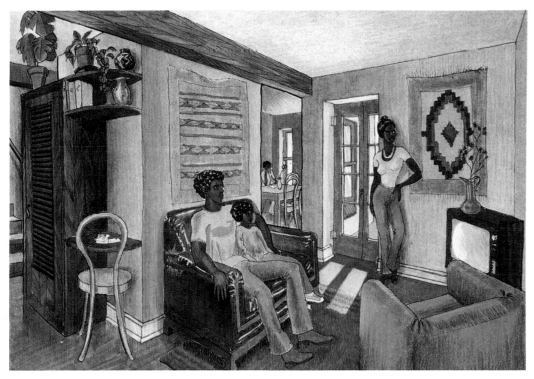

C10–49.
Artist: Margaret Alice Smith
Type of drawing: illustration of a finished design
Original size: 12″ × 18″
Paper: black-line diazo-print paper

C10–50.
Artist: Katy Liske
Type of drawing: life drawing
Original size: 10″ × 15″
Paper: Crescent textured illustration paper

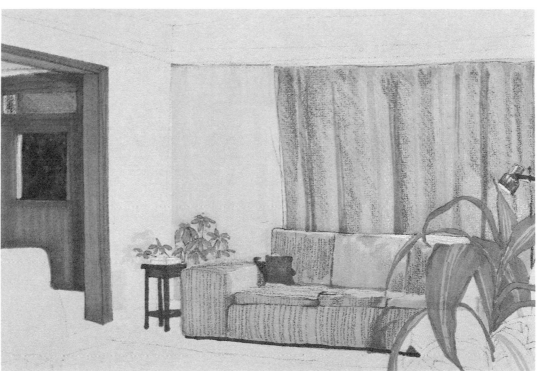

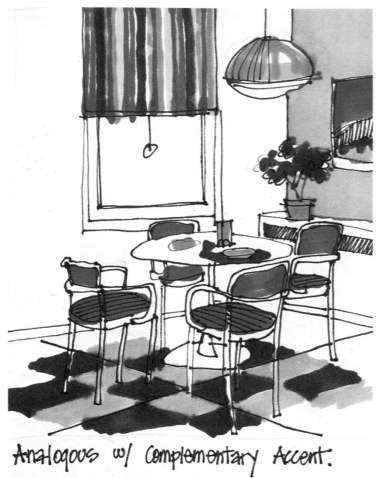

Analogous w/ Complementary Accent.

'Natural' + Black + White

C10–51, C10–52, C10–53, C10–54.
Artist: Rick Cranmer
Type of drawing: three studies,
one interior color-composition exercise
Original size: 6″ × 8″, 6″ × 8″, 8″ × 9″,
18″ × 21″, respectively
Paper: three sketchbook paper (Strathmore 400),
one Strathmore Bristol, medium finish

Complementary.

C10–55, C10–56.
Artist: Christopher Belknap
Type of drawing: illustration of a finished design utilizing a SRTA solar-collection system
Original size: 8″ × 22″, 12″ × 21″, respectively

Unites are modular
similar window
paintures give the
complex a certain
character. Would be
very fine from the
inside.

First look at facade →
Recess windows to block
out glare. Skin concrete.

Looks real heavy.

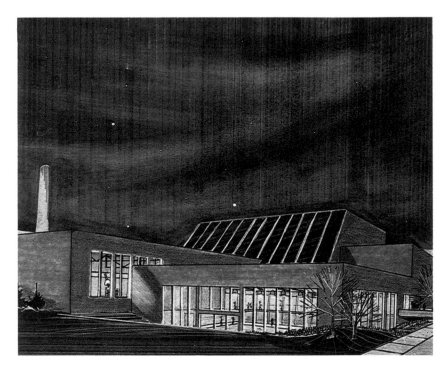

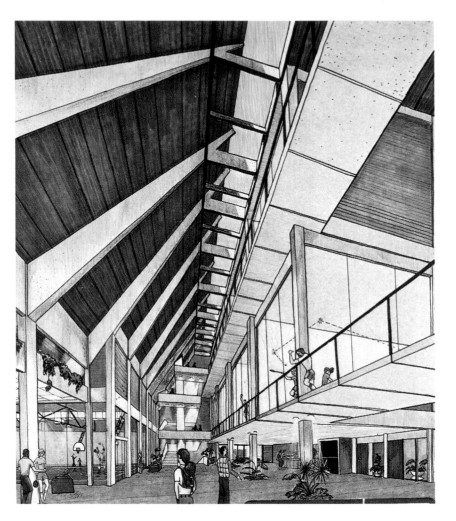

C10–57, C10–58.
Artist: Christopher Belknap
Type of drawing: illustration of a finished design for a recreation center
Original size: 11″ × 14″, 18″ × 20″, respectively.

C10–59.
Artist: Arthur C. Sturz
Type of drawing: life drawing
Original size: 8″ × 11″
Paper: sketchbook paper (Strathmore 400)

C10–60.
Artist: Tom Lyon
Type of drawing: fantasy drawing
Original size: 11″ × 14″
Paper: charcoal paper

C10–61.
Artist: Chester C. d'Autremont, Jr.
Type of drawing: life drawing
Original size: 6″ × 8″
Paper: sketchbook paper (Strathmore 400)

C10–62.
Artist: BJR Inc., Ann Arbor, Michigan
Type of drawing: illustration of a finished design for Merrick Mall, Wayne State University

C10–63.
Artist: BJR Inc., Ann Arbor, Michigan
Type of drawing: illustration of a finished design for Merrick Mall, Wayne State University

Appendix A

Marker-brand Cross-reference Chart

This chart cross-refers AD markers, Magic Markers, and Design art markers. The AD markers recommended for the palettes in Chapter 1 are italicized. Marker colors identified by an asterisk (*) denote close but not exact matches with the AD marker color. The addresses of the three marker manufacturers are:

AD Marker	Magic Marker	Design Art Marker
Cooper Color, Inc.	*Magic Marker Corporation*	*Eberhard Faber, Inc.*
3006 Mercury Road South	Glendale, New York 11227	Crestwood
Jacksonville, Florida 32207		Wilkes-Barre, Pennsylvania
Tel: (904) 733–2855		18703

AD Marker	Magic Marker	Design Marker
Air Force Blue (9)	Colbalt Blue (A-455)	
Amber (63)		
Apple Green (28)		
Aqua (117)	Aqua (A-627)	
	Mint Green (A-686)	
Aquamarine (114)	Holiday Blue (A-451)	
Arctic Blue (113)		

AD Marker	Magic Marker	Design Marker
Aspen Gold (49)	Bitter Sweet (A-777)	Yellow Orange (207-L)
Azure (110)		Blue-0 (265-L0)
Banana (44)	Patrician Yellow (A-778)	
Beaver Brown (87)		
Beige (137)	Brick Beige (A-291)	
Black (98)	Black (A-100)	Black (229-L)
Blueberry (96)	Wild Violet (A-481)	*Blue Violet (224-L)
	*Methyl Violet (A-500)	
Blue Glow (106)		
Blue Green (16)	Blue Green (A-679)	*Blue Green-9 (205-L9)
	*Turquoise (A-487)	
Blueprint (12)	*Chicory Blue (A-480)	Blue (265-L)
Blue Violet (1)	Blue Violet (A-513)	
Blush (152)		Red Orange-1 (226-L1)
Brick Red (74)	Dark Brick Red (A-311)	*Mahogany (343-L)
Bright Magenta (88)	Fuchsia (A-348)	Red Red Violet (306-L)
Buff (139)	Barely Beige (A-822)	*Red Brown-0 (213-L0)
Burnt Sienna (75)	Burnt Sienna (A-280)	Red Brown (213-L)
	*Mahogany (A-241)	
	*Light Mahogany (A-349)	

AD Marker	Magic Marker	Design Marker	AD Marker	Magic Marker	Design Marker
Burnt Umber (71)	Burnt Umber (A-279)	Brown (293-L)	Dark Olive (24)	Marine Green (A-638)	Green Orange Green-9 (248-L9)
	*Gothic Oak (A-221)	*Red Brown-9 (213-L9)		*Flagstone Green (A-611)	
	*Africano (A-262)		Dark Tan (53)	Clay (A-208)	
	*Light Gothic Oak (A-219)	*Natural Oak (383-L)	Dark Yellow (43)	Colonial Yellow (A-771)	
Cadmium Orange (64)	Cadmium Orange (A-802)		Deep Magenta (89)	Deep Magenta (A-345)	Red Violet (234-L)
Cadmium Red (79)	Cadmium Red (A-310)		Delta Brown (57)		
Cadmium Yellow (42)	Cadmium Yellow (A-704)	Yellow Gold-1 (227-L1)	Desert Tan (146)	Dark Suntan (A-202)	
Canary Yellow (131)	Dandelion (A-773)		Dutch Blue (11)	Larkspur (A-482)	Blue-9 (265-L9)
Celery (126)	Hansa Yellow (A-790)	Yellow Green-1 (208-L1)		*China Blue (A-491)	*Blue Black (365-L)
Chartreuse (36)				*Mariner Blue (A-490)	
Cherry (68)	Cherry (A-231)	Cherry (323-L)	Electric Blue (102)	Manganese Blue (A-427)	
	*Light Cherry (A-229)	*Brown-1 (293-L1)		*Bayberry (A-489)	
	*Terra Cotta (A-331)	*Pale Cherry (333-L)		*Delphinium Blue (A-488)	
	*Brick Red (A-341)		Emerald Green (21)	Ocean Green (A-648)	
Chocolate (86)			Evergreen (20)	Pine Tree Green (A-646)	
Chrome Green (35)			Extra Black (99)	Double Black (A-101)	
Chrome Orange (62)	Chrome Orange (A-803)		Flesh (149)	Blush (A-812)	Light Flesh (267-L)
Chrome Yellow (143)			Flesh Glow (155)	*Flesh(A–864)	
Citron (40)	Canary Yellow (A-713)		Forest Green (26)	Forest Green (A-600)	
	*Shocking Green (A-695)		Frost Blue (112)	Cool Shadow (A-612)	
	*Daffodil (A-780)			*Frost Blue (A-441)	
	*Citron (A-791)		Gold (47)	Ivory (A-779)	
Cobalt Blue (10)			Golden Ocher (45)	Mustard (A-618)	Gold (234-L)
Colonial Blue 1(8)				*Sunbeam (A-772)	
Cool Gray #1 (181)	Cool Gray #1 (A-111)		Goldenrod (46)	Golden Yellow (A-774)	Yellow Gold (227-L)
Cool Gray #2 (182)	Cool Gray #2 (A-112)	*Grey-2 (229-L2)	Golden Tan (52)	Caramel (A-204)	Yellow Brown (233-L)
Cool Gray #3 (183)	Cool Gray #3 (A-113)			*Spice (A-209)	
Cool Gray #4 (184)	Cool Gray #4 (A-114)	*Grey-4 (229-L4)	Grape (95)		*Violet (254-L)
Cool Gray #5 (185)	Cool Gray #5 (A-115)	*Grey-5 (229-L5)	Grapefruit (129)	Barium Yellow (A-706)	
Cool Gray #6 (186)	Cool Gray #6 (A-116)	*Grey-6 (229-L6)	Grass Green (122)	Grass Green (A-676)	
Cool Gray #7 (187)	Cool Gray #7 (A-117)	*Grey-7 (229-L7)	Green Glow (123)		
Cool Gray #8 (188)	Cool Gray #8 (A-118)	*Grey-8 (229-L8)	Holly Green (22)		
Cool Gray #9 (189)	Cool Gray #9 (A-119)	*Grey-9 (229-L9)	Ice Blue (105)	Pale Blue (A-407)	
Cool Gray #10 (190)			Indigo (2)		
Coral (158)	Coral (A-361)	Red Orange-2 (226-L2)	Jade (25)		
Cream (132)	Buttercup Yellow (A-708)		Kraft Brown (55)		Yellow Brown-8 (233-L8)
	*Primrose Yellow (A-775)		Lake Red (169)	Peony Pink (A-364)	
Crimson (82)	Lipstick Red (A-312)	Red Violet Red (256-L)	Lavender (176)	Lilac (A-560)	
	*Crimson (A-347)		Leaf Green (29)		
Crystal Blue (108)	Robin's Egg Blue (A-483)		Lemonade (125)		Yellow-0 (257-L0)

AD Marker	Magic Marker	Design Marker
Lemon Lime (124)		
Lemon Yellow (41)	Lemon Yellow (A-715)	Yellow (257-L)
	*Dark Yellow (A-714)	
	*Yellow (A-716)	
	*Tulip Yellow (A-739)	
Life Red (80)		
Light Blue (104)	Light Blue (A-411)	
Light Green (119)	Spectrum Green (A-684)	Green Yellow Green-1 (238-L1)
Light Ivy (136)	Putty (A-628)	
Light Olive (33)		
Light Red (78)	Lipstick Orange (A-322)	
	*Poppy (A-315)	
Light Sand (138)	Powder Pink (A-808)	
Lilac (92)	Lavender (A-567)	
Lime Glow (127)	Green Bice (A-795)	
Linden Green (37)	Erin Green (A-683)	Green Yellow Green (238-L)
		*Yellow Green (208-L)
Madeira Rose (172)	*Heather Pink (A-365)	*Red Violet-0 (234-L0)
Magenta Glow (167)		
Marigold (61)	*Honey (A-804)	
Maroon (85)	Chinese Red (A-371)	*Red-9 (336-L9)
	Venetian Red (A-329)	
	*Cranberry (A-366)	
	*Flag Red (A-330)	
Mauve (177)	Mauve Shadow (A-502)	Violet-0 (254-L0)
Maze (133)	*Old Ivory (A-781)	
Medium Olive (39)	Spanish Olive (A-668)	*Yellow Green Yellow (267-L)
Midnight Blue (3)		
Mint (121)		
Mocha (70)	Caribe Cocoa (A-242)	Pale Oak (253-L)
	*Light Walnut (A-269)	
Moss Green (27)		
Naples Yellow (135)		Brown-0 (293-L0)
Navy Blue (7)		
Nile Green (30)	Nile Green (A-677)	
Nubian Brown (73)	Dark Bark (A-276)	Dark Oiled Walnut (393-L)
Old Gold (48)	*Midas Gold (A-776)	

AD Marker	Magic Marker	Design Marker
Olive (31)	Olive (A-667)	Green Orange Green (248-L)
Orange Glow (157)		
Orchid (175)	Petunia Pink (A-370)	Violet-1 (254-L1)
Pale Aqua (116)		Green-0 (258-L0)
Pale Burgundy (173)		
Pale Cherry (148)		
Pale Flesh (147)		*Orange-0 (266-L0)
Pale Indigo (179)		
Pale Lime (118)		
Pale Olive (34)	Pale Olive (A-617)	
	*Old Bronze (A-680)	
Pale Orange (145)		
Pale Sepia (50)	Pale Sepia (A-207)	
Pale Veridian (111)	Mint Blue (A-421)	
Pale Yellow (130)	Yellow Spark (A-770)	Yellow-1 (257-L1)
	*Pale Yellow (A-707)	
Palm Green (32)	New Leaf (A-681)	
Peach (153)	Tangerine (A-805)	*Orange-1 (266-L1)
		*Dark Flesh (276-L9)
Peacock Blue (13)	Peacock Blue (A-439)	Blue Green Blue (255-L)
Pink (163)	Pink (A-393)	
Pink Glow (165)		
Pink Magenta (170)	Shock Pink (A-308)	
Plum (93)	Grape (A-514)	
Powder Pink (161)		Red-0 (336-L0)
		*Red Orange-0 (266-L0)
Process Blue (15)	Process Blue (A-447)	
	*Tahitian Blue (A-486)	
Prussian Blue (6)	Prussian Blue (A-410)	
	*Antwerp Blue (A-448)	
Pumpkin (150)		
Purple Sage (178)		
Red Clay (67)	Salmon (A-372)	
Red Glow (166)		
Red Raspberry (77)	Geranium (A-346)	
Redwood (69)	Redwood (A-271)	California Redwood (373-L)
Rose Glow (162)		
Rouge (164)		
Royal Purple (91)	*Baroque Purple (A-561)	Violet Red Violet (214-L)
	*Royal Purple (A-368)	

AD Marker	Magic Marker	Design Marker
Rubine Red (84)		
Ruby (83)	Carmine (A-325)	
Rust (154)	*Lipstick Natural (A-302)	*Pale Mahogany (353-L)
Saddle Brown (59)	Leather (A-251)	Saddle Leather (223-L)
Saffron (66)	Chinese Orange (A-809)	Orange (266-L)
Salmon (160)	Apple Blossom (A-360)	Red-1 (336-L1)
	*Peach (A-304)	
	*Pale Rose (A-369)	
Sand (142)	Sand (A-287)	
	Orientale (A-712)	
Sanguine (65)	Sanguine (A-807)	
Sapphire (107)		
Scarlet (81)		Red (336-L)
		*Red-8 (336-L8)
Sea Blue (14)	*Fathom Blue (A-484)	
Sea Green (17)	Ocean Blue (A-688)	
Sepia (56)	Sepia (A-237)	
Shadow Pink (168)	Scallop Pink (A-363)	
	*Begonia Pink (A-362)	
Shocking Pink (171)	Cerise (A-367)	Red Violet Red-1 (256-L1)
		*Red Violet-1 (234-L1)
Sky Blue (103)		
Slate Blue (97)	Flagstone Blue (A-401)	
Slate Green (18)	Teal Blue (A-678)	
Space Blue (101)		
Spruce Green (23)		
Steel (180)	Steel (A-131)	Yellow Green-0 (208-L0)
Sunbeam Yellow (128)		Light Flesh-1 (267-L1)
Sunset Pink (156)		
Suntan (140)	Light Suntan (A-222)	Raw Wood (283-L)
Super Black (100)		
Tangerine (151)		
Tan Glow (141)		
Tobacco (60)		Red Brown-8 (213-L8)
True Blue (5)	*Flag Blue (A-446)	*Blue Violet Blue (275-L)
	*Phthalo Blue (A-405)	

AD Marker	Magic Marker	Design Marker
Turquoise Blue (109)	New Blue (A-485)	Blue-1 (265-L1)
Turquoise Green (115)		Green-1 (258-L1)
Ultramarine (4)	Ultramarine (A-412)	
Umber (58)		
Van Dyke Brown (72)	*Flagstone Red (A-351)	
	*Light Bark (A-206)	
Veridian (19)	Malachite (A-636)	Green (258-L)
		*Green-9 (258-L9)
Vermillion (76)	Vermillion (A-801)	Red Orange (226-L)
		*Red Orange-8 (226-L8)
Violet (94)	Violet (A-515)	Violet-8 (254-L8)
Violet Glow (174)	Hot Pink (A-306)	
Walnut (54)	Walnut (A-273)	Walnut (168-L)
	*Kelp Brown (A-216)	*Pale Walnut (273-L)
Warm Gray #1 (191)	Warm Gray #1 (A-121)	Warm Grey-0 (209-L0)
	*Brick White (A-191)	
Warm Gray #2 (192)	Warm Gray #2 (A-122)	
Warm Gray #3 (193)	Warm Gray #3 (A-123)	
Warm Gray #4 (194)	Warm Gray #4 (A-124)	*Warm Grey-4 (209-L4)
Warm Gray #5 (195)	Warm Gray #5 (A-125)	*Warm Grey-5 (209-L5)
Warm Gray#6 (196)	Warm Gray #6 (A-126)	*Warm Grey-6 (209-L6)
Warm Gray #7 (197)	Warm Gray #7 (A-127)	*Warm Grey-7 (209-L7)
Warm Gray #8 (198)	Warm Gray #8 (A-128)	
Warm Gray #9 (199)	Warm Gray #9 (A-129)	
Warm Gray #10 (200)		
Watermelon (159)	Deep Peach (A-303)	
Wheat (144)		Yellow Orange-1 (207-L1)
		*Red Brown-1 (213-L1)
Willow Green (120)	Willow (A-685)	
	*Lime Green (A-608)	
Wine Red (90)	Red Violet (A-545)	
Yellow Glow (134)		
Yellow Green (38)	Yellow Green (A-606)	Yellow-9 (257-L9)
	*Chartreuse (A-637)	
	*Bright Green (A-682)	
Yellow Ocher (51)	Yellow Ocher (A-282)	

Appendix B

Hue Charts of AD Markers and Prismacolor Pencils

This appendix shows the AD markers and Prismacolor pencils[1] arranged into hue charts according to the Munsell system of color notation.[2] Each color is positioned, according to its hue, value, and chroma, as it appears on a good-quality white paper. If you are using a marker brand other than AD, use Appendix A to cross-refer to your marker brand.

1. The AD marker Glow series (Yellow Glow, Orange Glow, Lime Glow, etc.) and the Silver, Gold, Copper, and White Prismacolor pencils have been omitted from these charts.

2. Note, however, that these arrangements are not intended to represent accurate Munsell standards but rather that the positions of the colors have been visually approximated, as accurately as possible, using the Munsell format. In addition, note that the descriptive names of the hue chart on the left-hand side of each page in Appendix B (Reddish Yellow-Red, Green Yellowish Green, etc.) are those of the author and not of Munsell Color. The descriptive names of the value and chroma positions (very high, medium weak, etc.) are also those of the author and not of the Munsell system.

Since many of the marker and colored-pencil hues fall in between the 10 major Munsell hues (Red, Yellow-Red, Yellow, Green-Yellow, Green, Blue-Green, Blue, Purple-Blue, Purple, and Red-Purple), 10 "in-between" hue charts are provided, which borrow the names of the hues to either side—Reddish Yellow-Red, Yellow Reddish Yellow, Yellowish Green-Yellow, and so forth.

If a color did not fit into one of the 20 hues provided, it was placed in the chart into which it most closely fit and positioned according to its value and chroma. When a number of colors are so similar as to require the same position or "box," all the colors are listed, with the color most closely matching the Munsell description for that position listed first and the remaining colors listed in order of accuracy, with the least accurate color listed last.

The Prismacolor pencil colors were applied with full hand pressure. The word "pencil" appears after their names.

Using the Hue Charts

Once Chapters 5 through 7 are reviewed, the uses for the 20 hue charts (and 1 gray chart) shown here begin to become obvious. The *relationships between* the various colors are readily apparent when these media are systematically arranged according to their hue, value, and chroma. As such much of the usual experimentation used to explore these relationships can be eliminated. For example, rather than testing all one's markers and colored pencils to find those of, say, medium value (Munsell value 5), the hue charts can be consulted and will show *Life Red, Tobacco, Burnt Umber, Burnt Ochre* (pencil), *Slate Blue,* and so forth. A number of these colors might then be chosen for a composition in which medium value is one of the unifying themes.

In a more complex example it might be decided that the hues red-purple through yellow are to be arranged into an analogous-hue scheme. Consulting the hue charts on these pages, the *Wine Red* marker is chosen from the Red-Purple hue chart, the *Coral* marker from the Red hue chart, the *Pumpkin* marker from the Yellow-Red hue chart, and the *Lemon Yellow* marker from the Yellow hue chart. There are additional reasons for selecting these particular colors from the hue charts. In addition to the fact that they all have the same medium-strong chroma, note that, beginning with the red-purple *Wine Red* marker, the colors also increase in value as they progress around the color wheel to yellow. Since the colors relate in a number of ways—orderly progression of both hue and value while chroma remains constant—the stage is now set for the designer to experiment with the arrangement of these colors into a composition.

The Munsell System of Color Notation

Although knowledge of the Munsell notation system is not necessary in order to appreciate or use this book, an understanding of it is useful when it becomes necessary to succinctly communicate or specify a color in this widely known color language.

A more elaborate Munsell color wheel shows the 10 major Munsell hues each divided into 10 "hue steps," giving a 100-hue color wheel. Thus the hue Red (R), for example, actually extends from 0 (zero) R (a red purplish red) to 10R (a yellow reddish red), with 5R in the middle the truest or "reddest" red. This is why the 10 major hues are written "5R," "5YR," "5Y," and so on. Consequently the hues directly between the 10 major hues are written "10R," "10YR," "10Y," etc., and are named by the author as "Reddish Yellow-Red," "Yellow Reddish Yellow," "Yellowish Green-Yellow," and so forth.

The Munsell notation for a color is written as a type of fraction. The *Brick Red* marker color, for example, is written as "10R 6/8" and described as a "medium-high value, medium-chroma reddish yellow-red." The numerator 6/ describes the value of this color relative to a scale that ranges between 0/ (absolute black) to 10 (absolute white). Since neither of these theoretical absolute values is attainable here, the value scale on the left side of each page of hue charts ranges only from a low of 2/ to a high of 8.5/. The denominator /8 in the description of the *Brick Red* marker indicates the position of the chroma of this particular color on a scale of /0 (neutral gray) to /16 (in special cases). As with the value scale, the chroma scale for the hue charts shown here is limited and ranges from a weak of 2/ to a strong of /14.

Decimals are used when more precise notations are needed; a typical notation might be 3.7 YR 8.3/4.2. Though such exact notations are beyond the scope of this book, note that changes in the value scale of the hue charts take place in half-steps because of the slight difference in the values of many of the markers and colored pencils charted. Thus a *Sea Green* marker would be noted as 5BG 6.5/8.

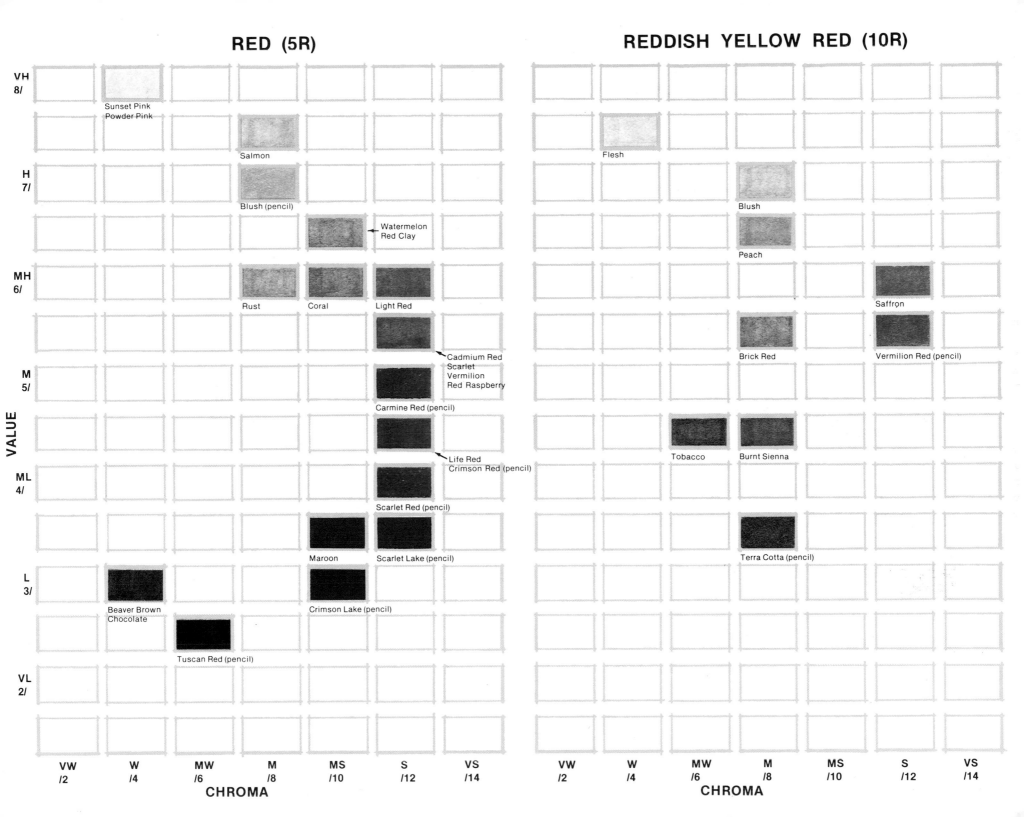

RED (5R)

REDDISH YELLOW RED (10R)

VALUE

| VH 8/ | | Sunset Pink Powder Pink | | | | | |

Salmon

H 7/
Blush (pencil)

Watermelon Red Clay

MH 6/
Rust　　Coral　　Light Red

Cadmium Red
Scarlet
Vermilion
Red Raspberry

M 5/
Carmine Red (pencil)

Life Red
Crimson Red (pencil)

ML 4/
Scarlet Red (pencil)

Maroon　　Scarlet Lake (pencil)

L 3/
Beaver Brown
Chocolate

Crimson Lake (pencil)

Tuscan Red (pencil)

VL 2/

| VW /2 | W /4 | MW /6 | M /8 | MS /10 | S /12 | VS /14 |

CHROMA

Flesh

Blush

Peach

Saffron

Brick Red　　Vermilion Red (pencil)

Tobacco　　Burnt Sienna

Terra Cotta (pencil)

| VW /2 | W /4 | MW /6 | M /8 | MS /10 | S /12 | VS /14 |

CHROMA

YELLOW-RED (5YR)

YELLOW REDDISH YELLOW (10YR)

VALUE

VH 8/

Beige
Light Sand

Buff
Pale Flesh

Light Flesh (pencil)

Pale Orange
Chrome Yellow

Pumpkin
Flesh (pencil)

Naples Yellow Gold Banana

Wheat Old Gold Goldenrod

H 7/

Pale Cherry

Marigold

Golden Tan
Tangerine

Suntan Desert Tan

Chrome Orange

Yellow Orange (pencil)
Aspen Gold

Sand Yellow Ocher
Pale Sepia
Sand (pencil)

MH 6/

Mocha

Orange (pencil)
Amber

Cadmium Orange
Sanguine

Yellow Ochre (pencil)

Kraft Brown

M 5/

Sepia Cherry

Van Dyke Brown Umber Saddle Brown Redwood

Burnt Umber
Walnut

Burnt Ochre (pencil)

Dark Tan

Raw Umber (pencil)

ML 4/

Nubian
Delta Brown
Dark Brown (pencil)

Sienna Brown (pencil)

Burnt Umber (pencil)

L 3/

VL 2/

| VW /2 | W /4 | MW /6 | M /8 | MS /10 | S /12 | VS /14 |

CHROMA

| VW /2 | W /4 | MW /6 | M /8 | MS /10 | S /12 | VS /14 |

CHROMA

YELLOW (5Y)

YELLOWISH GREEN YELLOW (10Y)

	VW /2	W /4	MW /6	M /8	MS /10	S /12	VS /14
VH 8/	Sunbeam Yellow	Maize	Cream	Canary Yellow / Pale Yellow / Cream (pencil) / Grapefruit	Lemon Yellow	Lemon Yellow (pencil) / Dark Yellow / Cadmium Yellow	Canary Yellow (pencil)
H 7/			Golden Ocher				
MH 6/							
M 5/							
ML 4/							
L 3/	Sepia (pencil)						
VL 2/							

VALUE (vertical axis label)

CHROMA (horizontal axis label)

	VW /2	W /4	MW /6	M /8	MS /10	S /12	VS /14
VH 8/	Light Ivy	Lemonade	Celery				Citron
H 7/		Pale Olive					
MH 6/			Medium Olive				
M 5/			Olive				
ML 4/							
L 3/							
VL 2/							

CHROMA

GREEN-YELLOW (5GY)

GREEN YELLOWISH GREEN (10GY)

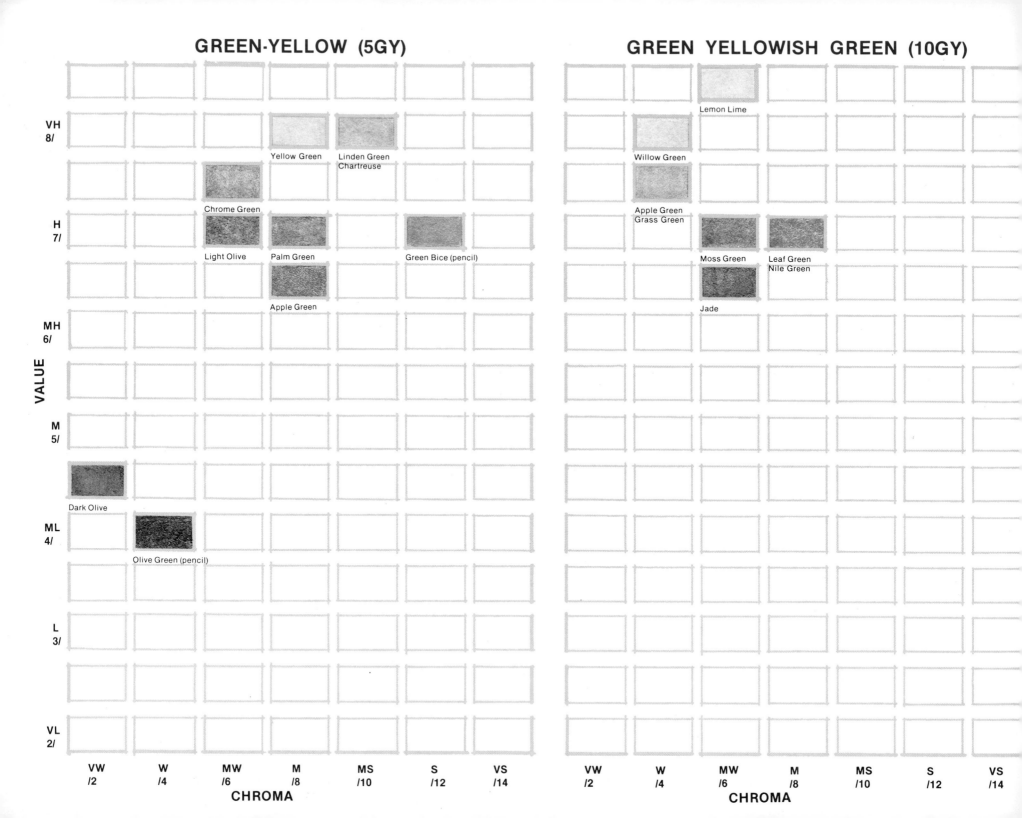

VALUE

VH 8/

Yellow Green

Linden Green
Chartreuse

Lemon Lime

Willow Green

H 7/

Chrome Green

Light Olive

Palm Green

Green Bice (pencil)

Apple Green
Grass Green

Moss Green

Leaf Green
Nile Green

Apple Green

Jade

MH 6/

M 5/

Dark Olive

ML 4/

Olive Green (pencil)

L 3/

VL 2/

| VW /2 | W /4 | MW /6 | M /8 | MS /10 | S /12 | VS /14 |

CHROMA

| VW /2 | W /4 | MW /6 | M /8 | MS /10 | S /12 | VS /14 |

CHROMA

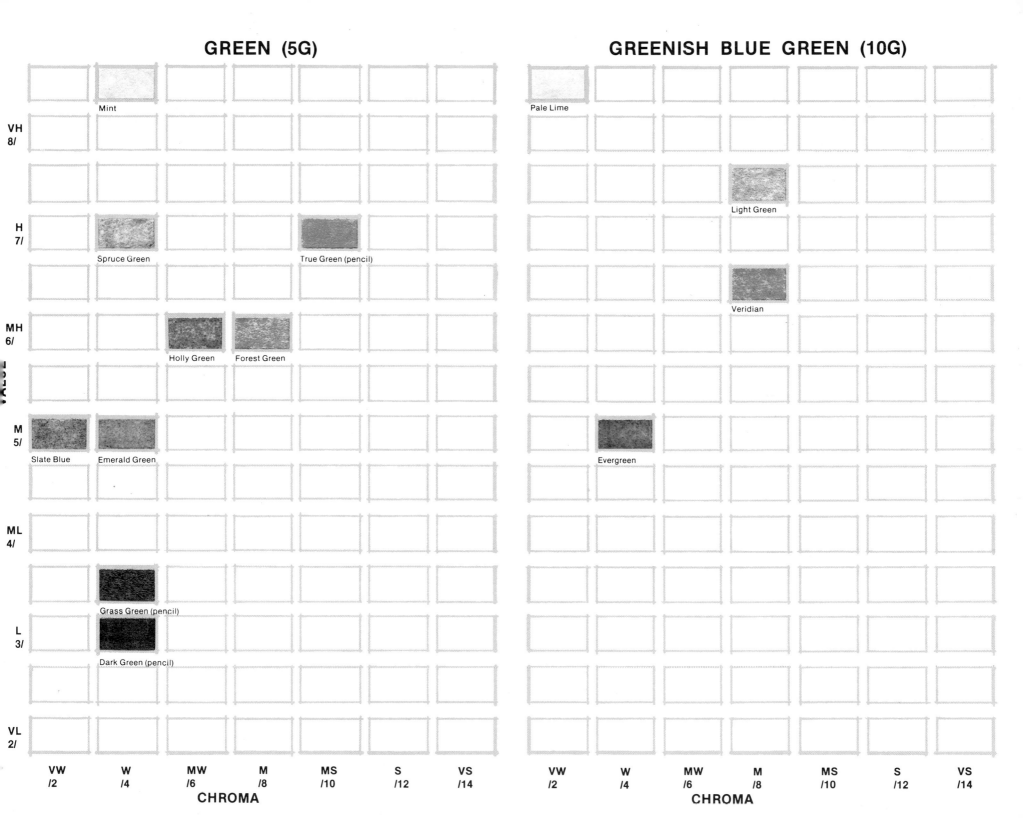

GREEN (5G)

GREENISH BLUE GREEN (10G)

Mint

Pale Lime

VH 8/

Light Green

H 7/

Spruce Green

True Green (pencil)

Veridian

MH 6/

Holly Green

Forest Green

M 5/

Slate Blue

Emerald Green

Evergreen

ML 4/

Grass Green (pencil)

L 3/

Dark Green (pencil)

VL 2/

| VW /2 | W /4 | MW /6 | M /8 | MS /10 | S /12 | VS /14 |

CHROMA

| VW /2 | W /4 | MW /6 | M /8 | MS /10 | S /12 | VS /14 |

CHROMA

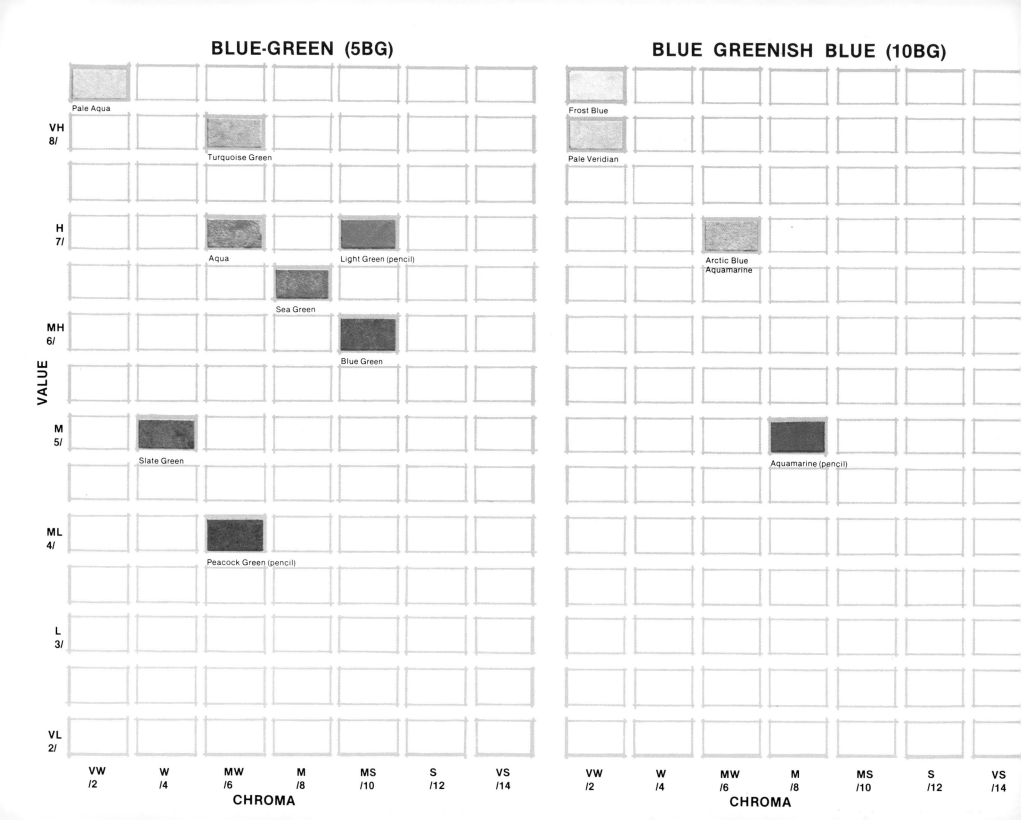

BLUE-GREEN (5BG)

BLUE GREENISH BLUE (10BG)

VALUE

Pale Aqua

VH
8/

Turquoise Green

H
7/

Aqua · Light Green (pencil)

Sea Green

MH
6/

Blue Green

M
5/

Slate Green

ML
4/

Peacock Green (pencil)

L
3/

VL
2/

Frost Blue

Pale Veridian

Arctic Blue
Aquamarine

Aquamarine (pencil)

| VW /2 | W /4 | MW /6 | M /8 | MS /10 | S /12 | VS /14 |

CHROMA

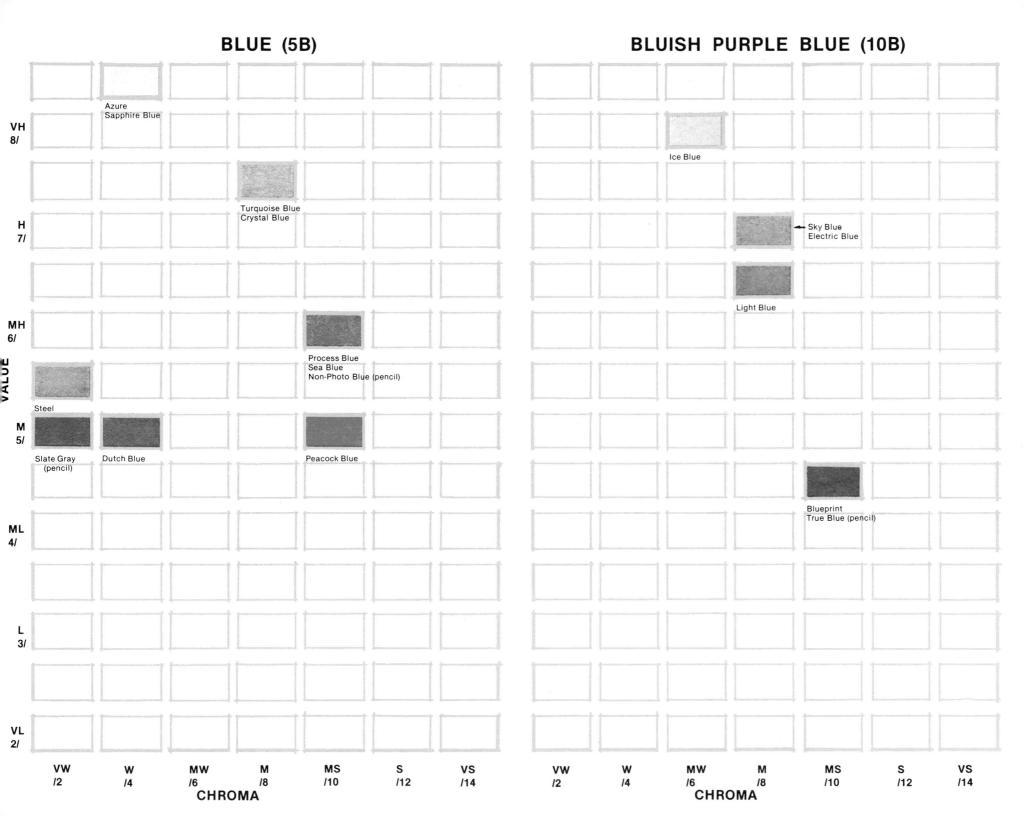

BLUE (5B)

BLUISH PURPLE BLUE (10B)

VALUE

VH 8/

H 7/

MH 6/

M 5/

ML 4/

L 3/

VL 2/

Azure
Sapphire Blue

Turquoise Blue
Crystal Blue

Process Blue
Sea Blue
Non-Photo Blue (pencil)

Steel

Slate Gray
(pencil)

Dutch Blue

Peacock Blue

Ice Blue

Sky Blue
Electric Blue

Light Blue

Blueprint
True Blue (pencil)

| | VW /2 | W /4 | MW /6 | M /8 | MS /10 | S /12 | VS /14 |

CHROMA

| | VW /2 | W /4 | MW /6 | M /8 | MS /10 | S /12 | VS /14 |

CHROMA

PURPLE-BLUE (5PB)

PURPLE BLUISH PURPLE (10PB)

VALUE

VH
8/

H
7/

Space Blue

MH
6/

Light Blue (pencil)

← Cobalt Blue
True Blue

M
5/

Colonial Blue Air Force Blue

Blueberry

Blue Violet
Indigo

ML
4/

Prussian Blue

Ultramarine
Ultramarine (pencil)

Copenhagen Blue (pencil)

L
3/

Blue Violet (pencil)
Midnight Blue
Navy Blue

VL
2/

← Indigo Blue (pencil)

Pale Indigo

VW /2	W /4	MW /6	M /8	MS /10	S /12	VS /14

CHROMA

VW /2	W /4	MW /6	M /8	MS /10	S /12	VS /14

CHROMA

PURPLE (5P)

PURPLISH RED PURPLE (10P)

VH 8/

Mauve

H 7/

Purple Sage

Lavender
Lavender (pencil)

MH 6/

Light Violet (pencil)

Lilac Orchid

Grape

M 5/

Royal Purple

ML 4/

L 3/

Violet Violet (pencil)

Plum Purple (pencil)

VL 2/

VW /2	W /4	MW /6	M /8	MS /10	S /12	VS /14

CHROMA

VW /2	W /4	MW /6	M /8	MS /10	S /12	VS /14

CHROMA

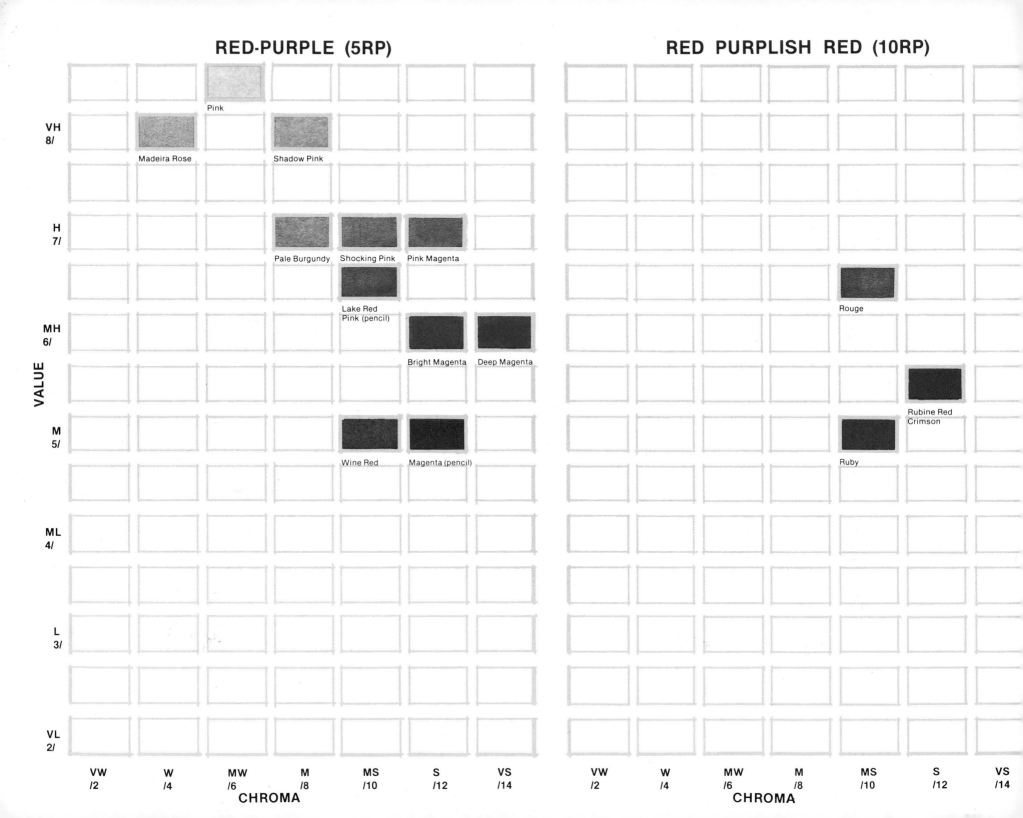

RED-PURPLE (5RP)

RED PURPLISH RED (10RP)

VALUE

VH 8/

H 7/

MH 6/

M 5/

ML 4/

L 3/

VL 2/

Pink

Madeira Rose

Shadow Pink

Pale Burgundy

Shocking Pink

Pink Magenta

Lake Red
Pink (pencil)

Bright Magenta

Deep Magenta

Wine Red

Magenta (pencil)

Rouge

Rubine Red
Crimson

Ruby

| VW /2 | W /4 | MW /6 | M /8 | MS /10 | S /12 | VS /14 |

CHROMA

CHROMA

WARM GRAYS		COOL, COLD GRAYS		BLACK
MARKERS	**PENCILS**	**MARKERS**	**PENCILS**	

	WARM GRAYS		COOL, COLD GRAYS		BLACK
	←Warm Gray #2 Warm Gray #1		←Cool Gray #2 Cool Gray #1		
VH **8/**	Warm Gray #3		Cool Gray #3	Cold Grey Very Light	
H **7/**	Warm Gray #4	Warm Grey Very Light	Cool Gray #4		
	Warm Gray #5		Cool Gray #5		
MH **6/**	Warm Gray #6	Warm Grey Light	Cool Gray #6	Cold Grey Light	
M **5/**	Warm Gray #7		Cool Gray #7		
ML **4/**	Warm Gray #8		Cool Gray #8		
	Warm Gray #9	Warm Grey Medium	Cool Gray #9	Cold Grey Medium	
L **3/**	Warm Gray #10	Warm Grey Dark	Cool Gray #10	Cold Gray Dark	Black Extra Black
VL **2/**					Super Black Black (pencil)

Appendix C

Color Wheel

The color wheel is a hue, value, and chroma reference. The large color rectangles on the color wheel show the 10 major Munsell hues, while the small rectangles show hues halfway between the major hues. All 20 hues shown are in the strong-chroma range. The hue names are the same as are used in Appendix B, where the AD markers and Prismacolor pencils in that hue are charted according to their value and chroma. Appendix B also contains an explanation of the Munsell notation used here in parentheses.

The vertical gray scale on the left shows 7 neutrals that range from very high to very low in value and correspond to the Munsell values 2/ through 8/. Although a scale of neutrals theoretically ranges from absolute black to absolute white (neither of which is achievable here), the scale shown is limited to values corresponding to the scale of values in Appendix B. The Munsell values 1/ and 9/ are not shown.

The horizontal chroma scale at the bottom of the page shows one gray and six reds—all at the same medium value—with the chroma of the reds becoming successively stronger (less grayish, more pure) as one progresses from left to right.

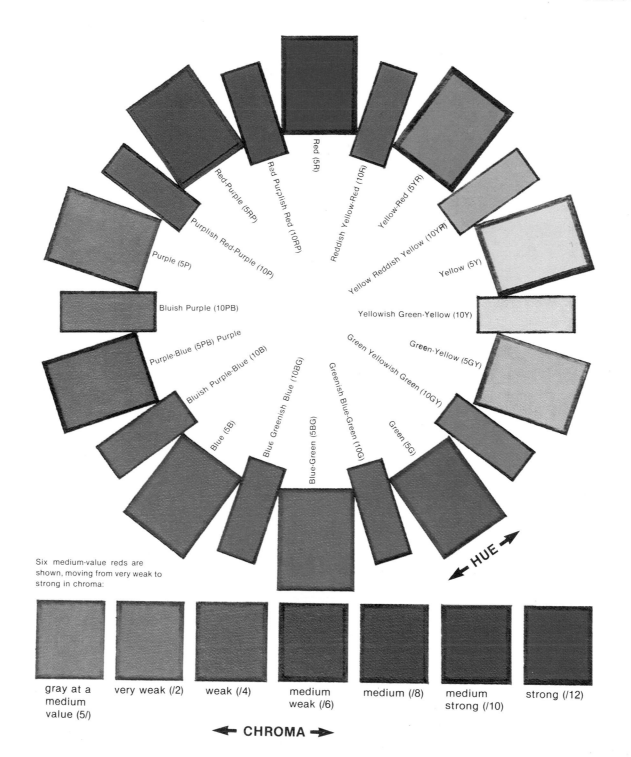

VH
8/

H
7/

MH
6/

M
5/

ML
4/

L
3/

VL
2/

← VALUE →

Red (5R)

Red Purplish Red (10RP)

Red-Purple (5RP)

Reddish Yellow-Red (10R)

Yellow-Red (5YR)

Purplish Red-Purple (10P)

Yellow Reddish Yellow (10YR)

Purple (5P)

Yellow (5Y)

Bluish Purple (10PB)

Yellowish Green-Yellow (10Y)

Purple-Blue (5PB) Purple

Green-Yellow (5GY)

Bluish Purple-Blue (10B)

Greenish Yellowish Green (10GY)

Blue (5B)

Blue Greenish Blue (10BG)

Green Yellowish Green (10GY)

Green (5G)

Blue-Green (5BG)

Greenish Blue-Green (10G)

HUE

Six medium-value reds are
shown, moving from very weak to
strong in chroma:

gray at a
medium
value (5/)

very weak (/2)

weak (/4)

medium
weak (/6)

medium (/8)

medium
strong (/10)

strong (/12)

← CHROMA →

Annotated Bibliography

Ball, Victoria Kloss, *The Art of Interior Design*, Macmillan Company, New York, 1960.

Birren, Faber, *Color for Interiors*, Whitney Library of Design.

Birren, Faber, *Color, Form, and Space*, Reinhold Publishing Corporation, New York, 1961.

Birren, Faber, *Principles of Color*, Van Nostrand Reinhold Company, New York, 1969.

Conran, Terence, *The House Book*, Mitchell Beazley Publishers Limited, London, 1974. A book full of ideas and color photographs of contemporary residential interior designs and details. A terrific color reference for drawing.

Demachy, Alain, *Interior Architecture and Decoration*, William Morrow and Company, New York, 1974.

Ellinger, Richard G., *Color Structure and Design*, Van Nostrand Reinhold Company, New York, 1963. One of the best books on color that I encountered in my research. It clearly states a usable theoretical basis for working with color harmony.

Faulkner, Ray and Sarah, *Inside Today's Home*, Holt, Reinhart, and Winston, New York, 1975. A thorough book (in its fourth edition) covering just about every aspect of contemporary residential interior design, including basic design principles and a brief history of interior design. Though it contains only 61 color photographs, the 840 black-and-white photos give the reader an excellent design resource. The use of color in exteriors is briefly covered.

Faulkner, Waldron, *Architecture and Color*, John Wiley and Sons, Inc., 1972.

Gatz, Konrad and Wallenfang, Wilhelm O., *Color in Architecture*, Reinhold Publishing Corporation, New York, 1968.

Graves, Maitland, *The Art of Color and Design*, 2nd ed., McGraw-Hill Book Company, Inc., New York, 1951.

Guptill, Arthur, *Color in Sketching and Rendering*, Reinhold Publishing Corporation, 1949. Probably one of the best books of all time on watercolor rendering for architects. It is filled with information and tips ranging from mixing basics to the subtleties of shadows. It includes many truly exquisite renderings by professionals of the late 1920s and early 1930s.

Halse, Albert O., *Architectural Rendering*, McGraw-Hill, New York, 1960. A good reference that explains the basic techniques used in various types of architectural rendering, including pencil, pen and ink, charcoal, watercolor, tempera, airbrush, and pastels. Examples of student and professional renderings that utilize these various media are included. Most are black and white, with some in color.

Itten, Johannes, *The Art of Color*, Reinhold Publishing Corporation, New York, 1961. A sensitive treatise on color, discussed in terms of its seven contrasts and exemplified by large color reproductions of great paintings from history.

Kautzky, Theodore, *Pencil Pictures*, Reinhold Publishing Corporation, New York, 1947.

Lockard, William Kirby, *Design Drawing*, Pepper Publishing, Tucson, 1974. Covers the basics of drawing for designers, with emphasis on the use of perspective drawing as the most suitable approach to three-dimensional design. A good reference for useful perspective and shade and shadow construction methods. A step-by-step section on drawing people is included.

Lockard, William Kirby, *Drawing as a Means to Architecture*, revised edition, Pepper Publishing, Tucson, 1977.

Magnani, Franco, *Interiors for Today*, The Whitney Library of Design, New York, 1975.

Martin, C. Leslie, *Architectural Graphics*, Macmillan Company, New York, 1970. A standard reference for classic construction methods of architectural drawing. Thoroughly covers the topics of perspective, shade and shadow construction, paraline drawing, and exploded-view drawing, among others.

Martin, C. Leslie, *Design Graphics*, Macmillan Company, New York, 1968. Similar in content to *Architectural Graphics*.

Munsell, A. H., *A Color Notation*, Munsell Color Company, Baltimore, 1975. This book comes with the Munsell Student Charts (10 hue charts of the basic Munsell hues and one Munsell color wheel, including a value scale) and explains the Munsell system of color. The book and charts are excellent and inexpensive color references to use in conjunction with this book. They can be ordered from Munsell Color, 2441 North Calvert Street, Baltimore, Maryland, 21218. Telephone: (301) 243-2171.

Pile, John (ed.), *Drawings of Architectural Interiors*, The Whitney Library of Design, New York, 1967. An excellent collection (and one of the only ones I know) of drawing of interiors. Drawings by such notables as Neutra, Kahn, Wright, and Le Corbusier are included. A good reference for drawing style, effects, and techniques but unfortunately contains little color.

Plumb, Barbara, *Young Designs in Color*, Viking Press, Inc., New York, 1972. A collection of photographs of contemporary interiors, entirely in color.

Porter, Tom and Mikellides, Byron, *Color for Architecture*, Van Nostrand Reinhold Company, New York, 1976. A book long needed in the field, which will hopefuly initiate a renaissance of color in architecture. It includes an examination of the psychological effects of environmental color and its functions and a discussion of the Natural Color System. A variety of color plates show new and exciting uses of color, most notably in urban and industrial landscapes.

Renner, Paul, *Color Order and Harmony*, Reinhold Publishing Corporation, New York, 1964.

Rowe, William, *Original Art Deco Designs*, Dover Publications, Inc., New York, 1973.

Sargent, Walter, *The Enjoyment and Use of Color*, Dover Publications, Inc., New York, 1964.

Smith, Charles, *Student Handbook of Color*, Reinhold Publishing Corporation, New York, 1965. A clear and concise examination of the visual effects and illusions caused by combinations of colors, centered upon the Ostwald System.

Walker, Theodore D. (comp.), *Perspective Sketches II*, PDA Publishers, West Lafayette, Indiana, 1975. A compilation of perspective drawings, from quick sketches to finished renderings, by landscape architects. A good reference for drawing styles and techniques used in the field. A few color plates but mostly pen and pencil.

Walker, Theodore, D., *Plan Graphics*, PDA Publishers, West Lafayette, Indiana, 1975. A good idea book for techniques used in drawing exterior design plans, including site analyses, master plans, and finished site plans. Drawings of landscape-design elevations also appear. Pen, pencil, and marker—no color.

Wilson, José and Leaman, Arthur, *Color in Decoration*, Van Nostrand Reinhold Company, New York, 1971. Color photographs of contemporary interiors with some discussion of the use of color and pattern.

Wise, Herbert H. and Friedman-Weiss, Jeffrey, *Living Places*, Quick Fox, New York, 1976. A little gem of a picture book, all in color, showing contemporary interiors featuring mostly natural materials, especially wood. For that reason a good color reference for drawing various woods.

Glossary

abstracting, abstract out The indication in a drawing of only the most noticeable qualities of materials. This usually includes color, most conspicuous texture, and values due to illumination.

analogous colors Colors allied to each other due to their side-by-side relationship on the color wheel.

atmospheric perspective An illusion of distance created in a drawing by progressively weakening the chromas and increasing the values of the colors of objects (such as landforms) as they recede into the distance.

background (of a drawing) Usually the part of a drawing that occurs in space *behind* the center of interest.

background (of a print) The general tone or value of the printed (or exposed) print paper. For most colorwork on prints a high-value (approximately Munsell value 7) background is usually most appropriate.

base, marker base The initial coating of color, applied by marker, to a particular surface or area of a drawing. Colored pencil is often then applied to alter its color dimensions.

black-line print A reproduction of a drawing, usually by diazo or a similar process, that has a gray background and lines that range from gray to black.

blue-line print, blueprint A reproduction of a drawing, usually by diazo or a similar process, that has a bluish background and blue lines.

brilliance The chroma of a color, also referred to as intensity, saturation, or purity. The less brilliant a color, the more grayish, and vice versa.

brown-line print A reproduction of a drawing, usually by diazo or a similar process, that has a brownish background and brown lines.

chroma The strength of a color. The chroma of a color may vary on a scale from weak to strong, with weak-chroma colors grayish and strong-chroma colors pure. Various other names for chroma include saturation, purity, brilliance, and intensity.

color solid A geometric model, roughly in the shape of a sphere, that shows the interrelationships of the three dimensions of color.

color wheel A circular arrangement of hues as they occur side by side in the visible-light spectrum (i.e., as seen when sunlight is refracted by a glass prism). The color wheel is often used to select hue schemes for color compositions.

complementary hues Hues that are diametrically opposite each other on the color wheel. When these hues are placed side by side, each makes the other appear its most intense.

composition of color Any arrangement of colors that is intended to be seen together as a whole.

contrast A distinct difference between two parts of the same color dimension, which may range from subtle to strong.

cool gray A gray that is very slightly bluish, such as that produced by a cool-gray marker or cold-gray colored pencil.

cool hues Hues that are associated with cool temperatures. Blue-green, blue, purple-blue, and purple are cool hues on the Munsell color wheel, with red-purple and green forming the border between warm and cool hues.

cross-hatching A visual texture, created with pencil by means of superimposed crossing arrays of usually parallel lines.

diazo print A reproduction of a drawing made by the diazo printing process. Such a print is quickly produced by exposing the drawing along with unexposed print paper to a special light and then to a developer, usually ammonia. Diazo prints are commonly made on blue-, black-, or brown-line paper, although other colors are available.

diffuse shadow edge A shadow edge that gradually changes from shadow to light and forms no distinct boundary.

dimension of color A measurable visual quality of color. Each color has three dimensions: hue, value, and chroma; and each may theoretically be altered without disturbing the others.

distinct shadow edge A boundary that forms a definite division between shadow and light.

dominant, dominance That which occupies the most area in a drawing. One part of each of the three variable color dimensions should dominate in a color composition.

flavoring The application of a subtle wash of color to a surface with a colored pencil, using a small amount of pressure.

foreground The part of a drawing that lies in front of the center of interest.

gradation A change by degrees. This term is usually used to discuss a gradual change in value.

graded wash A colored-pencil covering, applied with varying pressure, that changes gradually over a given surface.

grain The texture of a drawing paper. A fine-grain paper has little texture, while a coarse-grain paper is quite textural or bumpy.

harmony of color The pleasing relationships of colors in a composition. One way of approaching these relationships is by having each area of color that is subordinate in one dimension repeat at least one or preferably two of the dominant parts of the other two dimensions.

highlight The lightest spot or area of a surface, caused by direct reflection of the light source.

hue The name of a color and one of its three dimensions.

hue chart A chart that shows in an orderly fashion the ranges of value and chroma for a particular hue. The extent of these ranges is dependent upon the color medium used.

hue scheme A set of hues chosen for their particular relationship on the color wheel for combination in a composition. Hue schemes have evolved over the centuries and are intended as guidelines, not laws.

indistinct shadow edge See *diffuse shadow edge.*

key The dominant value or group of closely related values in a color composition. In a high-key composition lighter values are dominant, while in a low-key composition darker values are dominant.

lightness The degree to which the value of a color approaches white.

line media Media used to make lines. With the marker/colored-pencil method felt-tipped and fountain pens work best.

lowlights Small areas of shade or shadow on an object that usually has highlights as well.

marker A coloring device, used like a pen or pencil, that customarily has a chisel- or wedge-shaped compressed-felt tip. The coloring medium is usually a mixture of aniline dye and xylol solvent, which is transparent on paper and dries quickly. The dyes in markers fade after exposure to light, and color drawings that are to be displayed for any amount of time should be protected by a clear-plastic sheet or glass that contains ultraviolet-light-screening agents.

marker base The initial coat of color applied by a marker to the surface of a drawing.

medial mixture The color created as the result of a visual averaging or mixing of several different colors.

mingling An intermixture of different colors in which each color retains some of its original identity. Minglings were often used in watercolor renderings, and similar effects may be achieved with colored pencils.

monochromatic The use of a single hue. In monochromatic-hue schemes the dimensions of value and chroma may vary, but only one hue is used.

Munsell Student Charts A series of 10 hue charts and another chart containing the Munsell color wheel, a value scale, and a sample chroma scale. These charts are useful references for color compositions and can be obtained from: Munsell Color, 2441 North Calvert Street, Baltimore, Maryland 21218. Telephone: (301) 243–2171.

Munsell System of Color A system of color in which color is organized visually rather than according to the mixture of pigments or dyes. It was originated by Albert H. Munsell in 1898, and the Munsell Color Company was formed shortly before his death in 1918. This system, like all color systems, originated from the need to describe colors in definite terms.

naturals Colors that occur in nature. In interior-design work the colors of wood and leather (reds, yellow-reds, and yellows with lower ranges of value and chroma) are often referred to as naturals.

neutrals White, black, and the grays.

pattern Markings, usually repetitive, that are visible by virtue of their contrast with the background. Among the patterns used in interiors are checks, stripes, plaids, polkadots, floral designs, hexagons, and repeating designs.

persuasive drawing A drawing done at the end of the design process that is used to persuade or sell a client or others on the design. This term was coined by William Kirby Lockard in his book *Design Drawing*.

principles of composition Fundamental postulates, common to all the creative arts, that are employed to create order from chaos. The basic principles are harmony, rhythm, and balance, aspects of which are dominance, contrast, and repetition. They are meant to be used as guidelines rather than as laws.

print A reproduction of a drawing. In the context of this book a print is made by the diazo printing process.

progression A scale of colors formed by the orderly variation of one, two, or all three dimensions. Progressions can be chosen from hue charts or a color solid or formulated by invention, provided that the variation of dimensions is *consistent* among the colors used.

rendering A term usually used to denote a more elaborate, finished drawing such as a persuasive drawing.

repetition The distribution of the dominant qualities of a color composition throughout the composition in order to unify it.

restraint The limitation of a color dimension to variation only within a given range.

scheme of hues A selection of hues, chosen from a particular pattern on the color wheel, for a color composition.

shade The lack of light on a surface that faces away from the main light source.

shade (of a color) The color resulting from the addition of black to a pure hue.

shadow The absence of direct light on a surface, caused by an intervening object.

source file A file of color clippings, usually from magazines, which is used as a color, form, light, and texture reference for drawing.

spectrum value The inherent value of a color at its strongest chroma.

stipple The addition of small dots to a drawing with a pen or pencil, usually to create a visual texture.

subordinate area An area in a color composition that does not possess the dominating limits placed on any *one* color dimension.

tint The color resulting from the addition of white to a pure hue.

tone The color resulting from the addition of gray to a pure hue.

toned paper Any paper that is not white but has a gray or colored surface. The toned papers most commonly used for the type of drawing discussed in this book are diazo-print papers, which run at a faster-than-usual speed through the print machine.

triad Any three hues that are equidistant on a color wheel and whose connecting paths form an approximate equilateral triangle.

value The lightness or darkness of a color or a colorless area.

value opposition The contrast caused by the meeting of two opposite graded washes.

vellum A translucent drawing paper suitable for diazo printing. A common type is Clearprint 1000H.

visual mixture, medial mixture The color resulting from the blending by eye of several different colors.

warm gray A gray that is very slightly reddish, such as that produced by a warm-gray marker or colored pencil.

warm hues Hues that are associated with warm temperatures. Red, yellow-red, yellow, and green-yellow are warm hues on the Munsell color wheel.

wash A coating of colored pencil, usually applied over a marker base.

Index